(SOLOMON)

WITHDRAWN

(SOLOMON)

The Vision
of
Simeon Solomon

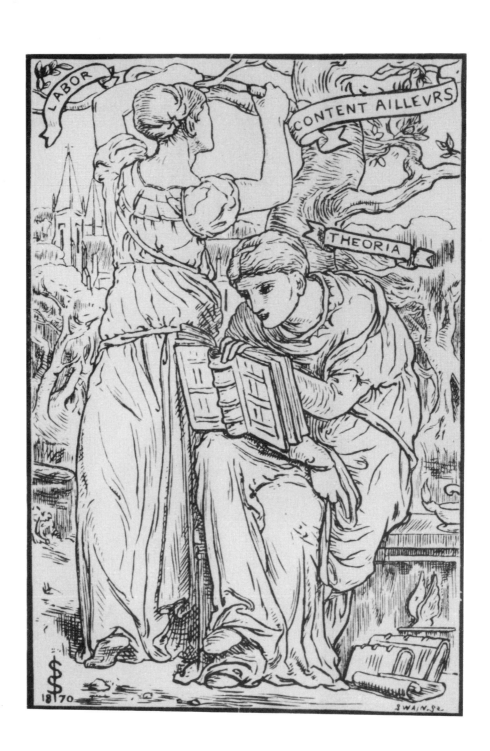

The Vision of Simeon Solomon

by
Simon Reynolds

Including a reprint of Simeon Solomon's
A Vision of Love Revealed in Sleep
originally published privately in 1871

CATALPA PRESS LTD.
STROUD, GLOS.
1984

Published 1985 by
Catapla Press Ltd.
Upper Vatch Mill, The Vatch, Slad, Glos,
04536-4270

Copyright© 1985 Simon Reynolds

Printed in England

Bound by Braithwaites of Wolverhampton

ISBN 0 904995 07 0

*The hand which hath long time held a violet
doth not soon forego her perfume, nor the cup
from which sweet wine had flowed his fragrance.*

John Addington Symonds
from "The Idyllists", *Studies of the Greek Poets,* 1873.

*I dreamed we were together on blue waves
Sailing at eventide an unknown deep,
Where charmed islands bathed in summer sleep,
Breathed shrill sea-music from their agate caves:
Love, the immortal youth of sixteen years,
With wings upon his shoulders and a star
Trembling above those eyes that pierce so far
Beyond the future of man's hopes and fears,
Steered us with singing: but I might not heed;
For with a dread my gaze was fixed on high,
Where burned the broad red sail against the sky,
And on the sail the semblance of a steed,
White as sea-foam and winged, which snorting bore
A dead man o'er blue waves for evermore.*

John Addington Symonds
from "Stella Maris", *Vagabunduli Libellus,* 1884.

PREFACE AND ACKNOWLEDGEMENTS

A Vision of Love Revealed in Sleep, Simeon Solomon's prose poem, since its original limited private publication in 1871, has not been republished in the United Kingdom. As an integral part of the spectrum of Pre-Raphaelite literature, the unavailability of this work makes a reprint long overdue.

Although, in publications concerned with the period, a number of authors have written about Simeon Solomon, only one American book has, so far, been dedicated exclusively to the artist: *Simeon Solomon, An Appreciation* by Julia Ellsworth Ford, published by Frederic Fairchild Sherman in New York in 1908.

The intention of this publication is to reprint *A Vision,* fitting the prose poem into its correct context in Solomon's life story and into the spectrum of his visual creative work. It is not my aim to write a full biography since Mr Lionel Lambourne fortunately already has this project well in hand. This book does, however, collate a wide range of previously scattered material, both published and unpublished, from which pieces we must endeavour to assemble a composite picture of Solomon's life. Although Solomon almost invariably signed and dated his pictures he very rarely dated his letters, making the correct sequence of his correspondence almost impossible to follow. Picture titles, over the years, have changed considerably, rendering exact identifications hazardous at times.

Nevertheless it is hoped that this accumulation of facts, combined with a regrettably incomplete number of illustrations of his better paintings and drawings, will throw some light on the hazy career of this neglected but highly talented artist.

This book would never have been possible without the initial assistance received from Mr Lionel Lambourne and the guidance that his earlier publications on Solomon have afforded me. I would like to express my gratitude for this help. I should also like to acknowledge and thank the following individuals and institutions for either their active assistance and advice or their kind loan of the photographs without which this publication would be meagre indeed:
Mrs Gayle Seymour; Mr Peter Day; Dr Paul Delaney; Mr David Gould; Mr Kent Hawkins; Mr Charles Jerdein; Mrs J. Carver; Mr D.F. Cheshire; Mr Raphael Salaman; Mr Steven Jones; Mr Christopher London; Mr Christopher Newall; Miss J. Ryan; Mrs Marjorie Salaman; Mrs Barbara Peck; Mr Peter Rose; Mr Albert Gallichan; Miss Pamela Solomon; Mr John Constable; Professor John Sparrow; Mr M. Parkhouse; Miss Isabelle Goldsmith; Mr R. Girouard; Mrs Berta Wortham; Mrs Betty Greaves; Mr Robert Walker; Mr David Swarbrick; Mrs Manson; Mr Julian Hartnoll; Professor M. Allentuck; Mr Robert Isaacson; Mr Ian Anstruther; Mr John Speed; Mr Stuart Pivar; Mr William Coltart; Mr Stephen Calloway; Mr Christopher Wood and the Christopher Wood Gallery, London; The University College of Wales; The National Library of Wales; The British Library; The Westminster Library; The Eastbourne Central Library; The Witt Library, Courtauld Institute of Art; The Senate Library, University of London; The Syndics of Cambridge University Library; The Library of the Royal Academy, London; The Houghton Library, Harvard University; Christie Manson & Woods Ltd.; Sotheby's Belgravia and Sotheby Parke Bernet & Co.; The Royal Albert Memorial Museum, Exeter; Mr Peyton Skipwith and The Fine Art

Society, London; The Piccadilly Gallery, London; J.S. Maas & Co. Ltd., London; The Hugh Lane Municipal Gallery of Modern Art, Dublin; The City Art Gallery, Manchester; The Whitworth Art Gallery, Manchester; The Fitzwilliam Museum, Cambridge; The Ashmolean Museum, Oxford; The Fogg Museum, Harvard University; Fondazione Horne, Florence; The Leger Gallery, London; The Henry E. Huntington Library and Art Gallery, San Marino, California; The Tate Gallery, London; The Museum of Fine Arts, Boston; The Ben Uri Art Gallery, London; The Yale Center for British Art; The Lady Lever Gallery, Port Sunlight; The Walker Art Gallery, Liverpool; Barry Friedman Ltd., New York; Mr Christopher Forbes and the Forbes Magazine Collection, New York; Warwick District Council Art Gallery & Museum, Leamington Spa; The Jewish Museum, London; The City of Birmingham Museum & Art Gallery and all those owners of illustrated paintings that I have so far been unsuccessful in tracing.

I would especially like to thank Mrs Alma Jackaman for typing my script, Mr Ian Kenyur-Hodgkins for arranging its publication, and my wife, Beata, and children Stefan, Olivia, Leila and Rupert for their general forbearance whilst the work was in progress.

The author would, incidentally, be very interested to hear of any Solomon paintings or drawings, especially from the artist's early life, that this publication might possibly bring to light.

CONTENTS

PLATES

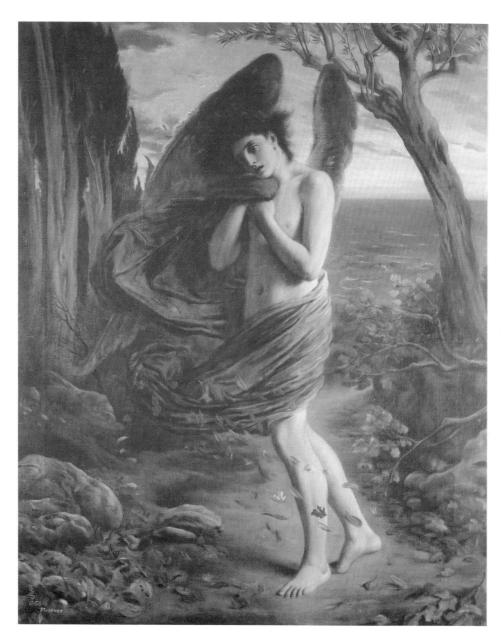

1. LOVE IN AUTUMN
 Oil 1866 Florence 84 x 66 cms. Private collection, London.
 The apex of Solomon's work as a Symbolist. This motive was used in
 A Vision of Love Revealed in Sleep.

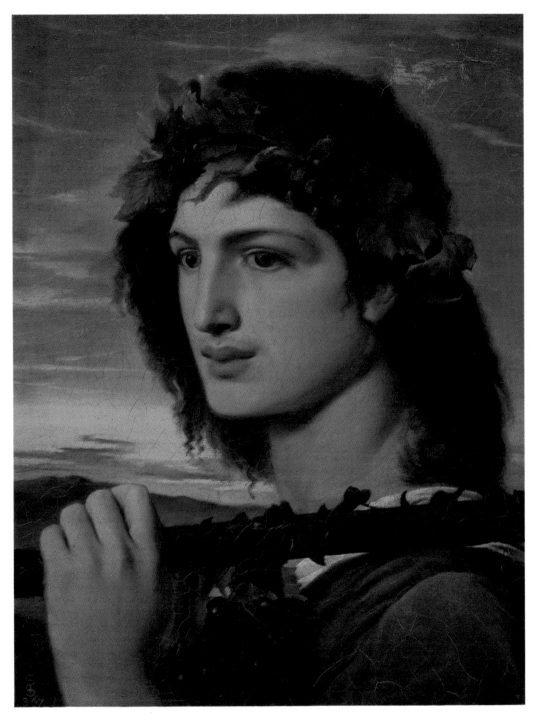

2. BACCHUS
 Oil 1867 50.8 x 66 cms. City of Birmingham Museum and Art Gallery.
 The dramatic painting which Walter Pater admired at the Royal Academy.

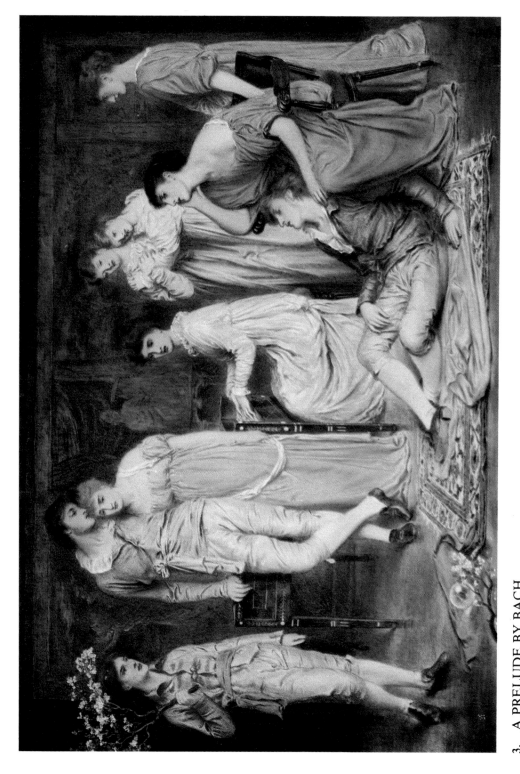

3. A PRELUDE BY BACH
Watercolour 1868 41.6 x 63.5 cms. Private collection, Norfolk.
Solomon's most gracious conversation piece.

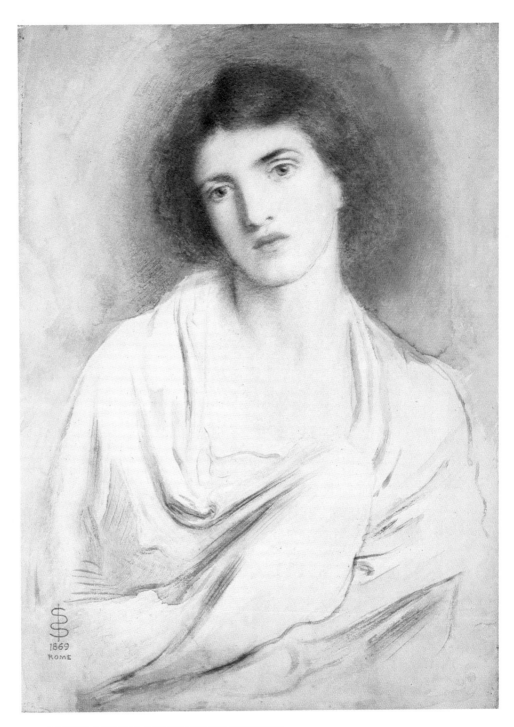

4. PORTRAIT OF AN ITALIAN YOUTH
Watercolour 1869 Rome 36.4 x 26.3 cms. University College of Wales, Aberystwyth.
Portrait of Solomon's Roman friend from his 1869 visit to Rome; bought by George
Powell.

5. IN THE SUMMER TWILIGHT Private collection, London.
 Watercolour 1869 50.8 x 69.8 cms.
 An Idyll depicting the Italian type of youthful beauty.

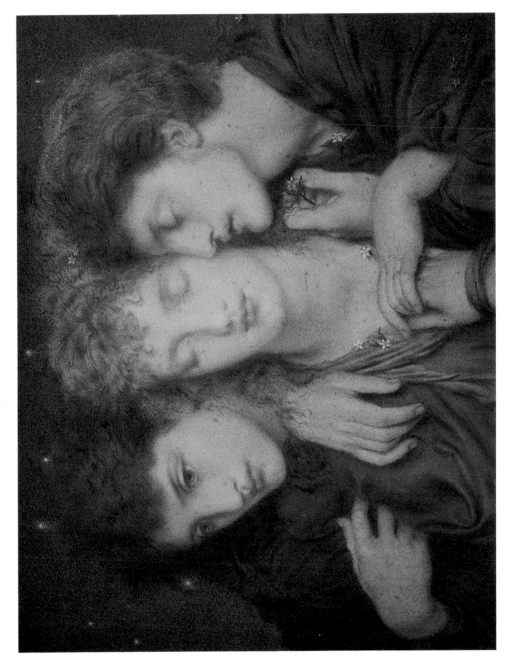

6. **THE SLEEPERS AND THE ONE THAT WATCHETH**
 Watercolour 1870 45 x 30.7 cms. Leamington Spa Art Gallery.
 A development of a drawing of the same subject of 1867. The painting of dreams and melancholy that
 Arthur Symons so admired; the inspiration of John Payne's three sonnets included in *Intaglios*.

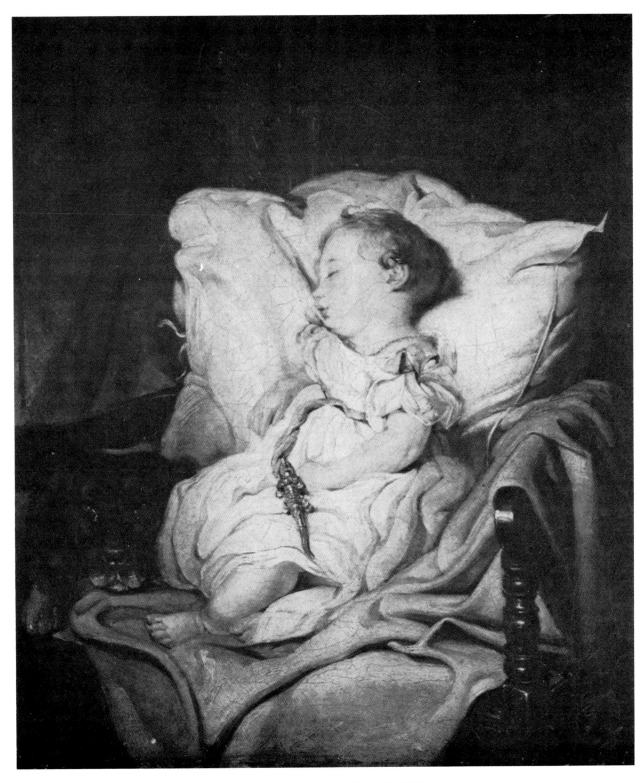

7. SIMEON SOLOMON AS A BABY BY ABRAHAM SOLOMON
Oil 1841 33.5 x 29 cms. Private collection, Hertfordshire.
Are the seeds of alcoholism already apparent in baby Simeon's facial expression?

CHAPTER I

The Young Artist

To burn always with this hard gemlike flame, to maintain this ecstasy, is success in life... while all melts under our feet, we may well catch at any exquisite passion, or any contribution to knowledge that seems by a lifted horizon to set the spirit free for a moment, or any stirring of the senses, strange dyes, strange colours, and various colours, or work of the artist's hands, or the face of one's friend... we are all under sentence of death but with a sort of indefinite reprieve... we have an interval, and then our place knows us no more... Our one chance lies in expanding that interval, in getting as many pulsations as possible into the given time. Great passions may give us this quickened sense of life, ecstasy and sorrow of love... Only be sure it is passion – that it does yield you this fruit of a quickened, multiplied consciousness. Of this wisdom, the poetic passion, the desire of beauty, the love of art for art's sake, has most... .

Walter Pater, from the "Conclusion" to *The Renaissance* 1868.[1]

Simeon Solomon was not the only young aesthete to derive inspiration from these provocative words from the pen of the shy and retiring Fellow of Brasenose, Oxford. Solomon, albeit in the different idiom of painting, had already reached the same artistic conclusions. In 1867 Solomon exhibited his oil painting *Bacchus* (Plate 2) at the Royal Academy. It caught Walter Pater's eye and in "Study of Dionysus"[2] Pater wrote "In a Bacchus by a young Hebrew painter... there was a complete and fascinating realisation of such a motive; the god of the bitterness of wine, of things too sweet; the sea water of the Lesbian-grape become somewhat brackish in the cup." However it is illuminating to note that when Pater published this paragraph on *Bacchus* he omitted any mention of Solomon's name. Solomon had fallen into disgrace and Pater was nothing if not cautious.

It is probable that Oscar Browning introduced Solomon to Pater sometime in 1868, and a friendship, which was to prove lifelong, soon developed between them. This relationship, at least in the early years, was to prove mutually rewarding. The youthful Solomon fascinated the don with his good looks, natural charm and witty conversation, whilst Pater offered classical erudition – a quality much admired by Solomon – and a certain tranquil wisdom. Pater's aesthetic creed made a deep impression on Solomon. He enjoyed meeting the don's literary friends, such as the poet Gerard Manley Hopkins and Ingram Bywater later Regius Professor of Greek at Oxford. Greater however was the appeal of Pater's entourage of the flower of Oxford's youth; the don and the artist shared a penchant for youthful male beauty. Although less immediately apparent, it is certain that Pater's influence on Solomon was as great as that of Swinburne or his artist friends Edward Burne-Jones and Dante Gabriel Rossetti.

Many and varied were the outside influences that served to fuel the meteoric rise and premature eclipse of Solomon's career. Although quick to

learn and precociously talented, Solomon's character was all too vulnerable to fervid intoxication and covert corruption. Behind his natural innocence lay an inner weakness which was to lead him inexorably to self-destruction.

Michael Solomon and his wife, Kate née Levy, were orthodox Jews. During the closing years of the eighteenth century Aaron Solomon, Michael's father, left Leghorn in Italy to settle in London, where he founded a flourishing millinery business. For a time Michael continued his father's trade but later redirected the firm into the embossing of doilies. A wealthy man, Michael was to become the second Jew to be accorded the Freedom of the City of London. Kate, who was known for her dark semitic beauty, sensitivity and amateur artistic talent, gave birth to eight children. Simeon, her youngest child, born on October 9th 1840 at Sandys Street, Bishopsgate Without, inherited many of his mother's characteristics. Michael did not long outlive the birth of his youngest son and Simeon was to turn to his brother Abraham, sixteen years his senior, as the father figure in the family.

Abraham was little more than seventeen years old when he painted his sensitive little oil of his baby brother Simeon (Plate 7). By the time Simeon had reached his early teens Abraham was an established Victorian painter of 'genre'' subjects such as his famous Royal Academy railway paintings *1st Class – The Meeting* and *3rd Class – The Parting*. Simeon followed his brother's footsteps, commencing his artistic studies at the age of ten in Abraham's studio at 18 Gower Street. The artist depicted in Simeon's watercolour *The Painter's Pleasaunce* of 1861 (Plate 22) is almost certainly his brother Abraham. His sister Rebecca, probably the model for Simeon's watercolour *Lady in a Chinese Dress* of 1865 (Plate 33) was eight years his senior. She had inherited her mother's striking Hebrew beauty and a lively artistic talent which was to benefit from her position as John Everett Millais's studio assistant. George du Maurier, the cartoonist and author, records visits to the Solomon family where he enjoyed both

their lavish hospitality and cultivated society [3].

It was Rebecca who taught Simeon to know and love the *Talmud* and to translate its mystic imagery into drawings inspired by the draftsmanship of her mentor Millais. She and Abraham sent young Simeon to Leigh's Art School in Newman Street and subsequently Cary's Academy in Bloomsbury. By 1855 he was studying with Edward Poynter and Henry Holiday at the Royal Academy School. One year later he formed a sketching club with Henry Holiday, Albert Moore and Marcus Stone. At about this time William Holman Hunt joined his wide circle of friends and it was probably through Hunt that Solomon met Frederic Shields. The sketching club introduced Solomon to country excursions and two enjoyable journeys were undertaken in the company of Henry Holiday, to the Lake District and later to Betws-y-Coed in Wales. David Cox had turned this remote but delightful village into a second Shoreham, a gathering place for young artists of the day. William de Morgan and his family were also companions on this trip.

These were happy days. Solomon lived with his mother and exchanged hospitality with the families of his brother artists. Cherished by his friends for his lighthearted charm and mischievous wit, he enjoyed a lively and entertaining social life. Henry Holiday in *Reminiscences of my Life*[4] writes vividly and enthusiastically about Solomon, with whom he shared a passion for music. He recounts how Solomon brought hilarity to the Artists Army Corps[5]. Upon being requested to swear an oath of allegiance he asked "Would the sergeant be satisfied if I just said 'drat it', as I have a conscientious objection to stronger language?" But in the same book Holiday sadly apologises for even introducing Solomon's name; fearful for his own reputation, he even fails to acknowledge Solomon's inspiration for some of his best paintings, namely those based on the theme of Joseph in Egypt. George Price Boyce, the watercolourist, in his *Diaries*[6], recounts a

visit to Abraham Solomon's studio in April 1857, when he was struck by Simeon's "remarkable designs showing much Rossetti-like feeling." In January 1859 Boyce mentions taking Solomon to see some of Rossetti's paintings at the Hogarth Club[7], whilst in April of the same year he mentions meeting Solomon and Edward Poynter at William Burges's rooms when he persuaded Solomon to give him a caricature of William and Jane Morris, newly drawn by the artist.

Sir William Blake Richmond, who met Solomon at the Royal Academy School in 1858, writes of him generously in *The Richmond Papers*[8]:

> Simeon Solomon was a fair little Hebrew, a Jew of the Jews, who seemed to have inherited a great spirit, an Eastern of the Easterns, facile and spasmodically intense, sensitive to extreme touchiness, conscious of his great abilities, proud of his race but with something of the mystic about him which was Pagan, not Christian. Quaint was his humour. He touched all subjects lightly and with so much brilliancy that the follies he uttered and wrote seemed to be wise and witty sayings. He twisted ideas, had a genius for paradox, and when in a humorous vein, speaking with assumed seriousness, he convulsed his friends with laughter by his strange weird imagination. When I first knew Simeon Solomon in 1858 his art was at its zenith. It was about this time that he made a noble series of designs wholly inspired by the Hebrew Bible, which were indescribably ancient-looking and strangely imbued with the semi-barbaric life it tells of in the *Book of Kings* and in the *Psalter of David*. So strongly was this the case that they seemed to be written in Hebrew characters; no one but a

Jew could have conceived or expressed the depth of
national feeling which lay under the strange, remote forms
of the archaic people whom he depicted and whose
passions he told with a genius entirely unique.

However, Richmond terminates his sketch by deploring Solomon's
development:

There are few more melancholy figures in the history of
genius than that of this vivid young Jew with his poetical
soul and his distorted mentality, a prey to forces against
which he was powerless to battle.

Solomon first visited Paris in 1859, gaining, no doubt, an early
impression of the art of Gustave Moreau and the French Symbolist school,
then in its infancy. Some years later he was to describe this period as
follows:

A History of Simeon Solomon from his cradle to his grave.
As an infant he was fractious. He developed a tendency
towards designing. He had a horrid temper. He was
hampered. He illustrated the Bible before he was sixteen.
He was hated by all his family before he was eighteen. He
was eighteen at the time he was sent to Paris. His
behaviour there was so disgraceful that his family – the
Nathans, Solomons, Moses, Cohens etc. et hoc genus
homo – would have nothing to do with him. He returned to
London to pursue his disgraceful course of Art, wherein he
displayed such marvellous exquisite effects of coleography
that the world wondered. He then turned his headlong
course into another channel – that of illustrating books for
youths. His *Vision of Love Revealed in Sleep* is too well
known. After the publication of this his family repudiated

him for ever. His appearance is as follows: very slender, dark, a scar on one or two eyebrows, a slouching way with him, a certain nose, one underlip.

That is Simeon Solomon[9].

There is a drawing in the British Museum by Solomon dated Paris 1861 from which we must infer that he made a further visit to Paris in that year.

Dante Gabriel Rossetti had long been Solomon's idol but it was not until early in 1858, when Rossetti was already thirty years old, that they actually met. Some months earlier, through an introduction by the sculptor Alexander Munro, Rossetti had invited Solomon to his studio at 14 Chatham Place, but Solomon postponed the visit explaining that he was "not yet advanced enough in manners" to present himself to the master. However, once they did meet, Rossetti invited the talented youth to work in his studio, teaching him the rudiments of Pre-Raphaelite draftsmanship and design[10]. With Rossetti, Solomon participated in the design of stained-glass for Morris, Marshall, Faulkner & Co. With Burne-Jones, in 1863, he worked on the stained-glass windows of All Saints Church, Middleton Cheyney, Northamptonshire, where he created the east window depicting the Tribes of Israel, and, about the same time, Rossetti used Solomon as a model in his *Sermon on the Mount* designed for Christ Church, Albany Street, London. In 1861 Solomon also collaborated in the decoration of a bookcase by William Burges, now in the Ashmolean Museum, Oxford. Work by both Simeon and Rebecca is to be found on the Rathbone Chess Table now in the Walker Art Gallery, Liverpool. It was at Rossetti's studio that Solomon met Frederic Leighton, William Morris and Edward Burne-Jones, whose ethereal style of painting was to have a considerable influence on the progress of Solomon's talent. Through Rossetti he also met the art dealer Murray Marks and collectors such as James Leathart and Thomas Plint, *nouveau-riche* industrialists who proved reliable patrons for Solomon

and his artist friends. Other patrons included Solomon's relations, Dr Ernest Hart and the Salamans, also Mr Craven and the most loyal of all his benefactors, William Coltart. Holman Hunt, Burne-Jones and even Rossetti, as far as his egotism permitted, seem to have developed a genuine fondness for Solomon, an affection that survived the tribulations of the coming years.

Most of Solomon's early paintings and drawings are based on themes from the *Talmud,* in particular *The Song of Solomon,* whose sonorous and sensual ritualism appealed profoundly to the young artist. At the age of sixteen he had already completed illustrations for *The Song of Solomon*[11], (Plate 13) and *The Book of Ruth,* although no record of these latter drawings remains. Burne-Jones, seven years Solomon's senior, was so impressed by the limpid grace of the eight drawings for *The Song of Solomon* that he insisted that Solomon was "the greatest artist of us all; we are mere schoolboys compared with you". A seventy-eight page sketch book,[12] which contained many drawings from these early years, provided his artist friends with ample evidence of his precocious talent and roguish humour. Typical of the same humour is Solomon's unpublished skit on the Pre-Raphaelite Brotherhood (PRB). Sometime in the late fifties, using Ruskin's *Pre-Raphaelitism* as a base, he wrote a mock self-interview entitled "The PRB Catechism for the use of disciples of that school (the monitor should if possible have red hair)." Ruskin comes in for merciless ridicule:

> What have you to say regarding the works of Turner?
>
> Regarding Turner I hold it my duty to admire and revere his works for Ruskin has spoken much about them in his books.
>
> Have you any further reasons?

No, for it is our natural condition not to esteem his works a
two penny piece!

Later, on the subject of Ruskin, Solomon comments, "I hold that he can not
be wrong, and when he contradicts himself he must be considered to have
two opinions, both of which are right, though different." In 1871 he wrote
another skit, this time on astronomy, and probably based on the treatise that
Solomon quoted to Burne-Jones and Poynter at a dinner party given by
Henry Holiday in 1864.

Solomon's first Academy picture, drawn and exhibited in 1858, was a
biblical sketch entitled *Isaac Offered;* but success at the Academy came
only in 1860 with his oil painting *The Mother of Moses* (Plate 18), an essay
on the subject of maternity, both tender and profound. In the *Roundabout
Papers* of 1860 Thackeray lavished praise on this painting, commenting "I
found it finely drawn and composed. It nobly represented to my mind the
dark children of the Egyptian bondage." The *Westminster Gazette* thought
otherwise, "Two ludicrously ugly women, looking at a dingy baby, do not
form a pleasing object."

Solomon's first book illustration was *The Haunted House,* drawn in
1858, to be etched as an illustration to the poems of Thomas Hood.[13] In
1862, the year of his brother Abraham's early death in Biarritz, Solomon
contributed two woodcuts depicting sacred ceremonies from contemporary
Jewish life, *Lighting the Candles on the Eve of the Sabbath* (Plate 25) and
The Marriage Ceremony to *Once a Week* volume VII, and a drawing
called *The Veiled Bride* to *Good Words.* In 1866, continuing the theme that
had inspired his illustrations for *Once a Week,* Solomon contributed ten
Rembrandtesque wood-engavings (cut by Butterworth and Heath) to *The
Leisure Hour* volume XV (Plate 26)[14]. Forrest Reid in his *Illustrators of
the Sixties*[15] says of these woodcuts: "Each one of these drawings is
brimmed up with atmosphere – an atmosphere strange, sad, exotic, alien...

Its emotion is a kind of nostalgia, a homesickness, a sickness of the soul..."
Richmond tells us that Solomon had already commenced the drawing of
this series as far back as 1858 (see Page 5) and his description of their
excellence tallies with that of Forrest Reid. During the early 1860s
Solomon prepared twenty biblical drawings to be engraved by the Dalziel
Brothers who in fact used six as illustrations for *Dalziel's Bible Gallery* in
1880. All twenty were eventually used as illustrations for *Art Pictures from
the Old Testament,* 1897 (Plates 34 and 35).

Solomon exhibited biblical scenes at the Royal Academy each year
until 1865 when his *Habet* (painted 1864 but present whereabouts
unknown) caused a stir amongst the critics. *Habet,* illustrating White
Melville's novel *The Gladiators,* represents an ancient Roman gladiatorial
combat: Roman ladies are calling for the death sentence on a fallen
combatant and their elegant figures vividly depict a fine yet merciless
feminine cruelty. In a letter to Isabella Blagden of November 26th 1866[16],
Robert Browning, who had noticed *Habet* at the Royal Academy,
described it as "the best picture in the Exhibition where I saw it – that
Habet, which was fine indeed." Robert Browning was soon to join the circle
of Solomon's eminent friends. After the success of *Habet* Solomon was to
move away from his traditional Hebrew subjects towards his own
idiosyncratic style of classicism. The Dudley Gallery also patronised
Solomon, arranging a one-man exhibition to promote his drawings and
watercolours which were gaining popularity amongst a small but discerning
clientèle. In 1865 Frederic Hollyer issued a portfolio of twenty photographs
of Solomon drawings, some somewhat risqué in subject-matter, dedicated
to Edward Poynter, and Hollyer continued subsequently to photograph
most of Solomon's paintings and drawings.

Solomon's move to classical themes coincided with a falling away of
his Hebrew beliefs in favour of the then fashionable Oxford Movement

towards Roman Catholicism. The Church of Rome's facade of pomp and ceremony much appealed to the aestheticism of the artist. The faith and imagery of his forefathers was however never fully abandoned. The sincerity and archaic remoteness to be found in his Hebrew paintings stems directly from a profound understanding of his racial heritage. His work in this tradition is often considered to out-shine that of his later allegorical pictures; certainly in some of his early drawings and watercolours there is to be found a delicacy and refinement which is clearly on a par with Rossetti's and Millais's early oeuvre. This Pre-Raphaelite influence is especially evident in such drawings as *David playing to King Saul* (Plate 16), and *Dante's first meeting with Beatrice* (Plate 28).

His portrait drawings are rare but he did draw his friends Burne-Jones, Swinburne[17], Lord Tennyson, Blake Richmond, Oscar Browning (see page 17 for comments on these two drawings) and even, in 1872, *Walter Pater* (Plate 61), who was most reluctant to sit to any artist. But the most remarkable of these portrait drawings is his own self-portrait of 1859 when he was nineteen years of age (Plate 8). His epicene sensitivity, intense sad eyes and sensual mouth are, in this drawing, more vividly apparent than in any photograph (Plate 9) or written description of the young artist (see Page 21). After the death of his brother Abraham, Solomon moved studios many times, from 18 Gower Street to 18 John Street, Bedford Row (his mother's home), from 26 Howland Street to 106 Gower Street and on to 12 Fitzroy Street. At first he shared lodgings with his sister Rebecca, but later, having established his bachelor independence, his habits became increasingly nomadic and his relationship with his elder brother Sylvester, and the rest of his family, tenuous in the extreme. Rebecca's behaviour was equally erratic and her affair with Swinburne proved as unsatisfactory as might be expected from the poet's physical and emotional inadequacy.

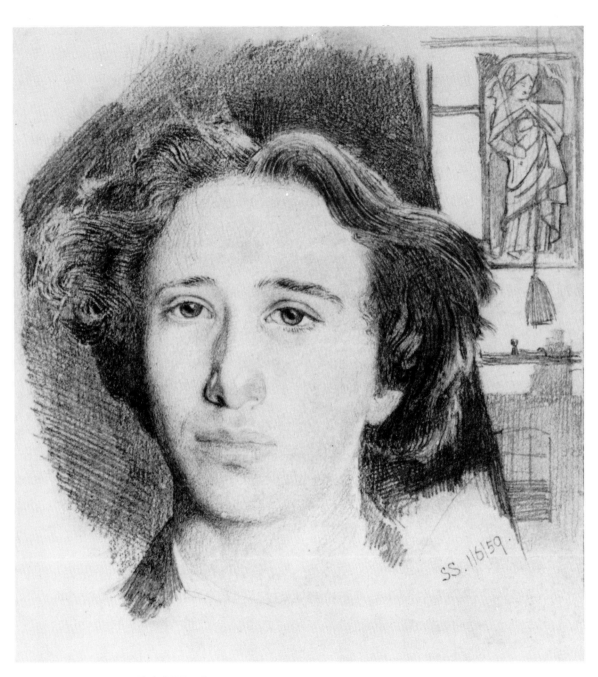

8. **SELF PORTRAIT AGED 19**
Drawing 1859 16.6 x 14.7 cms. Tate Gallery, London.
Solomon's best portrait drawing.

CHAPTER II

Amongst the Aesthetes

Algernon Swinburne, the poet, then aged twenty three, was delighted to meet Rebecca's younger brother, three years his junior, at Rossetti's studio. They soon struck up a lively friendship. For his part Solomon was dazzled and flattered by the poet's attentions. Swinburne, a dramatic and controversial figure with a shock of red hair and a lean and willowy figure , was already famous. His febrile yet brilliantly quixotic poetry, like Rossetti's own poetic work, expressed in words much of the artistic imagery of the Pre-Raphaelite Brotherhood. Unfortunately the influence of Swinburne's unstable character on the all too impressionable Solomon was to prove fatal. The artist's youthful innocence was no match for his mentor's capriciousness. Swinburne's nick-name for Solomon, "The Lamb", was all too apposite. Before long both Solomon and "Ned" Burne-Jones were drawing frivolous illustrations to Swinburne's de Sade-inspired *Lesbia Brandon* and "The Flogging Block", an unpublished poem on the esoteric pleasure of the rod[18]. Burne-Jones wrote to Swinburne "of his whole morning spent in making pictures with the "Jewjube" to themes that Tiberius would have given half his provinces for." Regrettably Burne-Jones was far too discreet to keep either these drawings or their related

correspondence. Swinburne, on the other hand, retained many of his friends' letters, including those from Solomon, and these have been edited by Dr Cecil Lang in *The Swinburne Letters*[19]. Some of Solomon's related drawings are also extant, (Plate 40).

Rupert Croft Cooke in his chapter on Solomon and Swinburne in *Feasting with Panthers*[20] quotes extensively from *The Swinburne Letters* and it is soon apparent from their correspondence between 1869 and 1870 that Solomon, in pretending to be a disciple of de Sade, is simply pandering to Swinburne's predilections. In September 1869 Solomon replies at length, and in a frivolous vein, to what must have been a scandalous letter from Swinburne's pen. He explains that the excitement he derives from the rod is relative and that "my affections are divided between the boy and the birch." In November 1869 he writes to Swinburne: "I had a shocking dream the other night, I dreamed that a cat and a sheep had connection and the hideous offspring appeared a few minutes after the event, it was a little black creature with long nails of wire which fastened into me and as I pulled them out they became alive like worms, ...". T.Earle Welby, in *The Victorian Romantics*[21] gives us a facsimile of Solomon's letter to Swinburne of May 15th 1871 concerning the trial of the transvestites, Boulton and Park, an event which caused some public stir due to the accused's acquaintance and incriminating correspondence with various figures in public life. There is no record of Swinburne's reply, indeed such may have been his lack of interest in the subject that he did not bother to reply at all. Boulton and Park were eventually acquitted along with their other accomplices, a judgement which delighted Solomon[22].

Solomon's efforts to amuse Swinburne were already leading him into theatrical charades of questionable taste. Dr G.C.Williamson, in *Murray Marks and his Friends*[23], writes of Solomon: "Once, in fact, at Swinburne's house, he assumed Greek costume, and, with laurel wreath and lyre,

ERRATA

THE TITLE OF PLATE 33 SHOULD BE CORRECTED TO "THE JAPANESE FAN", WITH A JAPANESE RATHER THAN A CHINESE SETTING.

sandals and long flowing drapery, looked a veritable Apollo, with exquisite profile and brilliant far seeing eyes." Whilst at more private moments, in Rossetti's home at 16 Cheyne Walk, he and Swinburne would pursue each other stark naked, cavorting rowdily "like a couple of wild cats" round the artist's studio, earning thereby Rossetti's chagrin at the interruption of his work.

Through Swinburne's introduction Solomon was invited, in the summer of 1868, by the notable hedonist and patron of the arts Richard Monckton Miles, Lord Houghton, to visit his Yorkshire estate, Fryston Hall. Here likewise Solomon appeared in fancy dress, impersonating a Jewish prophet he declaimed long passages of Hebrew ritual in a sonorous voice, (Plate 9). Whilst staying at Fryston he met Oscar Browning, a rich Etonian tutor with classical and pederastic tastes. After Yorkshire Solomon visited the Lake District with Cyril Flower, later Lord Battersea, a noteworthy collector of fine art. Back in London he led an active life, his time being spent between painting commissions for his friends at his studio at 12 Fitzroy Street and frequenting his clubs, the Savile Club at 15 Savile Row and the Arts Club in Hanover Square. In 1868 he presented Pater with the drawing *The Song of Solomon* (Plate 49), which was presumably a study for a now untraced oil of the same subject.

Oscar Browning retained most of the voluminous correspondence addressed to him and thirty-four letters from Solomon have survived[24]. It seems that Browning went abroad after their meeting in Yorkshire and Solomon wrote to him at Eton to welcome him home. Solomon was invited to pay a winter visit to Eton and this visit appears to have been a roaring success. In future letters Solomon drops the formal approach of "My dear Browning", in favour of "My dear Oscar", an intimacy rarely permitted by Browning. Their subsequent correspondence consists for the most part of frivolous badinage and risqué gossip about their lives and loves. When in

England, Solomon spent much of the next four years travelling between Browning at Eton, Pater at Oxford and his artistic obligations at his London studio.

After his first visit to Eton Solomon writes:

> How is the dear slim angel out of the circular Botticelli? Present my spiritual kiss to him if you please, also to Julian Storey and the sad beauty of the bank. Do you keep a thermometer for testing love at Eton? I think you should, for I am certain that Love proceeds from one person to another in waves on the air – at Oxford I should think it would always be 110 in the shade and thousands in the sun.

The circular Botticelli was a copy executed in Florence for Browning but the identity of the enchanting bank-clerk remains a mystery. Solomon refers to him again in a further letter: "How is the fine gold becoming dim at the bank? I am trying to remember his face for the principal youth in my picture." Of Gerald Balfour, one of Browning's favourite pupils, Solomon writes "Balfour should be beaten, he should be scourged with rods of iron, pray, my dear Oscar, beat him till the wings, which are latent in his shoulder blades, sprout."

Solomon did his best to entice Browning to visit him more frequently in London:

> ... do let me know when you can come. I want especially to have two evenings – one for youth and beauty, the other for intellect that dear abode of love. [Thomas] Hood will be here and is anxious to meet you, I hope we shall be able to dine together. I went to Oxford for a night and lunched, etc. with him, he was so kind and sweet but I wish he was a year or two younger.

On another occasion he writes "I want you to see my new young friend – he has the face of an angel – I draped him in silk attire the other day and he was delightful and O! he is so, so kind." In the winter of 1868, when planning his two portrait drawings of Browning, Solomon wrote frivolously to his friend, "I want to draw you... as the Bridegroom in *The Song of Songs*. I shall crown you with a circlet of embracing loves, and the spikes shall be represented by wings and myrtles." In reality these portraits are somewhat mundane. Amongst Solomon's minions, about whom he wrote glowingly to Browning, were a certain "Hughes" and the "youthful Robertson". In a list of his oeuvre Solomon mentions a drawing of two heads (possibly Plate 52) of two youths who were to become the portrait painter Johnston Forbes-Robertson and the historical genre painter Edward Robert Hughes. Both artists would have been in their teens at the time of the Solomon-Browning correspondence, which incidentally, apart from two subsequent begging letters, terminated in 1872.

Irony sometimes creeps into Solomon's letters to Browning: "It is such a comfort to me to reflect that while the lack of the 'Common basis of a classical education' precludes all possibility of intellectual equality it does not banish me utterly from your presence: my friends and I have much enjoyed your little trumpet blast of superiority over me, ...". From these and further letters to be quoted in their correct contexts it is apparent that this lively and mutually rewarding friendship played a vital role in Solomon's life over a period of five years. The only criticism that one might be tempted to level at Browning and his influence upon Solomon is that he undoubtedly encouraged the artist to indulge the homosexual proclivities that were latent in his nature.

It was through Swinburne that Solomon encountered another eccentric character of the aesthetic movement, George Powell, a Welsh squire with tastes similar to those of Browning, if somewhat more rustic. Solomon

shirked the long journey to Powell's home, Nanteos near Aberystwyth, but Solomon's letters to Powell[25] give ample evidence of the Welshman's active involvement in his London social life. There is a marked similarity in these letters to the Browning correspondence: "I took the liberty of borrowing your Petronius, I wanted to read it to a sympathetic audience of one." "Please keep yourself disengaged for Thursday evening next, I am going to have a party, but I know what an elephant you are – I am going to put an agreeable looking Italian person in the white silk you wrote of." This would seem to have been the same "new young friend" about whom he wrote to Browning and one wonders if it may have been his Italian model Gaetano Mao? In a number of his compositions Solomon used this young Calabrian of Greek origin as a model, having discovered him about this time playing a harp in Gower Street. However, Gaetano's beauty was such that Solomon soon lost his services to his brother artists, George Heming Mason, Leighton, Holiday, Burne-Jones, (who employed him to sit for *Love amongst the Ruins*), and finally Blake Richmond, in whose studio Gaetano remained. In another letter Solomon asks Powell if he will halve the guinea cost of twenty photos of a model that he nicknames "the Good Shepherd", "if he will sit in that attractive costume." Powell also proved a useful patron commissioning paintings from both Solomon and his sister Rebecca.

Solomon, however, did not restrict his journeys to Eton and Oxford. In the autumn of 1870 he travelled to Yorkshire to visit his friend John Roddam Spencer-Stanhope, the Pre-Raphaelite painter; this journey took him as far as Tynemouth and back via Manchester and Warrington. In the autumn of 1870 and again in the following spring he visited the authoress Mrs Pender Cudlip and the Thomas family in Torquay. To Swinburne he writes "I beg to state that I did not pend her cudlip."

By far the most ambitious of his travels were his three journeys to Italy. 1866 found him in Florence studying the Old Masters, in particular the

works of Botticelli, Luini and Sodoma, artists whose influence was to be felt in the development of Solomon's painting. He rented a studio at 14 Langarno Acciajoli and executed what is probably the finest oil of his classical period, *Love in Autumn* (Plate 1). That winter he reached Rome where he painted *Rosa Mystica* (Plate 45), his vividly sensual watercolour *Bacchus* (Plate 43), and his watercolours *A Greek High Priest* (Plate 47) and *A Saint of the Eastern Church* (Plate 48). Back in London he completed his celebrated oil painting *Bacchus* (Plate 2) which Pater was so much to admire at the Summer Exhibition of the Royal Academy.

In 1869 Solomon and Browning, accompanied by young Gerald Balfour, visited Italy. In Rome Solomon continued his study of the Old Masters, waxing lyrical about Titian's *Sacred and Profane Love* whilst attempting to teach a somewhat prosaic Browning an appreciation of the nuances of colour to be found in the masterpieces of the Renaissance, in addition to the niceties of the pictorial line. In *Memories of Sixty Years*[26] Browning complains that, whilst in Rome, Solomon created nothing more than a drawing of an Italian youth[27] whose beauty had deeply impressed the artist (Plate 4). In a letter dated December 2nd 1919, addressed to Joseph Leftwich, Browning comments "I do not remember the name of the Roman boy, who was beautiful and quite innocent. He thought that people were circumcised in the forehead." Solomon remained in Rome with the young Italian whilst Browning continued on to Sicily with Balfour. Browning was however unjust in accusing the artist of idleness, beside the brilliance of the "drawing of an Italian youth" Solomon was hard at work on another creative project, not painting this time, but rather his prose poem, later to be published as *A Vision of Love Revealed in Sleep*. Undoubtedly the Italian youth proved a decisive inspiration for the poem; surely it is he who becomes the mystic figure of the "Soul" or the artist's *alter ego*.

On August 20th 1917 Edmund Gosse wrote to Robbie Ross on the

subject of Solomon[28]; he terminates the letter with the statement that Solomon had been obliged to leave England in 1870 to avoid the possible repercussions of the breaking of a potential scandal at home. Browning only tells us that he financed and accompanied Solomon on another trip to Rome in order to observe the splendour of the First Vatican Council. Again Balfour seems to have accompanied the friends but once more their paths were to divide once they reached their destination. Solomon found a new attachment, Willie, whose home was at Warrington but whose presence in Rome remains unexplained. Solomon and Browning appear to have had separate lodgings since Solomon writes from 51 Piazza Barberini "I will be at the Braccio Nuovo tomorrow morning soon after ten with Willie who has been inexpressibly sweet to me – we shall dine this evening at the Botticella." Whilst in Rome Solomon painted his watercolour *Dawn* (Plate 58).

Browning and Balfour pressed on south to visit Naples and upon their return to Rome Browning was surprised to find that Solomon had departed with Willie. In a letter from Hotel Vittoria, Venice, Solomon sent Browning his abject apologies for his ill-mannerly disappearance. He relates how they visited Florence, where they were invited to a strawberry party by Mrs Trollope, and how they subsequently made their way to Venice. Upon his return to England, Solomon again wrote to Browning describing the remainder of their trip; how they had travelled via Verona and Mont Cenis; how they had got separated at a little station near Chambery where Willie had managed to get himself left behind, and how Solomon had reached Paris alone but had re-found a penniless Willie upon meeting the next train from Italy.

To make amends to Browning, Solomon, upon his return to London, set about preparing his friend's bookplate (Plate 54), a labour of love that caused the artist some trouble and disappointment. He sent Browning the

drawing and asked his friend's approval since he himself was dissatisfied with his endeavours to portray the conflict between the figures. In a letter from Warrington, where he was visiting Willie, he writes "I am disappointed with the cutting [the bookplate had been engraved by Swain]... and I sincerely hope you will not be disappointed with it... The dear Roman Willie lives here or rather near – I have had him photographed in divers manners, I think the result very successful but you shall judge for yourself." Long after, whilst reminiscing about his friendship with Solomon, Browning was to blame Solomon's wayward behaviour and drunkenness on Swinburne's bad influence. He comments that Solomon's "only true friends apart from artists were Pater and myself whom he really loved and we loved him. Simeon was certainly not good-looking, rather the reverse, he was thick and not physically impressive. He was very Jewish but not of an attractive type."[29]

It is however clear from Solomon's letters during this period that he was working hard at some of his best paintings. In November 1869 he tells Swinburne of his watercolour *In the Summer Twilight* (Plate 5) which he is painting for "a most charming little clergyman who unites religious unction with the broadest aesthetic views."[30] In 1870 he wrote to Browning "I have such a strange thing, yea, two strange things, to impart when we meet – I want you to see the 'Sleepers and Watcher' which I am now painting." This is his mystical watercolour *The Sleepers and the One that Watcheth* (Plate 6), for which he had done a preparatory chalk drawing in 1867.[31]

Work may have been Solomon's excuse for the disorderliness of his lifestyle in the early 1870s but the true responsibility lies rather with a growing inclination to drink to excess. Solomon tells Browning "George Howard called the other day, I hope he doesn't want to lecture me." Howard, later 9th Earl of Carlisle, was not only a talented amateur artist but also a keen advocate of temperance! Upon his return from Italy, in

1870, Solomon visited Murray Marks to gain advice as to how he could sell a portfolio of drawings; Marks offered to help but was struck by an evident degeneration brought on by alcoholic over-indulgence.[32] The self-indulgence in Solomon's personal life was not however restricted to alcoholism. His eccentric lifestyle was governed by the cult of youth, an idiosyncrasy of character taken, in his case, to a dangerous excess. Decorative youth alone monopolised his canvases whilst its accompanying imagery permeated deep into his psyche. His hankering after his own lost youth led him to shed his beard, an act contrary both to Victorian and Jewish convention.

It is evident that Solomon's role of *poseur,* similar to that which Wilde was later to adopt before his downfall, was highly embarrassing to the artist's family. They apparently protested at his meretricious conduct and on February 21st 1870 he apologised profusely, if somewhat ironically, to his sister-in-law Eliza, Mrs Sylvester Solomon:

> My behaviour has been perfectly disgraceful. I can hardly
> ask you to forgive me, but I hope you will do so without. I
> shall go and see you one evening this week if I can, but I
> must not make a promise, for when I have made one I have
> always a desire to break it. That is giving myself a pretty
> character, isn't it?
> Believe me, in spite of my conduct.[33]

The publication in June 1871 of *A Vision of Love Revealed in Sleep* contributed further to Solomon's alienation from both his family and the staider elements of Victorian Society.

At this stage in the narrative of Solomon's career we should dwell awhile on his artistic progress, on the acclamation or disparagement that his exhibited pictures received. After the artist's first visit to Italy, Italian themes and the languorous sensuality of Latin beauty recur constantly in Solomon's subsequent work. Years later, to Julia Ellsworth Ford, the

American writer, Solomon spoke with nostalgia of his longing to return to Rome, "if my shoes would take me across the water I would walk every step of the way."[34] It was Solomon's love of Italy which must have created a bond with Frederic Leighton, in whose palatial home, Leighton House, he was a welcome guest.

By the late 1860s the transference to pagan and classical themes was almost complete. Where Solomon still painted religious subjects such as *Carrying the Scroll of the Law* (Plate 46)[35], *A Greek High Priest* (Plate 47), *A Saint of the Eastern Church* (Plate 48) and *The Mystery of Faith* (Plate 57), the ambience is one of physical intensity encompassed in a glowing incense-pervaded sanctuary, atmospherically esoteric, pagan rather than Christian, Solomon's figures cease to depict historical or specific religious personalities; instead, impersonal in subject, they don a mystical often androgynous aura of sanctified youth, enigmatic, deified and isolated. In his classical paintings the naked or richly clothed bodies are handsome yet hollow shells; each incorporate figure harbours an individual yet universal soul. The eyes become dim portals to opaque pools of reflection; enchanted they lead us to the soul's inner depths. In various contexts in *A Vision of Love Revealed in Sleep* Solomon himself provides the key to this private world into which we are initiated through the silent imagery of his brush. Quoting from *A Vision,* his allegorised characters speak directly of his paintings:

His Soul: His face had on it the shadow of the consciousness of glad things unattained, as of one who has ever sought but never found, upon whom the burden of humanity lies heavy; his eyes, half shaded by their lashes, gave forth no light.

Love is the crown over us and the light about us. But through the veil of the darkness of the world this is not seen or known of men, but only through the spirit may it be made clear unto us; and the

> spirit soars aloft rejoicing and is girt about with delight because
> of it.

Time: In his eyes there shone a light of infinite memories.

Death: His bent face was overshadowed by the exceeding sadness of
 one who knows the thoughts of men.

Love: There lay the shadow which falls upon one not remembered. His
 eyes were yet soft with the balm of sleep, but his lips were parted
 with desire.

Most of his paintings at this time, and indeed to his life's end, bore allegorical titles such as Love, Sleep, Night, Memory etc. They represent ethereal figures, alone or grouped symbolically together, they tell the story of the transience of beauty and the fragility of human love. Often the figures are silhouetted against a deep azure star-studded sky, rich garments envelope them, blossoms lie listlessly in their languid hands or autumn leaves drift aimlessly across the canvases; the many-coloured wings of angels protect mortal frailty and the myrtle branch whispers evocatively of love and death. Those pictures directly illustrating *A Vision* are amongst the best in this idiom: *Love in Autumn* (Plate 1); *Until the Day break and the Shadows flee away* (Plate 52); *Night and her Child Sleep* (Plate 68) and *Then I knew my Soul stood by me, and he and I went forth together* (Plate 10), which Solomon actually used as the only illustration in the Ellis edition of his prose poem.

Arthur Symons in his *Studies in Seven Arts*[36] admired *The Sleepers and the One that Watcheth,* (Plate 6), which he describes as:

> Three faces, faint with languor, two with closed eyes and
> the other with eyes wearily open, lean together, cheek on
> cheek, between white, sharp-eyed stars in a background of
> dim sky. These faces, with their spectral pallor, the robes
> of faint purple tinged with violet, are full of morbid

delicacy like the painting of a perfume. Here as always there is weakness, insecurity, but also a very personal sense of beauty... .

Some of Symons's other comments, referring to Solomon's later paintings, are more mixed:

A void and wonderfully vague desire fills all these hollow faces, as water fills the hollow pools of the sand, they have the sorrow of those who have no cause for sorrow except that they are as they are in a world not made after their pattern... These faces are without sex; they have brooded among ghosts of passions till they have become the ghosts of themselves; the energy of virtue or of sin has gone out of them, and they hang in space, dry, rattling, the husks of desire.

If the Pre-Raphaelite artists often drew their subject matter from the poets, so also did the poets write sonnets to Solomon's paintings. Three sonnets in John Payne's *Intaglios,* written in 1871, were inspired by *The Sleepers and the One that Watcheth* (Plate 6), (see Page 99). Swinburne published his poem "The End of a Month" in April 1871 in Vol.1 of the Oxford monthly review, *The Dark Blue,* and Solomon illustrated the poem with a drawing of two heads. Solomon's *Damon and Aglae,* exhibited at the Academy in 1866, was the inspiration of Swinburne's poem, "Erotion", that speaks poignantly of the transience of human love:

... What even though fairer fingers of strange girls
Pass nestling through thy beautiful boy's curls
As mine did, or those curled lithe lips of thine
Meet theirs as these, all theirs come after mine;
And though I were not, though I be not best,
I have loved and love thee more than all the rest...

However there are other pictures by Solomon of this period, mostly of groups of youths and maidens, which, although painted with "an exquisite and epicene sensibility," exhibit an excess of delicacy bordering on flaccidity and preciosity. This criticism can be levelled at such works as *The Death of Love* (Plate 39); *A Youth relating Tales to Ladies* (Plate 56) and *The Singing of Love; Love amongst the Schoolboys* (Plate 38), might also be grouped in this category, but, like *The Bride, Bridegroom and Sad Love* (Plate 36), and *Socrates and his Agathodaimon* (Plate 37), its originality lies in the overt moral provocation of its subject-matter. *Love amongst the Schoolboys* (Plate 38), belonged to Oscar Wilde and was sold at the time of the dispersal of his Tite Street home. Wilde, who had known Solomon personally, was much distressed at the loss and, from Reading Gaol, he castigated Bosie (Lord Alfred Douglas) for failing to repurchase the treasured drawing. Wilde, however, had already set the fashion amongst the young Oxford aesthetes of the 'eighties and early nineties'. Any undergraduate whose walls did not boast a Solomon watercolour, drawing or even one of that excellent set of photographs of Solomon's work taken by Frederic Hollyer, risked being considered by his more fashionable neighbours to be a mere philistine.

The art critics of the day were less flattering. Sidney Colvin, the leading art connoisseur, who was later to be knighted and given the Slade Professorship, was a personal friend of Solomon. To Swinburne, in a letter of November 1869, Solomon had heralded the forthcoming publication of a new art periodical, *The Portfolio,* and in the March edition of 1870 Sidney Colvin wrote a number of critical essays entitled "English Painters of the Present Day." Solomon was the subject of essay IV which was illustrated by a Hollyer photograph of *Until the Day break and the Shadows flee away* (Plate 52)[37]. For the most part Colvin eulogises Solomon but his praise is spiced with a clear critical warning. Although he compliments

Solomon on the success of *Habet* he questions such subjects of "strained and painful passion." He writes of the Dudley Gallery's exhibitions of Solomon's watercolours:

> In the management of water-colour Mr Solomon developed
> a peculiar genius. He produced a richness and splendour
> of effect in the imitating of lustrous or metallic surfaces,
> cloths of gold or silver, or gold or silver ornaments,
> crowns, chains, caskets or chased work, that no other
> painter has rivalled.

Colvin prefers the "purely Pagan studies" to those attempting a "mystical union of Pagan and Christian symbolism." Of the former, Colvin writes:

> Far more admirable have been some purely Pagan studies,
> especially two of the Dionysiac kind[38], one quite early and
> one more recent, in which solid richness of execution and
> intensity of sentiment – sentiment bordering a little on the
> crapulous, but here thoroughly in its place – have been
> carried about as far as they could go.

Of Solomon's contemporary classical designs Colvin comments that the:

> designs [are] always full of the prettiest painting, abounding
> in poetry both of colour and feeling, in grace although not
> in strenuousness of form and composition, in charm and
> beauty: but apt to err a little, I think, on the side of
> affectation and over-doing in the facial type, of insufficient
> manliness, of ambiguous and indiscriminate sentimentalism.

Colvin terminates his essay with a challenge to Solomon:

> ...while sometimes a study of one or more heads shows a
> real insight into, and real power of rendering, the more
> impassioned and mysterious kind of beauty in the faces of
> men and women. In the meantime, Mr Solomon has not

yet, I think, achieved any important work that is quite worthy of his powers; and one can not help wishing that he would bend himself to some grave enterprise of the old Biblical or Roman kind, instead of dispersing his energy in hints, sketches, and fancies however exquisite.

Solomon was not insensitive to criticism either personal or professional but on this occasion he seems to have chosen not to heed this sound and friendly counsel proffered to him. A harsher note of warning, likewise ignored, came from the pen of Robert Buchanan. In his famous attack on "The Fleshly School of Poetry" in the *Contemporary Review* of October 1871, Buchanan extended his criticism of Rossetti and Swinburne:

> English society goes into ecstasy over Mr Solomon's pictures – pretty pieces of morality such as *Love dying by the Breath of Lust*... Painters like Mr Solomon lend actual genius to worthless subjects and thereby produce monsters – like the lovely devils that danced round St. Anthony.

Even Robert Browning, in a letter to Isa Blagdon of February 24th 1870, waxed critical of the direction into which the artist's work was progressing:

> Simeon Solomon invited me the other day to see his pictures, but I could not give the time: full of talent, they are too affected and effeminate. One great picture-show at the Academy – the old masters' exhibition, – ought to act as a tonic on these girlish boys and boyish girls, with their Heavenly Bridegroom and such like.[39]

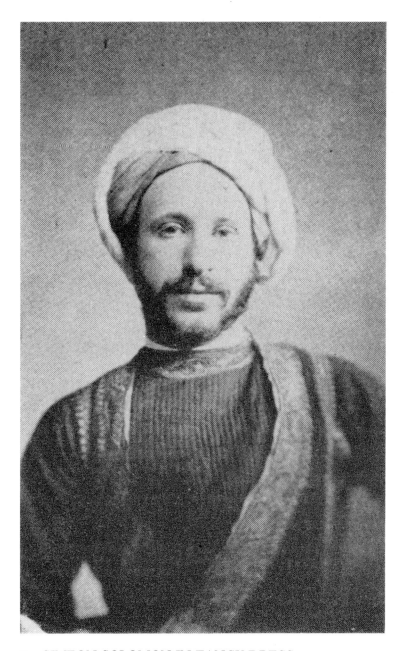

9. SIMEON SOLOMON IN FANCY DRESS
Photograph late 1860's.
A typical masquerade during the period
of Swinburne's influence.

CHAPTER III

Solomon had been preparing his prose poem for two years, since its initiation in Rome in 1869. He was determined to prove, both to himself and to others, that, like Rossetti, he too could be master of two mediums of art. Rossetti had just published the *House of Life,* Pater had won renown from his articles in the *Fortnightly Review,* Swinburne's *Atlanta in Calydon*[40] was the rage in advanced literary circles, so now the gauntlet lay at Solomon's feet. Beside the writings of his friends, his sources of inspiration were wide; Plato, Dante, Milton, Shelley, Keats and Novalis had much to offer whilst *The Song of Solomon* remained his primary inspiration. Nevertheless there is much of Solomon's own original and creative thought to be found in *A Vision of Love Revealed in Sleep* and a style of writing that created a considerable following on the romantic fringes of English literature. Marked similarities are to be found in John Addington Symonds's "The Valley of Vain Desires" and "The Lotus-Garland of Antinous"; in James Thomson's *The City of Dreadful Night*; in Lord Alfred Douglas's "Two Loves" and in A.E.'s "The Divine Vision". John Trinick in his little known *The Dead Sanctuary* and even W.B. Yeats, in his mystic poems, owe Solomon a debt. Solomon's influence on later painters is more limited but a clear and probably direct connection comes to mind in the sententious

haunted figures of the Belgian Symbolist, Fernand Khnopff. A more distant similarity can be found in the hieratic stylisation of the youths painted by the French Symbolist, Charles Filiger, and, from the same school, the dream-world of Lucien Lévy-Dhurmer.[41]

Although Solomon's tastes were extravagant he was not a rich man. His fractious relationship with his family must have limited the support he could expect from that quarter and his paintings never gained the type of recognition that built substantial fortunes for artists such as Millais and Leighton. His Academy pictures did not always sell and the prices he obtained for his watercolours at the Dudley Gallery were paltry. It was evident that monetary considerations would have to play a sizeable role in Solomon's determination to publish his prose poem, upon which he had been working since May 1869. His other main consideration was the somewhat risky nature of its content; in all probability Solomon dared not risk the probable humiliation he might suffer were he to attempt to hawk the script round the reputable London publishers. In consequence he decided to publish privately. Before, however, taking his irrevocable step he arranged for Spottiswoode & Co. to print a few copies of his prose poem, at that time entitled *A Mystery of Love in Sleep,*[42] for distribution amongst his close friends to test their reactions.

However, by the spring of 1871, he had decided to go ahead with the publication, despite his apprehension concerning costs. To Swinburne he mentions his fear that he might lose his entire £100 investment, whilst to Browning he writes:

> I have made a careful drawing of a frontispiece and I am
> thinking of designing a simple cover myself. I am going to
> publish it MYSELF but Ellis (Rossetti's publisher) was
> with me yesterday and has kindly given me permission to
> put his name in the titlepage – I hope it will assure? I do not

expect to make anything, certainly very little, by it but I
must not lose – its price will be 5/-.

Browning must have approved of his plans because Solomon's next letter
reads:

> I am very glad you approve of my plan and, apparently, do
> not think it 'in-for-a-dig' for me to publish myself, the fact
> is that it is the only possibility of making the thing at all
> pay, getting 3/9 for a 5/- book that will cost getting to at
> least 2/9 with the incidental expenses and selling only a
> limited number of copies would be a dead loss – I really
> think it will be a nice book – I should so like you to see it in
> its finished form.

Early in May 1871 Solomon wrote to Swinburne to ask him to review
A Vision in *The Dark Blue.* On May 15th Solomon wrote further to say that
he had pre-empted Swinburne's reply in the affirmative by warning the
editor to reserve space in a summer edition, at the same time excusing his
presumption by explaining that if he did not look after his own interests no
one else would. To humour Swinburne, he reassured the poet that he had
destroyed the latter's recent letter on the subject of a chorister. In June
1871 Solomon privately printed five hundred copies of *A Vision of Love
Revealed in Sleep* which were obtainable from the author himself or
P.S.Ellis at 5/- a copy. Woe betide any friend who did not pay for his copy –
even Browning got chased for the money! This edition has a blue cloth
binding decorated in gold with allegorical floral designs of myrtle and
poppies from the artist's own hand, along with a quote from *The Song of
Solomon:* "Until the day break and the shadows flee away." This edition
also contains a single Hollyer photographic illustration (Plate 10).

In June 1871 Solomon wrote to thank Swinburne for his kindness in
agreeing to write the review that he had requested. It appeared in the July

edition of *The Dark Blue*. Despite the fact that not everything the poet had to say about *A Vision* and its author was complimentary, it is probable that the publicity did help to sell the book. It is not easy to précis Swinburne's article, especially since he dedicated more space to criticising Solomon's paintings than to the prose poem itself. This may have been as a result of a written advice from Solomon that "you [Swinburne] would probably speak of my pictures and drawings and use the booklet only as a sort of accompaniment."

> Dim and vague as the atmosphere of such work should be, this vision would be more significant, and not less suggestive of things hidden in secret places of spiritual reserve, if it had more body of drawing, more shapeliness of thought and fixity of outline... We miss the thread of union between the varying visions... it might have been well to issue with the text some further reproductions of the designs.[43]

About the paintings Swinburne waxed more lyrical describing them as "music made visible":

> Grecian form and beauty divide the allegiance of his spirit with Hebrew shadow and majesty: depths of cloud unsearchable and summits unsurmountable of fire darken and lighten before the vision of a soul enamoured of soft light and clear water, of leaves and flowers and limbs more lovely than these... There is a questioning wonder in their faces, a fine joy and a faint sorrow, a trouble as of water stirred, a delight as of thirst appeased... hardly a figure but has some touch, though never so delicately slight, either of eagerness or weariness, some note of expectancy or of satiety, some semblance of outlook or inlook... passion

that makes havoc of love, and after that even of itself also: of death and silence, and of sleep and time... all designs [are] full of mystical attraction and passion, of bitter sweetness and burning beauty... the sadness that is latent in gladness; the pleasure that is palpable in pain... All the sorrow of the senses is incarnate in the mournful and melodious beauty of those faces; they have learnt to abstain from wishing; they are learning to abstain from hope... In these pictures some obscure suppressed tragedy of thought and passion and fate seems latent as the vital veins under a clear skin. Intentionally or not as it may be some utter sorrow of soul, some world-old hopelessness of heart, mixed with the strong sense of power and beauty, has here been cast afresh into types... Others, as the *Bacchus,* have about them a fleshly glory of godhead and bodily deity, which holds at once of earth and heaven: neither the mystic and conquering Indian is this god, nor the fierce choregus of Cithaeron... There is a mixture of the utmost delicacy with a fine cruelty in some of these faces of fair feminine youth... Other faces again are live emblems of infinite tenderness, of sad illimitable pity.

Solomon wrote to Browning:

Procure *The Dark Blue* for July – in it you will find Swinburne on me – it is hot and strong and brilliant but there is a good deal in it untrue for there is a place in my artistic character unperceived, or at all events, misunderstood by Swinburne – you will see what I mean if you read it.

To Swinburne, Solomon wrote a letter of complaint which earned him

a reprimand from the poet. Cringingly apologetic and self-deprecatory Solomon replied in late October as follows:

> I received your letter of yesterday and I am sorry to find from its tone that what I said in mine must have been very awkwardly and ungraciously done. It is very difficult for me to know what to say to you but I am quite sure that whatever I may say will not imply a want of gratitude for and acknowledgement of your kindness in writing the article in *The Dark Blue.* And you must promise to forgive me if I speak the whole truth about it. When you sent the MS and I read it, I saw and appreciated the full beauty of the paper and the great honour that had been done me by the most brilliant of our writers, but I saw that there were certain parts which I could have desired to be omitted but I dared not ask you to eliminate or even to modify them, for I thought it would have been a liberty, and, as a beggar who had so large a boon conferred upon him, I felt it would have been unjustifiable: when the article appeared in print one or two very intimate friends said 'eloquent and beautiful as it is, I think it will do you harm!' You know, of course, my dear Algernon, that, by many, my designs and pictures executed during the last three or four years have been looked upon with suspicion, and, as I have been a false friend to myself, I have not sought to remove the impression, but I have gone on following my own sweet will; in pecuniary and some other ways I have had to suffer for it, and shall probably suffer still. I really hardly know how to say any more, but I wish to make you feel that what I said in my last letter and what I repeat in this arises from

no want of gratitude for the honour you did me and the
kindness you showed me and I hope you will send me a
letter absolving me from such an imputation in your mind.

The overt flattery in this letter seems to have humoured Swinburne
who answered with a letter of appeasement, to which, in turn, Solomon
replied in a tone of relief. Shortly thereafter he retired to Eton, no doubt to
unburden his woes to Browning. A coolness between the artist and the poet
seems to have developed out of this exchange of letters although their
correspondence does not cease. In November 1872 Solomon wrote to
Swinburne, "Have you heard that Johnson has left and changed his name to
Cory, it is creating a sensation at Eton?"[44] Slowly, however, at least in
Swinburne's case, the old friendship gave way to a stance of hypocritical
moral indignation and mockery. Swinburne never permitted his review to
be reprinted and its first reappearance in print did not occur until after his
death, namely in the September 1908 edition of the American periodical
The Bibelot. John Addington Symonds also reviewed *A Vision* in *The
Academy* of April 1st 1871, warmly praising Solomon's dual artistic
creativity. This review likewise reappeared, if posthumously, in the
February 1909 edition of *The Bibelot,* after a reprint of *A Vision* which
spread over the January and February editions.[45] *A Vision* also received a
brief and not altogether flattering review in *The Athenaeum* of March 25th
1871. The early dates of these reviews suggest that the edition utilised by
the critics must have been that of *A Mystery of Love in Sleep;* nevertheless
the prose-poem already bears its new title.

CHAPTER IV

A Vision of Love Revealed in Sleep

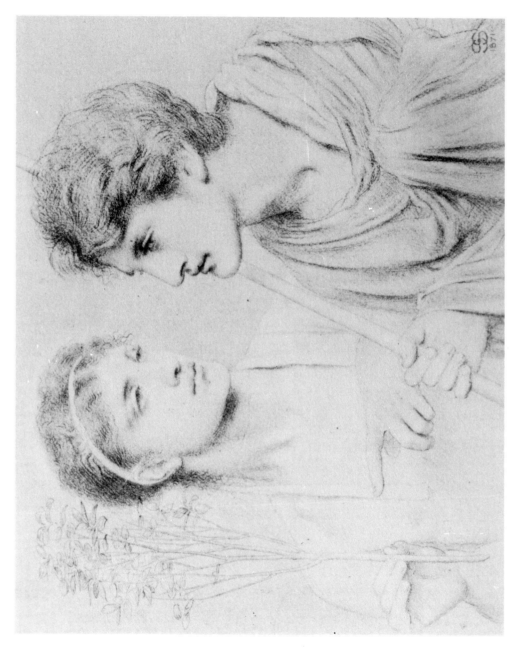

10. THEN I KNEW MY SOUL STOOD BY ME, AND HE AND I WENT FORTH TOGETHER
Hollyer photograph of drawing 1871.
Frontispiece to Hollis edition of *The Vision of Love Revealed in Sleep.*

A VISION OF LOVE

REVEALED IN SLEEP

Until the day break
And the shadows flee away
SONG OF SONGS

BY

SIMEON SOLOMON

London

PRINTED FOR THE AUTHOR

TO BE HAD ALSO OF F. S. ELLIS, 33 KING STREET, COVENT GARDEN

1871

VRBI · ROMAE · MENSI · MAIO · ANNO · MDCCCLXIX

IN · MEMORIAM

D · D · D

A Vision of Love revealed in Sleep.

UPON the waning of the night, at that time when the stars are pale, and when dreams wrap us about more closely, when a brighter radiance is shed upon our spirits, three sayings of the wise King came unto me. These are they:—*I sleep, but my heart waketh;* also, *Many waters cannot quench love;* and again, *Until the day break, and the shadows flee away;* and I fell to musing and thinking much upon them. Then there came upon me a vision, and behold, I walked in a land that I knew not, filled with a strange light I had not seen before; and I was clad as a traveller. In one hand I carried a staff, and I hid the other in the heavy folds of a colourless garment; I went forward with my eyes cast upon the earth, pondering, and dazed as one who sets forth upon a journey, but who knows not yet its goal. Then I besought my spirit to make itself clearer before me, and to show me, as in a glass, what I sought; then knowledge came upon me, and I looked within my spirit, and I saw my yearning visibly manifested, and great desire was born, and sprang forth and strengthened my feet and quickened my steps. Now I stood among olive-trees, whose leaves and boughs lay still upon the air, and no light was cast upon them. Then the

B

44

deep silence was broken by the stirring of the spirit within me ;
my frame appeared to be rent, and a faintness fell upon me, and
for a little space I knew nothing, so powerfully the spirit wrought
within me. Then afterwards, as when one who works miracles
lays his healing finger upon another who is maimed, and makes
him whole, so was my strength renewed, and I lifted up my eyes ;
and behold, the form of one stood by me, unclothed, save for a
fillet binding his head, whereof the ends lay upon either side
his neck ; also upon his left shoulder hung a narrow vestment ;
in his right hand he bore a branch of dark foliage, starred with
no blossoms ; his face had on it the shadow of glad things
unattained, as of one who has long sought but not found, upon
whom the burden of humanity lies heavy ; his eyes, half shaded
by their lashes, gave forth no light.

I knew that my Soul stood by me, and he and I went forth
together; and I also knew that the visible images of those things
which we know only by name were about to be manifested unto
me. When I gazed into the lampless eyes of my Soul, I felt that
I saw into the depths of my own spirit, shadow meeting shadow.
Then my Soul first spoke, and said unto me, *Thou hast looked
upon me, and thou knowest me well, for in me thou but seest
thyself, not hidden and obscured by the cruel veil of the flesh. I
am come forth of thee for thy well-doing, therefore see to it that
thou do me no injury. By me shalt thou attain unto the end I
know thou seekest, for he whom we go forth to find may only in
his fulness be manifested by my aid ; for when he appears to*

those who, with dimmed eyes, grope in the waking darkness of the world, I am put aside, and he is not fully known. By me alone shalt thou behold him as he absolutely is ; but in visions shall he be seen of thee many times before his full light be shed upon thee, and thy spirit shall be chastened and saddened because of them, but it shall not utterly faint. Look upon me, and I will support thee, and in thy need I will bear thee up. Looking upon me thou shalt read thine inmost self, as upon a scroll, and in my aspect shall thy spirit be made clear. Come.

Then we went forth towards a dim sea at ebb, lying under the veil of the mysterious twilight of dawn. On its grey sands sat one whom I knew for Memory. Over her face passed the changeful alternations of sun and cloud, shade and shine ; the voice of the shell which she held to her ear unburied the dead cycles of the soul ; it sang to her of good and evil things gone by, and her introverted eyes looked upon them as when one looks in a mirror upon all else save oneself. My Soul turned his dusky eyes upon me, and then I too heard the voice of the shell ; and the ocean cast up my dead before my eyes, and all was unto me as though it had not gone by. Memory bore upon her head and breast a light rain of faded autumn leaves and blossoms, and upon her raiment small flecks of foam had already dried ; her lips trembled with the unuttered voices of the past, but she did not weep.

Then I was carried back in the spirit to the time past, and as I walked forth by my Soul, my gaze was drawn inward, and I

46

beheld myself in one of the sunny places of the world; and there was a mist arising from the joy of nature, and my spirit seemed to dance within me. And I beheld, after a space, that the mist formed itself into many visible objects, which all gave me a delight such as one feels in looking upon the golden circles which play within the depths of a sun-lighted pool; and beyond the mist I discerned the forms of many whom Memory brought back to me; they had no radiance about their heads, but their countenances bore no shadow upon them, and the light in the air wherein they moved made a music which was very pleasant unto me. As the heart sits enthroned within the body, and its pulses inform it, so sat one in their midst whose spirit made their feet to dance and their mouths to sing; she rested beneath the shade of an autumn apple-tree, and the sun had kissed her body as it had kissed the fruit of the tree and made it glow: she was naked, but guile was removed from her, therefore she knew it not: the aspect of her face was as that of the face of a child who hears new things, and holds its breath, lest the one who relates them should make too quick an end; her grey eyes looked forth without fear, and in their soft depths were mirrored the things about her that she loved so well; by her side sported all joyous, simple creatures, and she was of them and one with them; the shadow of the burden of consciousness had not fallen upon her; she had not known the sickness of the soul, for within the ark of her body the soul had found no resting-place. Looking upon her, I saw that she was good, but I knew that there was

that about her that left me not content; she was even as sweet notes heard once and lost for ever.

Then I withdrew my gaze from my spirit, and raised my eyes and looked upon my Soul, and he spoke these words unto me: *It is well that thou hast thus looked upon Pleasure which is past, for with the greater ardour dost thou now desire him whom we go forth to seek: canst thou bear to look forward?* Then, as we went along, while the shallow wave drew back from the grey beach, my spirit took upon itself a great sadness; and lifting my eyes I beheld one, whom I then knew not, seeking shelter in the cleft of a rock. The shame that had been done him had made dim those thrones of Charity—his eyes; and as the wings of a dove, beaten against a wall, fall weak and frayed, so his·wings fell about his perfect body; his locks, matted with the sharp moisture of the sea, hung upon his brow, and the fair garland on his head was broken, and its leaves and blossoms fluttered to the earth in the chill air. He held about him a sombre mantle, in whose folds the fallen autumn leaves had rested: and now he came forth of his sheltering place, and as he went along the light upon his head was blown about in thin flames by the cold breath of the sea; and I saw moving beside him in the grey air the spirits of those who had brought him to this pass, and the sound of their mockings fell upon my ears. Then my spirit sighed very heavily within me, and I could look no longer, for I discerned in that company the image of myself; and then all this vision passed away.

I held my regard upon the earth, and marvelled at what I had seen; and I communed in sadness with my spirit, for I then knew the part I had taken to hold Love in contumely, and how I had been one of those who plant rue, thinking to behold myrtles spring therefrom; and my spirit being chastened, I lifted my eyes to my Soul, and I saw upon his face the pale light of sorrow; yet I remembered how he spoke to me at the first, and told me that he would uphold me, and that my spirit should not faint utterly. Then he and I went on gradually ascending a sandy slope, patched here and there with scanty grass; and against the pale sky we saw one, for whom, looking upon him, my Soul dissolved in tears, so stricken with unavailing sorrow was he, so wounded beyond the hope of healing, bound hand and foot, languishing under the weight of his humanity, crushed with the burden of his so great tenderness. I looked upon the face of my Soul, and I knew that he, in whose presence we now stood, was Love, dethroned and captive, bound and wounded, bereft of the natural light of his presence; his wings drooping, broken and torn, his hands made fast to the barren and leafless tree; the myrtles upon his brow withered and falling; and upon that heart, from whose living depths should proceed the voice of the revolving spheres, there was a wound flowing with blood, but changing into roses of divinest odour as it fell. I stood motionless, my eyes refusing to look longer upon my stricken lord, then drawn unto my Soul, from whom I had no comfort; the voice of the shell of Memory yet sounded

in my ears, and I knew that the divine captive read my spirit's inmost thoughts; from his lips proceeded inaudibly the words, *Thou hast wounded my heart.*

After a moment of mystical agony, I raised my eyes; and behold, the vision of Love was gone. Yea, and upon my own heart the words of Love became engraven, and ringed it about with flame; and then I knew to the full how my hands had been among those which had bound and wounded Love thus. Albeit my spirit found how unworthy it was to receive the odour of the roses which came forth of his heart, yet it clung about me, and became as it were a crown to my head, and I was even lifted up because of my humiliation. Then I turned unto my Soul, and saw that his gaze was bent upon me with pity, and he spoke these words: *Alas! look well into thy spirit, search thy heart and pluck from it its dead garlands, cast them from thee and make it clean, and prepare it for him who shall hereafter enter therein; thou art even puffed up because the wound thou hast been one of those to deal sends forth divine fragrance; rather lament that thou hast not left whole the temple whence it comes forth: of thee and of thy like is its destruction: let us go upon our way.* Then we set forward, and silence was between us; the burden upon my spirit lay very heavy, and I knew not how to raise my eyes.

And now a sound of great lamentation clove the dull air; it was as the wail the mother lifts up when the last of the fruit of her body is wrested from her; it was as the cry of one whose

anguish may know no respite, whose soul is rent and cast abroad; it entered deep into my spirit. Then he who walked by me spake these words : *Canst thou lift thy gaze upon her who comes across the sea, upon her who is ravening like it, and is one with it? Look well upon her, for thou shalt behold in her one who would dash thee aside from the path which thou hast chosen. Look well unto thy heart, lest her breath dry up its springs. Behold.* Then I looked out to sea, and there came towards us one whose name I knew was Passion, she who had wounded and had sought to slay Love, but who, in her turn, was grievously wounded and tormented in strange, self-devised ways. The glory of her head was changed into the abiding-place of serpents whose malice knew no lull; her wasted beauty preyed upon itself; her face was whitened with pale fires, a hollow image of unappeased desire ; her eyes flowed with unavailing tears ; in her right hand she bore a self-wrought sword of flame, and in her left the goodly fruits and flowers she held were scorched and withered, and crawled upon by evil things ; her feet were bound in inextricable folds ; she was borne forth she knew not whither ; her breath was as the breath of the hungry sea, and rest shall not be given unto her. And then the gentle voice of Memory spoke to me, and told me how she who was thus tormented had been at the first like unto her whom I saw in the spirit beneath the shade of the apple-tree, lying in the light of peace ; and how the sun had also shone upon her, and made her face to shine ; but she looked beyond the fair and happy things that were about her, and lusted

after she knew not what; and then the pleasant place wherein she abode with her happy fellows was taken from her, and, as one who hungers after what he has wittingly lost unto himself, so she craved and was not satisfied; she set at naught the gracious things that had been given unto her, and became the paramour of Hate; then she went about seeking to woo Love to her evil ends, and she fared to him as one humble and poorly clad; and Love had pity upon her, and bent his ear to her supplications, for he knew her not; but anon her aspect waxed cruel, and fierce, deceitful flames went forth of her eyes, and dreadful things clung about her, and shamed the air that he made holy, and with her fiery breath she well-nigh slew him; and when I looked upon her and knew that she would have slain Love, pity was congealed in my heart. Then the voice of the shell spoke to me by the spirit, and said, *Thou hast no pity on thyself.* And this vision also passed from us.

Then my Soul spoke unto me these words: *It is even so, thou hast no pity on thyself, for thou too hast essayed to slay Love, as it has been shown to thee, thou hast wounded him: let us set forth, and I will show thee a vision of that which may yet be averted.* Then we fared along by the sea, and its hollow breath fell sore upon my spirit: and anon we came upon a crowd who all bore different aspects, and again among these I chose forth one who was myself; some were mocking, and some carried an air of scorn upon them, and others of deceit; some feigned mourning, and others were not moved by what they saw. Then

I approached, bent down by a great awe of sorrow; and through my tear-dulled lashes I looked upon him who had been bound and wounded. He lay as one without life; the voice of his heart was dead within him; looking upon his face it seemed as if the end of all had come, and the air about him was laden with lamentations; upon his pallid brow one had thrown a spray of yew, but his body lay untended, and none had clothed him with his last garment; a thin flame rose from his heart and hovered upon it; and the cords wherewith he had been bound to the tree yet confined his hands, his feet, and his shattered wings; the light about his head had gone, and in its place the sea-froth made a crown; they who were gathered about him when we drew near had left him one by one. For myself a burning shame wrapped me round, and I sank upon the earth, and utterly abased my spirit for a space; then I heard the voice of my Soul speaking to me, and I lifted my eyes, and behold, the dolorous vision was gone. And, my heart laden with weeping, I turned unto my Soul, and he said these words unto me: *Did I not tell thee at the first that whilst thou hadst me by thy side, and didst me no injury, thy spirit should not utterly faint; therefore be not cast down at the grievous vision we go forth from beholding, but lay it as a sign upon thy heart; so shalt thou be warned in good time. We now bend our steps towards one who is mighty indeed, and it is given to no man to overcome him; yet when thou shalt look upon him, thou shalt see of how mild an aspect he is, and so thou shalt put terror away from thee. Come.*

And we yet went forth by the sea, until we came upon a temple standing alone ; the breath from the heart of the sea came up as the litanies of the dead who lay beneath it, and girt it about and fell cold upon my spirit, and well-nigh made the pulses of my life to cease ; but my Soul, faithful as when he first bent his eyes upon me by the olive-trees, supported me ; and the door of the temple being touched by the branch which he bore, opened of itself, and my spirit yearned for the further and dreadful mystery that was to be shown me. It was well for me that there abode one beside me who would hold me up, or my heart, frozen within my breast, would have refused to support me, fainting as I was. I raised my eyes, whereof the light had gone out in the black air about us, and sought help of my Soul. He bent towards me, and said, *Cast fear from thee. Behold, thou shalt not fail.*

Before us and over us was a shadow as of the darkness before all things were ; Hope was removed from the midst of it, and, looking upon it, Despair seemed to be enthroned therein ; and the spirit wholly forgot that light had ever sprung forth upon the universe. Again I sought succour of him who stood beside me, and again it was vouchsafed to me : then, essaying to strengthen my eyes, I looked forward, and I beheld, slowly revealing himself in the heart of the thick darkness, one seated upon a dim and awful throne ; he was wrapt about with sighs for raiment, and cypress, heavy with the tears of ages, was the crown upon his head ; although his face was hidden in his potent hands when first he was manifested to my sight, yet I knew he wept,

and his weeping was as the gathered-up lamentations of all time ;
how sore it fell upon my heart I may not say ; and a great pity
was begotten within me, which went forth upon my spirit, to-
wards his throne. Anon he lifted his face, and the sadness and
mourning which go forth of the hearts of all men seemed trans-
figured upon it, and I saw that it was overshadowed with the
dark mystery of life : it appeared to me as the face of one who
dwells for ever without the Holy Place, upon whose brow the
highest radiance may never fall. Then I thought upon the words
my Soul had spoken to me, before we entered herein, when he
told me how mild of aspect was the face I should look upon. For
I saw that his mien had in it an exceeding gentleness, as of a
creature that desires to caress and to be caressed, but who
dares not approach, lest he bring terror with him—as of one who
throughout all eternity bears upon him a loveless burden,
whereof he may not rid himself : his was the pallor of one who
had wrestled with another strong as himself, and had prevailed,
but whose own dominion was as gall to him, the knowledge of
whose hateful might gnawed his own spirit through and through
with an unquenchable fire, whose power was his humiliation,
whose strength his weakness. For a moment's space I could not
look upon him, for the memories of his prowess crowded within
my heart, and surged up in a bitter stream into my eyes. Then
I sought the face of my Soul, and I saw upon its darkness the
answer to my unuttered question, and I knew that I stood in
the presence of him who had done battle with Love, Death,

who would love us did he dare, whom we would love did we dare ; for, when he folds us about with the chill white raiment, he sets the seal of his love upon us ; and, as the bridegroom and the bride stand linked together, overshadowed by the mystic saffron-coloured veil, and one spirit makes them one ; so, at that hour when time slips from us, are we wedded to him before whom I stood, and with the sacrament of his kiss he signs us unto himself, and makes us of one flesh with him.

Then I lifted my eyes and looked yet again, and I saw that one stood by the throne, who held his finger upon his lip ; he bore in one hand a crystal globe wherefrom the eyes of Death were ever averted, for he might not look therein ; upon his head there bloomed a lotos flower, and lotos flowers hid his feet ; the fathomless silence of the tomb came up and clothed him as with a pall, and he was girdled round with mystery, and mystery was written upon the air about him ; his eyes were fixed upon the globe he held, and made dim because of what he saw therein ; and the secrets of the tomb came forth and racked his face, and his face sweated with the pallid fires that rose from the dead he looked upon. And now my spirit welled up beseechingly within me, and looked forth of my eyes, and I turned them upon my Soul's face, as if supplicating ; and his face was towards mine, and he knew the question that rested upon my lips, and he spoke and said, *Seek not to look upon the globe, for thou assuredly knowest it is given to no man to search its depths and live. He who bears it is Eternal Silence. Behold how his face*

is seared and furrowed with the things he knows, with the secrets that are laid bare to him. Let his name be a sign unto thee. He ceased to speak, and my spirit was drawn inward, and I pondered upon what he who brooded upon the throne before me had wrought; and I marvelled the more at his might when I had seen how humble of demeanour he was; and these thoughts came upon me:—When he had rent asunder those newly come together and made one, when he had set at nought the bitter desire of years and the late-found joy, did he wear upon his countenance that great sadness, well-nigh sweet? When the shriek of the mother shattered the night, because the sole one left of her withered blossoms had been plucked by him, and she was left as an uprooted plant cast upon the wave, was he then crowned with humility? When I thought upon those who had made the face of her that bare them to shine, and were as the sun's kiss to her, and how he had wrapt them in his chill raiment one by one in her sight, and I looked upon his eyes whence the tears ceased not to flow, my heart failed within me, and my marvelling became too hard for me. Then I turned towards my Soul and sought his gaze; he fixed it upon me, and spoke these words : *I have read thine inmost thoughts, and they are hard indeed. Of the thing whereon thou hast pondered thou canst, of thy nature, know nothing, but only this :—When he, before whom we stand, bends his face over those whose spirits wing them away, he takes upon it the exceeding gentleness thou hast seen, albeit it is not beheld of them who stand by sorrowing; for they*

have not looked upon his face; therefore they know it not until he lays his finger upon their lips, and touches them with his own. Let us go forth upon our way. And he led me as who should lead one lately risen from the couch of disease, weak, and before whom the earth seems to spin, and darkness was upon us.

And my Soul said, *Raise thine eyes and behold somewhat which shall gladden them, as it hath gladdened all men before. Let the balm of this vision sink into thy spirit; so shall it make thee whole of the sickness that came upon thee in the house of Death.* I lifted my eyes, and I saw coming towards us what had the appearance of a bird moving softly along the still, grey air. As it approached us, I perceived two presences, one reclining upon the other who gently fanned the air with great wings. And now a deep calm fell upon my spirit, such as one feels when the burden of a sharp trouble is averted, and my Soul and I wept when we saw him who was being thus carried towards us; he lay lightly across the breast of his supporter, cheek reposing against cheek; upon his head were two small fair wings, and round his brow were bound the flowers and buds of poppies; upon his face there shone a distant light of childhood; his parted lips breathed forth peace; the one who bore him smiled upon him, and rejoiced because of his burden. I knew that he who was winged was called Divine Charity, and his charge Sleep.

When we went forth out of the temple wherein abode Death, we came to a strange land stretching far out towards the wan sea, and inland the earth was overgrown with rank weeds; and

ever the voice of the shell of Memory sounded in my ears, and the land to right and left of me seemed to image my past years; the comfort which I had had of Sleep departed from me, and when I sought the eyes of my Soul no rays of consolation came forth therefrom, no blossoms of golden light yet starred the dull branch he bore: the shadow of the house of Death lay heavy upon him.

Albeit the burden of great bitterness that was shed upon my spirit by him I saw upon the gloomy throne had choked up the springs of my heart, yet within my breast the flame of yearning towards him who should be the end and crown of my journeying burst forth and impelled me onward; and my spirit told me that in a short space I should look upon him, in what guise I knew not. Therefore I turned my questioning eyes upon my Soul, and a light of sadness fell upon me from his face, and he spoke and said these words: *Alas! not yet shall it be vouchsafed unto thee to behold him in his sovereign glory, clad in radiance, but thou shalt see him as he has been carried forth whence we last looked upon him with grief-dulled eyes, when he was as one bereft of life. He, whose bliss it was to make his burden Love, is a supreme spring of pity, and men laving themselves in the streams that go forth of him, account them blessed; the hurt that has been done them passes by; they are made whole, for he slowly, yet surely, heals them; in his arms the broken of spirit are cherished; and when he holds the hearts that are cleft to his breast, they are once more bound together.* And I raised my eyes after he had spoken

these words, and sought to gather strength to look upon the coming vision.

Now again two came towards us, one bearing the other, and treading down the dark growth of weeds that thickened about us. When I saw him who reposed in the other's arms, a trembling seized me, and an awe came upon me—the awe which is begotten of exceeding pity : around his head shone a faint and flickering light, his white and perfect body was flecked here and there with blood, and, as when we saw him by the sea, betrayed, wounded, and helpless. He who supported him was ravaged with the storms of ages ; in his eyes there shone a light of infinite memories ; in his ears there rang the voices of unnumbered years ; his mien had in it the great tenderness of one unconquerable ; as a mother encircles with her arms a beloved and sorrowing child, and softly murmurs to him the songs of his infancy, so he pressed his bruised and smitten charge to his breast, comforting him with the universal voice.

And when this vision was fulfilled, the shell of Memory again sang in my ears, and I knew that what had past was the image of somewhat long gone by ; and I humbled my spirit when I knew that I had been among those who consign Love to the arms of Time ; casting the potent lord upon the earth, and taking no heed of him ; leaving the bruises wherewith he had been buffeted to be tended perchance of none. The earth was now covered with poppies, and the air was heavy with their odours, and I would fain have sought Sleep, but that I knew it

was forbidden unto me ; moreover, it was given me to know by
my Soul, through the spirit, that another vision was shortly to be
vouchsafed unto me. The air was murmurous with faint sounds
borne on the odour of the poppies : these were the echoes of the
voices of my past years. I again sought the eyes of him who
walked beside me, and, by the pale light of the first stars, I saw
reflected in their depths the vague image of something which
stamped a calm upon them; yet, as we set forth along that
mystic land, our hearts were still burdened with the weariness
of sorrow hard to cast away from us. Then, as my Soul turned
towards me, I saw, in the shadows that gained strength about us,
that a great presence was gathering itself, and, as we gazed
upward, our vision rested upon one seated ; around her head
burned the light of the new-born stars, whose harmony made
glad the pulses of the air ; from her wide brow went forth a
healing balm ; in her aspect all men seek their rest and hide
them in her shadow. She bore upon her knees one still beau-
tiful, but pallid with woes, riven with wasting troubles, weary
and dying ; within her heart she hid his passing spirit ; the
waning golden light about him faded in the gloom of her hair,
the falling blossoms of his head lightly strewed her dusky
raiment wherewith she wholly enfolded him ; he sank beneath
her sacramental kiss, and Day was lulled to death in the all-
embracing arms of Night.

And now we went forth upon our dimly lighted path,
where the red and purple of the poppies faded into sombre

grey beneath the faint rays of the lately risen stars, and the depths of the still pools which lay to right and left of us sent up their pale reflections, and ever the utterances of the sea of my life spoke to me by the voice of the shell of Memory : and this night seemed to be a figure of my years gone by.

After my spirit had bent itself to the pondering of these things, I turned towards my Soul, and I saw that his eyes were heavy with the sense of what was to come ; also my spirit leapt up, for albeit I was yet ignorant of what was to be shown forth, a voice within me told me that it should be of much import ; and I bent towards him who was with me and gazed earnestly upon him, as one importunate, and who sought to be prepared and made ready to receive what would be to his great benefit. And my Soul, seeing my urgency, spoke and said, *Look well upon this shortly to befall us, and take great heed unto it, for it will be of weight to thee; and it shall be, as it were, the opening of the scroll whereon we may read the rest. He, whom we relax not in seeking, shall again be revealed unto thee; but, alas, again the pulses of thy heart shall fail when thou seest him; and by the lesson of the vision shalt thou learn that thou art yet unready to behold him in his fulness; yea, and this shall not be the last trial put upon thee. Now shall be set forth before thee somewhat of the history of his shame whom we seek, and, how, as one who brushes not away the cobwebs that have gathered themselves together upon the fair sculpture of one divine, and has even said Ha, ha, at the spiders busy upon it; so have men laid upon him the darkness of the earth, as*

a thick veil wherethrough his light shall not come. I cease; the vision will unfold itself clearly in thine eyes. Then I looked forward, and I saw that we approached what appeared to be a temple in ruin, long forsaken and not remembered; its crumbling marble walls and pillars, worn by time and storms, glimmered dimly beneath the stars; about it lay the decayed fragments of its dead beauty, and its entrances were choked up with poppies and clinging weeds, but to my spiritual vision there appeared a radiance about it that made me know that the light of him whom I sought penetrated the depths of its enduring gloom. Our heads bowed, and in silence we approached the entrance; we put aside the rank growths which sought to hinder our going in, and stood on its grass-grown threshold; then the silence of my heart was broken by its weeping, and a faintness fell upon me when I lifted up my eyes to the vision now revealed to me. Before us was an altar-like monument carved with a legend of old time, whereon the joyful creatures who sported in procession across it were wasting in decay, time-discoloured and riven; upon it he lay, whom, when we stood in the presence of Death, we saw borne to earth by Divine Charity; he was wrapped about with the slumber of those upon whom no shadow has fallen, upon his face there lay that far-off light of childhood; the mildness of his half-formed smile drew the spirit unto itself, his lashes were yet moist with late-shed tears, born not of sorrow but of tenderness; looking upon him, our wave-tossed spirits found their haven, and rest fell upon us.

Before I dared to look upon him who was present with Sleep, and whom I have not wearied of seeking, I saw by the spirit that one rose impalpably from the heart of the poppies, and hovered upon them, lapped in his half-shut wings; his eyes were not covered by their lids, yet it seemed as if slumber had fallen upon them; he fixed his mystic gaze upon a crystal globe he held in both his hands, wherein I knew by the spirit he saw pass the dreams of those who sleep beneath the stars; his locks were softly lifted by the air, and his lips trembled with the weight of the myriads of visions he called forth; his bent face was over-shadowed by the exceeding sadness of one who knows the thoughts of men.

Again I raised my eyes, and I saw her who had lately been revealed to us receiving the passing breath of day; with unrelax-ing gaze, and eyes from whose depths comes forth all gentleness, she watched Sleep, her beloved son; and she, to whom all was as an open scroll, wept when she looked upon him whose heart was as the heart of a little child; her dusky locks flowed forth upon the air, and from their shade the stars sent down their beams; her garments were fragrant with the blossoms begotten of Day's death, and hymns proceeded from the silence that was about her; upon her all-supporting arms, and hidden in her raiment, she bore those who slept and dreamed, and those who watched; she whispered peace unto those who know it not when she is not; she put away from them the sword, and healed the wounds that gape and bleed when

she is not by to close them; she drew the spirit of the mother to her child who dwells in far-off lands, and in her arms the long-separated were brought together; beneath her shadow the lost little one yet again nestled upon her mother's breast; she hid the stricken in her heart, by her the forsaken were taken back to the hearts of the forsakers; she brooded over the uncared-for with the soft care of her wings, and by her the forgotten were brought to remembrance.

Then I sought my Soul in trembling, for I knew that there was one present on whom I had not yet dared to look, and my Soul said to me by the spirit, *Behold him whom we seek, but we are not yet prepared.* Then I turned my gaze upon him; in the gloom of the unremembered temple he sat in all lowliness upon the fragment of a broken frieze, whereon the sculptured histories of his ancient glory crumbled and fell away, forgotten and un-cared for, blighted by the breath of ages, stained with the rust of storms that know no mercy; his red and golden raiment hung loose about his limbs, and the blossoms from his hair had fallen crisped and dead upon his shoulders; the tears of a divine agony yet lay upon his cheek; the radiance which I had seen by my spirit, before my feet had gained the threshold of the temple, sprang from the wound upon his heart; and when I looked upon and saw it illumine the dim eyes of my Soul, my spirit abased itself, and my gaze fell upon the earth. Then I knew that this vision had been fulfilled, and my heart, ringing with the inner voices of the things that had been revealed to us, and my eyes

laden with their images, I again turned unto my Soul, and saw that upon his countenance rested the light that came forth of Love's wound, and made it shine ; and, as we departed from the temple, I rejoiced secretly at this ; also I felt strengthened and gladdened at heart because of Sleep ; and my spirit was softened by reason of his smile. And we turned our steps towards the waning stars.

And the awe which comes upon man at the passing away of night fell upon us, and I bethought me again of the words of the wise king, *Until the day break, and the shadows flee away.* And a strong yearning was begotten within me, and a sob burst forth from my mouth up out of my heart, and my lips said inaudibly, *Ah, that the day would break, and the shadows verily and indeed flee away*; and the spirit essayed to escape, and in travail I sought help of my Soul, and it was given unto me, and he spoke these words : *Put thy sorrowing away from thee, for the sword shall not again cruelly cleave thy spirit ; yet, as I told thee before we stood upon the threshold of the ruined temple we have erewhile left, another trial shall be laid upon thee, and the spirit must needs crouch beneath the weight of it ; but, albeit sorrow shall go up as a mist before thee, when thou beholdest what is at hand, thou shalt see, as behind a thick cloud, the presence of light ; in the coming vision shall be dimly heralded his effulgence ; it shall appear in thine eyes as it were the strong weeping that goes before joy ; and as the springing forth of hope from despair : it shall not be seen of thee as a dark mystery ; thy spirit will look*

into it and know it. He made an end of speaking, and by the pale beams of the sinking stars I saw an image dimly mirrored in his eyes. I removed my gaze from his face, and looked abroad, and beheld, dark against the wan air of the dying night, Love seated upon a throne lowly and poor, and not worthy to bear him,—no longer, indeed, wounded and bleeding, but still bereft of his perfect glory; in his eyes there shone a soft light of suffering not yet past, but on his brow, where poppies were mingled with the myrtles, there lay the shadow which falls upon one not remembered; upon his parted lips hovered the half-formed smile of a child who halts between weeping and laughter; he was fully clothed in raiment of dim and sullied red and gold; in one hand he bore a poppy branch bound about the myrtle, from which the stars had fallen one by one, and in the other a golden globe whose brightness was obscured and shamed by dust; his feet were wholly hidden in the thick growth of weeds and poppies that crowded round his throne; he spoke no word, only the faint sounds in the air about him and the grief-dimmed eyes of my Soul told me that he was Love imprisoned in an alien land of oblivion—forgotten, put away.

Again my heart sank, and the flowing of its streams waxed dull, and the words of him bound by the sea burned upon it with a more ardent flame, and the vision we passed from filled my eyes, and came forth of them in bitter tears; yet I forgot not the saying of my Soul, that this should be as the darkly revealed sign of the joy to come, for was not Love enthroned—poorly

indeed—and had not the shadow of suffering well-nigh lifted, albeit indeed its sear remained? But I called up strength, and bound it as a girdle about me, and looked upon the countenance of him beside me; and behold, upon it, despite the eyelids drooping with foregone grief, I saw the longed-for smile, and I took content upon me.

Our course now lay along an upward slope, whereon the poppies waxed scantier, and the weeds less rank; a soft mossy grass soothed our wayworn feet, and I could see by the light of the dying stars that small golden blossoms lay in a pattern upon the sward. As we neared the brow of the hill, I knew that a yet unseen and mysterious presence was about to be revealed to us; soft breezes bore his light to us upon their wings, and voices from the passing Night spoke to us of him; he was half-seated, half-lying, upon a height beyond which was stretched out the faintly glimmering sea; there lay upon him yet the shadow of the Night, but his face had upon it the radiance of an expected glory, the light of glad things to come; his eyes were yet soft with the balm of Sleep, but his lips were parted with desire; his breath was as that of blossoms that awake and lift up their heads and give forth their odours; his dusky limbs were drawn up as if in readiness to depart, and his great and goodly wings softly beat the air; with one hand he cast away his dim and dewy mantle from him, and with the other he put aside the poppies that had clustered thickly about him; as he turned his head to the East, the poppies fell from his hair, and the light rested

upon his face; the smile it kindled made the East to glow, and
Dawn spread forth his wings to meet the new-born Day. And
when the Day was seated on his throne, we passed along a
pleasant land that lay beneath the light of a great content;
and the radiance yet lingered on the countenance of my Soul,
and the sadness that had made the curves of his mouth heavy,
and had dimmed his eye, now gradually departed, and there
came upon him an aspect of calm, as of one certain of a good
thing shortly to befall, although he knows not fully what it may
be; and when I looked upon his eyes my spirit took heart, and
I girded myself and set forward with my head no more bent;
and we were met by many who had been shown me in my
former dreams, and who all bore the reflection of a light upon
their faces.

Also I saw with great joy many whom I knew by name,
and who were dear to me, and they were clad in garments
of beauty, so that it joyed my eyes to behold them. And it
appeared to me as though I felt beating upon my breast the
warmth that came from theirs towards me; and youth was set
as a crown upon their heads, and they bore branches blossoming
from the breath of youth, and its divine essence coloured all the
air about them; and I discerned one face in that company
beloved of me beyond the rest; a northern sun had set a ruddy
sweetness upon it, and southern suns had kissed it into perfect
bloom; from the depths of the grey eyes welled up and sprang
forth the spirit of Love, and, most loath to depart, yet brooded

upon them as the dove in early time upon the waters ; a sacred light, as of the guileless dreams of childhood, looked out from them and gladdened my own, and the softness of Sleep was bound upon the head. When I looked upon the face, I felt, indeed, that my travail was well-nigh over, and as it passed from me, and was lost to me, my spirit bathed its dusty wings in the warm, glad tears that bubbled from my heart, and was refreshed. And when the throne of day was set well-nigh above our heads, and there was that in the air which moves the heart of nature, we rested ourselves beside a running stream, whose waters brought joyous sounds from afar, as it were the long-forgotten songs and gentle voices of our childhood, yet laden with a heavier and fuller harmony from a source we knew not yet ; and as we journeyed on in the dawn of the evening, an awe fell upon me, as when one enters upon a new and unknown way, and all the air about teemed with the echoes of things past and the vague intimations of things to come.

Then my Soul turned towards me and spoke these words : *Lay upon thy spirit a glad humility, and essay to strengthen thine eyes, that they may bear to behold the things which shall shortly be brought before thee to thy comfort and solace. As thou hast hitherto only seen him we seek sinking beneath the burdens that have been laid upon him by thee and by the like of thee ; as thou hast seen the glory about him shattered and made dull by reason of the wounds and weakness the bitter darkness of the world has inflicted, so shalt thou now behold him gathering his natural power about*

70

him, and clothed with light ; but not yet shall it be given to thee to see him in the plenitude of his glory. I will support thee. Look up.

And now I raised my eyes and looked upon the stream, and it seemed to me as though the waters were cleft apart, and there was a hollow in their midst; and lo, the air about it appeared changed, and its pulses stood still, and the sounds I had heard borne on its wave collected themselves together and took form; and the form was of the colour of the sun-lighted sea, and within it I saw one borne gently upward, naked, and glowing exceedingly; the stars of the living myrtles burned fresh upon his hair, and his countenance was as the supreme excellence of youth transfigured, the wound upon his heart was healed, and on its place I saw burning a ruddy flame, whereof the tongues came forth to me and touched my own, whereon were engraven the words which I heard Love speak when we saw him bound to the tree, and in their stead the flame wrought this saying, letter by letter, *Many waters cannot quench Love, neither can the floods drown it ;* and now the radiant mist wherein he was lifted up rose and enfolded him, and hid his aspect from me, and its form was dispersed, and it was changed to gentle sounds in the stream, and all the air about became as it was before.

Then I turned my eyes upon my Soul and saw that he appeared well pleased, and the sparkling light sent up from the ripples of the stream whereby we sat played across his brow and illumined his dusky hair. Then I knew that I should be gladdened by what he was going to tell me. He spoke and said, *Thou hast*

well seen that the travail of Love is past and gone by, and content and joy are spread over the whole air because of it. Now there will arise upon thy vision a mystery which thou wilt, of thy nature, comprehend but dimly; yet fail not to look well upon it, for by it the springs of the heart of the universe are fed and made glad; and because Love is thus gone up from the wave in thy sight, it is given to thee to look upon it.

He ceased to speak, and I turned my gaze in the direction where I had seen the last vision; and behold, again the air seemed changed, and I saw a happy light gathering itself there, and it seemed, as it were, to be formed of the warmth which makes the earth bring forth its fruit; and there appeared to me within the light an inner living glow, and the glow divided itself in twain, and became two Holy Ones, each having six wings; their limbs moved not, but the ardour wherewith their spirits were endued bore them along. As one sees in a soft air two flower-laden branches bend one towards the other, and, mingling, send forth a two-fold fragrance, so I saw one of these impelled towards his fellow and lightly touch him, and a living pulse seemed to beat in the flame that went forth from them, and a form was given to it, and a heart informed it, and all the fire-coloured air about it breathed hymns at this marvellous birth. Albeit, my spirit had not yet been fully purified, so that I should clearly know what this mystery showed forth; yet I was greatly rejoiced in that it was given me to see it. And now my Soul turned towards me and spoke these words, *What thou hast just beheld it is vouchsafed*

to no man to comprehend, save he see the glory that comes forth of the Holy Place; therefore gird up thy spirit that thou be ready for the call of him who shall lead thee thereunto. What thou hast seen it was given to the three Holy Ones to know fully when they were cast into the furnace; for as the serpent-rod which the prophet threw forth swallowed its fellows, the greater eating the lesser, so did the fiercer flames of that Charity which thou hast erewhile seen wonderfully and mystically begotten go forth of the righteous children's hearts, and devour and utterly dry up the heat that burned about them.

He ceased to speak, and then I turned my gaze upon his eyes, and rejoiced greatly through my spirit to see a brighter glow upon them, as from the expected coming of the long-desired; and when I cast my eyes upon the earth I discerned there many happy creatures, joyous and beautiful, and such as have no existence in the neighbourhood of evil. After a space, and when my eyes had been gladdened by reason of these things, I again turned them upon my Soul, and I knew that what we sought would now shortly be revealed to us. A weakness fell upon me, but my Soul supported me; we looked forward, and saw one approaching clothed about with a soft light; he moved towards us, gently lifted by the spirit from the ground, neither flying nor running. Ever and again his feet, wherefrom sprang glowing wings, touched the earth and caused it to bring forth flowers; his head was bound with a fillet of violet, and violet blossoms breathed upon by Love; he carried a mystic veil of saffron

colour, which depended from his head upon his shoulders even to the ground, and his shining body was half girt with fawn-skin; in his hand he carried a staff, which was as the rod of the high priest, for as I looked upon it its barrenness burst forth in almond bloom; and, as when the prophet put away his shoes from off his feet before the Holy Place, and beheld the bush burning with fire but not consumed, even so I saw upon the staff the dancing tongues of flame cling round the wood, but leave it scatheless; and this thing appeared marvellous in my eyes, and I thought upon the words my Soul had spoken to me concerning the three Holy Ones, and how the fires which wrapped them about did but make them stronger and fairer than before.

And now, looking upon the face of him who came towards us, it appeared as the face of one dwelling in the Holy Place, glowing with the perfect peace which is shed of Love, for he had borne the Very Love within his hands, therefore upon him the shadow of the burden of humanity had not rested; and now, encouraged by his gentle mien, and by the strengthened light upon the eyes of my Soul, I went forward until I set myself in front of him who bore the saffron veil; the waves of Love that moved about him laved my face, they refreshed me, and appeared to make my self-consciousness sit lightly upon me, and to loosen me from the grip of my humanity, but it was not yet vouchsafed to me to cast it from me.

As the holy seer prayed to be purged of his transgressions by the burning coal of Charity, so I too desired that my lips

should be touched, and my eyes made clear and worthy to behold those things whence flow the springs of life. When the aspect of him who bore the blossoming staff fell full upon me it generated a stronger yearning towards the Beatific Vision, and the distant harmonies of the spheres became clearer unto me; I then first felt conscious that a faint light hovered about my own head, like that upon the head of my Soul, and the voice of him who bore the mystic veil spoke to me by the spirit, and I heard these words, *Before thou art worthy to behold Him whom thou hast so long sought in the perfect fulness of His glory, thou must be purged of all grossness, thou must be clothed utterly with change of raiment, and the dead fruit of thy heart and of thy lips must be put away from thee; and when these things shall have been done, yea, even then thou shalt not see His full effulgence with none between it and thee, but through the veil of Sleep shall it be revealed unto thee. Follow me.* Then, chastened by these words, I again bent my head, and my Soul led me forward.

Then I turned unto him and bent a look upon him as of one questioning, and, seeing my aspect, he turned towards me and spoke these words: *Wouldst thou learn who is this thus leading us on towards Him we seek; thou sawest his name upon his brow, but the lingering darkness of thy spirit forbade thee to decipher it aright; he it is whom thou hast known since first thou camest away from thy mother's breast, for with what thou receivedst therefrom, thou acceptedst him; looking upon him thou lookest upon what has ever dwelt within thy heart of hearts, for by him shall the Very Love be revealed unto thee; he has no beginning,*

for throughout all ages has he stood by and ministered to Him we seek and shown Him forth : it has been desired of many from the first years unto this day to put him aside and even to slay him, but, like the flame-girt, unconsumed staff he bears, he passes through the fire, and even in these latter days gives forth the light that has first been shed upon him. The violets upon his brow are those of young time, yet the dew is fresh upon them ; and though it was believed of many that his staff was sapless and withered, behold how the air about it is made fragrant by the blossoms that it bears. Faithful is he through all ; he holds on high his lamp so that those who look above the low fogs that cling about the earth may be led of it, and the flames about him penetrate the thick darkness of the waking world. Many have sought to tear the wings from off his feet that they may not see the light that springs forth from them ; yet still the radiance of Him whom he shows forth makes his feet shed light abroad, and still the earth yields flowers at his approach. Let us follow him.

He who bore the flame-girt staff floated lightly along his path of flowers, and the glow about his winged feet made their petals to expand. And now in all humility I stood upon the threshold of a glowing temple ; the air about it was moved by the breath of Him who dwelt within, its waves were heavy with the odours that came forth of His presence, and its pulses echoed with the voices of the worlds that revolve because of Him. Within the court of the temple I heard the sound of wings that ceased not to beat the air ; then a tremor came upon my hands

D

and feet, for remembrance brought to me the image of him
we saw by the grey sea, bound hand and foot, and the voice
from his heart sounded yet in my ears. Then one came
unto me, having six wings, which overshadowed my Soul
and me, and, though I looked not upon his face, I knew
he touched my forehead and lips with it, and they were
purified by fire, but not seared with its sting. Then his fellow
came unto me, and put away my traveller's garb from off me,
and clothed me with a vestment in colour like the heart of an
opal, and over my left shoulder he laid a stole tinted like a flame
seen through water, and he placed upon my head a veil which
covered my eyes, but did not dim my spiritual vision; and now
again the words which came from Love's mouth, when I saw
him bound by the sea, rang in my ears, *Thou hast wounded my
heart*, and a deeper humility fell upon me. Then I heard him of
the winged feet say unto my Soul, *He is prepared, come;* and I
was borne along by the spirit through the outer court and toward
the Holy Place, and ever the rushing sound of the wings became
louder and louder, and I knew that the temple was filled with
seraphim, for the veil which hung over my eyes but shielded
them from a light which, when it should fall upon them, would
blind them; also I knew that he whose head was bound with
violets had left us, and consigned me to the care of my Soul.

 Now there arose before me the image of him whom we had
seen sleeping in the ruined temple; his arms were wound about
his head, which lay back upon them; he was naked, but his

form was wrapped about with the soft star-lighted air ; his lashes were no longer moist with tears, but his face shone as became one through whom the Very Love was to be revealed. And now I felt the heart of the universe beat, and its inner voices were made manifest unto me, the knowledge of the coming presence of the Very Love informed the air, and its waves echoed with the full voices of the revolving spheres. Then my Soul spoke to me and said, *In the beginning of time the universe and all that was therein was grey, and its springs were without life, as a fair body, joyless and lacking beauty, because no spirit stirs it; light had not come upon it ; and, as when one is in a trance, the pulses are dead, and await the aid of that which shall enter them and make the dead alive; even so, there sprang forth, of its own power and holy ardour, a light over the face of all things, and the heat of it made them glow, and the grey became green: the golden air sang over all, and an universal hymn arose and went up, and its voice yet gladdens the circling worlds. As the prophet saw in the dark valley the dead bones come together and take life upon them, even so Love, who was the light, smiled upon the uninformed countenance of things, and it was kindled because of it; and there went from him a two-fold essence, whereof the streams have flowed for ever, and cease not to flow ; and by them are we upheld, and our spirits replenished ; and, as the priest holds the flower-starred crown over the heads of the bridegroom and the bride, so now and again do the streams unite within us, and Love, whence they go forth, is the crown over us and the light*

about us. But through the thick veil of the darkness of the world this is not seen or known of men, but only through the spirit may it be made clear unto us; and the spirit soars aloft rejoicing, and is girt about with delight because of it.

And now the image of Sleep filled the orbit of my sight, and through the veil of his form I saw him who bore the mystic saffron raiment wherewith he had covered his hands. My spirit well-nigh fainting, I turned unto my Soul, and knew by the increasing glow upon him that strength was given me yet again to lift my eyes. Well was it for me that what came was revealed to me through the veil of Sleep, else I could not have borne to look upon it.

From out the uplifted hands of him who stood within the Holy Place there sprang forth a radiance of a degree so dazzling that what else of glory there was within the temple was utterly obscured ; as one seeing a thin black vapour resting before the face of the mid-day sun, so I saw upon the radiance the brooding cherubim, their wings meeting, their faces hidden ; I saw within the glory, one who seemed of pure snow and of pure fire, the Very Love, the Divine Type of Absolute Beauty, primæval and eternal, compact of the white flame of youth, burning in ineffable perfection.

For a moment's space I shielded my eyes from the blinding glow, then once more raised them upon the Beatific Vision. It seemed to me as though my spirit were drawn forth from its abiding place, and dissolved in unspeakable ardours ; anon

fiercely whirled round in a sphere of fire, and swiftly borne along a sea of throbbing light into the Very Heart. Ah, how may words shew forth what it was then vouchsafed to me to know? As when the thin, warm tears upon the cheek of the sleeping bride are kissed away by him who knows that she is wholly his, and one with him ; as softly as his trembling lips are set upon the face transfigured on his soul, even so fell upon my heart, made one with the Heart of Love, its inmost, secret flame : my spirit was wholly swallowed up, and I knew no more.

* * * * * * *

Then all this wondrous vision was fulfilled, and looking upon the sky, I saw that the stars had set and the dawn had spread his wings over the world ; and again the words of the sage King, *Until the day break and the shadows flee away,* came into my mind.

THE END.

LONDON : PRINTED BY
SPOTTISWOODE AND CO., NEW-STREET SQUARE
AND PARLIAMENT STREET

11. **SIMEON SOLOMON IN OLD AGE**
Photograph, probably 1890's, by permission of the Syndics of Cambridge University
Library, from the archives of late Dr N.R. Salaman, FRS.
This photograph fits Bernard Falk's description from *Five Years Dead* of the ageing
Solomon as "quite bald, but a great bushy reddish-white beard made up for his lack of
hair. Being of small stature, he seemed rather over-weighted by his luxuriant chin
growth."

CHAPTER V

The Decline

At 7.10 p.m. on the evening of February 11th 1873 the police arrested Solomon in a public lavatory situated in Stratford Place Mews, off Oxford Street. He and his partner "in crime", George Roberts, a sixty-year-old stableman, were taken to the police station and medically examined; neither was found to be under the influence of drink. The offence of sodomy being unproven, they were charged next morning at Marylebone Police Station with gross indecency, a lengthy indictment which was so worded as to suggest that the offence was a personal affront to Queen Victoria, her peace and tranquillity and her sacred moral responsibility towards the nation. At the Clerkenwell Petty Session of February 24th, the accused pleaded not guilty to the charge, but both were found guilty: Roberts was sentenced to eighteen months imprisonment whilst Solomon's sentence was mitigated to a mere six weeks in the Clerkenwell House of Correction and a fine of £100. He was, however, held over for a further period under police supervision. It is not known why Solomon received more lenient treatment than Roberts; perhaps he bowed his head in more convincing repentance or maybe poor Roberts was simply unable to raise £100. In any case no mention of the incident appeared in the newspapers and with care no one need have been any the wiser.

Somehow, however, the rumour got around amongst Solomon's friends and upon his release he felt obliged to leave London for Devonshire where he stayed for some months as the guest of Mrs Pender Cudlip. This season of recuperation only eventually came to an end due to Solomon's drinking habits proving too much of a strain on the generosity of his hostess.

In the meantime rumours were rife. Swinburne had heard that something was amiss and on March 11th he wrote to Powell:

> Have you any news good or bad of our wandering Jew? The aberrations of that erratic vagrant from the narrow way are a subject of real uneasiness and regret to me. Let us, my brother, while we drop a tear over the sheep now astray from the true fold of the Good Shepherd, if not indeed irrevocably classed among the goats to be ultimately found on the left hand of the Good Shepherd, give thanks to a merciful Providence that we are not as this Israelite, in whom, if we have not been mistaken as to his character, I fear there must be a good deal of guile.[46]

Rossetti, in his letter to Ford Madox Brown of April 19th, asks:

> Have you heard these horrors about little Solomon? His intimate, [William] Davies, writes me: 'He has just escaped the hand of the law for the second time, accused of the vilest proclivities, and is now in semi-confinement somewhere or other, I have said little about it on account of the family who have suffered bitterly. I hope I shall never see him again. [Burne-]Jones has been most kind and considerate to his friends, though sickened to death with the beastly circumstances.'
>
> Poor little devil! What will become of him?[47]

Ford Madox Brown advised Edmund Gosse of the scandal and by the

summer the art dealer Charles Augustus Howell was corresponding with Rossetti on the subject.

Gosse kept an appointment to visit Swinburne at his London rooms on May 23rd but found that the poet had fled to Oxford, apparently in some consternation. No doubt Swinburne was aware how Lord Arthur Pelham Clinton, the thirty-year-old son of the Duke of Newcastle, had been implicated in the Boulton and Park case and had chosen to commit suicide rather than appear in the dock at their side. On June 6th, from Oxford, Swinburne wrote to Powell:

> I have been spending a fortnight in Oxford where I saw and spoke with a great friend of poor Simeon's, Pater of Brasenose, who has seen Miss Solomon, and appeared to have more hope of his ultimate recovery and rehabilitation than from the horrid version I had heard of the form of his insanity I had ventured to retain... I suppose there is no doubt the poor unhappy little fellow has really been out of his mind and *done* things amenable to law such as done by a sane man would make it impossible for anyone to keep up his acquaintance and not be cut by the rest of the world as an accomplice? I have been seriously unhappy about it for I had a real affection and regard for him – and besides his genius he had such genuinely amiable qualities. It is the simple truth that the distress of it has haunted and broken my sleep. It is hideous to lose a friend by madness of any kind, let alone this. Do you – I do not – know any detail of the matter at first hand? Pater I imagine did, and his tone gave me a gleam of comfort... [48].

On December 1st Swinburne wrote to Theodore Watts-Dunton:

> I had heard before that Simeon Solomon was in Devonshire

staying with some old friends; also that he had been giving
public readings in his own name from (I think) Dickens in
the neighbouring town with great success; and I have just
heard from Powell that it appears from his own account
that he is living in a round of balls and private theatricals.
Everything connected with him is so extraordinary that
nothing can be expected to happen in his case except that
which seems unlikeliest, and I suppose we shall hear next
of his presentation at court with a promise of the
rever[sio]n of Sir F.Grant's vacant president[ial] chair[49];
but in the meantime I h[ave wri]tten to Powell a long letter
of eld[er br]otherly advice not to be led away by any kindly
and generous feeling towards an unfortunate man, whom
he has been used to regard as a friend, into a renewal of
intimacy by correspondence or otherwise which might
appear to involve him in equivocal or questionable
relations with a person who has deliberately chosen to do
what makes a man and all who associate with him
infamous in the eyes of the world. It is something new for
me to come forward as a representative of worldly
wisdom; but as I said to P. I do not think I need fear to be
accused of lukewarmness in friendship or pers[on]al
timidity in the face of public op[ini]on; it is not exactly for
turning tai[l or dese]rting my friends when out of favour
[with] the world or any part of it that I have exposed myself
hitherto to attack; only in such a case as this I do think a
man is bound to consider the consequence to all his friends
and to every one who cares for him in the world of allowing
his name to be mixed up with that of a –let us say, a

Platonist; the term is at once accurate as a definition and unobjectionable as an euphemism.[50]

On January 2nd 1874 Swinburne wrote further to Watts-Dunton:

At the end of next week I am going into Cornwall for ten days with Prof. Jowett who has just paid us a new year's visit here. Between this and then the Master of Balliol will be at Torquay, where I am not sorry that I do not join him, as I have no wish, especially in his company, to encounter that of a Platonist of another sort than the translator of Plato – 'translator he too' as Carlyle might say, of Platonic theory into Socratic practice – should he still figure in that neighbourhood as the glass of fashion and the mould of form, if not (as I sincerely hope not) 'the glass wherein the noble youth' of the West Country 'do dress themselves'. Powell has answered to my little fraternal lecture on caution in that quarter very nicely, in two or three sensible and grateful words.[51]

Besides a brief mention of Solomon to Watts-Dunton in 1877, Swinburne does not refer to him again until a letter to Edmund Gosse of October 15th 1879 when he speaks of the artist as:

now a thing unmentionable alike by men and women, as equally abhorrent to either – nay, to the very beasts – raising money by the sale of my letters to him in past years, which must doubtless contain much foolish burlesque and now regrettable nonsense never meant for any stranger's eye who would not understand the mere childishness of the silly chaff indulged in long ago.[52]

This appears to be the only evidence that Solomon sold Swinburne's letters. It is fascinating to conjecture as to who bought them, for what

purpose, and where they may be today. Solomon would have had no compunction in earning drinking money from these souvenirs of the days when Swinburne had treated him as his confidant. His motives may well have been mirthful revenge as well as pecuniary.

It is clear that Watts-Dunton, who was to house and protect Swinburne in the poet's old age, would never have permitted further communication between his charge and Solomon. Long after Swinburne's death, when Thomas James Wise acquired, through Edmund Gosse, seven letters from Solomon to the poet[53], Gosse warned Wise:

> The enclosed letters from S.S. contain direct reference to
> his notorious vices, and an implication that A.C.S. was
> quite aware of their nature. I therefore suggest to you that
> they should be destroyed at once, if you agree. I have kept
> another note on S.S., which is quite innocuous and has an
> interesting feature.

It is remarkable how famous men, themselves far from virtuous, are wont to protect their equally discreditable friends, provided that they too are blessed with renown. Let rather those who have "fallen" in life carry the sins of their more fortunate, more callous, brethren.

There are three chief published sources of information about Solomon's subsequent years: Robert Ross's *Masques and Phases*[54], and his article in *The Bibelot* of April 1911; Julia Ellsworth Ford's *Simeon Solomon, an Appreciation,* and, most informatively, Bernard Falk's *Five Years Dead*[55]. Since however all three writers base their impressions on meetings they had with Solomon in his last years, little light is thrown on the immediate years following upon his conviction. It seems that by 1874 he was back in London, a return which must have been a painful experience for him. Indeed he had little choice but to return to his relations since he was now almost entirely dependent on their benefaction. His income from painting

was drastically reduced; not only were the coveted walls of Burlington House and the Dudley Gallery closed to him but most of his old patrons, whom he had met through his brother artists, withdrew their patronage. His friends amongst the aesthetes, themselves of questionable repute, dared not risk compromising themselves further by keeping the artist's company whilst his artist friends also distanced themselves from their disreputable associate. Deeply humiliated and saddened Solomon drowned his sorrows in alcohol; a bad habit became an incurable malady.

Unprepossessing though the incident was which led to his disgrace, it was the prudery and hypocrisy of Victorian society that aggravated the stigma. Even amongst enlightened artistic circles the outer facade of respectability had to be upheld and woe betide any who challenged this sacred precept. It is tragic that by so trivial but foolhardy an act he should have jeopardised so promising a career. Could it be that Solomon, consciously or unconsciously, had an "ambition to degradation"? He certainly resisted, at times aggressively, any attempt by friends or family to reform his profligate ways and to reinstate him in the society that had brought about his rejection. If despised he must be, then let him rather defy society, his assailant, than acquiesce to its laws and demands that were so foreign to his nature. By, however, refusing to don the coat of Victorian respectability, he condemned himself to an old age devoid of outer dignity, human love and hope.

Solomon continued to paint both Hebrew and classical themes, which, although imbued still with a rare spirituality, lacked much of the skill and inspiration that had been the hallmark of his work in more clement days. Drink made drastic inroads into his talent and necessity drove him to hawk his paintings round the London galleries. Falk tells us how he obtained advances from picture dealers of his earlier acquaintance against promises of work to be supplied. These promised pictures were, however, rarely

executed, his patrons receiving, in their stead, abuse and further financial demands. It is therefore understandable that certain exasperated dealers had recourse to locking the artist into a studio equipped with chalk and paper, releasing him only when he had reimbursed them with creative work. Solomon naturally rebelled against this forced labour and drew little more than half-hearted sanguine copies of his past favoured themes (Plates 70 and 71).

These drawings nevertheless sold and Solomon, for his part, was usually too inebriated or too indolent to exert himself further. So worthless were some of his pictures that his old friend, Murray Marks, the dealer, was wont to buy them simply in order to destroy them hoping thereby to protect what remained of the artist's reputation. From time to time however, from amongst these weak and repetitive works, some powerful yet exquisitely delicate drawing will stand out, a vivid manifestation of the latent genius which Solomon still possessed.[56] Such drawings achieve a dramatic impact through a strict economy of line and simplification of composition (Plates 76, 79 and 80); similarly certain watercolours recapture the rich colour spectrum of his heyday (Plate 75). Oils, however, are rare during these later years and when they do exist they are mostly muddy in colour and undefined in line. In any case his nomadic life and poverty is likely to have rendered this medium somewhat inaccessible.

When his income from selling drawings proved insufficient for his meagre needs, he turned to his relatives, who, despite his habit of pawning their gifts, supplied him regularly with new outfits of clothes. In an attempt to entice him to work his family rented a fully equipped studio for him; he used it however simply as a doss house. Losing patience his relations eventually consigned him to a mental home in 1880, although it was clear to all that his waywardness did not stem from insanity. Realising this fact the institution's head sent Solomon out to post a letter, presuming thereby that

he would avail himself of the opportunity to escape; far from it, Solomon returned smiling amusedly. Before long, however, his family agreed to his formal discharge and Solomon returned once again to his London haunts. His experience in confinement had however left their mark on Solomon; fortified in his distrust of his kin, he determined to free himself from all remaining constraints, choosing rather to join London's teeming vagrants rather than submit himself to further discipline. Frequenting the gutters of the city he slept and ate rough, earning pennies from selling matches and shoelaces in the Mile End Road and Whitechapel. In Houndsditch he associated with thieves; in Brompton Road he plied his trade as a pavement artist.

Like Paul Verlaine in Paris, Solomon, so long as his health held, sustained himself on alcohol, but when, in 1884, his constitution began to weaken, he was forced to take refuge in St. Giles's Workhouse, Seven Dials. He received kind treatment at St. Giles and chose to make it his base for the remaining twenty one years of his life. Indeed when offered alternative accommodation by a cousin he replied: "Thank you but I like it here, its so central." In 1886 Solomon suffered the double loss of his aged mother and his beloved sister Rebecca. Like her brother, Rebecca had undermined her health through alcoholism and her end came in a street accident, run down by a passing carriage.

In the mid-1880's the Estonian eccentric, Count Eric Stenbock, befriended Solomon, and in a letter to Frederic Hollyer, in 1886, Solomon raves about the exotic reception Stenbock gave him at 11 Sloane Terrace and his generous gifts of money and clothes. They shared a mutual taste for romantic music, recherché literature and homosexuality. By the autumn of 1888 Solomon was entertaining hopes of being commissioned to decorate Stenbock's home but by then the initial flurry of their friendship was waning and the Count was tiring of Solomon's continued importunities. Stenbock

commissioned no frescoes and indeed soon brought the association to a premature close.

A more virtuous boon companion of these days was the Catholic poet, Francis Thompson, who, like Solomon, lived the life of a tramp. Alice Meynell, the poetess and fellow Catholic, befriended both poet and artist and through her and Thompson's encouragement Solomon found his way to the Carmelite Church in Kensington Church Street. Here he found shelter, rest and consolation. This flirtation with Rome was however displeasing to his orthodox Jewish relatives and prejudiced his chances of enjoying their continued support. Some of his younger cousins, on the other hand, were fascinated by the colourful old reprobate in their midst. The late Clement Salaman remembered using the National Gallery as a place of rendezvous, where Solomon, to all appearances no better than a tramp, would act as a guide around his beloved masterpieces of the Italian Renaissance. Soon his sonorous voice and conspicuous knowledge would draw an audience of other museum guests away from their study groups and official guides.

When Ross met Solomon in 1893 he was impressed by the incorrigible cheerfulness and stubborn lack of repentance of this "small red man with laughing eyes." He was amiable in his intoxication and appeared to bear no grudge against his former celebrated friends who, for the most part, now chose to ignore his existence. Apparently content with both the bottle and his own personal filth, he never tired of relating the most exaggerated stories about his exploits, which, more often than not, were mere figments of his vivid and still creative imagination. One such story, which may be apocryphal, is that, having enjoyed afternoon tea with Sir Edward and Lady Burne-Jones, he subsequently broke into their home, The Grange, accompanied by the professional burglar Jim Clinch, who, however, was in an inebriated state equal only to his own. Their drunken curses and

clattering of the dining room silver soon roused Lady Burne-Jones who sent their son Philip to fetch a policeman. When the constable arrived he and Sir Edward surprised the culprits. The embarrassed Burne-Jones was obliged to bribe the law in order to save Solomon from arrest.[57]

Oscar Browning records the warmth of a chance meeting in Fleet Street. They greeted each other with "Oscar!" and "Simeon!", embraced and parted for ever, or so Browning tells us in *Memories of Sixty Years*. The Browning Archive however contains two begging letters from the artist, one from 113 Gray's Inn Rd. and another dated February 19th 1896 from 359 Edgware Rd. reading:

> I am in a little trouble just now. If you will kindly lend me
> eight or ten pounds until I have finished the picture I am
> painting I shall deem it a great favour.

History does not relate if Browning was sufficiently moved to make this required donation.

During the late 'eighties and early 'nineties Solomon enjoyed some belated acclaim in the aesthetic circles of the day. To Wilde he appealed as the eccentric precursor of his own creed of "Art for Art's sake." To Bernard Falk, the journalist, he was a notorious old misfit, worthy subject perhaps for a newspaper article. Falk tracked the artist down at a tavern he frequented near Seven Dials and was granted an interview. He could not however persuade the *Evening News* to publish his resultant article until after Solomon's death. Percy Bate in *The English Pre-Raphaelite Painters* of 1899 included a short section on Solomon[58], along with three illustrations from the artist's allegorical paintings of the late 'sixties and early 'seventies. Bate also wrote a critical introduction to a major exhibition of Hollyer's photographic reproductions of Solomon's pictures.

Julia Ellsworth Ford, who met Solomon at the photographic studio of Frederic Hollyer, gives an account of his vivid and amusing repartee and

his dedication to his beloved poets Keats and Shelley. She insists, somewhat improbably, that Solomon spoke warmly even of Swinburne to whom he accredited an introduction to Walt Whitman's *Leaves of Grass.* He may have remembered writing to Swinburne in May 1871: "I hear there is a new American poet. What do you think of him? I have not yet seen his work." Swinburne presumably led him to Whitman. A copy of *Leaves of Grass* must have lain conveniently to hand in Hollyer's studio because Solomon read out loud:

> A clear midnight
> This is the hour, O Soul, thy free flight into the wordless,
> Away from books, away from art, the day erased, the
> lesson done,
> Thee fully emerging, silent gazing, pondering the themes
> thou lovest best;
> Night, Sleep, Death and the stars.

Here lay the beloved themes of Solomon's own imagination. In *Simeon Solomon, An Appreciation* Ford illustrates a facsimile of Solomon's handwriting, quoting his favourite lines from Shelley's "Adonais".

> Life like a dome of many coloured glass
> Stains the white radiance of Eternity.[59]

Herbert Horne, the Arts and Crafts designer and editor of The Century Guild's magazine, *The Hobby Horse* from 1887 to 1891, seems to have met Solomon through Count Stenbock. He and another of the Count's friends, Dr T.Robinson, began collecting Solomon's drawings and a large number of letters to Horne survive at the Fondazione Horne, Florence. Horne ended his years in Florence, renowned as an eminent collector of early Italian Renaissance paintings, leaving a notable collection to the city. Much of the correspondence, dating between 1888 and 1893 consist of a record of rendezvous kept, missed or simply forgotten, but light is, from

time to time, thrown on the spasmodic work that Solomon still undertook and also on the noticeable degree to which the artist was still dependent on his relatives for accommodation and support. One long undated letter of 1889 was obviously written when Solomon was drunk and aggrieved at some unknown misdemeanour of Frederic Hollyer. The letter purports to be addressed by "The Angel Gabriel, Upper Circle, Heaven" to "His Servant" Solomon. Philosophising, he jots down ideas, vivid but disjointed:

> If in this life there is nothing, it follows that in the future there is something... the rose that hath hitherto had a pleasing perfume.

Of Hollyer, "The Holy man in Pembroke Square"[60], Solomon comments:

> Thou art now my Bishop and thou shall love the poor little ones, and feed them especially the poor lamb [Solomon] which hath need of thy sorrow... and there was enthroned the Anti-Christ, and in Pembroke Square they wailed and gnashed their teeth...

Solomon signed the letter "Rome in Sancti Petri".

Horne at this time shared a house in Charlotte Street with his co-editor of *The Hobby Horse,* Selwyn Image, and the Catholic poet Lionel Johnson. W.B.Yeats, speaking of his visits to their home in "The Trembling of the Veil[61], tells us how

> sometimes one might meet in the rooms of one or other a ragged figure, as of some fallen dynasty, Simeon Solomon the Pre-Raphaelite painter, once the friend of Rossetti and Swinburne, but fresh now from some low public-house. Condemned to a long term of imprisonment for a criminal offence, he had sunk into drunkenness and misery. Introduced one night, however, to some man who mistook him, in the dim candle light, for another Solomon, a

successful academic painter and R.A., he started to his feet in a rage with "Sir, do you dare to mistake me for that mountebank?".

Solomon continued to paint and in 1893, through the auspices of Herbert Horne, *The Hobby Horse* published one of his drawings of a *Medusa's Head.* There are many variations, mostly chalk drawings, of this theme (Plate 77). Another variation, *Let not thine Eyes see aught Evil but be its Shadow upon Life enough for Thee* (Plate 72) is a fine example of a bizarre symbol that Solomon used, from time to time, in his late drawings. This is the open staring eye super-imposed on the closed eyelid. The symbolism would seem to lie in the moral of this picture's inscribed title; evil weighs inevitably down upon us; let us not, open eyed, invite its entry into our souls. Some recognition also came Solomon's way; at the Manchester Royal Jubilee Exhibition of 1887, they showed two oils *Love in Autumn* (Plate 1) and *Hosannah* along with three watercolours, *Lady in a Chinese Dress* (Plate 33), *The Sleepers and the One that Watcheth* (Plate 6) and *It is the Voice of my Beloved that Knocketh* (Plate 66) whilst some years later the London Guildhall Exhibition of 1894 showed *Love in Autumn* (Plate 1) and *The Sleepers and the one that Watcheth* (Plate 6). The Glasgow International Exhibition of 1901 hung *Love in Autumn* (Plate 1) and *The Mystery of Faith* (Plate 57). Posthumously, at the Franco-British Exhibition of 1908, they hung *The Mother of Moses* (Plate 18) whilst the International Fine Arts Exhibition of 1911 in Rome showed the same oil and two watercolours, *A Greek High Priest* (Plate 47) and *The Mystery of Faith* (Plate 57).

On May 25th 1905, Solomon, as was his habit, went to visit his cousin George Nathan in the City, where he collected clothes and pocket money. Whilst returning to St. Giles he collapsed from a heart attack in Great Turnstile, Holborn. He was taken to King's College Hospital, from where,

despite his bronchitis and weak heart, he was soon discharged. On August 14th of the same year Solomon fell dead from a second heart attack in the dining hall of St. Giles's Workhouse. It is said that those who saw him in death remarked upon "the perfect serenity of his remarkable features". An enquiry was held on August 18th followed by a short report in *The Times*. Robert Ross in *The Westminster Gazette* wrote of Solomon: "Casting reality aside, he stepped back into the riotous pages of Petronius... There is hardly room for an inverted Watts." Solomon's relatives buried him in the Willesden Jewish Cemetery where sadly his tombstone is now hardly recognisable.

Conscience striken, the artistic establishment arranged a large one-man exhibition of Solomon's work that winter at the Baillie Gallery[62]. Some weeks later certain early Solomon paintings were included in a major retrospective exhibition held at Burlington House. London society admired these works of genius with condescension and pity; once again Solomon's paintings took their rightful place alongside those of his great Victorian contemporaries. But it was too late for the little Jew to reap the rewards of posterity's recognition; a recognition that perhaps even today does not do full justice to one of England's earliest and most original Symbolist painters.

Solomon probably never knew the poetry of the German classical poet August Count von Platen, but a few words from Platen's "Triston" make a fitting epitaph to the artist's tragic life:

> Wer die Schönheit angeschaut mit Augen
> Ist dem Tode schon anheimgegeben
> Wird fur keinen Dienst auf Erden Taugen
>
> . . .
>
> Wer die Schönheit angeschaut mit Augen,
> Ach, er möchte wie ein Quell versiechen!

(He who has beheld beauty with his eyes
Is already bound unto death
With Earthly duties he strives in vain,
. . .
He who has beheld beauty with his eyes
Into the earth he would dissolve, like the waters of a
Spring!)

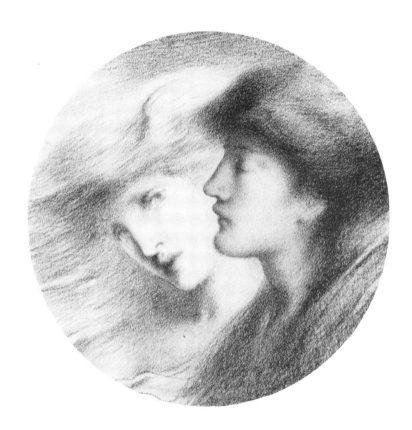

Let not thine eyes see aught evil itself, but be its shadow upon life enough for thee

John Payne's
SLEEPERS AND ONE
THAT WATCHES
from
INTAGLIOS, 1871,
pages 65/68

I

Will the day never dawn?
The dim stars weep
Great tears of silver on the pall of night;
And the sad moon, for weariness grown white,
Crawls like a mourner up the Eastern steep.
I strain my eyes for morning, while these sleep;
Dreaming of women, this one with the lips
Half-parted, haply, – that in the eclipse
Of a child-slumber, dreamless, folded deep,
Eyes seal'd as though a hand of sleep strew'd flowers
Upon their lids, and mouth a fresh-dew's rose,
Wet with the kisses of the night. The hours
Are very heavy on my soul, that knows
No rest: for pinions of the unseen powers
Winnow the wind in every breath that blows

II

Surely, a lance-point glitter'd in the west!
Some trumpet thunder'd out its voice of doom!
But no: my eyes are hazy with the gloom.
'Twas but the moon-rays glancing on the crest
Of the tall corn; some bittern from her nest
Roused by a snake: for, see, the twain sleep on,
And nothing stirs their slumber. Oh! for one
Sweet hour of falling through the deeps of rest
Within that lake of sleep, the dreamy shored!
One little hour of overlidded eyes
And folded palms! Ay me! the terror lies
Upon my soul; I may not loose my sword,
Lest I should wake beneath flame-girdled skies,
And tremble to the thunders of the Lord.

III

The blackness teems the shapes of fearful things;
Weird faces glare at me from out the night,
And eyes that glitter with the lurid light
Of lust and all the horror that it brings.
The air is stressful with the pulse of wings;
And what time clouds obscure the constant star
That overlooks my vigil from afar,
Strange voices tempt me with dread whisperings:
Dank hands clasp mine; and breathings stir my hair
That are no mortal's, wooing me to leap
Over the hill-crest, through the swarthy air,
Into the hollow night, and thence to reap
The wonder and the weirdness hidden there.
Ah God! the day comes not; and still these sleep!

Textual Notes

1 Although included in the 1873 first edition of *Studies in the History of the Renaissance,* this paragraph was omitted from the 1877 republication *The Renaissance : Studies in Art and Poetry,* which appeared shortly after Simeon Solomon's disgrace; see Michael Levey's *The Case of Walter Pater,* 1978.

2 This essay, first published in the *Fortnightly Review* of December 1876, was included in Walter Pater's *Greek Studies* of 1894.

3 See Daphne du Maurier's *The Young George du Maurier,* 1951, page 235.

4 Published 1917, see pages 40, 59/60, 65, 84/85, 98 and 114/115.

5 Formed in 1860 as part of the homeguard to protect England from possible French attack.

6 Published by the Old Watercolour Society, 1941.

7 The Hogarth Club was a membership club where artists showed their paintings to a restricted audience. It existed between July 1858 and August 1861 and was used as a testing ground for pictures to ascertain whether they would be suitable material for the Royal Academy Summer Exhibitions.

8 Edited by A.M.Stirling, published 1929, see pages 160/161.

9 See Julia Ellsworth Ford's *Simeon Solomon, An Appreciation,* New York 1908, page 24. Solomon was dramatising his disgrace and painting an untruthful bleak picture of his future relationship with his family.

10 See Dr Steven Kilsteren's article on Rossetti's influence on Solomon in *The Journal of Pre-Raphaelite Studies,* Vol II, No2, May 1982.

11 Julia Ellsworth Ford used these drawings as illustrations for *King Solomon and the Fair Shulemite from The Song of Songs,* New York, 1908. *The Art Amateur,* an American art periodical, used them as illustrations of an article on Solomon by Sidney Trefussis Whitehead, date untraced.

12 Owned by the Ein Harod Museum, Israel.

13 *Passages from the Poems of Thomas Hood illustrated by the Junior Etching Club,* published by E.Gambert & Co, 1858.

14 See Gleeson White's *English Illustration, the Sixties, 1855-70,* 1897, for a description of these various periodicals.

15 Published 1928, see page 104.

16 See Edward C.McAleer's *Dearest Isa, Robert Browning's Letters to Isabella Blagdon,* Austin, Texas and Edinburgh 1951, page 51.

17 This weak drawing, at the Fitzwilliam Art Gallery, Cambridge, was probably executed as late as 1888 when, according to a letter to Herbert Horne dated 31st December 1888, Solomon had drawn a number of portraits of Swinburne, presumably from photographs and memory.

18 Both these manuscripts can be found in the British Library (Manuscripts Dept. Ashley Papers), complete with some of Solomon's drawings and a number of his letters to Swinburne which Thomas James Wise obtained from Edmund Gosse.

19 Published New Haven, 1959; the source of most of Swinburne's letters in this publication.

20 Published 1967, see chapter 2.

21 Published 1929, see pages 53/56.

22 This trial is described in detail in Rupert Croft-Cooke's *Feasting with Panthers,* pages 47/55.

23 Published London and New York, 1919, see page 160.

24 The Oscar Browning Archive, now in the Eastbourne Central Library.

25 This correspondence with Powell is now in the National Library of Wales Aberystwyth.

26 Published 1910, see pages 106/109.

27 This watercolour was acquired by George Powell.

28 See *Robert Ross, Friend of Friends,* edited by Margery Ross, 1952, page 315.

29 See Ian Anstruther's *Oscar Browning,* 1983, page 58; see also pages 51/61 for a description of the relationship between Browning and Solomon. It is interesting how this critical appraisal of Solomon's physical appearance compares with the artist's own self-description on page 6.

30 The Rev Mr Hichens of St. Stephen's Vicarage, Canterbury.

31 Used as the frontispiece illustration of T.Earle Welby's *The Victorian Romantics,* 1929.

32 See *Murray Marks and his Friends,* page 159.

33 See Bernard Falk's *Five Years Dead,* 1938, page 326.

34 Ford, op.cit; page 24.

35 The Oil of this subject, exhibited at the Royal Academy in 1871 is owned by the Baroda Museum and Picture Gallery, Baroda, India; another oil of the same subject is to be found at the West London Synagogue.

36 Published 1906, see pages 59/61.

37 These essays were republished separately by Seeley Jackson and Halliday in 1871.

38 These paintings were presumably Plates 2 and 43.

39 McAleer, op.cit; page 331.

40 Solomon painted an oil entitled *Atlanta* in 1866 evidently inspired by Swinburne's book.

41 See Philippe Jullian's *Dreamers of Decadence,* first UK publication 1971, pages 47/48 and 156 where it mentions that Filiger met a fate similar to Solomon, also due to a homosexual scandal.

42 An example can be found in the British Library.

43 This has been attempted in this publication.

44 William Johnson, alias Cory, Etonian tutor and poet, was dismissed ignominiously from Eton due to a compromising letter he had written to a pupil having been passed by the boy's father to the headmaster, Dr Hornby. Browning was similarly dismissed, if on less specific grounds, three years later.

45 The American publisher, Thomas B.Mosher, also produced a vellum bound fifty copy edition of *A Vision* in 1909.

46 Dr Cecil Lang's *The Swinburne Letters,* Vol II, page 253.

47 *The Letters of Dante Gabriel Rossetti* edited by O.Doughty and J.Wahl, 1965/6, Vol III, page 1162. Note Davies's allusion to a previous scrape with the law, presumably the episode of 1870, see page 20.

48 Lang, op.cit; Vol II, page 253.

49 Of the Royal Academy.

50 Lang, op.cit; Vol II, page 261.

51 Ibid., Vol II, page 264.

52 Ibid., Vol IV, page 107.

53 Now in the British Library, (Manuscripts Dept. Ashley Papers).

54 Published 1909, see pages 135/147.

55 Chapter XXIII.

56 Some connoisseurs of Solomon's painting, such as Alfred Werner in his article on Solomon in *Art and Artists* of January 1975, prefer the artist's later work.

57 See *Self Portrait, taken from the Letters and Journals of Charles Ricketts, R.A.,* edited by Cecil Lewis, 1939, page 75. This episode is also mentioned by Oscar Browning in a letter to Joseph Leftwich dated September 23rd 1919 and described by Robert Ross in *Masques and Phases,* page 141.

58 See pages 64/65.

59 Ford, op. cit; page 23.

60 9 Pembroke Square was the address of Hollyer's studio.

61 From *Autobiographies,* 1926, page 208.

62 122 paintings and drawings were exhibited, see pages 177/178.

Black and White Plates

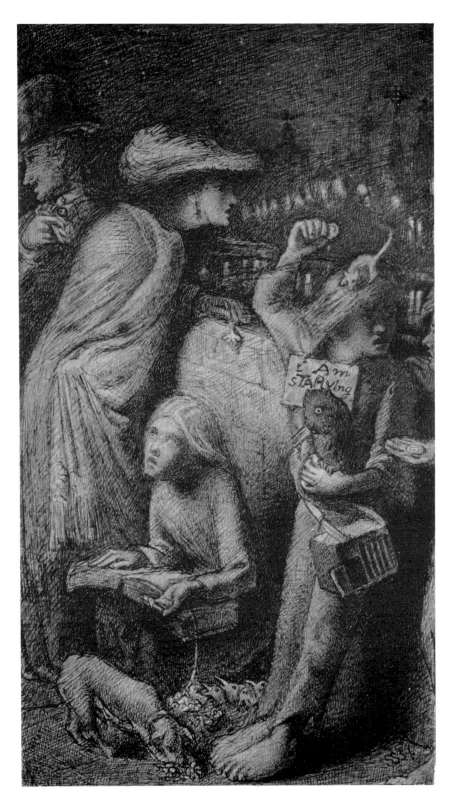

12. I AM STARVING
 Pen and Ink drawing 1857 17.1 x 9.5 cms.
 A work with sociological and comic overtones.

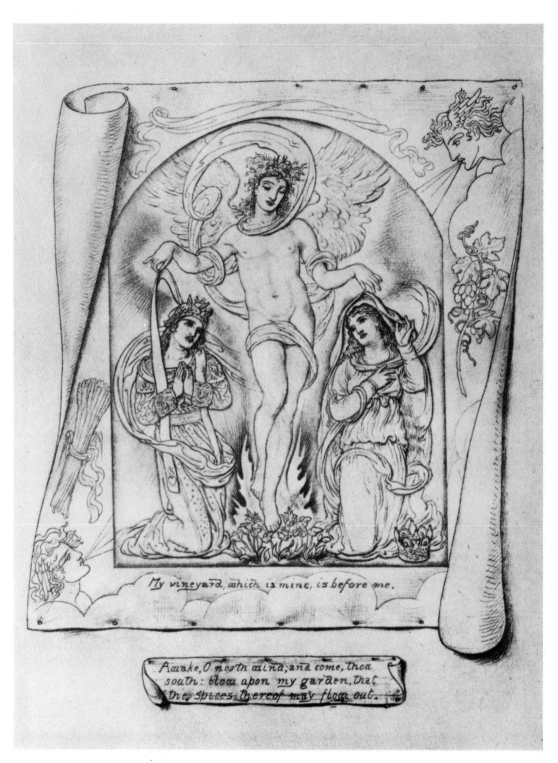

13. ONE OF THE EIGHT DRAWINGS FOR THE SONG OF SOLOMON,
 "MY VINEYARD WHICH IS MINE, IS BEFORE ME"
 Drawing 1859 measurements unknown.
 This series of drawings deeply impressed Sir Edward Burne-Jones.

14. THE DEATH OF SIR GALAHAD
Pen and ink and pencil drawing, undated 18.5 x 16.6 cms.
City of Birmingham Museum Art Gallery.
The influence of the Pre-Raphaelites is evident in this drawing.

15. MRS FANNY COHEN
Drawing 1859 13.2 x 14.2 cms. Fitzwilliam Museum, Cambridge.
The Cohens were cousins of the Solomons.

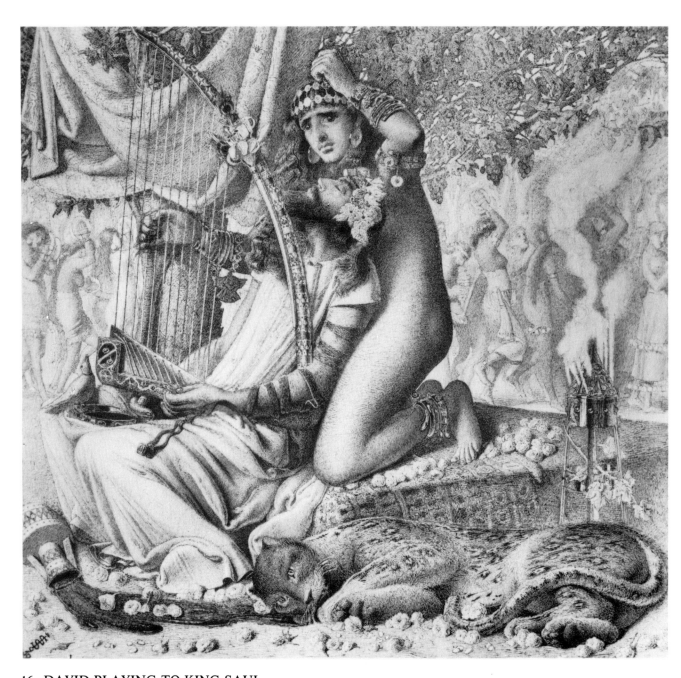

16. DAVID PLAYING TO KING SAUL
Pen and ink drawing 1859 26.5 x 28.1 cms. City of Birmingham Museum and Art
Gallery.
Solomon introduces an element of sensuality into a scene from the Bible. In the same
year Solomon painted an oil of this subject.

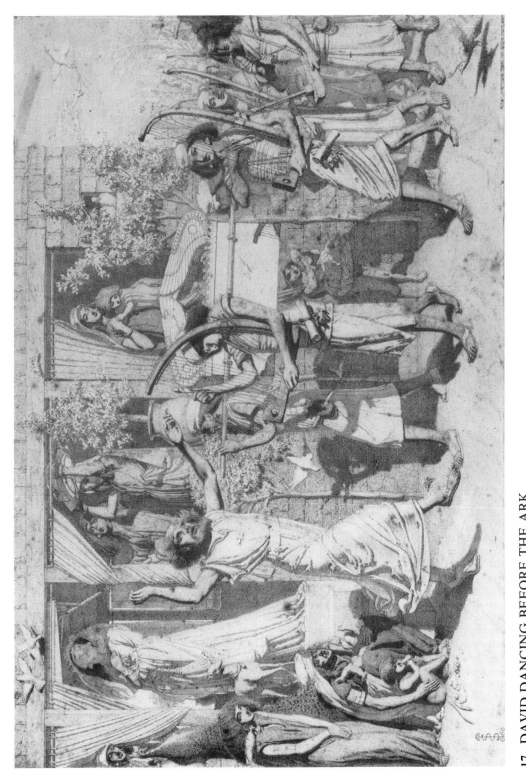

17.　DAVID DANCING BEFORE THE ARK　　　　Private collection, London; once owned by Lord Houghton.
Pen and ink drawing 1860 27.9 x 40.6 cms.
An intricate drawing illustrating an episode from the Book of David.

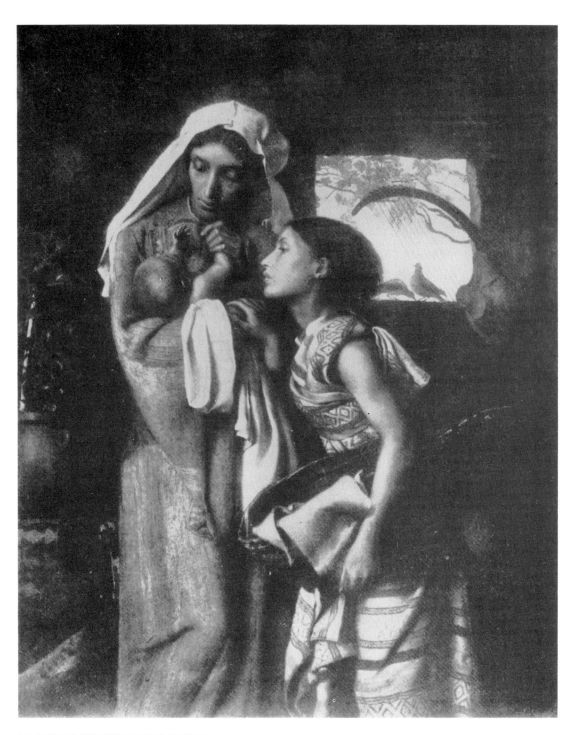

18. THE MOTHER OF MOSES
 Oil 1860 60.9 x 48.3 cms. Private collection, New York.
The Royal Academy painting admired by Thackeray.

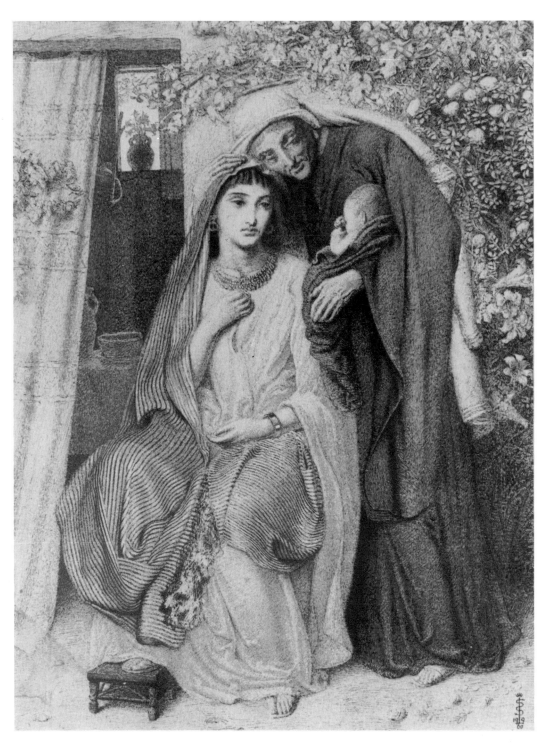

19. RUTH NAOMI AND THE CHILD OBED
Pen and ink drawing 1860 29.3 x 22.5 cms. City of Birmingham Museum and Art
Gallery.
This is a variation on the theme of Plate 18, engraved by Dalziel in 1865.

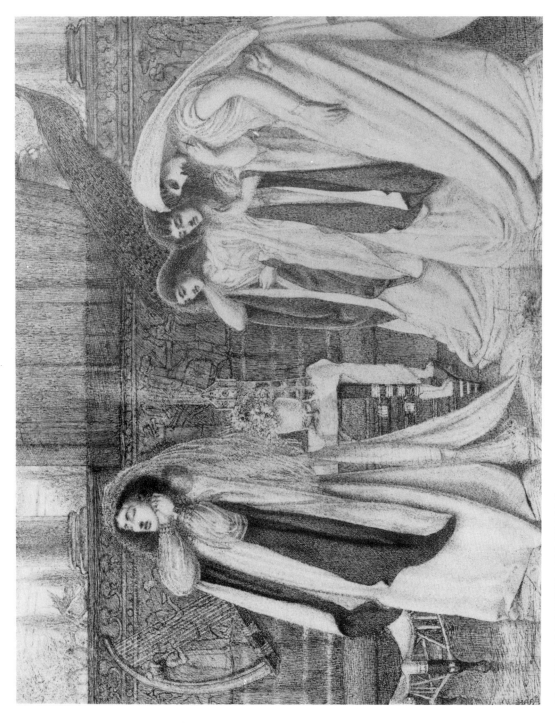

20. THE ANGUISH OF MIRIAM
Pen and ink Drawing 1860 28.6 x 33.6 cms.
A typical theme from the Talmud.

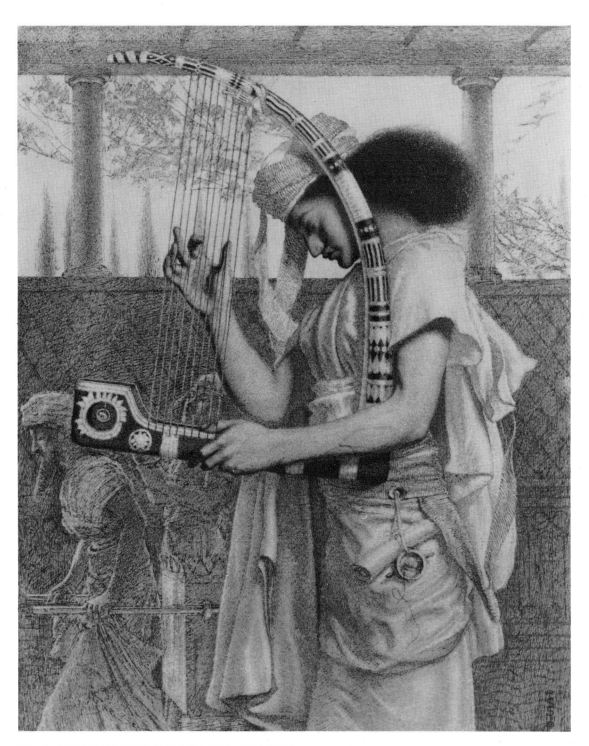

21. A JEWISH MUSICIAN IN THE TEMPLE
 Pen and ink Drawing 1860 28.5 x 24.8 cms. H.E.Huntington Art Gallery,
San Marino, California.
A study for the oil Hosannah.

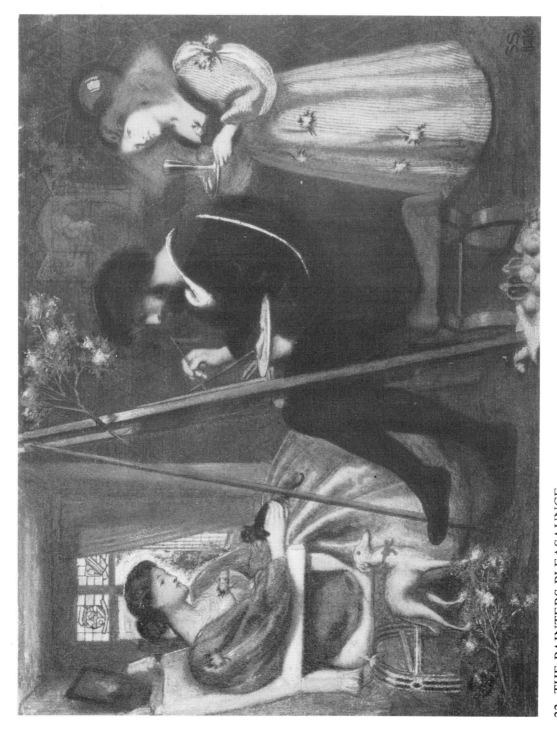

22. THE PAINTERS PLEASAUNCE Whitworth Art Gallery, Manchester.
Watercolour 1861 25.6 x 33.1 cms.
The artist is Abraham Solomon and the model probably Rebecca Solomon.

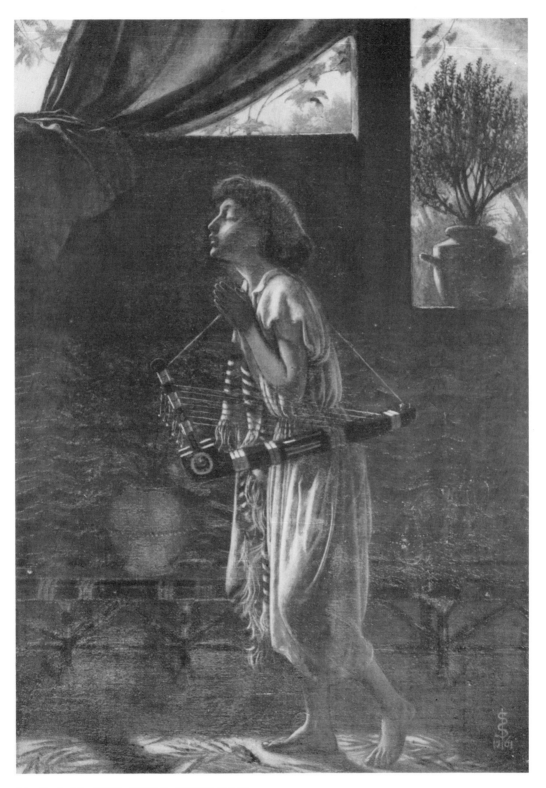

23. Probably THE CHILD JEREMIAH
 Oil 1861 33 x 24.1 cms. Private collection, Cheshire.
 A very intense little oil based on the theme of Hosannah.

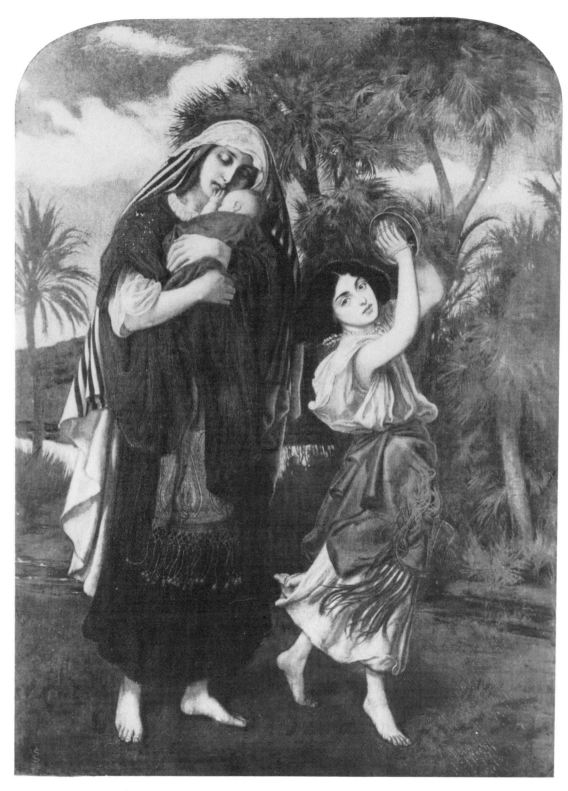

24. THE FINDING OF MOSES
Oil 1862 81.3 x 61 cms. Hugh Lane Art Gallery, Dublin.
Another variation on the theme of Plate 18.

25. LIGHTING THE CANDLES ON THE EVE OF THE SABBATH Private collection, London; from the drawing
Wood engraving for *Once a Week* 1862 9.5 x 12 cms.
at The Museum of Fine Arts, Boston.
An early essay into wood engraving.

26. THE DAY OF ATONEMENT
Wood engraving for *The Leisure Hour* 1862 9.6 x 13.3 cms.
From the series so admired by Sir William Blake Richmond and Forrest Reid.

27. SAPPHO (Study)
 Drawing 1862 33 x 36.8 cms. Tate Gallery, London.
 A study for Plate 32.

28. DANTE'S FIRST MEETING WITH BEATRICE
Pen and ink drawing 1863 33.6 x 36.8 cms. Tate Gallery, London.
Solomon's finest drawing in the style of an early Rossetti, depicting a scene from Dante's
Vita Nuova translated by Rossetti in 1861.

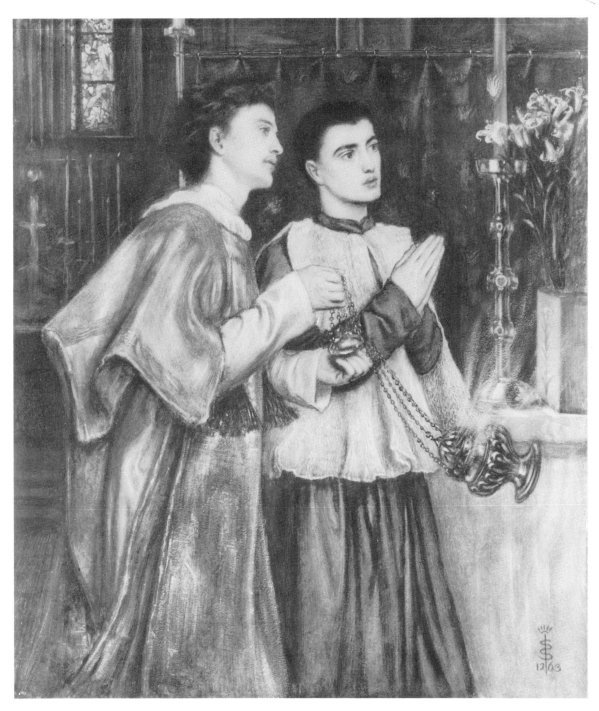

29. TWO ACOLYTES
 Water and body colour 1863 40 x 35 cms. Ashmolean Museum, Oxford.
 An early example of Solomon's aesthetic appreciation of church ritual.

30. JUDITH AND HER ATTENDANT GOING TO THE ASSYRIAN CAMP.
Watercolour 1863 50 x 39.4 cms.
Solomon's last Royal Academy painting, 1872.

31. SHADRACH MESHACH AND ABEDNEGO
Watercolour 1863 33.6 x 23.5 cms. Private collection, London and New York.
The figure on the right is Solomon, that on the left is Swinburne and the angel is said to
be Rebecca Solomon.

32. SAPPHO AND ERINNA IN THE GARDEN MATEIENE
Watercolour 1864 33 x 36.8 cms. Tate Gallery, London.
A charmingly composed watercolour of a risqué subject.

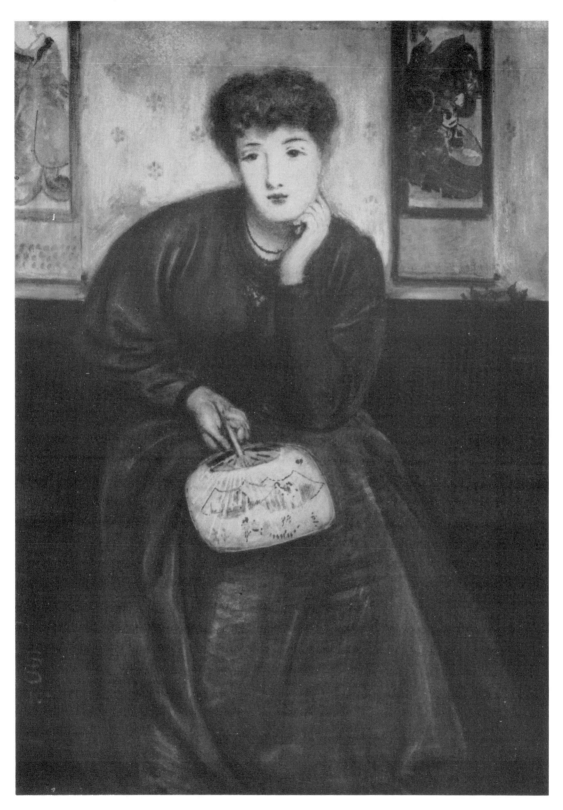

33. LADY IN A CHINESE DRESS
 Watercolour 1865 33.9 x 25.4 cms.
 Probably a portrait of Rebecca Solomon in a fashionable Chinese setting.

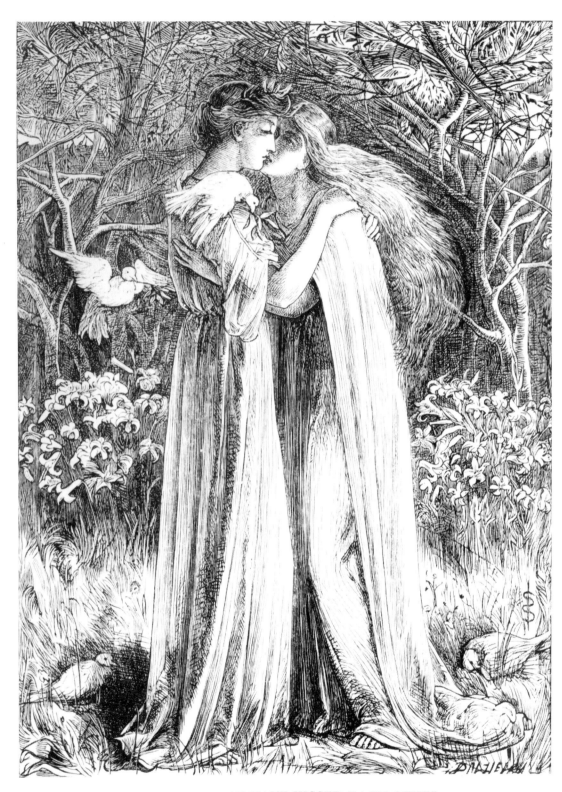

34. RIGHTEOUSNESS AND PEACE HAVE KISSED EACH OTHER
Wood engraving 1865 16.2 x 11.8 cms.
Engraved by Dalziel but only used to illustrate *Art Pictures from the Old Testament*
Certainly the most gracious of this series of engravings.

35. HOSANNAH
 Wood engraving 1865 from the Oil of 1861, 16.2 x 11.8 cms. Tate Gallery, London.
 Dalziel engraving used to illustrate *Dalziel's Bible Gallery*.

36. THE BRIDE, BRIDEGROOM AND SAD LOVE
Drawing 1865 24.8 x 17.10 cms. Victoria and Albert Museum, London.
A drawing on the theme of bi-sexual love.

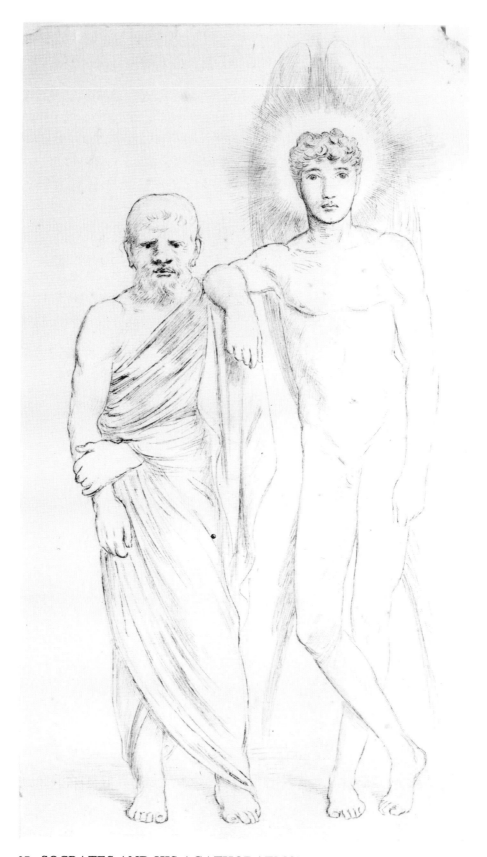

37. SOCRATES AND HIS AGATHODAEMON
Drawing undated 24.8 x 12.7 cms. Victoria and Albert Museum, London.
A comic drawing which preconceives the "Soul's" identity in *A Vision*.

38. LOVE AMONGST THE SCHOOLBOYS
Drawing 1865 24 x 34 cms. Private collection, Oxford.
A provocative drawing once owned by Oscar Wilde.

39. THE DEATH OF LOVE
Drawing 1865 23.5 x 33.6 cms. Private collection, New York.
A pretty folly on the theme of cupid.

40. SPARTAN BOYS ABOUT TO BE SCOURGED AT THE ALTER OF DIANA
 Hollyer photograph of drawing 1865.
 This ceremony at the altar of Artemis was an ideal subject to appeal to Swinburne's fascination with flagellation.

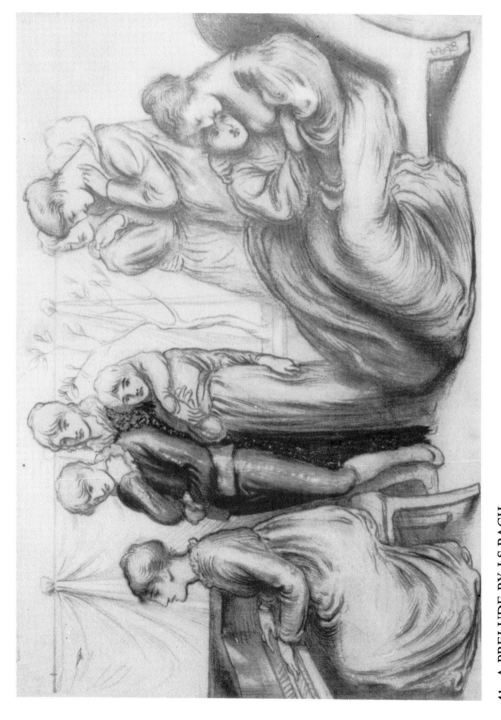

41. A PRELUDE BY J.S.BACH
Watercolour 1866 34.9 x 24.8 cms. Private collection, London.
A preliminary sketch which was perfected in Plate 3.

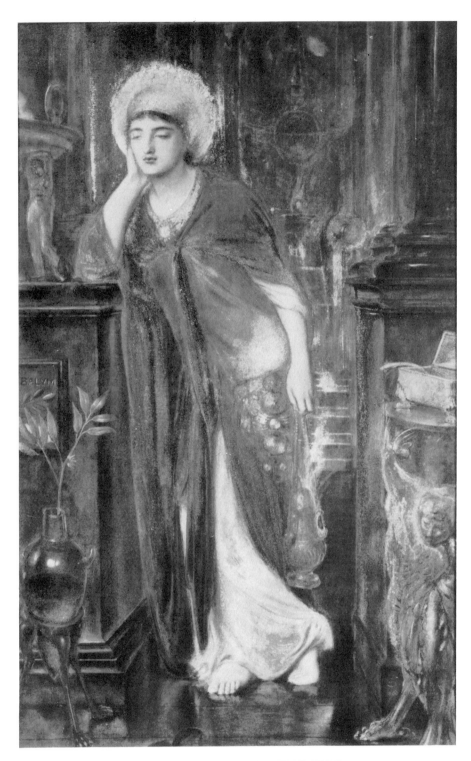

42. HELIOGABALUS, HIGH PRIEST OF THE SUN
Watercolour 1866 21.6 x 29.2 cms.
Forbes Magazine Collection, New York.
An androgynous figure from the decadent period of ancient Roman history.

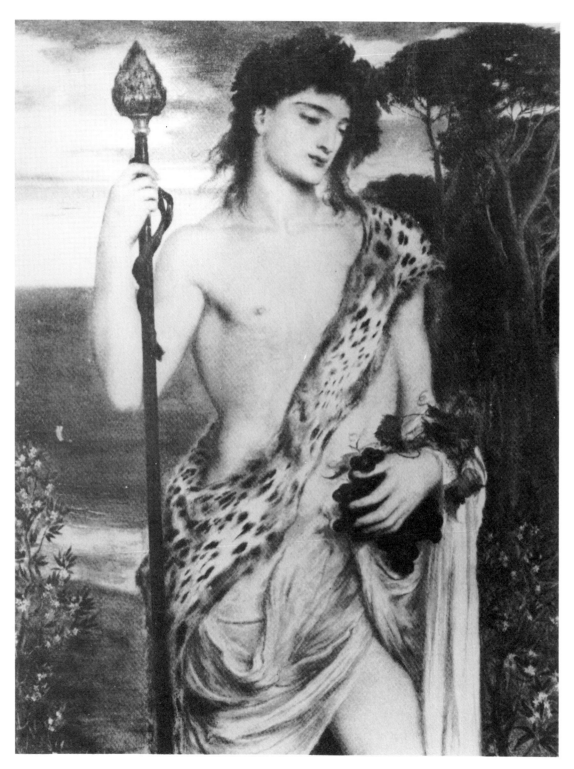

43. BACCHUS
 Watercolour 1867 Rome and London 45.5 x 37 cms. Private collection, Surrey.
 One of the two Bacchanalian paintings admired by Sydney Colvin.

44. A ROMAN LADY WITH A VOTIVE URN
Oil 1867 41.9 x 26.8 cms. Fine Art Society, London.
A formal painting in the classical idiom.

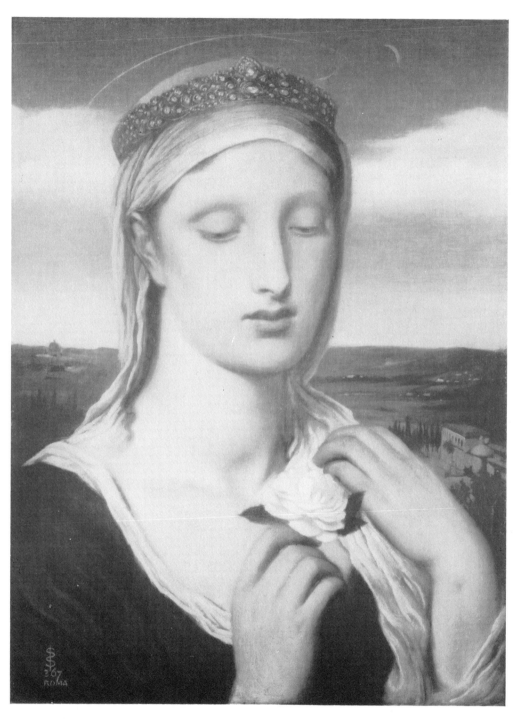

45. ROSA MYSTICA
Oil 1867 Rome 51 x 37.5 cms.
A head in the style of William Dyce and the German Nazarene; possibly influenced by Lord Leighton.

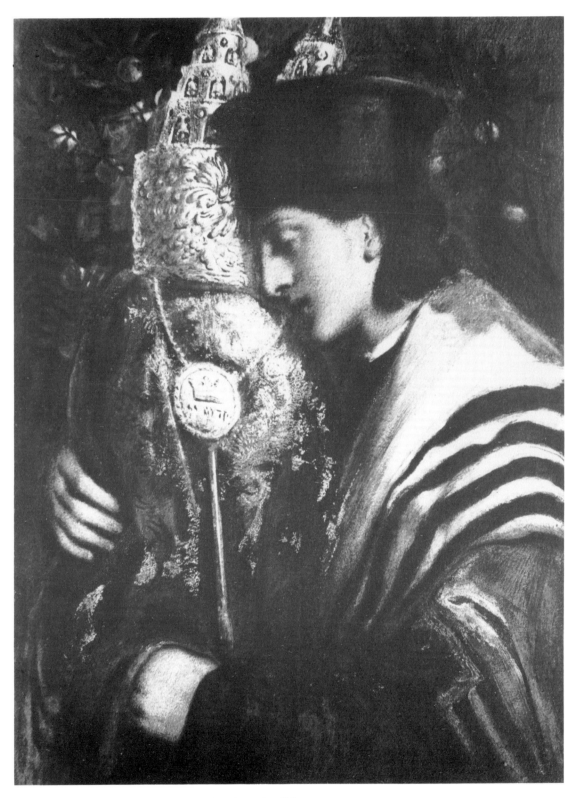

46. CARRYING THE SCROLL OF THE LAW
Watercolour 1867 Rome 35.7 x 25.5 cms. Whitworth Art Gallery, Manchester.
A study for the 1871 oil at the Art Gallery of Baroda, India and the similar oil, also
1871, at the West London Synagogue.

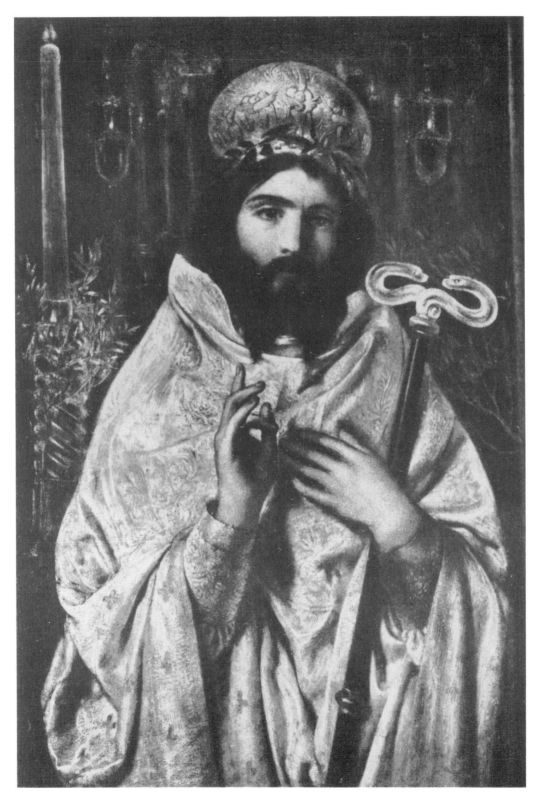

47. A GREEK HIGH PRIEST
 Watercolour 1867 Rome 43.18 x 30.48 cms. Private collection, New Zealand.
The exotic mysticism of the Greek Orthodox Church.

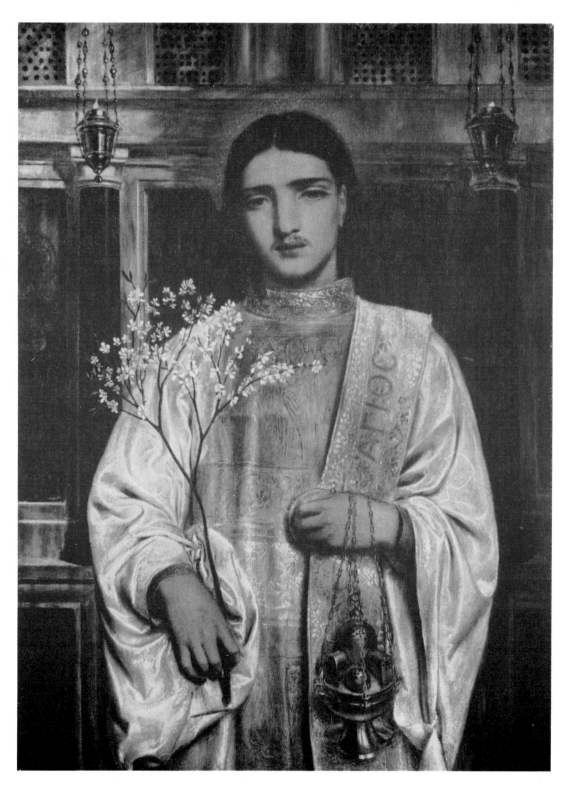

48. A SAINT OF THE EASTERN CHURCH
Watercolour 1867/8 Rome 45.6 x 32.8 cms. City of Birmingham Museum and
Art Gallery.
A similar ambiguous hieratic subject.

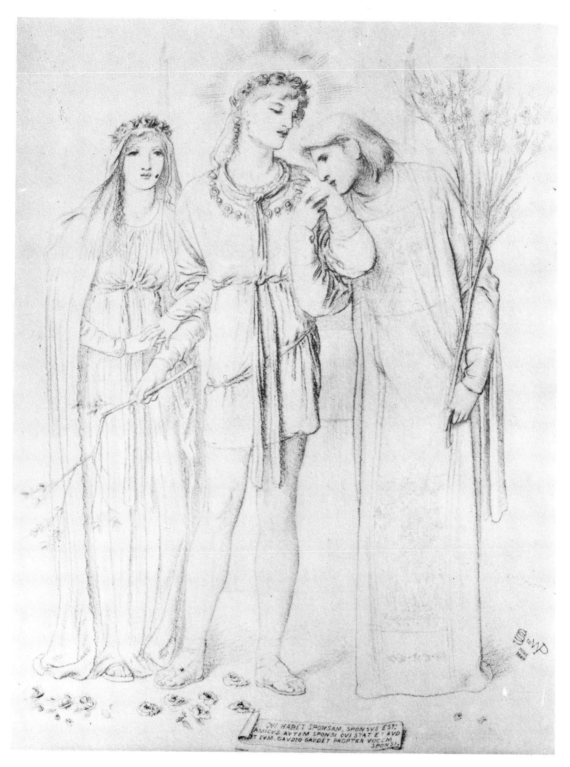

49. THE SONG OF SOLOMON
Drawing 1868 41.3 x 31.1 cms. Hugh Lane Art Gallery, Dublin.
A less provocative drawing on the theme of Plate 36. Solomon also painted a
watercolour on this subject and an oil entitled The Bride, the Bridegroom and the
Friend.

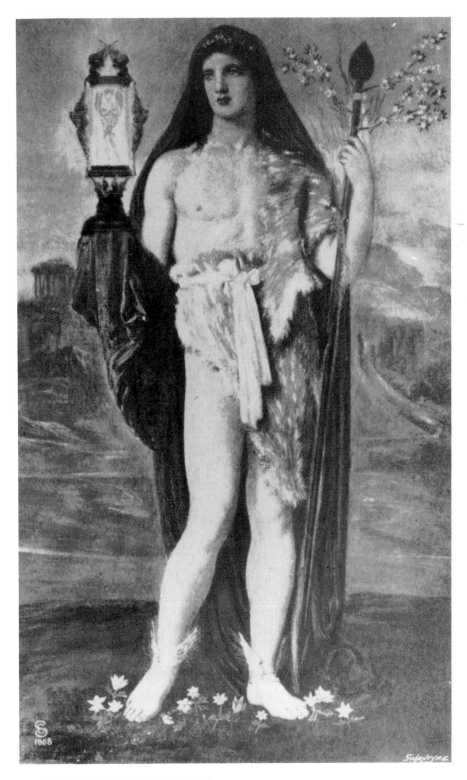

50. AMORIS SACRAMENTUM
Hollyer photograph of watercolour 1868.
A not altogether successful painting on the theme of deified youth,
once owned by Oscar Wilde.

51. HEAD AND SHOULDERS OF A YOUNG GIRL
Drawing 1868 36.5 x 29.2 cms. British Museum, London.
A striking but simple child study.

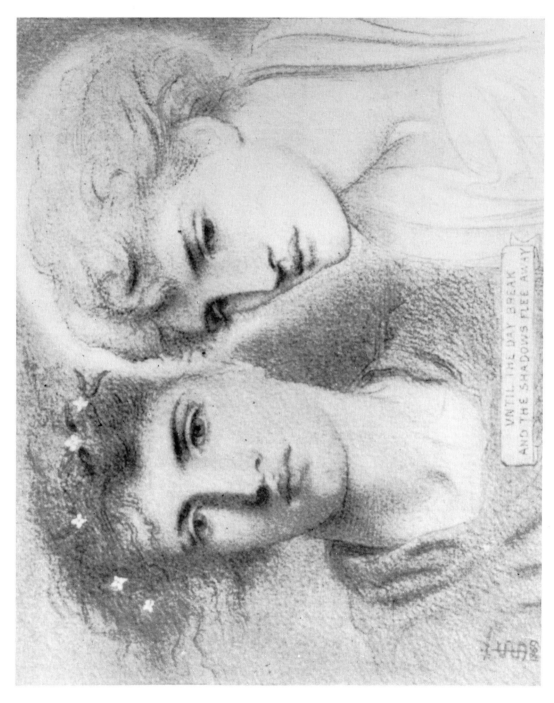

UNTIL THE DAY BREAK
AND THE SHADOWS FLEE AWAY

52. UNTIL THE DAY BREAK AND THE SHADOWS FLEE AWAY
Drawing 1869 13 x 15.5 cms. British Museum, London.
Possibly the drawing of Johnston Forbes-Robertson and Edward Robert Hughes.
Solomon also painted a watercolour with the same title.

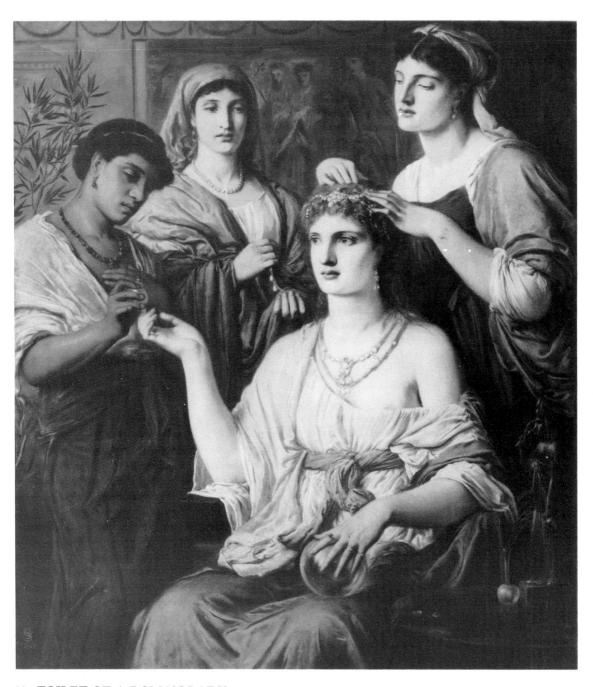

53. TOILET OF A ROMAN LADY
Oil 1869 111.7 x 96.5 cms. J.Hartnoll Art Gallery, London.
Largest Solomon painting traced so far.

54. LABOR, CONTENT AILLEURS, THEORIA:
BOOKPLATE FOR OSCAR BROWNING
Wood engraving 1870 13.5 x 10 cms. Author's collection.
Solomon's only bookplate.

55. MELANCHOLY
Drawing undated 34 x 15 cms.
Private collection, Wolverhampton.
A typical sketch related to Plate 3.

56. A YOUTH RELATING TALES TO LADIES
Oil 1870 35.5 x 53.3 cms. Tate Gallery, London.
A typical Solomon conversation piece.

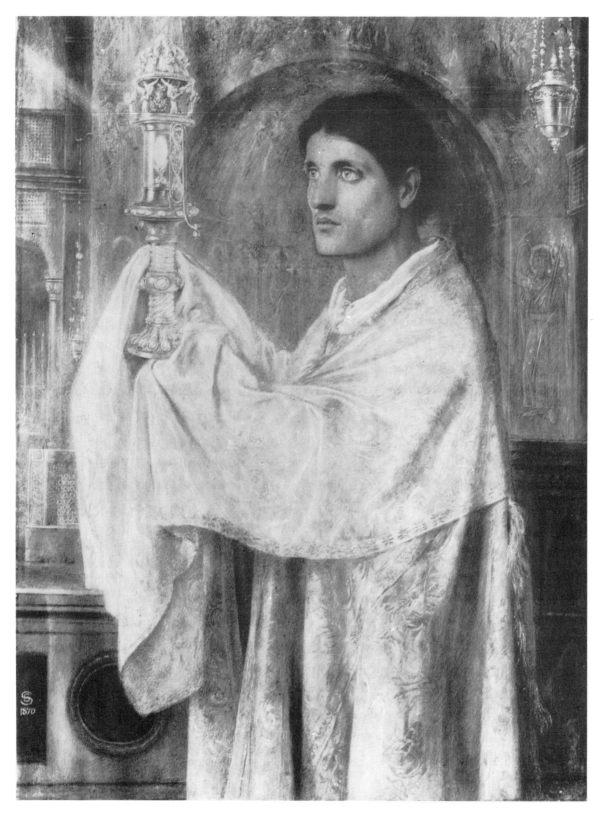

57. THE MYSTERY OF FAITH
 Watercolour 1870 20.3 x 15.2 cms. Lady Lever Art Gallery, Port Sunlight.
 A Roman Catholic theme possibly inspired by Solomon's visit to the First Vatican
Council. Solomon described this painting as his best watercolour.

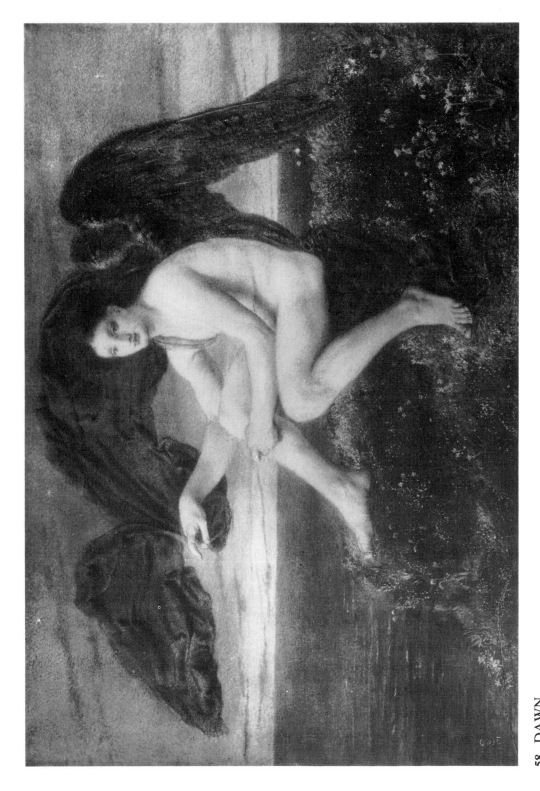

58. DAWN

Watercolour 1870 Rome – 1871 London 35.3 x 50.7 cms. City of Birmingham Museum and Art Gallery.
A theme derived from *A Vision*.

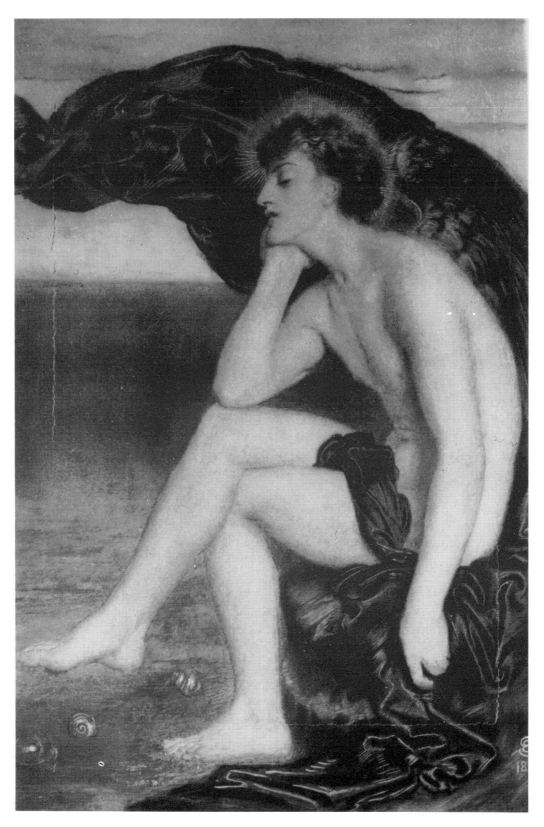

59. LOVE DREAMING BY THE SEA
Watercolour 1871 36 x 26.5 cms. University College of Wales, Aberystwyth.
Naked youth by order of George Powell.

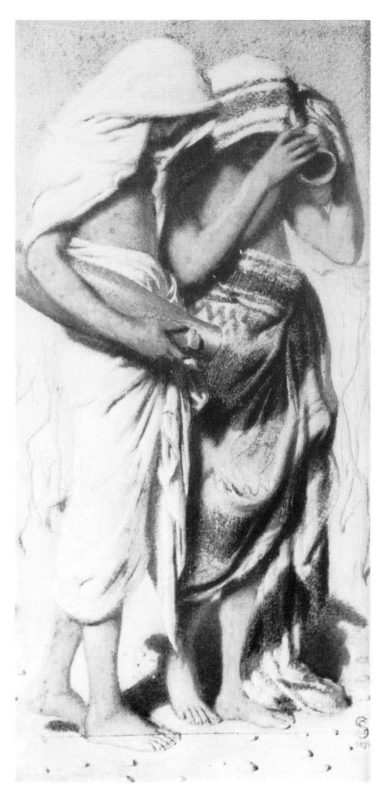

60. THE DROUGHT
Watercolour 1872 38.1 x 44.5 cms.
Private collection, London.
A powerful work, reverting to Solomon's biblical themes.

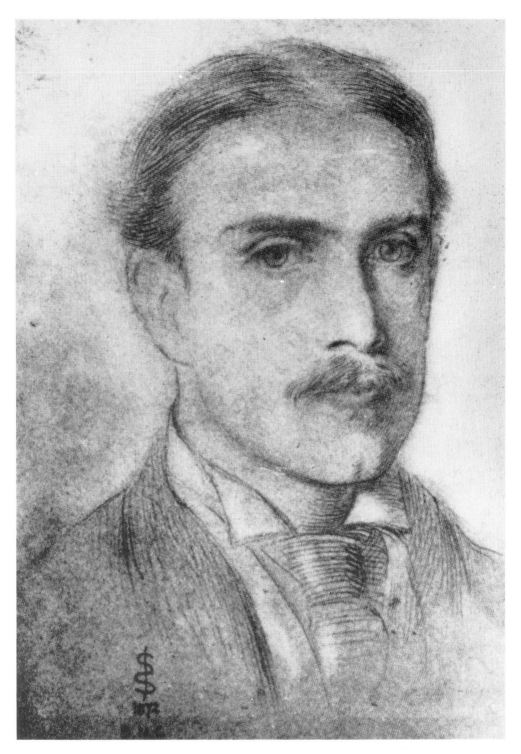

61. WALTER PATER
 Drawing 1872 17.1 x 9.5 cms. Fondazione Horne, Florence.
 One of the very few portraits for which Pater agreed to sit.

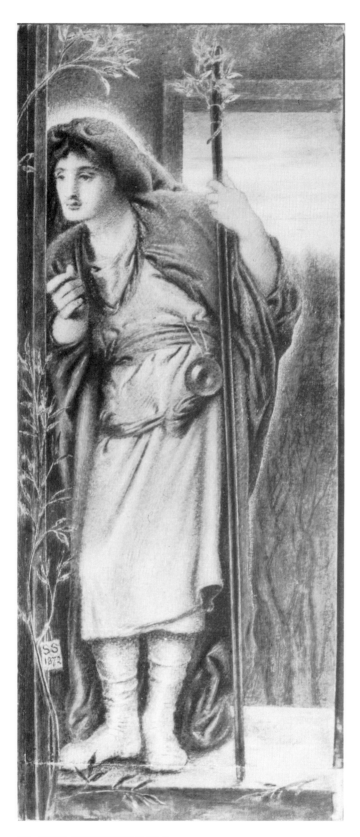

62. THE BRIDEGROOM
Watercolour 1872 38.1 x 16.8 cms.
Hugh Lane Art Gallery, Dublin.
A biblical study from *The Song of Solomon*.

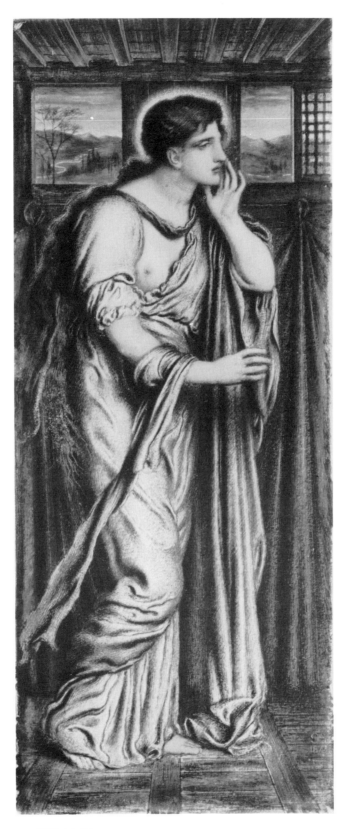

63. THE BRIDE
Watercolour 1873 38.1 x 16.8 cms.
Hugh Lane Art Gallery, Dublin.
The pair to Plate 62.

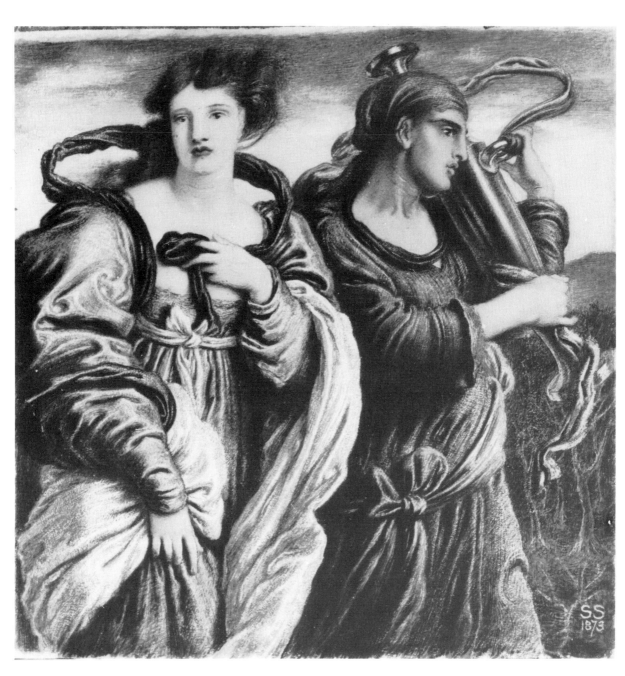

64. GREEKS GOING TO A FESTIVAL
Watercolour 1873 21.6 x 21.6 cms.　　Hugh Lane Art Gallery, Dublin.
An attempt by Solomon to capture movement in his figures.

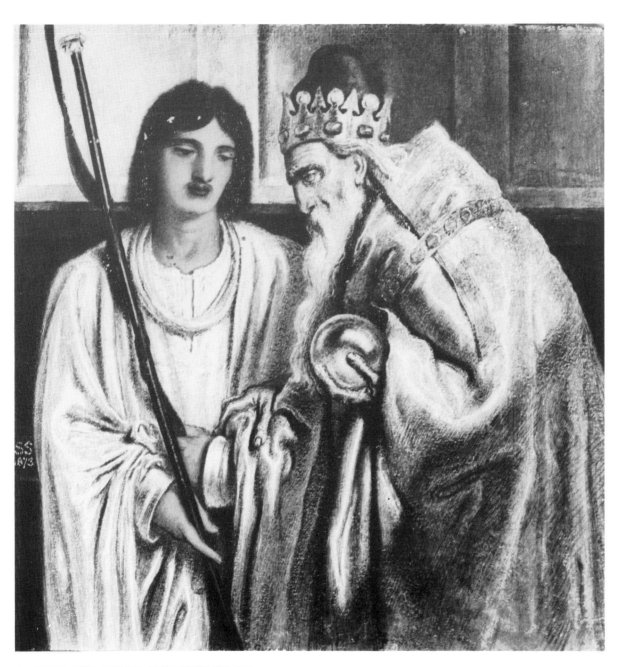

65. THE OLD KING AND THE PAGE
Watercolour 1873 21.6 x 21.6 cms. Hugh Lane Art Gallery, Dublin.
A study in youth and age.

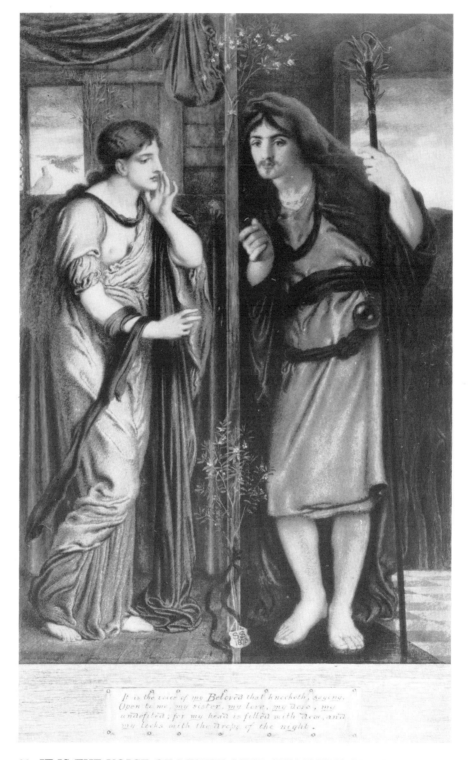

It is the voice of my Beloved that knocketh, saying.
Open to me, my sister, my love, my dove, my
undefiled; for my head is filled with dew, and
my locks with the drops of the night.

66. IT IS THE VOICE OF MY BELOVED THAT KNOCKETH
Watercolour 1873 49.5 x 33 cms.
A variation on Plates 62 and 63.

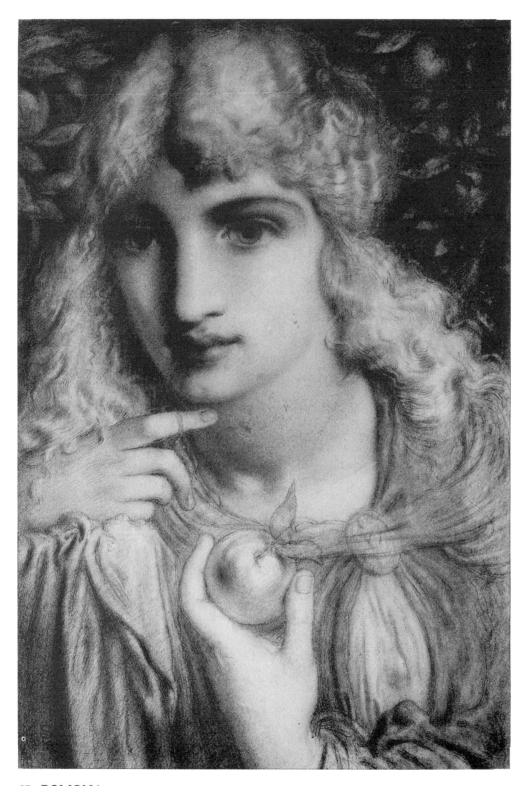

67. POMONA
 Drawing 1874 44.5 x 30.5 cms. Barry Friedman Ltd., New York.
 A Rossetti like "stunner".

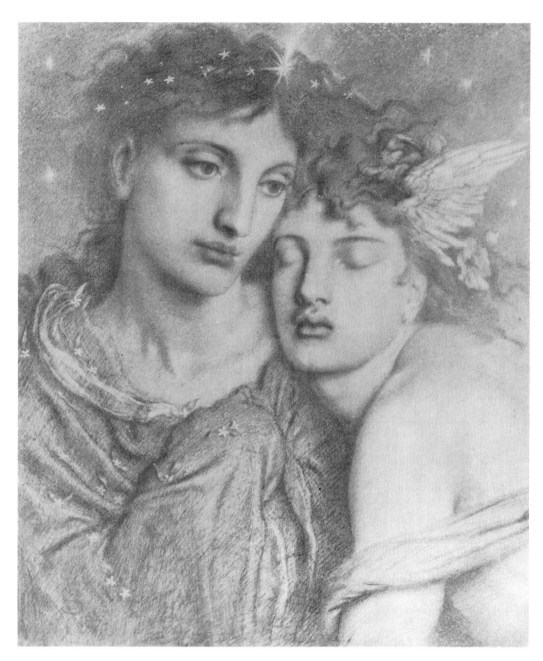

68. NIGHT AND HER CHILD SLEEP
Hollyer photograph of drawing 1875.
A poetic composition, Mother Earth, wise and sad; shelters the weary child that is
human love.

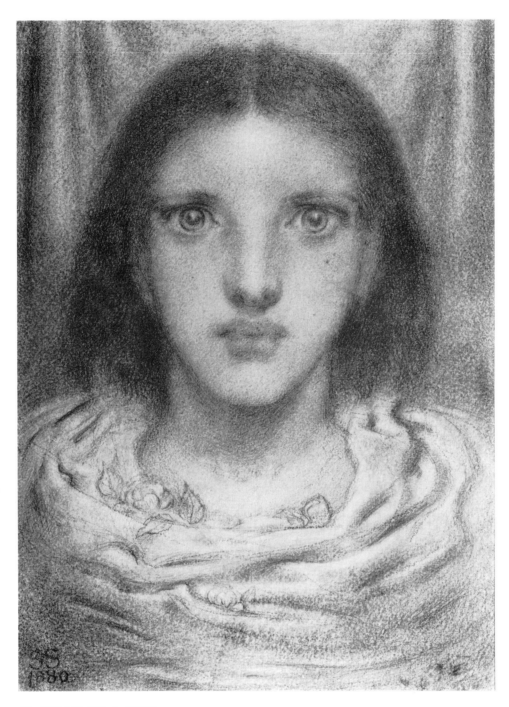

69. HEAD OF A GIRL
 Crayon and chalk drawing 1880 34.2 x 24.2cms. Fogg Art Museum, Cambridge,
 Mass. (Glenville L. Winthrop Bequest).
 A powerful study of eyes.

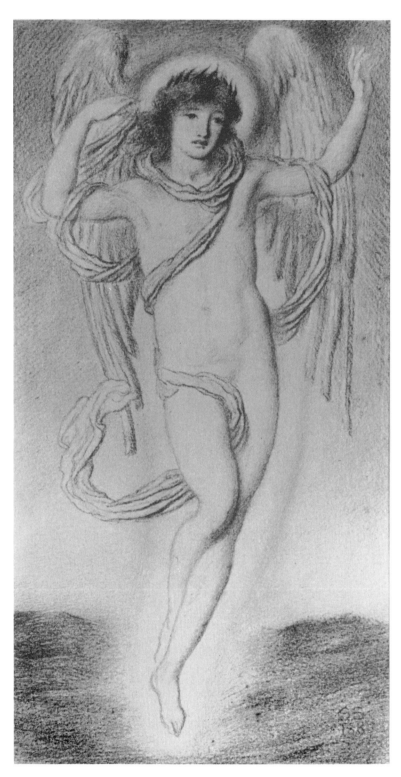

70. AN ANGEL
Drawing 1887 39.5 x 20 cms.
City of Birmingham Museum and Art Gallery.
One of Solomon's weaker late drawings.

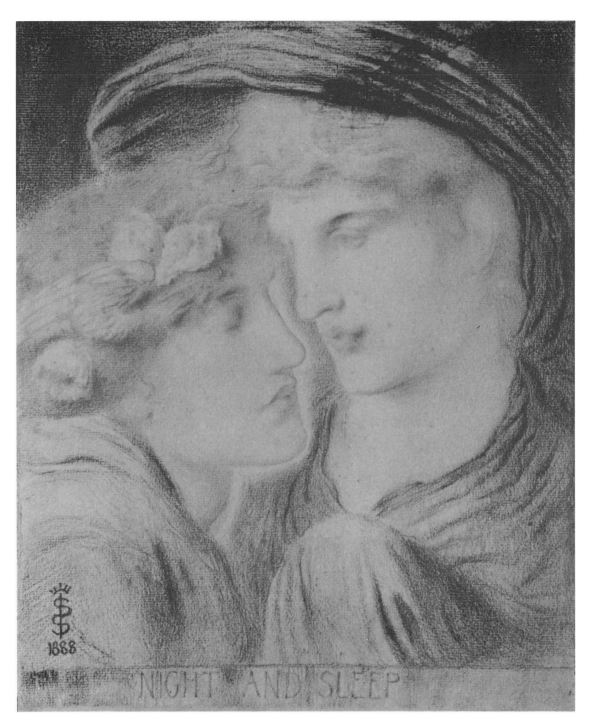

71. NIGHT AND SLEEP
 Blue and sanguine drawing 1888 35.7 x 29.5 cms. City of Birmingham Museum
 and Art Gallery.
 One of the many drawings on the theme of night and sleep.

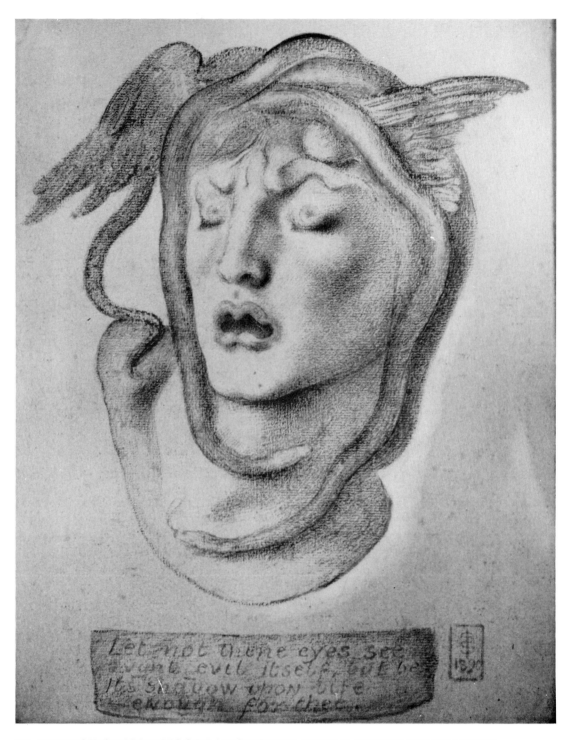

**72. LET NOT THINE EYES SEE AUGHT EVIL ITSELF, BUT BE ITS SHADOW
UPON LIFE ENOUGH FOR THEE**
Blue chalk drawing 1890 32.5 x 26.3 cms.　　Private collection, Somerset.
A striking Medusa's head with the symbolic open and closed eyes.

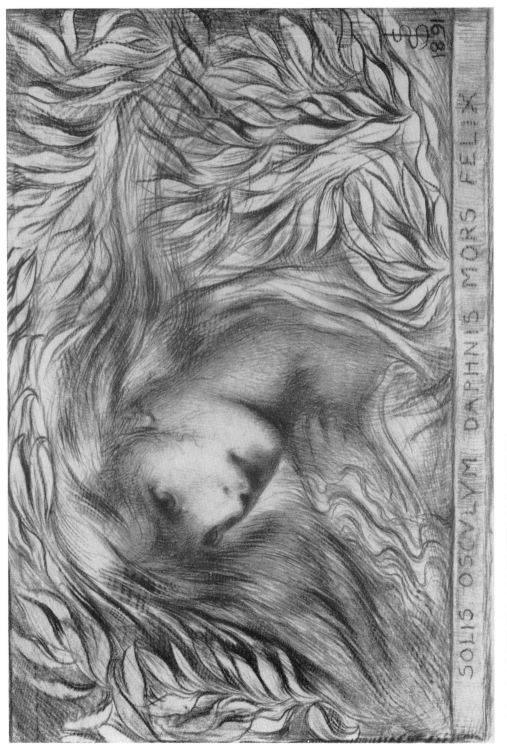

73. **SOLIS OSCULEM DAPHNUS MORS FELIX**
Sanguine chalk drawing 1891 33 x 49.5 cms. Private collection, Dordogne.
A graceful symbolist design.

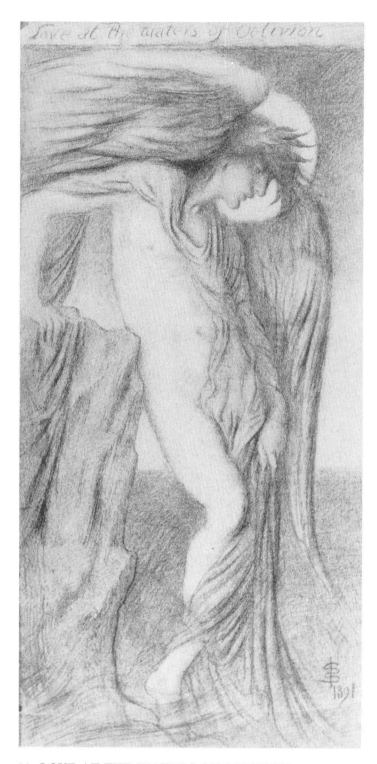

74. LOVE AT THE WATERS OF OBLIVION
Sanguine drawing 1891 60 x 28.6 cms.
Private collection, Sussex.
An essay in decadence from Solomon's later years,
once owned by Herbert Horne.

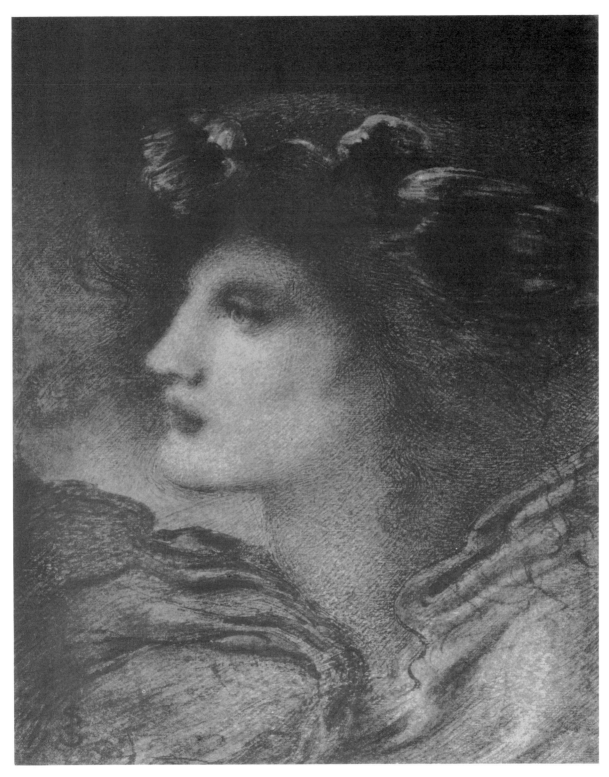

75. NIGHT
Watercolour undated 31 x 27 cms. Royal Albert Memorial Museum, Exeter.
A colourful watercolour of a much favoured subject.

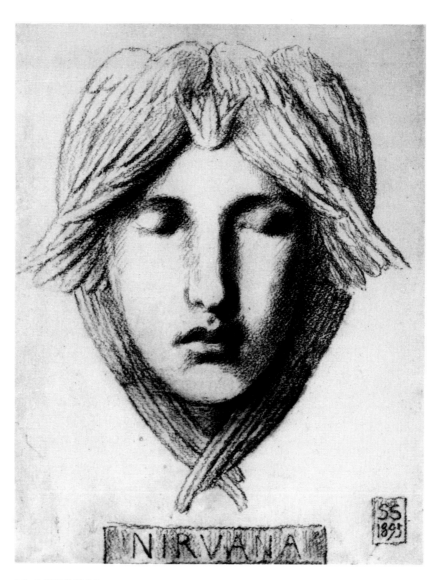

76. NIRVANA
 Hollyer photograph of drawing 1893.
 A delicate drawing of the theme of serenity.

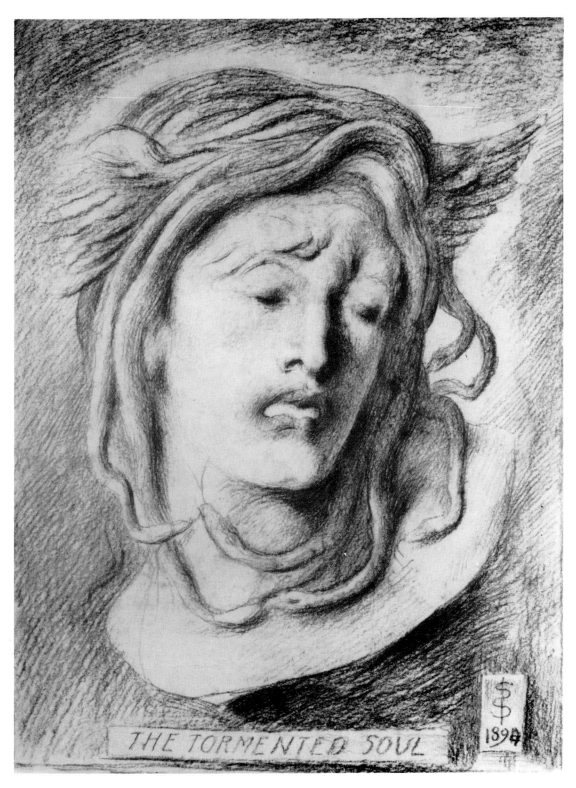

77. THE TORMENTED SOUL
Chalk drawing 1894 39.5 x 30 cms. The Piccadilly Gallery, London.
Another Medusa's head.

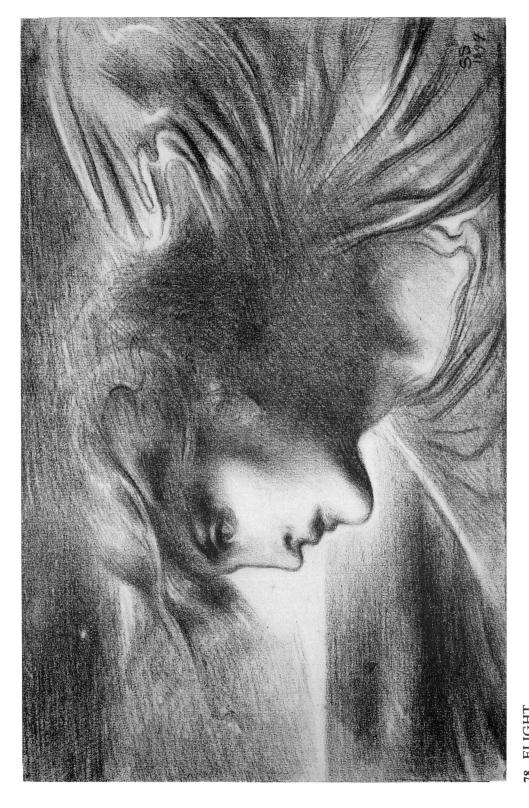

78. FLIGHT
Chalk drawing 1894 33 x 53.3 cms. Barry Friedman Ltd., New York.
A typical sketch commercialised by Solomon during his later years.

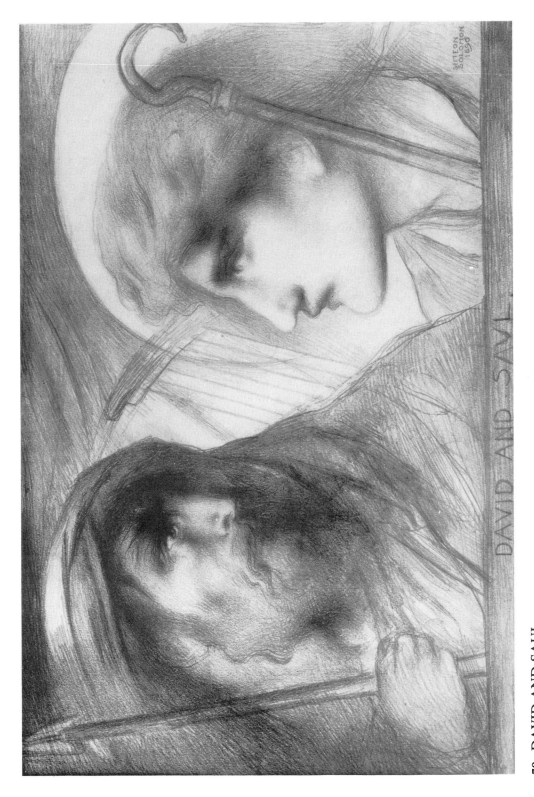

79. DAVID AND SAUL
Hollyer photograph of drawing 1896 26.5 x 28.1 cms.
One of Solomon's most powerful late drawings.

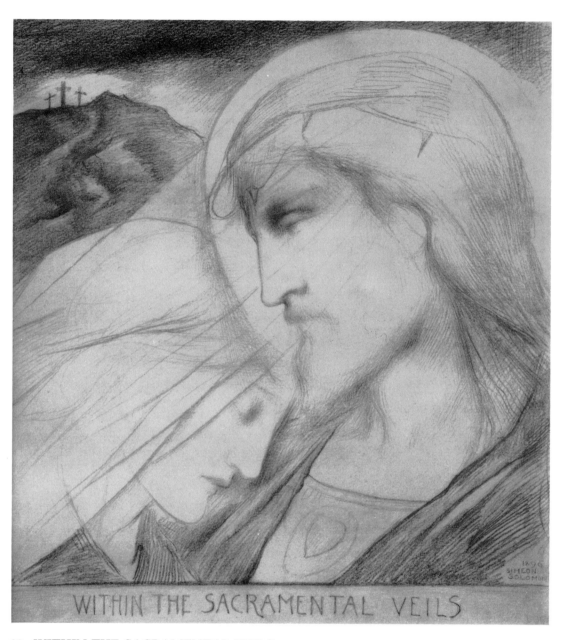

WITHIN THE SACRAMENTAL VEILS

80. WITHIN THE SACRAMENTAL VEILS
Hollyer photograph of drawing 1896.
A profoundly religious drawing possibly executed under the influence of Francis
Thompson.

Paintings by Simeon Solomon exhibited at the Royal Academy and the Dudley Gallery.

SHOWN AT THE ROYAL ACADEMY SUMMER EXHIBITIONS.
(Mediums indicated where known)

1858 "And the Lord said, Take now thy son, thine only son Isaac, and offer him there for a burnt offering upon one of the mountains I will tell thee of," another name for Isaac Offered (Drawing)

1860 The Mother of Moses (Oil)

1861 A Young Musician employed in the Temple Service during the Feast of Tabernacles (probably "Hosannah") (Oil)

1862 The Child Jeremiah (Oil)

1863 Juliette. (Watercolour)
The Betrothal of Isaac and Rebecca (Watercolour)

1864 A Deacon

1865 Habet (Oil)

1866 Damon and Aglae (Oil)

1867 Bacchus (Oil)

1869 The Toilet of a Roman Lady (Oil)

1870 A Youth relating Tales to Ladies (Oil)
Love Bound and Wounded (Watercolour)

1871 "The Law is a tree of life to those who lay hold upon it. The Supporters thereof are happy", another name for the Baroda edition of "Carrying the Scroll of the Law." (Oil)

1872 Judith and her Attendant going to the Assyrian Camp (Watercolour)

SHOWN AT THE ROYAL ACADEMY WINTER EXHIBITION 1906.

The Finding of Moses	(Oil)
Love in Autumn	(Oil)
The Mother of Moses	(Oil)
Hosannah	(Oil)
Night after the Ball	(Oil)
A Prelude by Bach	(Watercolour)
The Bride	(Watercolour)
The Bridegroom	(Watercolour)
Girl at a Fountain	(Watercolour)
A Greek High Priest	(Watercolour)
Lady in a Chinese Dress	(Watercolour)
Greeks going to a Festival	(Watercolour)
Poetry	(Watercolour)
The Old King and the Page	(Watercolour)
The Mystery of Faith	(Watercolour)
"And He shall give His angels charge over thee."	(Watercolour)

SHOWN AT THE DUDLEY GALLERY FROM 1866 to 1872.

Oil paintings

1867 Rosa Mystica
Love in Oblivion
Chanting the Gospel

1868 A Roman Lady with a Votive Urn

1869 The Bride, the Bridegroom, and a Friend

1870 The Evening Hymn

1871 Carrying the Law into the Synagogue at Genoa
Marguerite

1872 Love in Autumn

Watercolours

1866 Medea at Colchis
A Coptic Baptismal Procession
Crydippe with the Apple of Acontius

1868 Bacchus
A Greek High Priest
Heliogabalus, High Priest of the Sun

1869 A Saint of the Eastern Church
Sacramentum Amoris
A Song

1870 Three Holy Children in the Fiery Furnace
Carrying the Scroll of the Law
In the Summer Twilight
Autumn - Winter
The Sleepers and the One that Watcheth

1871 The Mystery of Faith
The Singing of Love

1872 Love dreaming by the Sea
Evening
Until the Day break and the Shadows flee away
Dawn
The Traveller and the Guide
(Probably Judith and her Attendant etc.).

Pictures by Simeon Solomon exhibited at the Baillie Gallery Dec. 9th, 1905 to Jan. 13th 1906.

1 Cupid (1883)

2 Atalanta (1866)

3 Chanting the Gospels (1867)

4 Love Bleeding (1870)

5 Three Priests (1865)

6 Moses (1876)

7 Ruth and Naomi (1861)

8 The Lemon Seller (1876)

9 Cupid's Playground (1883)

10 A Rabbi (1880)

11 The Prodigal Son (1863)

12 And Abraham kissed the Lad (1863)

13 All Allegory (1857)

15 Zephyr (1887)

16 "Suffer Little Children" (1884)

17 The Eternal Sleep (1887)

18 A Study (1865)

19 Biondina (1876)

20 A Daughter of Judeae (1864)

21 Love Singing to Memory (1862)

22 Hebrew maiden lamenting (1871)

23 The Magic Crystal (1878)

24 Love and Death (1865-74)

25 Perseus; A Type of Temptation (1886)

26 A Votive Offering (1863)

27 The Young Antinous (1884)

28 Scenes from the Life of David (1856)

29 A Hebrew Harpist

30 Crossing the Brook (1867)

31 "Many Waters cannot quench Love" (1895)

32 Study of a Head

33 A Triptych –

 (a)"I arise up to open to my Beloved"
 (b)"For Love is strong as Death"
 (c)"Arise my Love, my Dove, my Spouse"

34 Love in Autumn. Study (1894)

35 Sir Galahad (1889)

36 A Grecian Priestess (1865)

37 Sir Galahad

38 A Portrait

39 Abraham and Isaac

40 Carrying the Law (1856-75)

41 "The Destroyer" (1867)

42 "Behold, the Bridegroom cometh"

43 Bacchus (1883)

44 Hagar and Ishmael.

45 Jepthah and his Daughter

46 The Pot of Basil (1885)

47 The Token

48 Mystical Union (1865)

49 Helen (1883)

50 Study of Heads (1888)

51 "Et Lux in tenebris lucet" (1888)

52 The Unappeased Desire (1887)

53 The Winged and Poppied Sleep (1883)

54 The Dawn (1887)

55 Cupid, from "Cupid and Psyche"

56	"O, Salve Anita" (1855)	90	Memoria (1879)
57	Good-night (1861)	91	Study of a Child (1887)
58	Amor dei (1883)	92	A vision (1888)
59	Hebrew Maiden (1874)	93	Ianthe (1885)
60	Study for "The Prodigal Son" (1857)	94	Angel of Fire (1896)
61	Ruth and Naomi	95	Gesthemanis sudor sanguines
62	Nicodemus	96	Passionis Amoris fructus (1888)
63	La Figlinoglina degli Oleandri (1895)	97	Night and Her Child Sleep
64	Le Sieur Rene	98	Night and Morning
65	Portrait of an Englishwoman	99	St. John
66	The Artist's Mother	100	Young Christabel
67	The Archangel Gabriel (1896)	101	Diana and Endymion (1894)
68	Nirvana (1894)	102	St. Peter
69	Sintram (1885)	103	Christ and Peter
70	Christianity (1894)	104	Isabella (1897)
71	The Medusa Head	105	Hero
72	Dawn and Twilight (1895)	106	The Angel of Death
73	Beatrice	107	Dante in Exile (1895)
74	Miriam	108	An Allegory
75	Dawn (1880)	109	"Speak, Lord for Thy Servant heareth" (1905)
76	The Avenging Angel (1895)	110	"My Love is a Rose among Thorns" (1892)
77	Reverie	111	Orestes
78	Air (1866)	112	Angel of Death
79	The Evening Star (1890)	113	A Vision of Wounded Love (1893)
80	Ophelia (1887)	114	Christ Kissing Moses
81	The Angel of Death (1896)	115	The Avenging Angel
82	The Awakened Conscience	116	Young Pan
83	Anima mea tristis est (1886)	117	Galatea
84	Child with Apples (1881)	118	Six Panels forming a Screen
85	Immortal Love (1886)	119	Love dying from the breath of Lust
86	Maria foederis Arca (1896)	120	Love singing to Memory (1900)
87	Eight Designs for the Song of Solomon	121	Paolo and Francesca
88	The Angel of Children (1895)	122	Habet (an Autotype)
89	"Behold, this fair assemblage, stoles of snowy white, how numberless" Vision of Dante, Paradiso Canto XXX.		

Note: In the original Exhibition list no title appears against No 14.

Index

Excluding *A Vision of Love Revealed in Sleep* and Pictures by Simeon Solomon exhibited at the Baillie Gallery.

Laying the Elegant Table

Laying the Elgant Table

China, Faience, Porcelain, Majolica,
Glassware, Flatware, Tureens, Platters,
Trays, Centerpieces, Tea Sets

BY

INÈS HEUGEL

PHOTOGRAPHS BY

CHRISTIAN SARRAMON

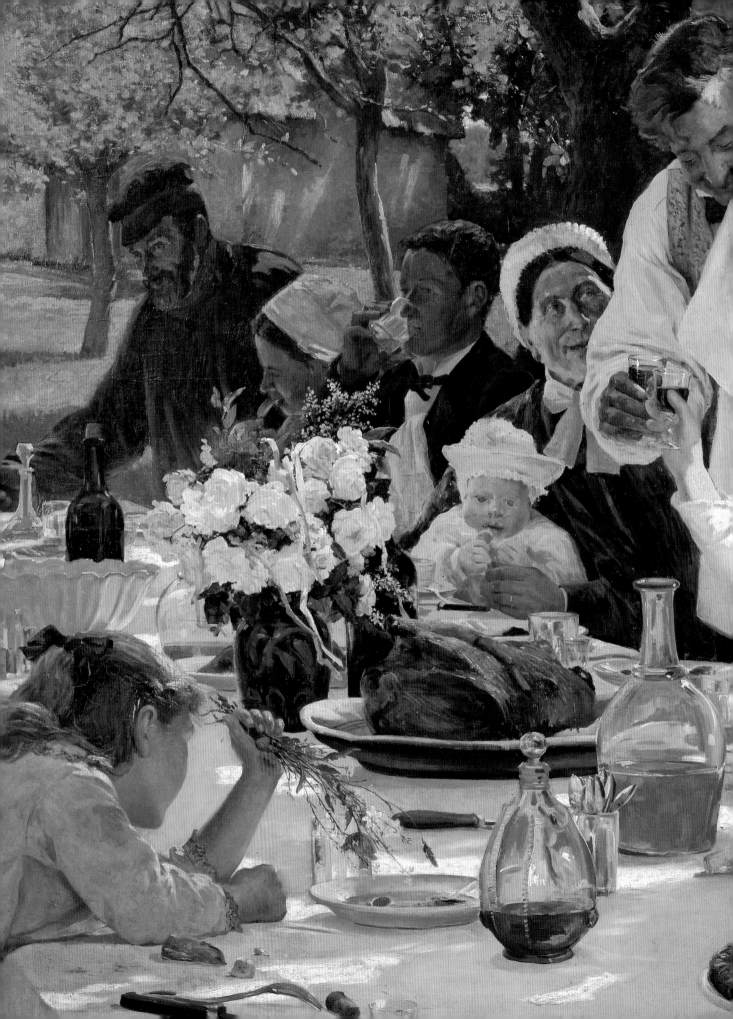

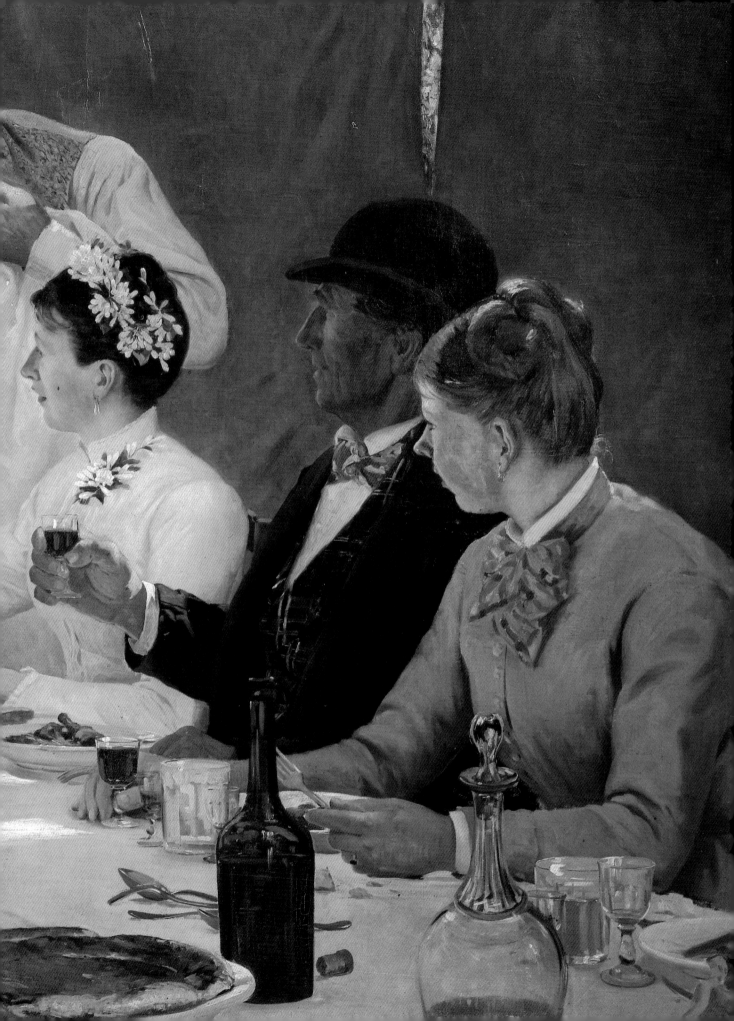

CONTENTS

Title page:
A dresser mellowed by time, a quilted
tablecloth, fine earthenware, and
delicate porcelain bought over the years
from secondhand dealers and shops:
these are some of the pleasures in store
for anyone with more than a passing
interest in the art of the table.

Preceding pages:
Detail of *The Wedding Meal at Yport*,
oil on canvas by Albert Fourie, 1886.
Musée de Rouen.

Opposite:
The display of a passionate collector:
Limoges porcelain cake and dessert
service (1860); English tea set (1910);
bone china tea and coffee set (1910).

A pretty tablecloth and fine English tableware for an *al fresco* meal.

The Art of Table Setting

From the spartan boards of the Middle Ages to the tables of our grandmothers, the laying of tables has evolved in step with technical advances in the manufacture of china, earthenware, glass, and metals. At the same time, it has been heavily influenced by the structure and organization of society.

Tankards and Trenchers

In medieval Europe, there was no such thing as a dining room. Instead, a long, narrow trestle table was set up in any room of the house that happened to suit the occasion. The diners sat elbow to elbow, on only one side of the board. A simple white linen cloth was spread, folded double on the diners' side of the table so they could use the slack to wipe their hands and mouths. The shared double-folded table napkin was eventually abandoned in favor of the towel, a separate piece of fabric laid on the main cloth. A trencher made of wood or metal served as a plate, along with a piece of bread on which successive foods were served. The diners ate with their fingers and left their sauce-soaked bread to be shared among the servants after the main meal. Sometimes, in order to reduce the workload for the servants, a flat-bottomed tin porringer with handles or lugs on either side might be placed between two guests. Using big spoons, which would be vermeil-plated in rich men's houses and in poorer establishments were made of pewter or wood, the various meats would be served in these bowls along with their sauces. The fork had not yet been invented, and pointed table knives, which began to appear at the table in the fourteenth and fifteenth centuries, were used to spear food and carry it to the mouth. Wine, often diluted with water, was served in a shared tankard, with guests taking turns to drink from it.

The Coming of the Fork

From the sixteenth century onward, the tablecloth was still white, either made of linen or cotton, and with damask religious or military motifs. It was laid on the table with its ironed pleats fully apparent, accompanied by ample, skillfully folded individual napkins. As the decades went on, napkin folds became more and more elaborate and sophisticated, taking the shapes of birds, butterflies, trees, flowers, seashells, and fish. The men knotted them around their necks to protect their fashionable but voluminous lace collars. The fork, which had come into use in Italy in the fifteenth century, was introduced to France by Catherine de Médicis at the court of her son Henri III. In its early stages, the fork had only two teeth and was used by several people at a sitting; for this reason it was viewed as unhygienic and took a while to catch on.

1.

1. Late-19th-century color print of a servant in livery, bringing a covered dish to the table.

2. The opulent effect of a tablecloth draped down to the floor.

3. Extravagant shapes and simple decoration of a cream-colored porcelain tableware from the 1930s.

Individual Place Settings

By the seventeenth century, people carried their own knives and forks in a case attached to their belt. The handles of the knife and fork varied in color according to the church calendar: white at Easter, black during Lent, and black and white at Pentecost. The host provided each guest with his own pewter plate and sometimes a goblet. Various prominent figures made contributions to the arts of the table— notably Cardinal Mazarin, who invented the concave plate (known as the *assiette à la cardinale*), and Richelieu, who brought round-bladed table knives into fashion. By the end of the century, matching forks and spoons were routinely placed next to plates at meals, while flowers made their appearance in the middle of the table, side by side with the vessels containing salt and spices.

The Sumptuous Tables of the Eighteenth Century

In the eighteenth century, meals all over Europe were predominantly served in the French style. Everything would be prepared before the guests' arrival, and tables were magnificently set. The plates were of fine china or soft-paste porcelain from a leading pottery, and the utensils were made of silver or vermeil. Knives, forks, and spoons were placed in such a way as to show off the armorial bearings engraved on them. The dishes for the first course would be served according to a precise and practiced order, with dish-covers to keep the food hot. As soon as all the guests were seated, the servants uncovered all the dishes at the same time, to dramatic effect. After the guests had eaten as much as they wanted of the first course, a second set of utensils was laid, then a third, and so on. The middle of the table was dominated by a centerpiece of silver or porcelain, which contained spices and served as a base for lamps and candles. Only one glass was provided per person, and each glass was placed in a basin of ice on a sideboard or dresser big enough to contain one or several glasses at a time. In the latter case, its rim would be notched so the glasses could be sloped into molds within the ice. Meanwhile the wine bottles were placed in other basins or coolers. From 1750 and onward, damask tablecloths gave way to white-on-white embroidered tablecloths.

The Russian Style

In the nineteenth century, houses began to be structured in a different way. In general their rooms were smaller, and one room was definitively set aside for dining. The arrival of vast quantities of imported Indian cotton in England created a revolution of sorts; cotton replaced the old table linen, which was now enriched with open-work, embroidery, or appliqué. At the same time, the napkin grew more discreet, and its folding became a much simpler affair. The French style of serving meals

1.

2.

3.

gave way to the Russian style, with dishes being passed around by servants to each guest in turn, rather than being left on the table so the diners could help themselves.

Crystal and Silver Plates

The first major breakthrough in table setting was the arrival of crystal in France in the late eighteenth century, after its invention a century earlier by the English craftsman Ravenscroft. This led to the appearance of individual glasses—between three and six—on the table, for each different drink served. The second novelty was the invention by another Englishman, Elkington, of a silver plating process, which was immediately taken up in France by Christofle. This period also saw the beginnings of industrially produced knives, forks, and spoons, which allowed the new middle classes to match the aristocracy when it came to entertaining, at considerably lesser expense. Toward the end of the nineteenth century, specially shaped pieces began to gain importance: new items appeared for the table—such as fish knives and forks, oyster forks, sugar tongs, and dishes and plates specifically designed for asparagus, artichokes, or shellfish—while accessories, such as knife rests and napkin rings, were invented in response to the dining habits of a brand new middle class. Tablecloths generally stayed white, though colored embroideries were no longer the exception.

The Modern Table

In its time, art nouveau imposed its gentle shapes and undulating lines on the table, as it did on everything else. Tablecloths at the turn of the nineteenth century were more elaborate, being finely stitched with openwork, lace, and tone-on-tone embroidered flowers and insects. Knives, forks, and spoons bore exuberant vegetable motifs while larger pieces of tableware, though still busy in their effect, lost much of their late-nineteenth-century heaviness and pomposity. In the 1920s, the tablecloth finally became an object entirely of color, though its timid pastel tones were sometimes blended with white. At the same time, it became lighter and lighter, and was sometimes replaced by place mats. Organdy and cotton tablecloths with matching napkins—ever smaller in size—were all the rage: and before long cutlery was also redesigned for greater simplicity, acquiring colors of its own in the form of shagreen or semiprecious stone handles.

4.

5.

6.

7.

DINNERWARE

Old porcelain and earthenware plates have survived until today in every conceivable shape, color, and design and decorated with flowers, Asian motifs, animals, figures, and landscapes. Many are still being reproduced. We love them for their beauty, for the traditional skills, and talents they express, but also for what they evoke: Sunday lunches at a grandmother's house, for instance, or holidays at a family home. Whereas in the past, a household possessed one or several complete sets of table service, each of which included dozens of pieces, today we tend to buy in smaller batches—for example, six barbotine dessert plates, a plump vegetable dish, or even a series of nonmatching plates that share a common color or motif. A refined table tends to be second degree, exhibiting a mixture of styles and epochs, and as such is playful and easy to manage. An immense variety of table services are on offer at flea markets and antique shops. The opportunity is boundless for anyone looking to start a personal collection or for those who simply delight in tables set with an eye for fantasy and fun.

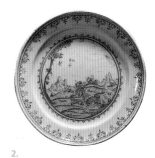

2.

3.

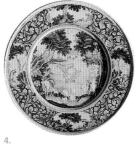

4.

Faience and Porcelain

Fine porcelain or bone china? Printed or painted decoration? In the broad and infinitely varied realm of ceramic terminology, it is not always easy to find your way. Here is a rough summary of what you need to know.

Origins

The first potters took clay and baked it to make it hard. Then, since their terra-cotta was porous, they had the idea of making it waterproof by covering it with varnish or enamel and firing it a second time. Chinese potters were already making ceramics in this method during the Neolithic age. Later, under the Tang dynasty (AD 618–907), merchants began distributing Chinese pottery in as far as the Islamic countries, where the products were immediately copied. During the thirteenth-century Islamic expansion, the new ceramic techniques spread to Europe, notably to Spain and Mallorca. During the Renaissance, the Italians in turn discovered the Hispano-Moresque *majolica* and developed their own techniques for manufacturing it in centers such as Deruta, Urbino, Gubbio, Siena, and Faenza. The French word *faïence* derives from Faenza: emigrant Italians from that town introduced this type of earthenware to France in the sixteenth century. Still, the most significant advance made by European potters was their discovery of the secret of how to make Chinese porcelain—nearly five hundred years after they first became aware of its existence.

Faience Earthenware

Faience, for the French, is pottery made from clay, colored in mass, permeable to water, and loose-textured, which is then covered in an opaque enamel made of a lead-alkaline solution to which tin oxide has been added. This glaze, which hides the original earth tint, can serve as a support for colored design, mainly cobalt blue.

For four centuries after the faience technique arrived in France, potters steadily improved the quality of their pieces. In doing so, they strove to refine their clay mixtures to make them harder and whiter, while at the same time perfecting their decorations using varied colors and ever more elaborate designs.

The first French faience potters in the sixteenth century practiced the technique of *grand feu* (hot firing), meaning they painted their designs directly on the raw enamel, later applying a cover and firing it at a very high temperature. This was the technique used in the great centers of Nevers, Rouen, Moustiers, Strasbourg, and Marseilles, making the best of a process that was unable to fix certain colors, notably reds. However, at the end of the seventeenth century, Hannong of Strasbourg invented *petit feu* (slow firing) procedure, which consisted of applying a polychrome design to a piece that had already been enameled and fired and refiring the piece in a kiln set to a lower temperature. This technique made it possible to fix very fine designs and a range of colors that would not tolerate higher temperatures, such as bright yellow and purple.

Preceding pages:
Plates can be decorated in several ways: by freehand; by a dotted ("pounced") pattern that the painter connects with his brush; by printing; or (as in this case) by stencilling.

1. *Rayonnant* pattern. Manufacture de Rouen, 17th century.

2. Hot-fired faience plate with hunting motif. Manufacture de Moustiers, circa 1740.

3. Hot-fired Italianate faience plate, "Rape of Europe motif," after Francois Chauveau. Manufacture de Nevers, circa 1680.

4. Faience plate, blue monochrome pastoral scene. Manufacture de Nevers, second half of the 17th century.

1. 2. 3.

4. 5. 6.

1. Hot-fired faience profiled plate. Marseille, 18th century.

2. Monochrome ruby-colored porcelain plate. Manufacture de Vincennes, circa 1750.

3. Art nouveau porcelain plate. Limoges, late 19th century.

4. Plate with floral and geometric decoration in 20th-century country style.

5. Porcelain cake dish with serrated rim pattern, circa 1920.

6. Faience plate made in southwestern France, circa 1940.

7. White porcelain dessert and cake plates, with molded weave pattern, perforated rims, and rose ornamentation, 19th century.

Fine Stoneware

As decorations grew more elaborate, English potters perfected the technique for making what is known as stoneware. Invented in 1720 in Staffordshire, this process was refined by Josiah Wedgwood in 1760. Wedgwood's stoneware was opaque, white or ivory in color, with a fine, dense, and ringing texture; it was also covered in a transparent glaze, relatively hard and consisting of a lead-alkaline mix. Stoneware was fired at a temperature of about 2000°F. The great advances here were in the color of the paste, which was much whiter, with an ever finer texture and much greater strength and durability than before.

The French reacted to the invasion of English stoneware by creating their own stoneware with the help of English potters who had immigrated to France. Throughout the nineteenth century, their pastes continued to improve: beginning with pipe clay, they moved on to the slightly superior Lorraine clay, then to fine stoneware in the English manner, and finally to feldspathic stoneware.

Bone China

Meanwhile, potters continued to pursue the secret of Chinese porcelain manufacture. The first Frenchman to discover a paste approximating to that of the Chinese in 1673 was Edmé Poterat of Rouen. But it was the factory at Saint-Cloud, protected by the King's brother Philippe d'Orléans and later by his son the regent, that perfected this so-called soft-paste porcelain, otherwise known as bone china. Other potteries followed suit, also with the support of illustrious protectors: Chantilly was sponsored by the prince of Condé, Mennecy by the duke of Villeroy, Sceaux by the duchess of Maine, and Vincennes—which later became the *Manufacture Royale de Sèvres*—by the King himself. The privileges they enjoyed allowed these potteries to function without having to worry about competitors and in the certainty that there would be financial support for their research. Throughout the eighteenth century, they continued to produce china of incomparable delicacy. Their privileges, however, were abolished by the Revolution.

1.

2.

3.

1. Faience vegetable dish, with cover and snake-motif knob and handles. Manufacture de Rouen, 18th century.

2. Rococo slow-fired faience compote. Manufacture de Strasbourg, circa 1755.

3. Rocaille porcelain bowl. Manufacture de Chantilly, 18th century.

4 and 5. Studies of shapes and decorations by Félix Bracquemond for a table service and various other objects commissioned by the Haviland porcelain works, circa 1876.

Hard-paste Porcelain

In 1789, a chemist named Boettger, working for a porcelain works at Meissen in Saxony, discovered a deposit of kaolin, the matter of which Chinese porcelain is partly composed, and finally realized the dream of European potters for centuries past: the creation of porcelain as beautiful as that of the Chinese. Boettger's hard-paste porcelain was made from a blend of kaolin, feldspath, and quartz.

The porcelain works of Strasbourg and Niderviller were the first in France to manufacture hard-paste porcelain, using kaolin imported from Saxony. Later, in 1768, a deposit of kaolin was found at Saint-Yrieix, near Limoges, by Mme. Darnet, the wife of a local surgeon, and thereafter hard-paste porcelain production developed in France on a major scale. Sèvres immediately built its own factory in Limoges. In Paris between 1780 and 1840, there were at least fifteen potteries producing porcelain of this type, with its signature whiteness and purity. Before long Limoges had become famous in both Europe and America as a center for porcelain manufacture.

Evolving Styles

In the seventeenth and early eighteenth centuries, faience plates imitated the forms developed by goldsmiths and silversmiths, especially their rocaille lines. They were cut in curved shapes and endowed with rice-grain decorations or ribbed and hand-painted with flowers, Chinese motifs, and foliated scrolls.

Under the Empire, these forms became more severe. Antiquity became the fashion. Plates were often octagonal, with gadroons or Greek borders in relief. Acanthus leaves, oak leaves, and swans were the principal themes of their decoration, invariably applied in a carefully balanced manner.

The Restoration and the July Monarchy in France saw a return to neo-Gothic motifs, and it was followed by a mix of styles known as eclecticism during the reign of Napoleon III, much given to pastiches of the past.

At the end of the nineteenth century, graceful birds or flowers in soft colors were distributed asymmetrically all over plates and dishes: this was the era when all things Japanese were in vogue.

In the early twentieth century, with the appearance of art nouveau, motifs borrowed from nature began to be more stylized. Later, in the 1920s and 1930s, art deco went in the opposite direction, favoring starkness, geometric motifs, and right angles.

TIPS FOR COLLECTORS

Distinguishing faience from porcelain
First, by its appearance: faience is matte and opaque; porcelain is thin and translucent. Second, by its feel: faience will be slightly irregular to the touch, whereas porcelain is regular and its enameling is uniform. Third, by its ring: faience makes a dull noise, but the sound of porcelain is crystalline. The sonority of a piece of porcelain will also reveal its condition—when perfect, its sound is clear and true; when restored, it rings more dully.

Distinguishing hard-paste porcelain from soft-paste boneware
If the dish has a smooth, cold, shiny, and clear-cut—almost sharp—edge, it is probably hard-paste porcelain. Boneware tends to be milkier, warmer, and more fragile.

Gray, pink, or red?
French faience earthenware from the eighteenth century has a bluish glaze. When the plate is turned over, you can see the initial color of the paste used, which in turn will indicate its provenance: the grayer pastes are from northern France, a pink tinge indicates Rouen, and the red is from the south of France.

The secret of the "ladybird"
Hot or slow firing? On the bottom of the plate, look for traces of "ladybirds," **pernettes** in French, which were the tiny dots of clay used by potters to stack the pieces in order to prevent spoiling them by contact with each other. Hot-fired pieces show three ladybird points, while slow-fired pieces show six or nine.

4.

5.

1.

SERVICE NA?LES

CREIL
ET
MONTEREAU

LABRADOR

EMAIL SANS PLOMB
DÉPOSÉ

2.

K G

LUNEVILLE · BADONVILLER

· FRANCE ·

3.

4.

1. Regional spoon rack with spoons and 18th-century faience dishes.

2. Mark of the *Naples* service. Manufacture de Faïence de Creil et Montereau.

3. Mark of the Manufacture de Faïences de Lunéville.

4. A collection of flower-patterned plates in a rustic sideboard.

5. Three Sarreguemines marks: *Tokio*, circa 1900; *Plumes de paon*, July 21, 1875; and *Marguerite*, a mark mentioned in the company's 1900 and 1925 catalogues.

5.

Marks and Signatures

Signatures may consist of the symbol of the factory, its initials, the initials of a craftsman, or the full name of the factory. The older insignia were usually those of the factory's sponsor; for example, Sèvres put the two interlacing L's of Louis XV, and Chantilly sported the Condé hunting horn. Sometimes, notably at Sèvres and Vincennes, the throwers and molders would work in their own small, distinctive signs, which are vital for recognizing certain porcelain pieces that carry no other stamp. After 1753, a letter corresponding to the year of manufacture was added to the usual signatures: A for 1753, B for 1754, and C for 1755. At the end of the alphabet, the next series began with AA, and so on. This dating system did not survive the Revolution.

As a rule, hard-paste porcelain is signed. For those looking for precise identifications, there are manuals that list all known signatures and stamps.

Diameters

In Europe, the classic dinner plate measures between 9 and 9³/₄ inches in diameter, while the American plate is broader, at 10 to 11 inches. The presentation plate is a recent invention, deriving from the hotel trade; 11 inches in diameter, its function is largely decorative. When setting tables, it is best to leave at least 16 inches between each plate. The bread-and-butter plate (6 inches), an English invention, goes on the upper left side of the dinner plate, while the crescent salad plate, which eliminates the need to change the main plate, is practical but seldom used. Dessert plates are readied in advance, to be brought in at the right moment.

Dinnerware

Dinnerware as we know them today first appeared during the nineteenth century, with the rise of an upper middle class from the new industrial milieus and the emergence of a bourgeoisie anxious to emulate the powerful. The porcelain and faience industries of the time had developed elaborate techniques to respond to these new demands, producing their wares in reasonably priced series. The house, and more specifically the table, became a way of displaying one's social position. Young brides had their trousseaus, bridegrooms their porcelain and faience. Complete set of dinnerware might run from dozens to literally hundreds of pieces. Essentially they consisted of main dinner plates, soup plates, and dessert plates, along with assorted vegetable dishes, tureens, and bowls.

TAKING CARE OF FINE PORCELAIN AND FAIENCE

To clean off grease marks
Soak the dishes in hot water with organic soap for twenty minutes, then remove stains with a brush. Rinse in cold water, dry, then place in an oven at low temperature (200°F) for half an hour. For persistent marks, repeat the process.

To remove stains
Rinse the piece in fresh water, then apply to the stain a mixture of distilled water (one part) and tap water (three parts), adding a few drops of diluted ammonia (be sure to do this in a well-ventilated area). Then place the piece in a plastic bag for twenty minutes before rinsing in fresh water.

To repair a crack
Clean the crack with a Q-tip and soapy water without submerging the plate. If this is not sufficient to clean it, rub with a toothbrush dipped in a diluted solution of acetone or cellulose. Rinse and dry.

Then, using a toothpick, carefully apply epoxy glue all along the crack. Place the piece in the oven, set at 200°F, for five minutes. This will make the crack open wide enough to draw in the glue.

Remove the plate from the oven, clean off the excess glue with burning alcohol, and apply adhesive tape around the piece. Place back in the oven for ten more minutes and set aside to cool.

1. Examples of different decorations for porcelain dishes. These decorations are sometimes applied around the rim of the plate only, sometimes also on the well.

2. Stylized porcelain service. Manufacture de Creil et Montereau, early 20th century.

1.

1.

Blue and White

Blue and white dinnerware and dishes are very common in every style and decoration and from every period. There is a simple reason for this: cobalt blue is the most amenable pigment in the world and also the most reliable, standing up extraordinarily well to oven heat. Over the centuries, every time a new technique came to light, it was always tested first with blue against a white background. So the family of blue and white ceramics is large and confusing and one in which everyone — the Chinese, the Dutch, the English, and the French — has copied and influenced everyone else. Here are the most important things to know.

2.

3.

4.

The Miracle of Chinese Porcelain

The first reference to blue and white ceramic that comes to mind is Chinese porcelain. In 1295, when Marco Polo returned from his travels in the East, he brought with him a variety of crockery made of material so transparent and white that he baptized it *porcella*, the name of a shellfish resembling it (a less poetic detail is that the shellfish itself was named for its likeness to a sow's vulva).

For several centuries, European potters and alchemists searched incessantly for the secret of this mysterious Chinese material; and indeed it was not until the late sixteenth century that Chinese porcelain began to reach Europe in significant quantities. In 1497, Vasco da Gama rounded the Cape of Good Hope, opening up vast new trading possibilities with the East. The Portuguese were followed by the Dutch, the English, and the French, all of whom had a period when they monopolized this trade. Hundreds of ships began sailing to and fro between the East and the West, loaded with spices and silks and ballasted by the porcelain packed in their holds. Between the early seventeenth and the end of the nineteenth century, millions of pieces, mostly blue and white, were imported into Europe, and the European imitations swelled the influx for two centuries.

Beautiful Blues

Porcelain had been manufactured in China since the Tang dynasty (AD 618–907). It owed its transparency to the composition of its paste — which is a blend of kaolin from Gaoling, a region of China in the province of Jingdezhen, and petuntse, a crystalline rock that was used for the glaze, fired at a temperature of between 2400 and 2650°F. At that temperature, only cobalt blue was entirely reliable.

Under the Ming dynasty (1368–1644), the porcelain industry was mostly concentrated in the same province of Jingdezhen, where, if we are to believe the Jesuit d'Entrecolles, no fewer than three thousand kilns were kept permanently lit. The traditional elements of Chinese design were pagodas, animals (dragons or storks), and flowers (peonies, lotuses, and chrysanthemums).

The first Chinese porcelain made for the foreign market was what the Dutch called *kraak porcelain*, which was blue and white. The center of the dish or plate was occupied by a motif such as a bird, while the edge was divided into eight or twelve compartments, narrow and broad by

1. Blue monochrome decoration of roses on oval dish, late 19th century.

2. Faience dish with Bérain-style decoration. Manufacture de Moustiers, 17th century.

3. *Copenhagen* pattern. Manufacture de Sarreguemines.

4. Faience plate called *Persée délivrant Andromède*. Manufacture de Moustiers, 17th century.

1.

2.

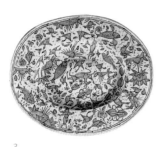

3.

1. *Orphée* bone china, printed plate. Manufacture Utzschneider, Sarreguemines, circa 1900.

2. *Flora* faience plate. Manufacture de Creil et Montereau.

3. Savona dish, Asian-inspired decoration. Manufacture de Nevers, early 17th century.

4. Detail of the rim of a faience plate decorated with a garland in relief.

5. Different tones of blue on 19th- and 20th-century plates.

6. Soft-paste porcelain plate with *à la brindille* decoration. Manufacture de Chantilly, 18th century.

7. Plate with rich floral decoration, late 19th century.

turns, and each contained decorative representations of animals, flowers, and Buddhist symbols.

In the seventeenth century, European aristocrats would commission magnificent services bearing their coats of arms along with nature scenes and landscapes. The fashion for this grew markedly after Louis XIV issued summary decrees directing that all objects in gold and silver had to be melted down to pay for his wars. Little by little, the Chinese themselves began to manufacture objects exclusively destined for Western consumption. During the first two hundred years of the Qing Dynasty (1644–1911), Chinese porcelain manufacturers continued to produce magnificent pieces, but in the nineteenth century their quality dipped, the market was flooded, imitations abounded, and prices fell.

Fine Delft

Having failed for the moment to penetrate the secret of Chinese porcelain, European potters contented themselves with imitating the way it looked. In the early seventeenth century, potters in Delft, Holland, began producing a fine tin-bearing earthenware, hot fired with delicate Chinese motifs, which were carefully reproduced at first and later freely interpreted. Even though the result was neither as solid nor as transparent as Chinese porcelain, the forty-odd Delft factories formed the principal European center for the production of ceramics between 1650 and 1750, and became the champions of a blue and white that was itself copied over and over.

The lambrequins of Rouen

Independently from the popularity of Chinese porcelain, the French were creating blue on white patterns of their own, some of which have survived to this day. Tin-slip (stanniferous) earthenware began to be popular with the French public from the end of the sixteenth century, largely thanks to Masseot Abaquesne who, in 1530, founded a factory in Rouen that began by imitating the then-fashionable Italian style. Later, by the end of the sev-

enteenth century, Rouen invented the blue design known in the nineteenth century as "lambrequin." This was inspired by the edges of the fabrics used by the upholsterers during this period to decorate the drapes and overhead linings of four poster beds. When applied to dishes and plates, this made for a symmetrical decoration of concentric embroidered friezes, which overflowed from the edge into the hollow of the piece. This pattern was later taken up by many of the other French potteries, notably Quimper and Gien.

The **Bérain** Style

Another world famous pattern was the *Bérain* style. In 1680, Pierre Clérissy founded a faience works at Moustiers, a small village in Haute-Provence. His first patterns were also in different shades of blue and were inspired by the hunting scenes of Antonio Tempesta, a sixteenth-century Florentine painter and engraver; he later moved on to the ornamental motifs of Jean Bérain (1639–1711), the King's designer and the official decorator for the royal galas. Bérain compiled a book of decoration that was enormously and steadily successful for two hundred years. His designs for porcelain were extraordinarily refined; drawing their inspiration from Italian grotesques, they featured small figures, mythical animals, masks, and flowers linked together by garlands, wreaths, and arabesques. Like the lambrequin motifs, these designs remain great classics of French ceramic art, and throughout the eighteenth and nineteenth centuries, they were steadily reproduced by France's manufacturers, especially those in the south.

The Chantilly **Brindille**

The earthenware manufacturers of the late seventeenth century, in their restless search for the secrets of Chinese porcelain, discovered a soft, creamy paste that allowed the application of very delicate patterns. This paste, having been invented at Rouen, was subsequently developed at

4.

5.

6.

7.

1.

Saint-Cloud, Chantilly, and Vincennes (which became Sèvres). Saint-Cloud in particular excelled at lambrequins and *Bérain* blue and white patterns. Chantilly then invented new blue and white designs of its own, which were both discreet and delicate: these were known as *à la brindille* (sprig), *à l'oeuillet bleu* (blue carnation), and *jet d'eau* (fountain) and were successfully copied by Arras.

English Willow Pattern

This hugely popular Chinese-influenced ware, with its weeping willow, was developed in England in the late eighteenth century, probably by Thomas Minton. Minton was then an apprentice engraver, but went on to found the famous factory that bore his name. Willow-pattern china was produced on an industrial scale throughout the nineteenth century. Its basic elements were the willows, but it also featured teahouses, boats, fences, three figures (as a rule), islands, and pairs of birds signifying love. This pattern, much beloved by the English, crossed the Channel and was reproduced in France in northern factories, such as Lille, Calais, and Douai, and in the east of the country. Its production has continued right up to the present day.

Impressions in Blue

In the second half of the nineteenth century and the early twentieth century, most potteries produced ordinary low-priced dinnerware, most of them in a palette of blues. These were sold all over France by peddlers who transported them on donkeys and mules. This was the case of two small communes of the Drôme, Saint-Uze and Saint-Vallien, which produced very hard-wearing faience, similar to stoneware and decorated with simple blue flowers. Along with such ordinary services, better quality ones with more elegant patterns were produced for the middle class. At last the latter was able to buy themselves complete services, run-

ning into the hundreds of pieces, which now hit the market in huge quantity. Now they could entertain like the aristocracy and the *grande bourgeoisie*. Not only the faience potteries, but also the porcelain factories depended largely on sales of such services in the second half of the nineteenth century and the early twentieth, shifting with the trend from art nouveau patterns to the more geometric outlines of art deco. This was the case of Creil, Montereau, Sarreguemines, and above all Gien. Founded in 1823, the Gien factory quickly began specializing in personalized, often numbered services. At the same time, it supplied perfect imitations of all the older styles, and after 1860 reverted to blue and white reprises of Rouen and Moustiers.

TIPS FOR COLLECTORS

Blue and white earthenware and porcelain have always been collectible.

Louis XIV and many French aristocrats began amassing blue and white Chinese porcelain from the moment it began to be imported; eventually they possessed many magnificent pieces and frequently displayed them on silver or gold mountings.

Today, blue and white can still be collected here and there, piece by piece, without spending too much money. It offers many options for beautiful table settings. For example, you can mix non-matching plates of the same shade of blue with different patterns; or mix blues of many different shades from pale to dark; or simply use one specific pattern. The possibilities are endless.

Charming blue and white earthenware services, the everyday tableware of our grandmothers, can still be purchased for bargain prices. But as soon as you go back to the seventeenth and eighteenth centuries, values rise very steeply. And it is out of the question to eat from such dishes since they are collector's items.

2.

3.

4.

2.

3.

4.

Single Color, Embossed, and Openwork Services

Single color ceramics show the quality of their paste and allow sculpted patterns. There is often a simplicity and sophistication about them. Their most charming examples are the green, brown, and sunshine-yellow wares of the south of France or the snow white and gold filigree of Paris and Limoges porcelain.

The Simplicity of Single Color

While craftsmen in faience seem to have had a marked preference for polychrome decoration, in the mid-eighteenth century, the factories of Saint-Clement, Strasbourg, and Marseilles were producing white earthenware—sometimes heightened with gold filigree—that was also of excellent quality. Moreover many fine single-color dishes with scrolled, curving, or multifoil shapes emerged from the kilns of Moustiers and its neighbor Varages, and also from Hautecombe, next to Lac du Bourget, and the potteries of France's south.

In the first half of the nineteenth century, manufacturers in eastern France and the Paris region developed an especially fine paste called pipe clay. It was a beautiful cream color, so beautiful that patterns were often not deemed necessary for it—a transparent covering was enough. In this way, vast numbers of round and octagonal plates, sometimes with gadroon edges

according to the style of the period, were produced and sold at very low prices. At the end of the century, many faience potteries produced utilitarian single-color crockery for daily use, finely enameled and in every pastel color, while porcelain manufacturers opted for white, pure and simple.

Pont-aux-Choux Cream

When fine faience was invented in England, it created a revolution in the industry. French potteries set about imitating it, and in 1740 the *Manufacture Royale des Terres de France, à l'imitation de celles d'Angleterre* was founded in rue Saint-Sebastien in the Charonne quarter of Paris. This earthenware factory was better known as Pont-aux-choux for its proximity to a bridge crossing a ditch where cabbages—*choux* in French—were grown. For fifteen years it produced cream-colored "English" ware of very high quality. Its shapes were largely taken from silverware;

1.

tled ware. Its ornamentation, like that of Pont-aux-Choux, was expressed in reliefs only, with the potter functioning as a sculptor. Its principal pattern was rice grain, but it also used vegetables and flowers. Castellet, a town neighboring Apt, was distinctive for its small flowerlets with five, nine, or twelve petals, its reeds, and its scrolls. As for the shapes, these too were strongly influenced by silverware. The plates were profiled, the platters oblong, and the other pieces covered in knobs in the shapes of animals and fruits, with branchlike lugs and handles. As time passed, these shapes became more and more spare.

The plates were octagonal, with gadroon edges and Greek borders, and rosettes and acanthus leaves took the place of more natural looking flowers. By the end of the nineteenth century, Apt had to compete not only with Sarreguemines but also with English faience and Limoges porcelain: and in the early twentieth century, its production ceased altogether. Other centers like Uzès, Vallauris, Aubagne, and Fréjus also produced fine yellow, cream, or white ware, while Dieulefit maintained a predilection for yellow-green and black.

Openwork and Braided

The small earthenware center at Langeais, in the Touraine region of France, made a specialty of openwork faience. Not only did it produce baskets with movable handles, decorated with vines, cherries, strawberry plants, pears, ivy, oak leaves, and acorns, it also manufactured plates with braided or perforated rims. This original technique was copied by Niderviller and Marseilles in the second half of the nineteenth century and subsequently by Malicorne after 1924. The woven faience baskets of Moustiers and Uzès were also famous, as were those of Hautecombe.

White Porcelain

Following the discovery of kaolin at Saint-Yrieux in 1735, two main centers—Paris and Limoges—began producing very high

it carried as colored decoration only very lightly worked reliefs of branches, checkerboards, and rice grains. The tops of Pont-aux-Choux tureen covers were shaped like flowers or vegetables, the pouring spouts were made like small branches, and the handles on the bigger dishes were in the form of animal heads.

Yellow Faience from the South of France

Apt, in the Vaucluse, was already a center for pottery before the Romans arrived there. But it was in the eighteen and above all in the nineteenth century that the town became famous for the quality and delicacy of its earthenware. Indeed some people think that stoneware was invented in Apt, and not in England. Whatever the case, Apt faience is highly original, especially in its color: Apt was devoted to yellow in all its nuances and also produced very fine marbled or mot-

2.

3.

4.

5.

1. Porcelain plates, with gilded edges and monogram.

2. Perforated plate with ornamentations in relief. Manufacture de Creil et Montereau, late 19th century.

3. Wedgwood porcelain plate with rim decorated in relief, 19th century.

4. Porcelain cake plate with string trompe l'oeil pattern, 19th century.

5. Shiny biscuit porcelain with fruit decoration, a copy of *Impératrice* pattern by R. Haviland and C. Parlon.

1.

quality porcelain. Paris was distinguished for the whiteness of its paste, its fine grain, and its perfect vitrification—many white dinnerware with simple gold trim were produced there—but in the end, Limoges won the ascendancy. The dynasties of Allaud, Tharaud, and Baignol established themselves as the masters of porcelain in Limoges after the Revolution, slowly perfecting their techniques. Etienne Baignol produced pure white china with gold edging; Tharaud worked on the contrasts between matte and enameled porcelain; and Allaud and his sons developed their distinctive broad bands of gold.

In the second half of the nineteenth century, the Pouyat family produced a paste of such whiteness and delicacy that it was baptized *mousseline* (muslin). Perforations were cut into the paste with a stylus to emphasize the happy contrast of transparency and opaqueness: these services were known as *grain de riz* (rice grain).

The traditional ornament craftsman found himself transformed into a sculptor, endowing pure porcelain with foliage and sheaves of wheat, and manipulating the contrast between biscuit and enamel: an example is the "Ceres" service, created in 1855 by the sculptor Paul Comolera.

Little by little, the white began to be trimmed and decorated with gold, with simple fillets, hound's tooth patterns, and florets. Figures festooned with flower garlands, ribbons, or knots adorned the white marriage services that became popular with the bourgeoisie as the very name of Limoges became synonymous with whiteness.

TIPS FOR COLLECTORS

Pont-aux-Choux pieces are very rare today, and their price reflects this fact. They are collector's items.
Older pieces from Apt or Castellet are also collector's items, but later imitations and even contemporary pieces made in the traditional method by potteries in the south of France are not without interest. Single-color, pipe-clay plates are also very charming, notably octagonal ones. But since pipe clay is a poor quality material, many items made with it will be scratched or stained, and their prices have stayed low. Gold and white Paris or Limoges porcelain is not hard to find, but with these pieces, it is important to check the state of the gold.

2.

3.

4.

5.

Illustrated Printed Plates

Illustrated plates, which were mass-produced in the nineteenth century, are still found in large numbers. They can be used as dessert plates or combined with flat plates with matching colors. In any case, their printed riddles, scenes from military life, and simple jokes have an old-fashioned charm that is irresistible.

2.

3.

4.

History

Who invented the process? The experts disagree. Sadler and Green of Liverpool are known to have applied engraving to the decoration of earthenware beginning in 1752. In France, Francois-Antoine Legros d'Anisy opened a factory exclusively devoted to printing plates and faience works such as Creil and Choisy, and even Sèvres employed him to decorate their products. The engravings were black and, sometimes, dark brown in color. Legros d'Anisy was given a silver medal at the 1819 Exhibition.

Before long, all the major stoneware manufacturers had set up their own printing shops. Creil was the first to use the process on an industrial scale.

Gazettes and Fables

Until about 1837, the designs were monochrome: blue, brown, or black were simply applied to white stoneware or to a paste colored using metal oxides (yellow backgrounds, essentially produced by Creil or more rarely green). Thereafter the plates became bicolored, with one impression for the center, in black for example, and another for the borders in blue, green, or red. Eventually the ware became multicolored, an effect that could be obtained by stenciling colors on to printed faience.

Prior to about 1830, themes remained sober, and patterns rarely differed from those of hand-decorated plates—the motif being centered in the middle of the plate while a border of acanthus leaves, oak leaves, and flowers ran around the rim. Mythology was one of the principal sources of inspiration, with scenes from the lives of heroes or gods surrounded by a frieze of palm leaves. The designers also drew freely on history; the troubadour fashion—launched by Charles X's daughter-in-law, the Duchess of Berry, with designs inspired by the works of Sir Walter Scott—was very popular for a time. The kings of France, the Revolution, and Napoleon were other favorites, as was geography, with sober views of towns, villages, and monuments. This was also the time when somewhat less serious themes such as La Fontaine's fables, songs and riddles first made their appearance.

Conundrums, Novels, and Songs

During the reign of Louis-Philippe, plates were loaded with a riot of colors, including bright yellow, orange, blue, mauve, and brown. The rims were covered with complicated patterns of fruits, bouquets, checks, and lambrequins, while the center was filled with humorous or fantastic decorations. But serious historical themes, geography, feats of arms, and portraits of great men were also much favored.

The Second Empire saw the return of the rococo style and more muted colors. Plates appeared with contours that imitated flower petals; their rims bore light

1. Faience soup tureen and soup plate from an archbishop's table service. Manufacture de Choisy-le-Roi, 1850. This type of service inspired decorations that were later printed and mass-produced.

2. Blue and sepia illustrated plate, leopard motif, from a set of wild animal designs.

3. Faience plate with rim decorated in relief, representing a pastoral scene, Second Empire period.

4. Blue and sepia illustrated plate: *Le duc d'Orléans aux portes de fer.*

1.

1. Study of a monogram for a table service. Atelier Emile Gallé, 1888.

2. The entire bowl of this platter is occupied by its illustration of a coronet entwined with ornamental foliage. Rim is decorated in relief, 19th century.

patterns of white-on-white relief, representing stitching, foliage, or basketwork. The decoration of the middle was in black, sepia, or gray, usually in medallions. Often the patterns referred to great inventions, works of art, Universal Exhibitions, or military achievements. Great novels of the period, such as *The Mysteries of Paris* or *The Count of Monte Cristo*, would be compressed into six plates. Songs appeared with one plate per couple. A humorous vein was widely exploited, with satires, charades, jokes, riddles, conundrums, and proverbs galore.

Toward the end of the nineteenth century, printed plates ceased to be merely black and white, and crockery was again flooded with colors. Dishes also became larger, echoing the satirical papers of the times and glorifying heroes and politicians. The patriotic theme—principally that of Alsace-Lorraine—was among the most popular; it was invariably handled humorously, as were scenes from military life. Religious iconography was also much appreciated, with plates serving as pages of the catechism. Also during this period, the first advertising plates appeared on the market.

After the Second World War, there was less interest in illustrated plates, even though themes such as the Tour de France, automobiles, and planes persisted.

Major Potteries

The Montereau works, in the Seine-et-Marne, was founded in 1745 and was among the oldest of its type. In 1775 it took the title of *Manufacture de la Reine* (The Queen's Pottery). The high quality of its paste rivaled that of Sarreguemines at the Exhibition of Industrial Products of 1801–1802.

The Creil manufacturer, on the banks of the River Oise, was founded in 1797 but did not really begin to function full blast until 1802. It became famous with the arrival of Charles-Gaspard Alexandre Saint-Cricq Casaux, who won a number of gold medals at various exhibitions of industrial products.

In 1819, the owner of Creil, M. Saint-Cricq Casaux, bought out the Montereau potteries. He began by renting them to a company run by Louis Leboeuf and Etienne Thibault in 1825, before merging everything into the *Societe des Faienceries de Creil et de Montereau*. In 1895, Creil closed down altogether and moved all its assets to Montereau. In 1920, Montereau went on to buy out Choisy-le-Roi, which ceased production in 1934. Montereau itself finally closed down in 1955.

In 1772, Joseph Fabry and the brothers Nicolas and Augustin Jacoby founded a faience works at Sarreguemines. In 1778 they recruited a young Bavarian, Francois-Paul Ultzschneider, who had worked for the famous English firm of Wedgwood. After the War of 1870, Sarreguemines was annexed to Germany with the rest of Lorraine and was forced to pay customs duty on the products it exported to France; whereupon it started a new factory within France at Digoin in Saone-et-Loire. From that time, all the output of Sarreguemines bore the names of both potteries.

TIPS FOR COLLECTORS

There are many delightful possibilities open to collectors of this kind of faience, whether they approach it by individual pottery, period, color, or theme. The most widely produced series are still very reasonably priced, but it is usually best to purchase items one by one, since complete series are always much more expensive. Currently, the most sought after names are Creil and Gien. Above all, look for pieces without any cracks or defects.

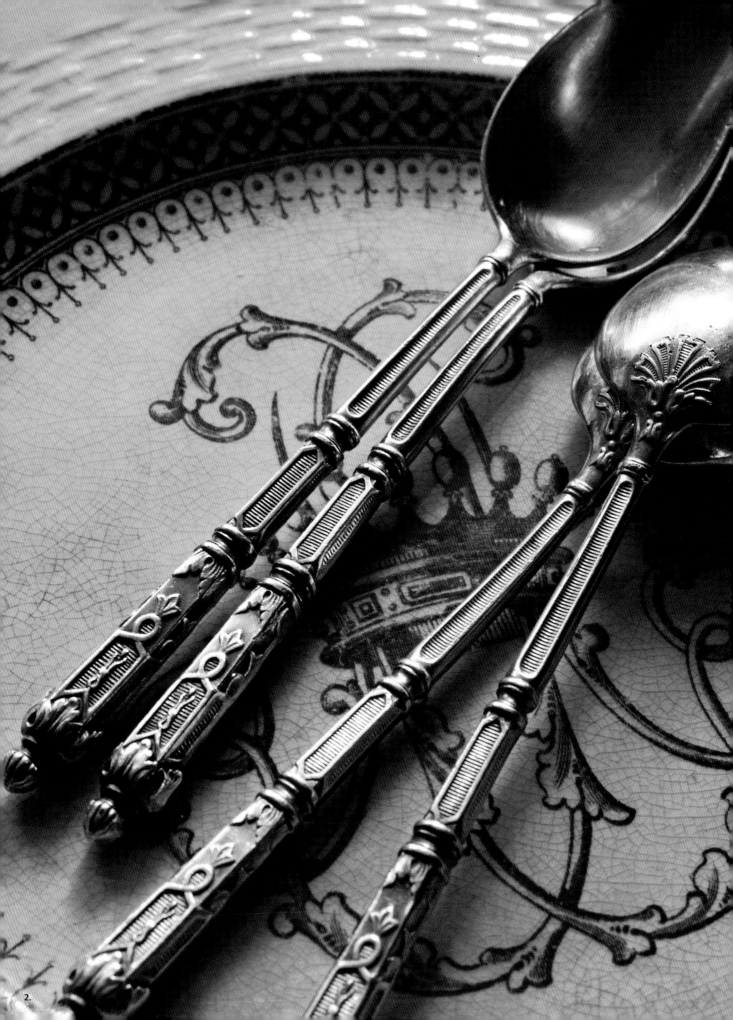

Flowers

Whether presented in simple lines or in sophisticated bouquets, naturalistic or stylized, flowers are the all-time favorite themes of ceramic decoration. Stylized flowers were already a feature of Ancient Egyptian pottery, as they were for medieval Islamic earthenware and ancient Chinese porcelain. In Europe, it was in the wake of Linnaeus, the Swedish botanist, that the eighteenth-century vogue for naturalism came about, bringing with it a pronounced taste for floral patterns.

The German Flowers of Meissen

The first European factory to feature flowers was Meissen, a village of Saxe in Germany where, in 1713, the chemist Friedrich Boettger discovered the secret of Chinese porcelain—that its paste was made with kaolin. In the 1720s and 1730s, Johan Gregor Herold created a floral decoration, *Indianische Blumen* ("Indian flowers"), influenced by Japanese asymmetry and coloring. This design was immediately copied by most of the other European factories. Ten years later, *Deutsche Blumen* ("German flowers") appeared; these were more naturalistic in conception and were sometimes surrounded by insects. The patterns were quickly taken up by Vincennes/Sèvres, which produced excellent versions of them.

The fleurs fines of Strasbourg

The invention of slow firing is attributed to Paul-Antoine Hannong, whose father, Charles-Francois, created the Strasbourg pottery workshop in 1709. With this new technique, the Hannong factory made a specialty of what was called *fleurs fines*, notably consisting of bouquets made up

of "swirling roses." These roses were often round, with a view straight into the heart of the blossom and its petals. The tones were invariably subtle, contrasting the carmine of the petals with the dark green of the thick stems. There were also bouquets made up of slender tulips with cornflowers and buttercups. These floral patterns were copied all over France, especially by Niderviller, Strasbourg's neighbor.

Marseilles Bouquets

The Marseilles region was another great center for earthenware, which was renowned for its flower patterns. The most celebrated potteries there were the ones founded by the Clérissy brothers at Saint-Jean-du-Désert in 1679, Joseph Fauchier, and Veuve Perrin. Toward 1750, these names began producing delicate floral decors, fired at low heat against white or yellow backgrounds. The Marseilles bouquets often represented roses and tulips blended with meadow flowers and handled naturalistically. They were the inspiration for other potteries all over the south, especially Moustiers.

1. Hand-painted porcelain, characterized by freshness of design and color.

2 to 4. Three faience patterns from the Utzschneider works at Sarreguemines: *Geranium*, circa 1890 (2.), roast meat platter, circa 1900 (3.), and *Pompadour*, floral decoration, 1880 (4.).

1.

2.

3.

4.

5.

6.

1 to 3. Different examples
of cornflower patterns on the
bowls and rims of plates.
Manufacture de la Reine,
18th century.

4. A romantic flower pattern by
Barbarin for *Vieux* Limoges
service. Haviland, 1855.

5. Decorations of violets by
Léonce Ribière, for Empress
Eugénie. Haviland, 1901.

6. Bright yellow *fleurs
parisiennes* by Girardin.
Haviland, 1885.

7. Flowers and gilded motifs on
the rims of an 18th-century-
style cake service.

8. A graceful flower pattern,
delicately outlined in sepia.

9. Moss roses hand-painted
on porcelain, with acid greens
and blues.

10. Flowering roses overflow
from the rims of these early-
20th-century cake plates into
the wells.

Thistles and Potato Flowers

Other, less famous potteries were also
creating original flower patterns. This was
the case of Meillonas, near Bourg-la-
Reine. This firm, founded in 1759, won
fame in 1759 with its hot-fired "man-
ganese pink" pattern. (The same pattern
made a name for the Tres-cloitres works
in Grenoble.) Meillonas was equally at
home with the use of slow-fired dcora-
tions, dominated by naturalistic stereo-
typical flowers.

Samadet, a small village in the Landes
department made a specialty of finely exe-
cuted flower designs, such as blue-hued
thistles and potato flowers. "Samadet
roses" were very original: unrealistic and
stylized, their blossoms were round with
straight cut, lacy petals and stalks that
were dead straight or studded with thorns.

Flowers on Soft-Paste Porcelain

Soft-paste (kaolin-free) porcelain had
appeared in Rouen in 1673 around the
same time as stoneware, as a result of
Edmé Poterat's work. However it really
came into its own with the products of

Saint-Cloud, Chantilly, Mennecy, Sceaux,
and of course Vincennes and Sèvres, at
the beginning of the eighteenth century.
Chantilly made a specialty of floral pat-
terns. After representations of strawberry
flowers in the Kakiemon style, more natu-
ral-looking flowers predominated, such as
bunches of roses, peonies, and primulas.
By the end of the eighteenth century,
Chantilly was specializing in stylized
sprays of flowers in blue tones notably *à
la brindille* (sprigs of heather) and *à l'oeil-
let* (carnations), which were echoed by
Orléans, Arras, Sèvres, and the factories of
Paris and southern and eastern France,
and also inspired the decorators of Creil
and Montereau.

Fifteen years after it was founded in
1735, the pottery at Sceaux invented
a stylized bouquet consisting of two flow-
ers side by side with a twig bearing small
round blossoms between the stalks.
Sometimes there would be one flower
only, purple in color with garish green
leaves. Mennecy, founded in 1737, special-
ized in bouquets of roses, peonies, and
tulips in pink tones.

7.

8.

9.

10.

1. A rotund tea set decorated with fresh, bright flowers.

2. Scattered flowers on a porcelain plate from Paris.

3. Bouquet of flowers in the center of a fragile faience plate. Manufacture de Niderviller, circa 1760.

4. Hand-painted flowers on these 18th-century, soft paste porcelain is the epitome of delicacy and precision.

1.

2.

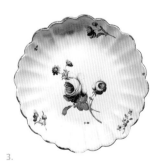

3.

The Roses and Cornflowers of Sèvres

The Vincennes pottery, founded in 1738, became the *Manufacture Royale* in 1752, under the aegis of Louis XV and his mistress Mme. de Pompadour. It began by imitating Saxony porcelain, notably with its "German flower" patterns. In 1756, Vincennes moved to Sèvres where, with its royal privileges, it was able to dominate the porcelain industry of the day. The factory itself was made up of a number of different workshops: paste makers, repairers, modelers, sculptors, gilders, and painters. In the painters' shop, some of the craftsmen specialized entirely in flower patterns.

After 1760, Sèvres adopted the pattern of *roses et feuillages* ("roses and foliage"); this consisted of small simple rose blossoms scattered across a white background. This became a lasting standard for Sèvres and was copied by Paris and Limoges.

In 1781, Marie-Antoinette, who had a passion for pinks and cornflowers, commissioned a service from the royal pottery known as *guirlandes de barbeaux* ("garlands of cornflowers"). Painted by Choisy and gilded by Chauveau, this service is produced to this day by the former *Manufacture Royale*. Cornflowers immediately joined roses as a predominant theme in porcelain plate patterns.

They were included in the inventories of most of the Paris manufactures of hard-paste porcelain, in scattered patterns, friezes, bouquets, and medallions, and were equally popular with the faience makers of eastern France and Savoy.

Miniature Roses of Limoges

The early years of Limoges were notable for their charming, somewhat simple polychrome flower patterns, either gathered in bouquets at the center of the plate and distributed in sprays around its edge or in the style of Louis XVI, with pink or blue cornflowers and green ribbons. Limoges copied the miniature roses of Sèvres, which then became "Limoges roses." Flowers were omnipresent, in the form of tulips and flat flowerets of the wallpaper type, and other floral patterns that imitated Chantilly, Sèvres, and Mennecy. These patterns were sometimes rimmed with *dents-de-loup* festoons.

4.

1.

1. The country charm of a dessert service sprinkled with roses and flowerets.

2 and 3. Sketches inspired by the vegetable designs of Emile Gallé's studio. Pattern for decorations of a faience vase, *Bambou*, 1878 (2.). Perforated paper for the decoration of a duck on earthenware, circa 1877 (3.).

Flowerets and Convolvulus

After 1850, flowers by the million blossomed on all forms of china and earthenware. Simple, unpretentious flowerets—roses and poppies—were painted on everyday faience, while more finely wrought flowers were devised for the table services of the middle class—essentially by Sarreguemines, Creil, Gien, Longwy, and Montereau, whose flower services of blue convolvulus against a white background became a great classic. At Niderviller, which had begun producing porcelain by this time, the patterns were a riot of red flowers, ranging from pale pink to dark red and multicolored bouquets. Occasionally there would be a new version of an eighteenth-century Sèvres pattern that came dangerously close to affectation, with flowers and gilding against a background of solid turquoise or pink.

Limoges and the Vogue for Japan

In 1842, David Haviland, the American importer of soft porcelain, was sufficiently impressed by the quality of Limoges china to found a decoration workshop of his own there. Within ten years he had his own factory in the town, producing porcelain exclusively for export to the United States. His sons Charles and Theodore then started a creative studio at Auteuil, managed by the painter Felix Bracquemond. It was the period when French artists were discovering Japanese prints and the works of Hokusai. The *fleurs et rubans* ("flowers and ribbons") pattern devised by Braquemond in 1879, along with Pallandres' 1883 *fleurs parisiennse* ("Parisian flowers") were characteristic of this trend.

Back in Limoges, the painter Georges Le Feure and the architect Edward Colonna came up with an art nouveau pattern for porcelain based on stylized vegetable motifs, many of them in relief and enhanced with pastel tones against a pale background. The painter Léonce Ribière designed two very pretty services: *Les Nymphéas* and *Caroline* on the theme of Parma violets. The latter was given by Theodore Haviland in 1901 to the Empress Eugénie, then aged seventy five.

TIPS FOR COLLECTORS

There is a very wide and varied choice of faience and hard-paste porcelain on the secondhand market.

Gien, Creil, and Montereau are all abundantly available. Nor are prices particularly high for Limoges flower-patterned services, bearing in mind that in this case, a complete service usually costs less than pieces acquired one by one. Series of dessert or cake plates in fine Limoges flower patterns can be found everywhere, selling at bargain prices. But plates designed by Suzanne Lalique, Jean Dufy, or Van Dongen are at a premium.

Japanese-style or art nouveau motifs have become rarities and are costly—as are older pieces of all kinds, which now tend to be confined to display cases.

2.

3.

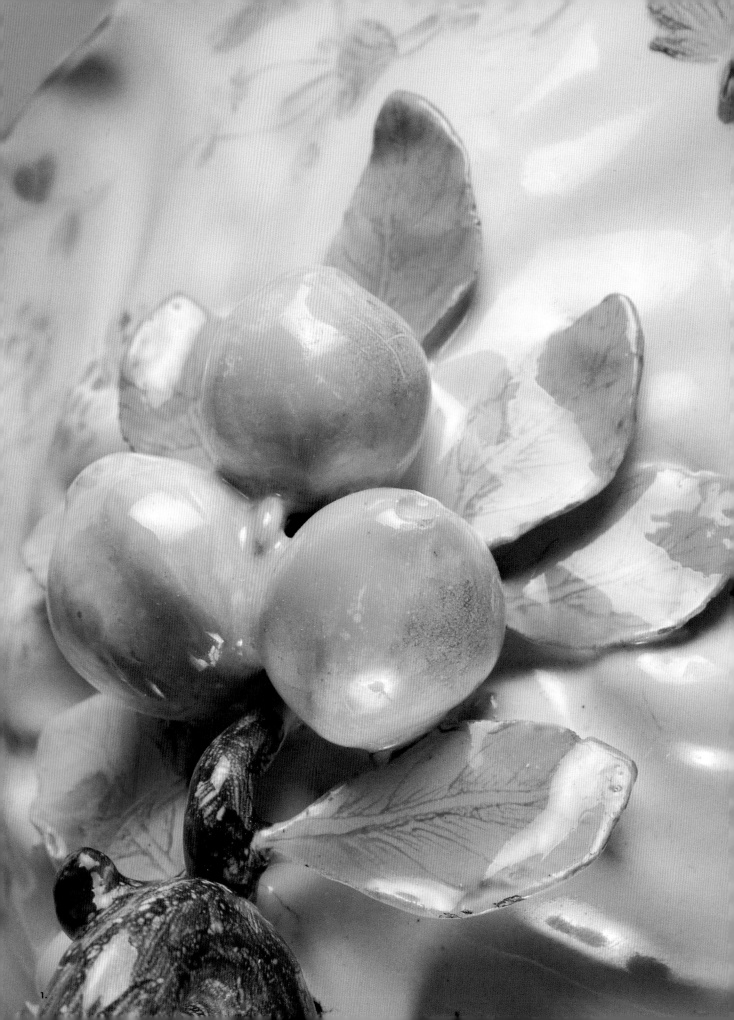

Barbotine Plates

These dazzling plates, with naturalistic motifs drawn from art nouveau, are like rays of sunshine on the table. They were only produced for about fifty years, but their blossoming patterns, which have often been copied but never equaled, have lost none of their appeal.

Barbotine

The original barbotine was a mix of clay and water used for molding a shape or sticking together the different elements of a piece of faience. The French gave the same name to a type of brightly colored, relief-patterned earthenware, which was produced between 1870 and the outbreak of the Second World War and which the English called *majolica*.

Strictly speaking, barbotine is a stoneware paste that lends itself particularly well to molding and delicate relief. Barbotine plates were made on the wheel or in molds. After drying, they were fired in the kiln at about 200°F, before being covered in a transparent lead enamel mixed with colored oxides. After that, they were refired at 1500°F.

The first French barbotines appeared around 1860. They were the work of Charles-Jean Avisseau, who was inspired by the work of Bernard Palissy. Arriseau's unveiling of his products at the London industrial exhibition aroused the admiration of Europe, and other great ceramicists flocked to his workshop in Tours. The fashion for barbotine was launched with the support of Napoleon III's niece, Princess Mathilde. Thereafter it was produced on a large scale until the 1920s, when it went into a gradual decline.

Naturalistic Decoration

Barbotine vases, planters, flower stands, jugs, asparagus plates, and shellfish dishes were adorned with dazzling naturalistic motifs and colors, and by 1880, barbotine dessert plates and fruit dishes were being produced in great numbers. Sometimes the plates and dishes were set into brass-wired mounts, which allowed them to be transformed into fruit or bread baskets.

When barbotine first appeared, neo-Renaissance style was in fashion, with acanthus leaves, lambrequins, and scrolls symmetrically positioned in relation to a central point. After this came the Japanese style, with its cherry blooms, bamboos, and birds freely represented anywhere on the piece; these in turn were superseded by the naturalistic, stylized patterns and flowers of art nouveau.

The principal themes of barbotine ware were leaves (ferns, ivy, and wild roses), vegetables (asparagus, artichokes, radishes, eggplants, and leeks), fruits (strawberries, pears, grapes, plums, and lemons), and flowers (daisies, sunflowers, roses, peonies, cornflowers, dahlias, violets, lilacs, and pansies).

From Sarreguemines to Vallauris

Sarraguemines was probably the most important pottery center in eastern France, employing about two thousand workers in the 1870s. The kilns of Sarreguemines steadily increased their production of barbotine ware, particularly after 1910, with each original becoming available in several versions and colors.

Lunéville, which was founded in 1720, earned the title of *Manufacture Royale* in 1772, under the protection of Stanislas Leszczynski. In the eighteenth century, Lunéville faience was celebrated for its quality as it moved from stanniferous earthenware to stoneware. Its production

2.

3.

4.

1. Decorative plate with fruits and leaves in relief. Manufacture de Longchamp, late 19th century.

2. Plate with vine-leaf design. Manufacture de Sarreguemines, late 19th century.

3. Rooster jug. Manufacture d'Orchies, late 19th century.

4. The deep, rich colors of an asparagus and artichoke plate.

1.

of barbotine ware was substantial and notable for its bright colors.

In the nineteenth century, Lunéville's subsidiary, Saint-Clément, turned out considerable quantities of plates bearing the popular rooster motif, while its extravagantly art nouveau barbotine ware differed from that of its rivals on account of its subtle patterning and the delicacy of its colors.

The exact origins of earthenware production at Longwy are not known, except that a pottery works was started there by the Boch family in 1801. From 1865 onward, Longwy focused on the technique of cloissonne enamel that was to make it famous. The Longwy works also produced shaded enamel and barbotine ware of very delicate manufacture, which were frequently of a single color and inspired by the East.

Clairefontaine, in the Franche-Comté near Vesoul, was known for its fine monochrome green and bicolored pink and white ware, while Salins produced large numbers of well-made plates with sophisticated flower and checkerboard patterns. The Longchamp pottery, founded very late in the nineteenth century, was known for its vases and plates decorated with fruits and flowers in relief.

There were also a number of potteries in northern France that produced substantial quantities of barbotine ware—notably Saint-Amand-les-Eaux, Onnaing near Valenciennes (famous for its jugs featuring different animals and public figures), Orchies, Dèvres, and Five-Lille.

The barbotine of Choisy, in the southern suburbs of Paris, and of Gien are perhaps the most beautiful of all. The celebrated green Choisy plate with its vine-leaf pattern was reproduced in the 1950s for Primavera.

Last but not least was the production of the Massier family—Delphin, his brother Clément, and his cousin Jérome—in Vallauris, a small village in the Alpes Maritimes. This famous workshop began by making fine monochrome glazes with Renaissance motifs in tones of turquoise, carmine, and green before graduating to naturalistic art nouveau barbotine ware

between 1860 and 1910. Their dessert plates and fruit dishes took the form of open daisies, pansies, and sunflowers.

Rubelles Plates

In 1838, Baron de Bourgoing went into partnership with Alexis de Tremblay to start a pottery at Rubelles, on the outskirts of Melun. In 1842, he invented *émail ombrant* ("shaded glazing"), the technique that consisted of stamping a pattern into stoneware paste and covering it with a layer of translucent colored glaze. The relief emerged under this glaze as the liquid settled into the hollows and the patterns stood out in lighter tones.

Landscapes, nature scenes, coats of arms, a variety of animals, and above all fruits (pears, cherries, grapes, red currants, black currants, lemons, quinces, and olives) were centered in the bottom of a round or multifoil plate, whose rim might be perforated, woven, or molded. The colors have a peculiar depth; cobalt blue, rusty brown, and a fine chrome yellow. The Rubelles workshop closed down in 1858, but its patterns continued to be imitated by Sarreguemines, Choisy, Longwy, Clairefontaine, Salins, Gien, Creil, and, above all, Le Mée-sur-Seine.

TIPS FOR COLLECTORS

Recently there has been a revival of interest in barbotine ware, and with it came an increase in the numbers of counterfeits. Lunéville, Saint-Clément, and Orchies are still affordable; prices for Choisy are on the rise; and Vallauris is heavily—and deservedly—sought after.

If you intend to use barbotine plates, it is best to select those that are in mint condition. Worn glazing makes the plates porous, which absorbs marks and stains.

As a general rule, the heavier the relief of a pattern, the older the piece.

Out of all ceramics, barbotine is the one that best lends itself to restoration. This has its advantages, but also its drawbacks, since the restoration work is often hard to detect.

2.

3.

4.

5.

SERVEWARE

Many dishes and receptacles that were well-known in their time are simply no longer made today. Such is the case of the celebrated eighteenth-century à oille stew pot, and even of the tureen, which today has a different shape to that of its ancestor. Gastronomic habits have also changed, and of course each category of food has its corresponding dish. Thus the soup tureen, a utensil much used in our grandparents' times, was progressively abandoned in the second half of the twentieth century when people consumed less and less soup—though today it is coming back strongly. Barbotine asparagus plates, bright and redolent of spring, are once again in favor. Other specific items that are less commonly used are fruit plates, fruit stands, and delicate plates for cake and tart.

And then there are all the other indispensable items of every shape and size. We buy them on impulse for their patterns and colors. With their blend of beauty and usefulness, they exemplify an ideal of refinement that enchants the aesthete and the gourmet alike.

Dishes from the Past

Old dishes and bowls, whose shapes have changed little over the centuries, have failed to compete effectively with the sheer diversity of modern products. In a sense they are the poor relations of the table. But perhaps the moment has come to restore them to their rightful place in the order; prices are low at present, and there are abundant pieces on offer.

Evolving Forms and Shapes

Toward the end of the eighteenth century, dishes differed little, except that each type existed in several sizes, sometimes up to twelve different sizes for the same pattern. They were generally less ornate than the equivalent "shaped" pieces. Under the French Regency, octagonal and hexagonal dishes had lightly gadrooned edges. Around 1730, the classic patterns were round and profiled, with five or six lobes; or oval, with six or eight. These types of dishes have remained current to this day. Under Louis XV, profiled dishes were covered in opulent and asymmetrical patterns, whereas in his son's reign there was a return to classicism with more symmetrical designs. The nineteenth century saw a return to older styles and rococo romanticism, with the trend for nature-inspired design prevailing by the close of the century. In the 1920s, art nouveau naturalism gave way to the sober, modernist style of art deco.

Specific Serving Dishes

While we acknowledge the enormous round venison platters of old, which were without contours and had narrow molded edges, it must be said that few serving dishes to speak of appeared before the nineteenth century. Beef and roast platters were equipped with detachable perforated drainers with four feet set in their raised rims. Big fish platters, which had similar perforated drainers, invariably caused a sensation when they arrived at the table: "The cold fish is laid on a long dish covered with an embroidered napkin, its edges encircled by flowers, periwin-

ETYMOLOGY

The word "platter" derives from the Greek *platos*, meaning broad." In 1328, the word *plat* in French designated a piece of crockery with a flat bottom, later expanding its meaning to cover the concave dishes used to transport food from kitchen to table and present it to best advantage.

Preceding pages:

Left: Cream-colored faience soup tureen. Manufacture de Sarreguemines, 19th century.
Right: Empire-style sauceboat, in the shape of an antique Roman lamp.

1. Concave platter and rectangular platter, silver-plated, 1930s.

2 to 7. Oval platters and round platters with contoured edges. From various Marseilles potteries, Louis XV period.

1.

2.

kles, primroses, and nasturtiums," says a 1925 guide to good living. Boiled beef dishes, by contrast, incorporated compartments for accompanying vegetables.

Materials

Traditionally, serving dishes were made of brass, silver, or vermeil; metal was usually preferable to ceramic because it did not break. But faience and porcelain makers eventually replaced their metalworking colleagues by borrowing their forms and molds. After 1830, round and oval serving dishes of different sizes made of earthenware and porcelain became as much a feature of table settings as the soup tureen or the vegetable dish. In today's jargon, they were "coordinated" with the rest of the table service. Nevertheless the invention of silver plate led to a substantial new production of dishes that generally imitated the shapes of the past. It was not unusual at the end of the nineteenth century for a household to possess both silver and ceramic serving dishes.

1. Round silver stew dishes with handles on either side, copied from various styles of the past, 19th century.

2. Square silver dishes, copied from various styles of the past, 19th century.

3. Hors d'oeuvre dishes of various shapes. The main structure is silver-plated metal, and the compartments for the hors d'oeuvres are made of crystal. Christofle designs, 19th century.

4. Soup tureen and typical Provencal platters, 17th and 18th century.

5. Cream-colored faience terrines from Lunéville.

TIPS FOR COLLECTORS

There is little demand at present for old serving dishes, and as a result there are plenty of bargains around. If the dish or platter is solid silver, then you must take account as always of the hallmark, the signature, the quality of the work, and the condition of the piece. If it is silver plate, choose with particular care because dishes of this kind were mass-produced and can be found everywhere—though if they were made by a famous firm like Christofle, there may be added value.

There is no shortage of ceramic serving dishes on the market. Their shapes may be commonplace, but good patterns and colors more than make up for this.

Carefully check the condition of the dish—no crack or chip is ever acceptable.

3.

4.

5.

Bowls and Old-Fashioned Platters

Terrines, stew pots, and porringers; these old-fashioned-sounding dishes are no longer much present on our tables. Instead they are kept on shelves or in display cabinets. Nevertheless, their former glory more than justifies the interest taken in them by lovers of the art of the table.

Sauceboats are rapidly becoming collector's items, while the good old soup tureen is now returning with a vengeance after a period in the wilderness. This is entirely because they are so attractive, with their elegant shapes and reassuring bulges. Some people use them at table; others set them around the house as planters or wall pockets.

2.

3.

4.

5.

6.

The **pot à oille**

Oille was a Spanish stew of various meats and vegetables, first mentioned in 1671. It derived its name from the Spanish *olla*, meaning a kind of cooking pot. *Oille* arrived in France about the time of Louis XIV's marriage to the Infanta Maria Teresa. In the eighteenth century, before the invention of the soup tureen, the *pot à oille* was the most important dish on the French table—a round, deep dish with an inside component that could be removed to make its contents easier to serve. It was between 7³/₄ to 11 inches in diameter, had four legs, two side handles, and a convex lid, and rested on a big stand known as a *dormant* ("sleeper"). It was accompanied by a round-bowled ladle. Under Louis XIV, the *pot à oille* was a sumptuous item, richly ornate and always made of silver. Indeed, it was the leading actor of the first course, which consisted of boiled meats and soup and often had an identical twin. The most famous *pots à oille* were made by Delaunay, Germain, Balzac, Meissonnier, Roettiers, and Auguste. Stoneware manufacturers copied it in their turn, with Pont-aux-Choux producing *pots à oille* inspired by metalwork, Joseph Hannong in Strasbourg creating trompe l'oeil cab-

bage patterns for them, and Veuve Perrin in Marseilles devising exquisitely delicate decorations for their outer surfaces. Under Louis XVI, the *pot à oille* became heavier and with the empire it took a more wide-mouthed form. It more or less vanished after the Restoration, at which time the soup tureen and the vegetable dish took its place.

The Terrine

The terrine, as its name suggests, was originally an earthenware dish used for stewing meats. Around 1720, this dish made the transition from the kitchen to the dining table and became just as refined as the *pot à oille*. Stoneware examples of these early terrines do exist, but most tended to be made of metal. The terrine was similar to the *pot à oille* inasmuch as it rested on four feet, had its own stand, was fitted with a removable cover, and sometimes contained another receptacle. But it was lower and oval in shape, not round (the oval was between 11 and 15³/₄ inches in length). The handles and lid were often decorated with hunting scenes. Its uses were various; stews were not the only dishes served in it. It had its own serving ladle, whose bowl was also oval.

1. Stoneware soup tureen, Empire period.

2 and 3. *Pots à oille*, slow-fired faience. Manufactures de Meillonas (2.) and de Hannong, in Strasbourg style (3.).

4 to 6. Slow-fired faience terrines. Manufactures de Marseille, 1760–1770.

1.

2.

3.

1. Louis XV hot-fired faience porringer. Manufacture de Moustiers, circa 1750.

2. Polychrome porringer, design inspired by the Imari Japanese style. Manufacture de Saint-Cloud, 18th century.

3. Porcelain porringer with "Three Graces" design. Manufacture de Limoges, 18th century.

4. Designs for silver sauceboats with either one or two pourers, copies of ancient oil-lamp designs.

5. Stoneware sauceboat with a single pourer and gadroon design. Manufacture de Sarreguemines, Empire period.

6. Faience sauceboat with printed *Flora* design. Manufacture de Sarreguemines, circa 1880.

4.

The Individual Porringers

The ancestor of our own concave plates, the porringer was a small flat-bottomed bowl whose shape harked back to the Middle Ages. It was one of the first individual containers to appear on European tables. In the seventeenth century, it incorporated two side grips, a removable lid to keep its contents hot, and the platter on which it stood. The most famous French porringer belonged to the Dauphin, Louis XIV's son. It dates from 1692 and is made of vermeil, with gilded side handles decorated with shells and dolphins.

The porringer was particularly well adapted to nursing women and to those in poor health who could only eat gruel and was a common gift to a newborn, presented in a leather pouch. Strasbourg specialized in the manufacture of silver porringers. Other factories produced many variations of it: for example, the famous Hannong porringers, also of Strasbourg, came in the shape of ducks, turkeys, geese, and vegetables.

TIPS FOR COLLECTORS

Pots à oille and terrines, whether made of porcelain or solid silver, are rare collector's items.
Strasbourg porringers made by Alerti, Imlin, or Kirstein are equally sought after.

The Sauceboat or Gravy Boat

The shape of the sauceboat has changed little over the centuries, either in metal or in ceramic. During the reign of Louis XV, it was shaped somewhat like a weaver's shuttle, or even an oblong boat, with two lips so that the sauce could be poured out from either end. It also had two side handles and formed a single piece with its stand. Vincennes and Sèvres produced many delightful variations on the sauceboat. Under Louis XVI and later under Napoleon, the most popular models took the form of antique oil lamps, helmets, or gondolas on pedestals, with a broad pourer on one end and a handle on the other. In the nineteenth century, it was fixed on a platter to protect the tablecloth and was an integral part of the table service. Noteworthy among the many faience and porcelain sauceboat designs was the degreasing sauceboat, which had a hood on the pouring lip that made it possible to skim grease from the surface of the gravy.

The Soup Tureen

The soup tureen made its first appearance at the very start of the nineteenth century. It was larger than the *pot à oille,* but resembled it in other ways—round and deep and with its own cover—and the notch in the cover accommodating the shaft of the ladle did not come until the twentieth century. Under the Empire, great metalworkers such

5.

6.

1.

as Odiot invented sumptuous tureens in the antique style, shaped like urns on pedestals and decorated with long-necked swans. After the Restoration, they assumed the round, bell-mouthed look we associate with them today; their covers had pinecones, artichokes, or tomatoes for knobs, and their handles were hollow. They often came in pairs, were part of a complete service, and existed in several sizes: for two, four, six, eight, ten, twelve, fifteen, or twenty-four people. They were made of silver or silver plate by leading nineteenth-century silversmiths like Hugo, Cardeihac, Lebrun, Ravinet d'Enfert, Tetard Freres, and Durand. In faience and porcelain, they were made by all the big potteries—Montereau, Creil, Sarreguemines, Lunéville, Gien, Saint-Clément, Longwy, and Quimper—which turned this comely, rotund object into a reassuring symbol of family virtues.

The Vegetable Dish

Smaller than the tureen, the vegetable dish with its English origins is sometimes confused with the porringer; it is round with two side handles and a cover lifted by a knob in the shape of a pinecone or a vegetable. The term first surfaced in the nineteenth century, but the object itself came into use much earlier in the 1730s and was often produced in matching pairs. When made of metal, it was sometimes accompanied by a hot plate.

The nineteenth century saw the birth of another kind of vegetable dish, which was rectangular with a cover that had a removable knob. If you took off this knob the cover could be turned over to make a second dish.

Earthenware and porcelain vegetable dishes reproduced on a smaller scale the shapes and patterns of the ordinary soup tureen. Among the most sought after are those with pinecone or garden vegetable patterns such as artichokes and carrots.

Le ravier ("Hors d'oeuvre Dishes")

The French word *ravier* probably derives from *rave*, meaning a member of the radish family. The *ravier* appeared on French tables in the 1830s as a dish for hors d'ocuvres. It was also called an *hors d'oeuvrier* or a *bateau à raves* ("radish boat") when it was longer and turned up at either end. Made in porcelain, faience, glass, crystal, and metal, it might be rectangular, oblong, or hexagonal in shape. It also came as several movable cups that formed compartments and were placed in a stand with a central handle or knob of nickel-plated copper or silver plate.

The Salad Bowl

The handle-less salad bowl has been a fixture since the seventeenth century. It was confined to the kitchen for most of its life and was only promoted to the dining table fairly recently, becoming an integral feature of table services in the late nineteenth century. Salad bowls were generally made of stoneware or porcelain and were originally much less common than the *pot à oille* or the terrine. Sometimes it was made of cut crystal, porcelain, or faience and was also sold on its own not only for serving salads but also fruits and side dishes.

TIPS FOR COLLECTORS

Soup tureens are abundant on the market and relatively cheap. It is always wiser to buy a tureen with the rest of its service than on its own. But you can still fall in love with a certain type of tureen knowing that it won't cost an arm and a leg.
A tureen is just as useful for serving vegetables or stews as it is for serving soup. Before making the purchase, make sure that the piece has no nicks or cracks in it; if the cover is missing, it may be used as a planter.

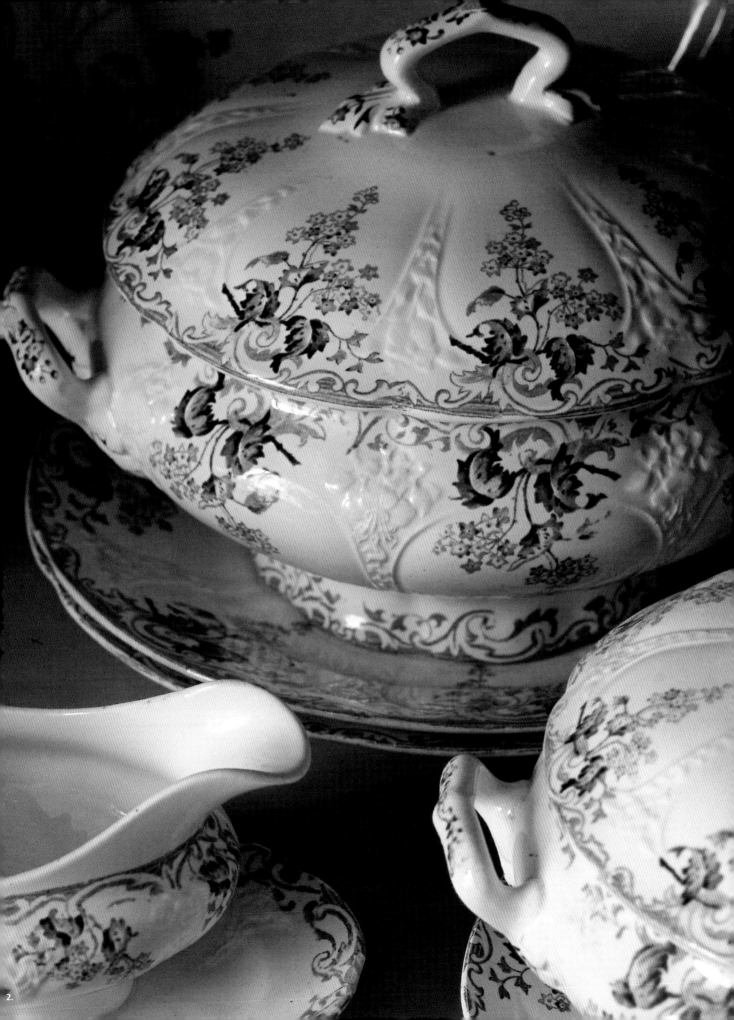

1.

2.

3.

1 to 3. All of these silver-plated models of serving dishes are copies of past styles: rectangular and oval, with cover (1.), vegetable casseroles by Christofle (2.), and soup tureens by Christofle (3.).

4. Soup tureen with refined rose design and a vegetable knob on the lid. German, early 19th century.

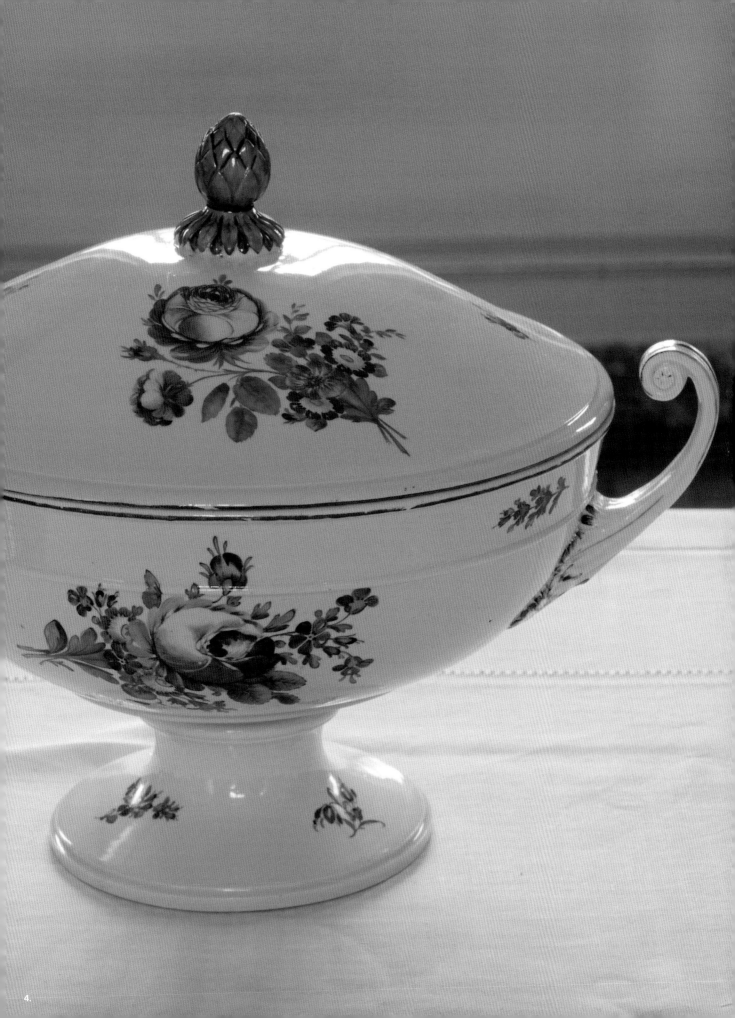

2. 3. 4.

Asparagus Plates, Artichoke Plates, Shellfish Plates

Once again, barbotine is king in this department, with its compartmented dishes, vegetables in relief, and fantastical shellfish. These make the brightest, most springlike table settings in the world.

For Asparagus and Artichokes

Asparagus and artichokes have been consumed in Europe since the seventeenth century, but it was not until the close of the nineteenth century that specific services were devised for them. All the leading barbotine makers seem to have produced enormous quantities of asparagus dishes. Did people eat more asparagus then than they do today? Perhaps, but it is certain that the techniques of the period for molding paste in relief made it easy to make compartmental dishes.

The asparagus service quickly won a place in the middle-class households. As a rule, it took the form of a dozen plates and a dish or two—one for serving, the other for clearing away—and a sauceboat. The plates would be decorated with a few asparagus shoots in relief or with artichoke leaves forming a separation between the space reserved for the vegetable and that for the sauce, and laid against a background of basketwork or a bed of foliage. The asparagus shoots were presented to the diners in a "cradle," usually made up of

a hollow bunch of asparagus on an oval or rectangular serving plate, sometimes as an integral part and sometimes not. Even great faience manufacturers produced their own version of these services, the most refined being those of Salins, Saint-Amand-les-Eaux, Longchamp, Lunéville, Orchies, and Sarreguemines.

Silver-plated asparagus dishes are also available, but they have none of the charm of barbotine, which goes so well with vegetable dishes and fruit.

Oyster Plates, Shellfish Plates, and Snail Plates

Equally amusing, but perhaps less varied, are barbotine oyster plates. They are nearly always round, hollow receptacles in the shape of *belon* or Portuguese oysters. In general there are six of these containers (though sometimes they run to twelve) with a seventh in the center for the lemon. Most of these plates are green in color, similar to the oysters themselves. But some manufacturers took liberties with reality and used white, gray, or pink tints.

1. A double asparagus cradle with a handle, resting on an imitation basket-weave earthenware dish.

2. A highly original asparagus dish, with two compartments, late 19th century.

3. A more classic pattern of asparagus dish. Manufacture de Sarreguemines, circa 1900.

4. Dish for a dozen oysters, with colored glaze. Manufacture de Sarreguemines, circa 1880.

1. 2. 3. 4.

5. 6. 7. 8.

9. 10. 11. 12.

TIPS FOR COLLECTORS

Asparagus and artichoke plates take up a lot of room and are seldom used, but they have real charm. When you take interest in such things, you'll find that they come in many varieties, with more or less delicate colors and craftsmanship that ranges from crude to highly accomplished. This explains why some are more sought after than others, Choisy-le-Roi is a case in point.

Complete services are rare; the sauceboat or the detachable strainer is frequently missing. On the other hand, the plates themselves are still readily available, especially in small series.

Always favor unblemished and unchipped pieces, especially if you expect to use them at the table.

1 to 8. Asparagus cradles

9 and 10. Asparagus dishes.

11. Snail dish, with silver interior.

12. Silver oyster dish.

13. Oyster plates with basket-weave relief.

14. The same oyster plates, in a single color.

13.

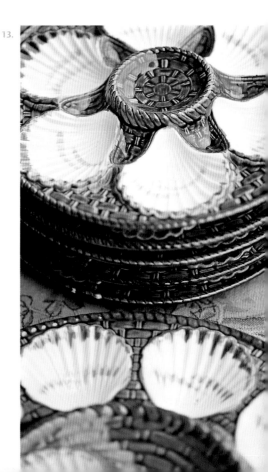

2.

Serving Eggs, Butter, and Cheese

Why not resurrect those peculiar objects known as egg carriers, eggcups, and butter dishes? Sunday brunch, for example, which is becoming a more and more popular custom, lends itself perfectly to their use.

The Presentation of Eggs

The egg stand, used for hard-boiled eggs, is made of small horizontal shelves of wood set around an upright post, with round holes for the eggs to stand in (today you can see many variations on this basic design on the counters of French cafés). The egg tray has a dozen holes for hard-boiled eggs and two small compartments for salt and pepper. The individual egg plate, usually made of earthenware, comes with eggcups, egg spoon, salt cellar, and candlestick. The egg ramekin takes the form of a small earthenware or porcelain pan with a cover and a lathe-turned wooden handle. Taking their cue from the English, the French adopted egg trays or egg services made of silver or silver plate with feet, a central handle, circlets able to hold four or six eggcups, and racks for the spoons. When they contained only two eggcups, they were known as *tete-à-tetes*.

Eggcups

The boiled egg was formerly considered a sovereign food for pregnant women and convalescents. Louis XV was the first to elevate it to the level of a dinner course. The king ate one egg every Sunday, out of a golden eggcup nestled in its own gold basket. Madame de Pompadour owned a

similar model in silver. Among other celebrated eggcups were those of the Dauphin, in sky blue Sèvres porcelain, and of Marie-Antoinette, who had a blue glass egg goblet set in a silver stand.

The first eggcups were made of precious metals, gold, or silver—or both, with the exterior of silver and the interior of gold. They were given as gifts to babies at their birth or christening and to couples on their engagement; they were accompanied by a drinking cup, a spoon, and a small dish. Each would be engraved with the recipients' monogram or adorned with hearts, birds, or flower patterns. Later came small masterpieces of faience and soft-paste porcelain, and in the nineteenth century the range of materials broadened to include vermeil, opaline, crystal, and barbotine and the pieces incorporated a whole array of nests, chickens and eggshells, paste glass, and pressed glass. The French phrase "*gagner le cocotier*," meaning "to win the coconut palm" is, interestingly enough, a deformation of "*gagner le coquetier*," meaning "to win the eggcup." At nineteenth-century fairgrounds, a common prize at shooting stands were pressed glass eggcups.

At the end of the nineteenth century, lavishly decorated silver plate was all the rage, with its fillets, gadroons, engravings,

3.

4.

5.

1. Egg stand, made of wire, late 19th century.

2. Silver eggcups of various designs. Some of these might have had gold interiors—which increased their purchase price by 2 francs in Christofle's 1913 catalogue.

3. Egg plate.

4. *Cocotte* for boiling six eggs. There was a larger model that could hold a dozen eggs.

5. Egg tray.

1 and 2. Cylindrical butter dishes.

3. Camembert dish.

4 to 6. Covered "churns" for butter or grated cheese.

7. Silver eggcup, 1950s .

8. *Diabolo* faience and porcelain eggcups.

9. Stylized flower-patterned faience eggcup.

10. Silver butter mold for making butter "shells."

1.

2.

3.

4.

5.

6.

grooves, ribs, friezes, and traceries. Patterns proliferated, and all manner of fantasy was indulged. Many eggcups were made of wood, especially box, olive, fruitwood, pine, and ash; exotic essences like ebony, sandalwood, and ironwood were also popular. They could be finely turned on a lathe or roughly sculpted, painted, lacquered, or pokerworked. Other materials appeared; eggcups went rustic, with stoneware and glazed earthenware, and then were reduced to their simplest form with aluminium, wire, enameled iron, and pewter. At the top end of the range, they were fashioned out of brass, horn, ivory, and finally of resolutely modern Bakelite.

Shapes

The basic shape of the eggcup always stays the same even though variations on the theme are infinite. Because it is such a small item, it is an ideal collector's item, on the condition that the collector adheres to a precise theme, ornamentation, or material.

The eggcup, which is seldom more than 4 inches in height, can be *á baluster*, meaning raised on a slightly rounded pedestal. It may also be a tripod, resting on simple balls or animal feet. The type known to the French as *demi-anglais* ("half English") has a short foot; the model known to the English as a "bucket" eggcup has no foot at all; and the *diabolo* or *bobine* is made up of two cones meeting at their narrow ends. Some eggcups come with a saucer on which the spoon can be laid and occasionally have their own built-in receptacles for salt and pepper.

Cheese Platters and Butter Dishes

Cheese was seldom consumed in the eighteenth century, though some—such as Brie—were included in favorite recipes. Fresh cheeses would be served as side dishes in charming *fromagers* (china

drainers). These were cylindrical pots with holes for draining the whey into a dish fitted for the purpose.

The practice of eating cheese at the end of a meal dates from the nineteenth century, when cut-crystal or ceramic platters with matching covers emerged.

The butter dish or butter pot, on the other hand, dates back to at least the fourteenth century in Europe. It may take the form of a churn or tub with two vertical tenons placed on a fitted platter; a small dish with small cover; or a crystal container placed on a metal saucer with a metal lid that may or may not swing open and shut on a pivot. The butter cooler is usually made of porcelain or porous clay, with a glass receptacle inside; cold water in the cooler keeps the butter at the right temperature. Finally, there is the two-piece butter mold; one part is perforated, and the other fits into it. The butter, when squeezed between the two, comes out in decorative petals.

TIPS FOR COLLECTORS

The eggcup is an ideal collector's item; it takes up very little space, includes every theme under the sun, and comes in every material from barbotine and boxwood to decorated glass.

The most expensive eggcups are made of silver; style and refinement are the main elements making for value, along with the hallmarks of well-known silversmiths.

For porcelain and faience eggcups, look for well-executed design, pristine condition, and signature. Eggcups made from rare wood essences are much sought after.

Finally, look for originality in the pattern. Eggcups were often sold in sets of six to twelve and can be reconstituted one by one with patient buying.

7.

8.

9.

10.

1.

2. 3. — 4.

Dessert Platters

"Dessert services are often made of cut glass, but silver and vermeil bowls are still highly coveted, and porcelain ones never go out of fashion," declares an early-twentieth-century guide to good living. At that time, people ate more sweets and puddings in general than we do today, and this practice was all for the good, since it led to the invention of all sorts of charming plates and dishes. It would seem that, in the past, fruit and cakes were often present on the table as decoration from the very start of the meal. For this reason, fruit dishes and fruit stands, which effectively functioned as graceful, tall centerpieces, were produced in twos and fours.

5.

The Compotes

The compote was used for stewed fruit (or compote) and also for fresh whole fruit, biscuits, creams, and side dishes. It had its own distinctive shape and outline: it had no wing or raised rim, but was relatively deep, so that it looked like a kind of basin with crenellated edges. When it had no feet, it could be triangular, square, rectangular, gondola- or shell-shaped, as exemplified by the compotes produced by the soft-paste potteries of Saint-Cloud and Sèvres. In the nineteenth century, the compote became taller with its own stand or pedestal of varying height. It resembled a goblet of blown glass, cut glass, faience, silver plate, bronze, or white metal. Often it was a part of a table service proper, in which case it would be monogrammed or emblazoned. The highly decorated, deeply cut crystal bowl with removable silver feet was especially popular at the end of the nineteenth century and often formed part of the centerpiece.

Fruit Baskets

As the nineteenth century progressed, it became more and more common for fruits and cakes to be presented in "baskets" that evoked their rustic origin. The earliest were made of porcelain, but between 1850 and 1880 they began to be manufactured in vermeil, gilded bronze, or silver-plated bronze. Sometimes the metal would be woven in imitation of basketry. After 1890, wickerwork made its appearance on tables.

1. Sketch of *Bambou* pattern, a tripod with two suspended crystal dishes engraved with a Greek motif. Christofle archives, circa 1860.

2 and 4. Designs for double-octagonal cake dishes: rosette pattern (left) and radiating pattern (right), as described in the contemporary Christofle catalogue.

3. Strawberry service comprising of metal frame, two dishes, sugar bowl, and creamer.

5. Reissue of a woven faience Provencal fruit basket.

1. Built-in ice buckets, for keeping ice cream and sorbets cool, made of silver plate and crystal. Christofle.

2. English stoneware preserve dish and plates. Wedgwood, 1930s.

Among other curiosities in the same line were the grape basket, an oval basket made of metal or withy, with a tall handle and hooks for hanging bunches of fruit; and the chestnut dish, made of porcelain or silver, with a lid imitating a folded-back, half-open table napkin. There was also the *marronière*, a kind of openwork porcelain basket for chestnuts.

Strawberry Dishes

Strawberries were highly appreciated in the nineteenth century, and nothing was too good for them when it came to dishes and bowls. "A store in Paris (Christofle) has just launched a new strawberry basket made of silver and crystal. This basket stands in the middle of a group that forms a centerpiece. All around are crystal vessels mounted in silver that serve to contain powdered sugar, kirsch, rum, maraschino, whipped cream, and slices of orange and pineapple, which diners can add to the strawberries to taste." When strawberries were served in quantity, they were simply laid in a bowl or in crystal set in a broad woven silver basket, where they would not be bruised. Other strawberry services consisted of two fruit bowls, a creamer, and a sugar bowl, which all fit into a single base. Charming pieces of the same kind were made in faience or barbotine, with incorporated strainers.

Ice Buckets and Coolers

In the eighteenth century, there was a craze in France for sorbets and ice creams. To satisfy this trend, a new category of dish was invented: the ice bucket or cooler. It was made up of three sections, which worked in a simple, ingenious way. The first part, on the bottom, was a two-handled bowl; a second bowl fit inside the first bowl; and over both bowls sat a concave, basin-shaped lid. The ice, which was taken from frozen ponds during the winter and stored in icehouses, was placed between the two bowls and in the hollow of the lid, and thus the sorbet and the ice cream could be kept cold. This system was perfected by Sèvres and imitated by the other soft-paste porcelain producers, before being manufactured in hard-paste porcelain. All in all, it was a magnificent, highly sophisticated object.

The craze for ices continued into the nineteenth century. People consumed them in the evening, as desserts, or after dinner in the salon, served in small individual china cups, each with its own cover, and presented on a matching tray.

Cake and Pie Platters

Porcelain makers invented a small, attractive platter with two side handles especially for cakes, with finely worked *ajouré* or lacework edges. In general, it was part of what was known as an "individual" service. The tart dish or pie platter, by contrast, was a flat item resembling the base of an actual tart, mounted on feet or on a pedestal.

TIPS FOR COLLECTORS

Nowadays, a fine, white cake platter in excellent condition, with a gold or otherwise delicately painted rim, can be purchased inexpensively.

Small ice cream pots on their matching trays, which are no longer much used, are nonetheless charming in their own fashion and have become purely decorative items.

1.

FLATWARE

Knife, fork, and spoon: these three essential tools took many centuries to reach the table, but once they did, they were there to stay. In the second half of the nineteenth century, with the invention of the silver plate, individual settings became the norm—which prompted Chatillon-Duplessis to write in the magazine **Salle à Manger** that "sooner or later somebody will invent an instrument for holding your fork for you." Thereafter, every different kind of dish had its own specific utensil.

Even though some of the flatware have ceased to exist—such as those peculiar forks with one outer edge for cutting, used for eating melons, fish, or cakes—their profusion is no cause for complaint. Some of the pieces invented in the nineteenth century are real jewels of their type, with which the goldsmiths and silversmiths of that prolific time raised the art of the table to unimaginable heights.

On the other hand, old silver—which had its heyday in the eighteenth century—remains a rarity because so much of it was melted down at one time or another by official order; and its price today reflects this fact. But a vast selection of flatware became available in the nineteenth century; patient and dedicated collectors will have little difficulty in finding whatever they are looking for at bargain prices.

Silverware

The art of the silversmith and goldsmith is among the oldest craft known to man. However, it was not until the discovery of the New World and its silver mines that the greatest European craftsmen were able to give free rein to their talents, as the rituals of the table began to require more numerous, varied, and sophisticated flatware and utensils. In the nineteenth century, silver plate began to replace sterling silver, further broadening the scope of table silver.

Old Silver

What we know as "old silver" really took off in the late seventeenth and eighteenth centuries, with great craftsmen such as Nicolas Delaunay, Claude II Balin, and Nicolas Bernier. Unfortunately, much of their work was melted down to finance the wars of Louis XIV in 1689 and 1709. For this reason, the future generation was robbed of many masterpieces of the French silver-smiths, though a few great items commissioned by foreign monarchs and aristocrats were preserved. Nevertheless, you only have to compare the scarcity of French silver with the abundance of English silver of the same era to understand to what point the former was laid waste. Apart from the sprinkling of prestige objects, only everyday objects like sugar and salt shakers, candlesticks, dishes with the corners cut off, goblets, porringers, and coffeepots remain.

The rococo style emerged around 1723, under the influence of Juste Aurele Meissonnier, who introduced the concepts of asymmetry and movement into orna-mentation. In diluted form, this style made its way into the ordinary tableware of the time, which is still appreciated and manufactured today: dishes with cham-fered rims, balustered teapots and cof-feepots, tulip-shaped cups, sugar bowls, salt cellars, candlesticks, and flatware with patterns of violins and seashells.

The silverware of the reign of Louis XVI saw a reaction to all this exuberance and then a return to the classicism of antiquity, sparked by the discovery of the ruins of Pompeii. Jacques-Nicolas Roettiers created a number of neoclassical masterpieces at this time, most notably for the Russian court.

Modern Silverware

The craft of the silversmith, which was all but lost during the Revolution, was reborn during the *Directoire* era and the Empire. Henri Auguste, Martin Guillaume Biennais, and Jean-Baptiste Claude Odiot were the masters of the time, creating monumental pieces covered in motifs in bas-relief and decorated with foliated scrolls, eagles, swans, and sphinxes, as Egypt became all the rage. The Louis-Philippe style, which accompanied the rise of a new middle class in France, coincided with the introduction of the new "head of Minerva" system of silver hallmarking. This nineteenth-century silverware has survived in abundance, seal-ing our abiding preference for the Louis XV rocaille style and the ribbons and gadroons of Louis XVI. While Froment-Meurice sup-plied the formal silverware of Napoleon III, the second half of the century was marked by a stylistic eclecticism that was charac-terized by elaborate Gothic, rococo, and Pompeian ornamentation.

The Revolution of Silver Plate

The greatest novelty of the nineteenth century was the introduction of silver plating by galvanoplasty, or electrodispo-sition. Starting in 1844, Charles Christofle began using a process invented in England

2.

Preceding pages:
Left: Silver spoons and ivory-handled, steel-bladed knives, 19th century.
Right: Louis XIV-style flatware.

1. Sterling silver vegetable dish, 18th century.
2. Sheffield silver egg tray and eggcups, 1840.

3.

4.

2.

1.

5.

by Elkington, which made it possible to cover a base metal with an outer layer of silver by electroplating. His products were highly successful, both among the bourgeois class, who wished to compete with and imitate the aristocracy, and among the aristocrats themselves, who were concerned about maintaining their prestige. Even the imperial family now found itself able to indulge its taste for pomp and luxury without going to excessive expense. Other gifted manufacturers followed where Christofle led; Boulenger, Ercuis, Armand-Calliat, and Poussielgue-Rusand. This period also marked the beginnings of low-cost mass production of silver plate on an industrial scale.

Toward the end of the century, ornamentation—often with vegetable motifs—became very popular, heralding the arrival of the Japanese style, naturalism, and art nouveau. Finally the 1925 style of Jean Puiforcat engendered new shapes that were much cleaner and more austere (see page 87).

Evaluating Silverware

The French word *orfévrerie* originally designated silversmiths' and goldsmiths' work. Later it was broadened to include the working of other metals and alloys including copper, brass, and nickel, which were plated with gold or silver. Thus the world "silverware" came to include the whole gamut of objects covered in silver plate.

A number of considerations come into play when you are estimating the value of a piece of silver, notably its specification, weight, crafting, and style. But the best indication of worth remains the hallmark, which gives the date, origin, and maker of the piece.

Specification

Gold and silver cannot be used pure for making utensils because they are too malleable and soft. What is known as "sterling silver" is actually a blend of silver with some other, harder metal, usually copper. Its specification is the percentage of precious metal contained in that blend.

For sterling silverware, there are two specifications: first, 925/1000 and second, 800/1000.

Hallmarks on Old Silver

So-called "old silver" originates in the period prior to 1838, the date when the Minerva-head hallmark first made its appearance. Before 1791, silverware had to carry four silver marks by law. These were:
· The master's mark, which usually consisted of the silversmith's initials.
· The guild-mastership's mark, indicating the town guaranteeing the quality of the metal. This was a letter indicating the date, which changed each year according to the alphabet.
· The charge mark was punched in during the manufacturing process by the farmer-generals whose function was to levy the silver tax, beginning in 1672. This mark was exclusive to each farmer-general and to each of France's thirty-one circumscriptions.
· The discharge mark, which proved that the tax had been duly paid and frequently took the form of an emblem—such as insect, flower, and ear.

After the Revolution, from 1798 to 1838, only three hallmarks were required:
· The master's or craftsman's mark.
· The guarantee mark, which was a rooster with its head turned to the left (pre-1809) and to the right (between 1809 and 1819). Between 1819 and 1838, the rooster was replaced by the head of an old man.
· The specification mark.

Modern Hallmarks

After 1838, so-called "modern" silver was bound by law to carry a charge mark, to which the manufacturer's mark would often be added. The charge mark remained a head of Minerva turned to the right until 1973, and thereafter turned to the left. This was accompanied by a letter of the alphabet that changed every ten years.

Silver Plate Hallmarks

Silver made in 1861 and after carries the maker's hallmark, which may be square or rectangular. After 1983, this mark became

square only and came with a number indicating the quality of the silvering along with the maker's symbol and initials.

Flatware may have one of two silver plating qualities (the minimum average thickness of the silver plating, in microns). Number One quality is 33 microns, and Number Two quality is 20 microns.

For decorative pieces, the norm is 10 microns for Number One quality and 6 microns for Number Two quality.

Sheffield Plate

Invented in 1742 by Thomas Boulsover, Sheffield plate is named after the Yorkshire town that was England's main center for silverware manufacture outside London and was made using the first process to make silverware out of anything but solid silver. It consisted in taking a sheet of copper and fusing molten silver to both sides and was very successful in both England and France until the invention of silver plating by galvanoplasty (or electrodisposition) in 1840.

Incised, Engraved, and Pierced

Incising consists of beating metal with a hammer or chasing tool to create patterns or matte backgrounds.

A *repoussé* or "chased" effect is obtained when the silversmith, working on the underside of his piece, hammers areas outward to create relief.

Engraving is done by working up a design with a chisel or other etching tool.

Gadrooning is a type of concave or convex decoration, oval in form and slightly elongated.

Piercing is a technique based on contrasts between bulges and hollows.

Vermeil, Inlaid Enamelwork, and Enamelwork

Vermeil is the effect of a layer of gold on silver.

Niello, or inlaid enamelwork, consists of working a mixture of sulphur, lead, silver, or copper into the etching of a piece, which is then fired to produce a decoration of black against silver.

Enamel is made up of an opaque or transparent glass paste, in powder form, which is applied to a silver background before being fired in a kiln where it solidifies. When it is held in by soldered partitions, enamel is known as cloisonne as opposed to champlevé, where the paste is cradled in small hollows or indentations in the surface of the metal.

TIPS FOR COLLECTORS

Strasbourg, Bordeaux, Lille, Paris, and Arras are all excellent marks for old silver, but beware of counterfeits: old silver marks are sometimes soldered to new pieces. It is always a good idea to check the date offered by the silver mark against the crafting and style of a piece, verifying the placement of the silver mark and its condition.

The presence of a coat of arms increases the value of the flatware, while a monogram has the reverse effect.

In general, the older the piece, the more prized it is.

6.

1. Silver box for individual napkin ring, flatware, and cup.

2. Silver box for dessert knife, flatware, and napkin ring.

3. Silver box for strawberry spoon and sugar spoon.

4. Box of teaspoons.

5. Box for fish service knife and fork.

6. Oak silver-chest, complete with drawers, lockers, and an interior lined with chamois leather.

7. Silver restaurant vegetable dish with cover.

7.

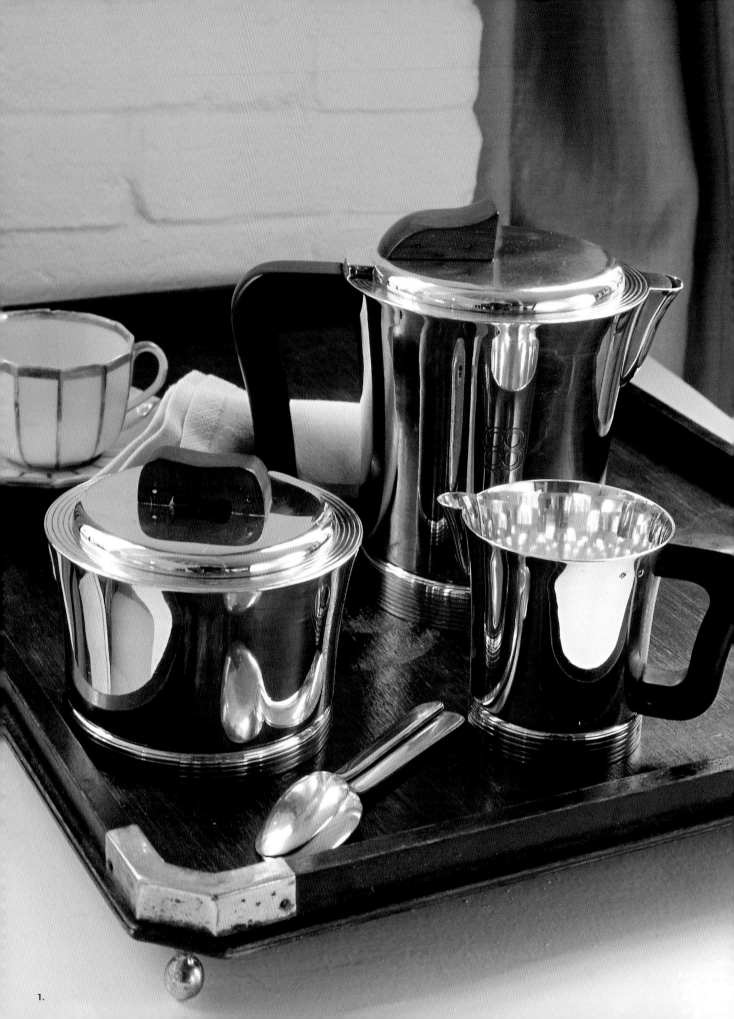

2.

1. Sterling silver coffee set with wooden knobs and handles. Puiforcat, 1938.

2. Four salt shakers with crystal containers for the salt. Original designs by Christofle, 1933.

3. Three designs for sugar shakers: narrow-ribbed, broad-ribbed, and lined sides. Original designs by Christofle, 1933.

Silverware from the 1930s

The silverware from the 1930s was way ahead of its time, resolutely rejecting the overloaded style of the nineteenth century and offering instead a brand new, unsullied modernity. It is much sought after today by collectors of fine tableware, who match it with contemporary china and earthenware.

The Art of Simplification

The Paris Decorative Arts Exhibition of 1925 saw the emergence of art deco, in reaction to the undulating outlines, invasive decoration and naturalistic style of art nouveau. Its guiding principle was a return to geometric rigor and pure lines completely innocent of superfluous ornamentation.

Jean Puiforcat (1897–1945) was a key figure among the creative talents of the period. The heir to a dynasty of silversmiths and a great admirer of Maillol, Puiforcat was a sculptor and mathematician who worked in his father's workshop before studying with the sculptor Lejeune. He planned his designs on paper, creating a wide range of pieces and a score of different silver patterns using geometric shapes as his starting point: spheres, cones, cylinders, and cubes. He made things simpler, endowing the fork with its former three prongs instead of four, giving a perfect oval shape to spoons, producing knives whose blades and handles were exactly the same width, and reintro-

ducing ivory, lapis lazuli, rock crystals, shagreen, and stone for handles. Other great silversmiths followed in Puiforcat's footsteps, notably the Maison Tétard, with Valery Bizouard and Jean Tétard, Aucoc, Hénin, Boulenger, Saglier, Laparra, Boin-Taburet, Cardeilhac, and Ravinet d'Enfert. Christofle, meanwhile, turned to great modernist innovators like André Groult, Luc Lanel and Louis Sue, or the Dane Christian Fjerdingstad.

TIPS FOR COLLECTORS

One thing to keep in mind is that second-hand knives, forks, and spoons sell at roughly a third of the price of the same patterns that are brand new, and serving utensils are a quarter of the price.

While solid silver art deco table settings by a famous maker can be as expensive as eighteenth-century pieces, geometric pieces can still be purchased today at bargain prices.

3.

Individual Flatware

In the seventeenth century, guests brought their own knives and forks to a meal, for the most part snugly nestled in a finely decorated pouch. The reign of Louis XIV saw the first flatware as we know them today. The three components—knife, fork, and spoon—were all laid on one side of the plate; they were made of silver or vermeil, and gold was the king's prerogative.

The Spoon

The spoon is of great antiquity, its oval shape being borrowed from the form of a cupped hand. It began as a simple piece of carved wood. During the Middle Ages, its bowl became more rounded, the handle was as broad as the end, and it was held in a fist. During this time, it was made of wood or pewter.

The fashion for elaborate lace ruffs and collars, which were easily ruined by spillage, logically inspired a longer, flatter handle toward the end of the sixteenth century. In the seventeenth century, the spoon became a refined, valuable object with an intricately carved handle, and by the end of the century, smaller specialized spoons had begun to appear for the new beverages of tea and coffee and for side dishes such as strawberries or boiled eggs. These spoons came in bone, ivory, or horn.

The Fork

The fork came into use in Italy during the fifteenth century, reaching France with Catherine de Medicis and the court of her son, Henri III. At this time it had only two prongs and was still short and rustic in appearance, with a thick stem and sharp angles. It would be shared by several people at once, a practice that came to be deemed unhygienic and dismissed by the French aristocracy. After 1640, it acquired a third prong and a stem ending in a dovetail, the precursor of the flat fork; the end of its spatula became trilobed (split into three lobes). Meanwhile Louis XIV continued to eat with his fingers. Around 1680, the fork was given a fourth prong, and its spatula became distinct from its stem; but still it was used by only a few. Even Louis XVI spurned it, preferring to skewer his food with the point of his knife. Forks only became the norm at meals at the end of the eighteenth century.

The Knife

In the Middle Ages, knives with pointed blades were generally used to pierce food and carry it to the mouth. During the Renaissance, the knife went beyond this purely utilitarian function to become a symbol of prestige: it would be made of gold or silver, with handles of ivory, mother-of-pearl and precious or semi-precious stones—which were popularly believed to give protection against poison. At the time everyone carried his own, usually folding, knife in a fine pouch at his belt. The handle would be of ivory finely carved with scenes from hunting or mythology, or with images of fantastic creatures when they were not made of hand-decorated faience. The blades were exquisitely etched and made of gold, silver, or steel. The main centers for knife manufacture in the seventeenth century were Paris, Strasbourg, and eventually Langres.

Under Louis XIV, knives began to be made with silver handles; silver was a malleable metal that allowed the smiths to make invisible solderings and devise more delicate decorations. Sadly, many of these pieces were melted down by official order of the French government to finance its wars and were quickly replaced by knives with faience, china, or rock crystal handles. Later, Cardinal Richelieu passed an

2.

3.

1. Silver-plated flatware, 19th century and 1930s.

2 and 3. From the top: oyster fork, cheese knife, butter knife, cutting-edge melon fork, and melon knife. This Christofle flatware are in the *Directoire* style (2.) and Louis XIV style (3.).

1. Christofle fish knives and forks.

2. Louis XVI-style, silver-plated knives, 19th century.

3. Silver-plated flatware, stylized flower motif, 1925.

4. Louis XIV-style, silver-plated flatware, 19th century.

5. Silver-plated flatware, late 19th to early 20th century.

1.

edict that made round-ended knives compulsory; it was said that he found Chancellor Séguier's habit of picking his teeth with the point of his knife thoroughly disagreeable. In the eighteenth century, the trend was for knives to have silver blades and filled handles of ebony or mother-of-pearl. At this time the blade began to have a prolongation (the "fang"), which was fixed into the handle.

In the nineteenth century, individual table knives became part of the household's cutlery cabinet, where—side by side with the fork and spoon—they formed the nucleus of the standard flatware or individual place setting. After 1850, the forging, stamping, laminating, and polishing of knife blades became mechanical and the creating of their handles became automated.

Proliferating Patterns

The second half of the nineteenth century saw the invention of silver plate and the mass production of new individual flatware. At this time, some manufacturers opted to make sets of knives that were no longer part of the service and harked back to the Renaissance and the Middle Ages with handles of ebony, ivory, or horn.

Special knives and forks for fish appeared at the close of the century; an interesting variant on these was the single fish knife-cum-fork—a fork with a cutting edge on one of its outside prongs. Prior to the First World War, the blades of fish knives, which like the forks that went with them, were traditionally made of silver plate and engraved with motifs inspired by nature; afterward, in the 1930s, there was a return to sobriety and the absence of ornamentation.

Silversmiths were freely inspired by the shapes of crustaceans and mollusks. The oyster fork, for example, quickly became a classic. Snails had their grips and their two-pronged forks, winkles their mini-forks, and lobsters their tongs and

scoops; even the consumption of crayfish required a specific utensil. Prawns had to be stripped of their armor "with a knife and fork—a complicated undertaking indeed," as a guide to good living noted in the early twentieth century.

Curiosities

A number of unusual items appeared on tables in the late nineteenth and early twentieth centuries. These included the marrow spoon, a kind of siphon with a hollow stem that scooped marrow from beef bones; the melon fork with a cutting blade; and individual asparagus tongs, which did not last long because "they were used to carry the *entire asparagus* to the mouth, a thoroughly inconvenient exercise that was carried out clumsily at best, and which led many tables to dispense with the use of these little instrument."

For desserts and fruits, there was a whole series of individual flatware; miniature forks and spoons, two-pronged cake forks, three-pronged fruit forks, silver- or vermeil-bladed knives with mother-of-pearl, ivory, or ebony handles, melon knives, and little butter spreaders. These dessert and fruit flatware were more densely decorated than other pieces, and the blades, the backs of the forks, and the bowls of the spoons were often engraved with flowing, nature-inspired motifs.

There were all manner of specific spoons; teaspoons, coffee spoons (which the French referred to as *à la russe*), mocha spoons, soup spoons, boiled egg spoons (these were often gilded to prevent oxidation caused by the egg yolk), soda spoons, coffee glass spoons with long handles, water glass spoons with a small pestle, instead of a bowl, for crushing sugar; sauce spoons, cake spoons, syrup spoons, and cocktail swizzlers.

Cutlery Cabinets

The earliest sets of table cutlery appeared

2.

3.

4.

5.

1.

2.

ETYMOLOGY

The French word **couvert**
("cover") originally meant
everything that covered the
table, hence the expression
mettre le couvert, meaning
"to set the table." It also
means the place setting with
knife, spoon, and eventually
fork—three utensils that are
now so familiar to us that we
forget they only arrived on
our tables as a team as
recently as the 18th century.

1. Steel- or silver-bladed knives
with ebony handles.

2. Steel- or silver-bladed knives
with ivory handles.

3. Cutting-edge melon forks with
ivory handles, 19th century.

4. Silver-plated flatware,
various styles.

in the eighteenth century and were kept in Levantine leather boxes, small cases, or specially adapted pieces of furniture. They were small, with six or twelve of each item. Much more complete sets arrived in the nineteenth century and became common during the reigns of Louis-Philippe and Napoleon III, with 100 to 150 pieces. At this time, they also turned into one of the principal symbols of middle-class affluence and for a century thereafter they remained, along with household linen, an essential element of the marriage trousseau.

Palm Leaves and queues-de-rat Spoons

Up until 1730, the spoon design known as *queue-de-rat* ("rat's tail"), on account of a narrow reinforcing bulge running length-wise along the outside of its bowl, was the most widespread in France. Afterward, the flat, plain, and unadorned model predominated right up to the Revolution.

Likewise, the coquille pattern, in the form of a stylized scallop, first emerged around 1700 and was quickly followed by the violon-coquille style. The scallop was sometimes enhanced by a fillet at this

time, and the first signs of a disconnecting of stem from spatula appeared

Under the Regency and in the reign of Louis XV, curves were accentuated, and ornamentation grew heavier and more asymmetrical as the rocaille style gained momentum.

The period of Louis XVI saw a return of austerity and discretion in the matter of ornament, with the arrival of simple knots, ribbons, acanthus leaves, and palm leaves.

Nineteenth-Century Fashion

Under the Empire, sobriety was the watch-word and antiquity the inspiration. During Louis-Philippe's reign, there was a revisit-ing of earlier styles, with the return of the flat and fillet patterns and pearl and ribbon motifs. Under the influence of England, the style of Napoleon III produced an upsurge of extravagant romanticism, with heavy, over-elaborate knives, forks, and spoons in a jumble of rococo and neo-Pompeian influences. But by the end of the century, the vogue for Japan had replaced this style with a graceful, encroaching form of orna-mentation, often inspired by plants and always sinuous in its lines.

3.

4.

1.

2.

3.

1. English fruit knife and fork with Japanese decorations.

2. English fruit knife and fork, in Louis XVI style.

3. English fruit knife and fork, with "modern" handle and *Directoire* blade.

4. English silver-plated fruit knives and forks with ivory handles, 19th century.

TIPS FOR COLLECTORS

The old flat and "rat's tail" spoons are the most sought after. As a rule, complete sets of old knives, forks, and spoons are rare and expensive. The best solution therefore is to deliberately select a model and then assemble a set piece by piece.

Large spoons are more readily available than large forks.

Houses like Christofle had many different patterns to offer, which, depending on the richness of their decoration, were called **simples**, **quarts-riches** ("quarter-rich"), **demi-riches** ("half-rich"), **riches**, and **très riches**. The **simples** sets tend to be more appreciated today than the **riches** and **très riches**.

Take particular care to check the condition of each piece. Forks should have straight prongs, all in good condition, with no ends missing. The handles of old knives should be impeccably joined and fixed to their blades. In almost every case, it is a bad idea to restore a knife—a modicum of wear and tear is perfectly acceptable.

A good flatware is one you use. Silver and plate knives, forks, and spoons are never more beautiful than when they are fulfilling their proper function. To keep them in mint condition, store them in a case of their own: this will prevent them from rubbing against each other and protect the metal from being dulled by the light. Hunt for an old empty silver case—or failing that, have one custom-made.

Washing and storing silverware

Silver and silver plate can be put in the dishwasher if it is not mixed with items made of steel.

Knives with filled-in handles or glued collars must be washed by hand, without being left to soak; the same goes for horn, ivory, or tortoiseshell.

It is recommended that all forks, knives, and spoons be carefully dried after washing to remove any lingering stains, and then stored in a dark place. Ideally they should be placed in a silver cabinet or in pouches, but chamois leather, black tissue paper, or aluminum foil are perfectly acceptable. Avoid all contact with rubber.

Restoring knives

The best course in most cases is to find a specialist, but certain repairs can be carried out at home, if done with care.

To reglue a knife handle, scrape the inside of the handle with an old screwdriver to remove any residual wax or glue. Again using the screwdriver, refill two thirds of the cavity with epoxy glue. Then press the "fang" of the blade home, taking care that the bolster adheres well to the handle. Remove any extra glue with a piece of soft cloth, then bind the two components in place with scotch tape. Leave to dry for twenty-four hours.

To de-oxidize a steel blade, clean it with half an onion or potato, then rub with a cork or very fine sandpaper.

To straighten a knife blade, hold the blade in a vise between two pieces of hardwood and lever it straight.

To repair a nicked blade, set it in a vise and smooth out the nicks with a fine file or fine-grained whetstone. Sharpen the entire cutting edge, then polish with sandpaper.

To sharpen a steel knife blade, rub it on an oiled whetstone. Under any circumstances, do not use this method on silver-plated blades.

Straightening the prongs of a fork

If the prongs are bent against each other, straighten them with a flat wooden ruler.

If they are bent forward or backward, wrap them in a cloth and squeeze them little by little in a vise till they reach the right alignment.

Removing a bump from a spoon

If this is inside the bowl of the spoon, place it on a wooden surface and tap it gently with a round-headed hammer.

If the bump is on the outside of the spoon, make a mold with spackle or putty, then stick the mold to a wooden mount. Lay the spoon over it and tap it gently with a round-headed hammer.

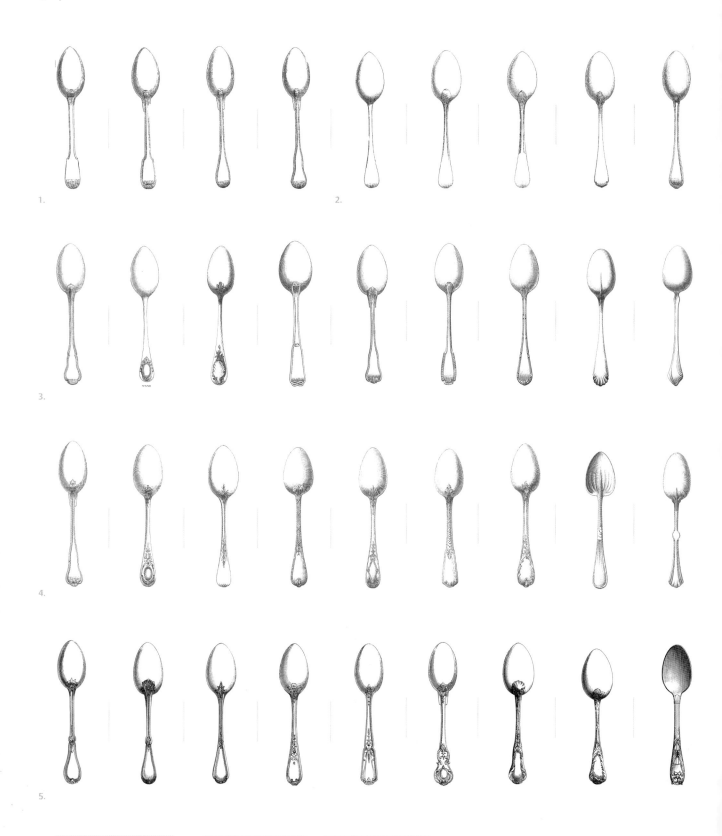

1.

2.

3.

4.

5.

1 to 5. Tea and coffee spoons by
Christofle: *Simple* series, 1891
(1.), *Quart riche* series (2.),

Demi-riche series, 1913 (3.),
Riche series, 1913 (4.), and
Très riche series, 1891 (5.).

6. Silver-plated flatware of
different styles, 19th and
20th century.

1.

Serving Utensils

Like individual flatware, serving utensils became infinitely various in the second half of the nineteenth century. There was no dish or dessert that didn't have its own special serving tools. Was this because silversmiths were engaging in marketing strategy, creating demand where there was none before? Or was it merely because of the sheer wealth and ostentation of the period? Whatever the answer, the adaptation of forms to specific functional uses, the manifold designs, and the diversity of patterns that were created during this time continue to delight us.

Hors d'oeuvre Sets

The hors d'oeuvre set was largely an invention of the turn of the nineteenth century. It comprised of a charming series of finely wrought pieces, among them the tuna scoop, which had holes to drain the oil from the fish; the butter scoop; the olive spoon, which was often elaborately decorated; and forks designed for sausages, gherkins, sardines, and pickles (reflecting the craze for all things English), which resembled miniature tridents. Another interesting item was the small paté scoop with its rectangular spatula.

Carving Meat and Presenting Fish

The service for game also had its moment of glory at the turn of the century. The head of the household was expected to officiate with carving knife and fork while his guests looked on; roast game would be brought whole to the table for him to cut up and serve. The fork was long handled, with three silver-plated prongs; the carving knife had a steel blade and sometimes it came with a matching sharpener. When a leg of lamb was served, the fork was replaced by a handle with a clamp or screw grip, which allowed the carver to hold the joint steady with one hand. The accompanying small vegetables were threaded onto skewers and laid beside the meat; sauces and gravy were served with gravy dippers or stew spoons, which were straight, bent, round, or oval and sometimes had two pouring beaks—one for fat, the other for stock. A two-pronged fork was used for serving cold cuts.

Fish was generally served with a flat trowel with a delicately incised blade.

Serving Asparagus

In Louis XIV's reign, asparagus shoots were already being cultivated in hothouses so they could be enjoyed all year round. The nineteenth century worked out imaginative new ways of presenting this delicious vegetable. They could be moved from cradle to plate with a simple broad scoop, with flat tongs with a handle, or with a utensil similar to salad scissors with a flat crosswise grip, or with a "hand," which was essentially a pair of tongs without a handle, squeezed with the fingers.

1. Sugar spoons: English, French, and perforated French, 19th century.

2 to 7. Strawberry spoons: perforated (2.), lined (3.), Louis XVI coat of arms (4.), Louis XVI crossed ribbons (5.), strawberry scoop with strawberry plant handle (6.), and sugar spoon with strawberry plant handle (7.).

1.

8.

2.

3.

4.

5.

6.

7.

1 to 8. Nutcrackers from the 1913 Christofle catalogue.

(1.) Sprung. (2.) Gadroon. (3.) Twisted. (4.) Lotus. (5.) Twisted with bobbles. (6.) Bamboo. (7.) Facetted (8.) With knife handle.

9. Serving utensils, 19th century.

10. Bone-handled salad spoon and fork; silver-plated serving knife and fork for fish, with sleeve handles, 19th century.

Following pages:

1. Assorted silver-plated serving utensils, Louis XVI style, circa 1880 and 1930.

2. English cake scoop.

3. French strawberry scoop, 19th century.

4. French, sterling silver, perforated cake scoop, 19th century.

5. English hors d'oeuvre or pickle fork, 19th century.

Salad Forks and Spoons

The long-handled salad fork and spoon were usually made of ivory or horn, since metal oxidizes on contact with vinegar; though their handles might be of silver or plate. The patent detachable salad utensil, which allowed the host to mix the salad with two hands, and then serve it using just one hand, had only the briefest of careers.

For Eggs

The boiled egg topper came in two forms: one like scissors and the other like a spatula with a hole in it. It was accompanied, as a rule, by a pierced egg spoon. Fried or poached eggs were served with a scoop similar to an ice scoop, but round: the ice scoop was invariably oval.

For Condiments

The tiny salt spoon and the no less tiny mustard spoon have existed since the eighteenth century. Sometimes they came with a matching cylindrical nutmeg grater; they were often as carefully decorated as their much larger brethren.

Cheese and Dessert Servers

Cheese was always served with the special steel-bladed knife that we know today. The bread that came with the cheese was picked out of the bread basket with a special fork or scoop, since it was deemed ill-mannered to reach over and take a piece of bread with your fingers.

Ice creams were served with a special knife or scoop; tarts were served with a scoop; and cakes with a cake knife.

Fruit and syrup spoons, long and sinuous, are especially elegant, as are strawberry spoons whose bowls, which are often in chased silver, are designed to resemble fruits. Grapes were cut with special silver grape scissors decorated with vine leaves and grape clusters. Finally, the punch ladle had a crosswise bowl that narrowed on each side to a beak for pouring; its handle was made of wood for three quarters of its length.

Confections

Powdered sugar was sprinkled with delicate fretted scoops or with round or oval perforated spoons whose inner surfaces were gilded. Sugarloaf, crushed beforehand with a hatchet, could only be served in the English style, with sugar tongs.

Other charming items in the repertoire of confection servers are the bonbon spoon, the sugar spoon, the *petit-four* scoop, the nut spoon, and the candied fruit fork.

TIPS FOR COLLECTORS

Silver serving utensils are a pure delight. There is so much pleasure in discovering objects such as these whose uses are mostly unknown to us today.

Some of the bargains you can still find today are small sets of silver hors d'oeuvre or dessert services with mother-of-pearl handles.

Carving knives and salad forks and spoons with ebony or horn handles are also highly affordable.

9.

10.

2.

3.

4.

5.

1.

2.

3.

1. Carving knife and fork,
leg-of-lamb set, sharpener,
tilting gripper, screw gripper, and
cutlet gripper.

2. Contoured fish serving knife
and fork, oval fish scoop, fish
scoop, lobster fork, snail fork,
and oyster fork.

3. Flanged salad spoon and fork,
Japanese salad spoon and fork,
English salad spoon and fork,
ladle, asparagus scoop, and
asparagus tongs.

4. Fruit spoon, ribbed fruit spoon, syrup spoon, double-beaked punch ladle, single-beaked punch ladle, and Maytrank serving spoon with perforated cover.

5. Louis XVI sugar spoon, Brazilian sugar spoon, sugar cutter-tongs, shell-shaped sugar scoop, and standard sugar scoop.

6. Ice knife, ice scoop, ice hook, tart scoop, nutcracker, and Louis XV grape scissors.

All these models are Christofle originals, except the second in (1.).

Deluxe Silverware

The silver of grand hotels, ocean liners, and railroads, with its charming but functional knives and forks, robust tableware and romantic monograms, strongly evokes the early years of a leisured society engrossed in its cruises, cures, and summer resorts.

On the Trains

In the years after 1880, the railroad network in France developed very rapidly as people flocked to the seasides of Brittany, northern France, and the Riviera. Empress Eugènie had launched Biarritz as a resort, and the English came in droves to winter in Nice. The Orient Express carried its wealthy passengers across Europe to Istanbul. Train travel caught the imagination and inspired filmmakers and writers. The *Compagnie Internationale des Wagons-Lits*, founded in 1884, carried its rich clients in luxury trains where they were expected to dress impeccably for dinner in restaurant cars worthy of luxury hotels. The railroad companies of Europe also owned the station buffets, and their flatware was specially commissioned from the great silversmiths, Christofle in particular, with every piece monogrammed. (CWL, or WL, were the monograms of the *Compagnie des Wagons-Lits*). The letters would be engraved on one side or the other of the knives, forks, and spoons, depending on whether they were made for English or French trains.

In Hotels and Restaurants

All along the coast from Le Touquet to Menton, in every ski resort and spa towns of France, luxurious palace hotels sprang up, many with casinos attached. Paris and her hotels—the Hotel du Louvre (1855), the Grand Hotel (1862), the Ritz (1898), the Crillon (1907), the Lutetia (1910), and the Claridge (1914)—attracted more and more tourists, notably when Universal Exhibitions were under way. Tens of thousands of monogrammed knives, forks, and spoons were turned out by the great silversmiths of France to equip these hotels.

On the Ocean Liners

The great shipping lines also turned to France's silversmiths, glassmakers, and porcelain manufacturers to design and produce tableware, crystal stemware, and silverware especially for them. This was the case of the liners *Ile-de-France* and *Atlantique* launched respectively in 1927 and 1930, and also of the *Normandie*, whose first crossing was made from Le Havre to New York in 1935. Puiforcat supplied the silverware for her luxury cabin suites, with an original pattern named for the ship, while Christofle furnished no fewer than forty-five thousand different pieces for the first and third class for Luc Lanel's *Transat* line. The tourist class tableware was assigned to Ercuis.

2.

1. Silver-plated restaurant duck press, with elephant heads.

2. Soup spoons, engraved "Atlantic Transport Line." England.

3. Silver-plated English dishes, utensils, and cutlery, from different hotels and restaurants.

1.

2.

TIP FOR COLLECTORS

Over the years many of the older grand hotels sold their silverware at auctions, where a collector could find plenty of bargains. This is no longer the case.

Hotel silverware was designed to withstand constant use and rough handling; it had to be very robust, and for this reason the layer of silver with which it was plated was often thicker than the legal norm.

If you are in the market for hotel flatware, you should expect them to be somewhat dented or worn.

While an anonymous monogram tends to lower the value of a piece, the initials of cruise lines such as the CGT (**Compagnie Générale Transatlantique**) will add value. The English in particular commissioned vast quantities of flatware for their yacht clubs, gentlemen's clubs, and assorted sporting associations, all of which had to have custom-made flatware.

How to clean tarnished silverware

There are all kinds of fairly straightforward techniques for cleaning silverware, which involves the use of potato peel, soot, and even powdered cuttlefish bone. Here are a few more that are equally simple and effective;

• Alcohol with a pinch of whiting works well as a cleaning agent, as does the pot liquor from boiled spinach or potatoes.

• For smaller objects, line a bowl with aluminum foil and pour in a mixture of hot water and plenty of coarse salt. Soak the objects in this solution for thirty seconds; remove and rub them vigorously.

• If the tarnishing is severe, try cleaning the piece with a solution of one part vinegar and one part ammonia. Make sure to do this in open air or in a well-ventilated room. Rinse and polish.

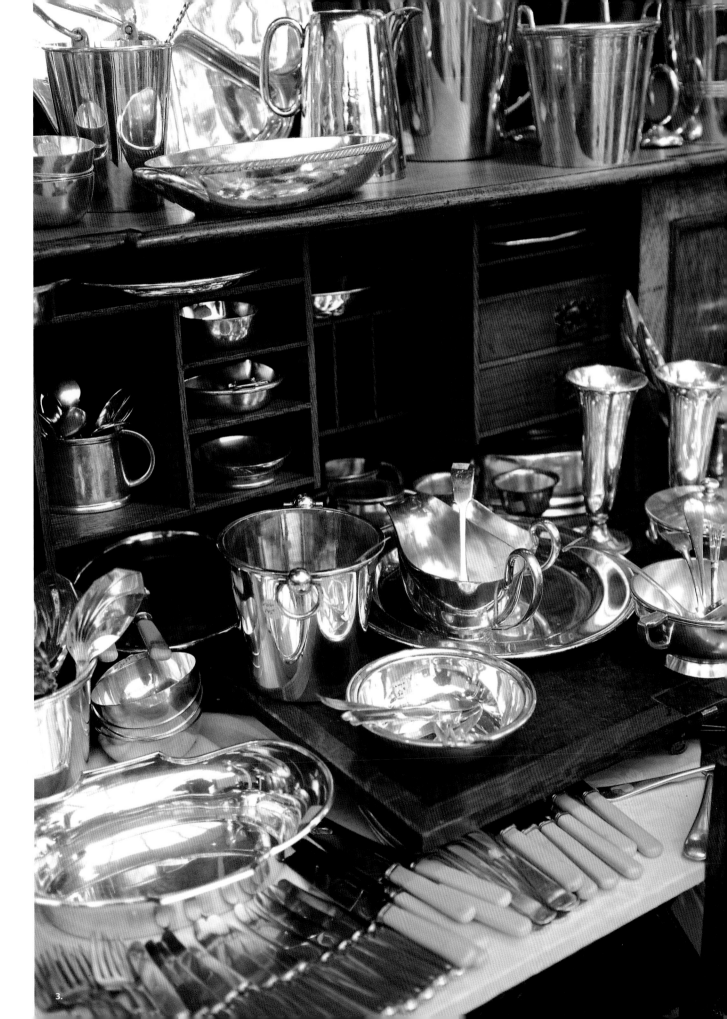

GLASSWARE AND STEMWARE

Our grandmother's cupboards were filled with crystal glasses that were only brought out on red-letter days. It went without saying that every family had its complete service of water tumblers, glasses for red and white wine, flute glasses and coupe glasses for champagne, and liqueur glasses of various types. Some families had several sets, usually made by Baccarat or Saint-Louis, the grandest and most expensive suppliers.

Times have changed. While everyone agrees that nothing compares to a clear crystal glass with a slender stem for drinking a fine red wine, a goblet or a mug will do adequately for drinking water, and champagne flutes can vary greatly, as can white wine glasses. Nor is it the custom nowadays to have matching glasses and decanters. People buy much smaller sets of glasses so they can vary their shape or color. It has also become possible to buy crystal glasses one by one, and this has motivated collectors to assemble sets of good glasses without any particular urgency and thus without bankrupting themselves. The art of laying an elegant table is much more flexible and relaxed than it used to be, with the result that charming items such as **bistrot** glasses, absinthe glasses, beer mugs, and other assortments, which can be found in any secondhand store, have begun to appear on people's tables.

Glass or Crystal?

Italy, Bohemia, and England successively dominated the European glass trade before France finally had its turn in the nineteenth century. At this time, French craftsmen began producing the crystal glasses of unsurpassed beauty, which came to adorn not only the tables of France, but also of czars and maharajahs.

Unknown Beginnings

No one knows for sure when glass was discovered, but four thousand years ago, it was already being made in Egypt, Italy, and Syria. And it was the glassmakers of Syria, in the first century BC, who invented the extraordinary technique of glassblowing, which spread rapidly throughout the Roman Empire and beyond and is still practiced today.

The Expanding Influence of Venice

At the beginning of the eleventh century, glass kilns were established in the Veneto region of Italy and around Genoa, producing glass of remarkable quality. In the fifteenth century, Venetians invented a white glass called *cristallo*, and Venice became famous for its enamel decorations; its glass imitated malachite and onyx, and filigree glass incorporated thin glass tubes. These products were exported all over Europe and created a Venetian style that remained unchallenged until the eighteenth century.

Bohemian Glass

The glass industry that had existed in Bohemia since the eleventh century began to grow seriously in the fourteenth century. The region produced a potassium-based, transparent form of glass, which was hard, shiny, and highly refractory with qualities that favored the kind of high-relief engraving that had formerly been restricted to rock crystal. In the sixteenth century, Caspar Lehmann invented a technique for cutting and engraving glass with a disc. After 1730, Bohemian glass gained prominence over the Venetian, and by mid-

century, Bohemian glassmakers had begun cutting glass that had two or more layers of color. This type of glass flooded Europe until the Seven Year's War, the continental blockade, and the Napoleonic Wars made international commerce almost impossible.

The English Invention of Crystal

In 1615, James I of England, facing a shortage of wood in his kingdom, made it illegal for glassmakers to use it for firing their kilns. In 1676, George Ravenscroft (1618–1681), a London glassmaker who had worked in Venice, began substituting coal for wood and, in the process, also replaced potassium with lead as an ingredient. He called the result "flint glass;" crystal had been born. Thereafter the invention of heavier cutting discs made it possible to obtain decorations of extraordinary precision. Taking over from Venice and Bohemia, this crystal remained a near total English monopoly for close to a hundred years, until 1782.

French Glass

During the Middle Ages in France, most of the glassmakers were itinerant and used up immense quantities of wood. In 1615, there were no fewer than three thousand glassmakers in the kingdom. It was not until the mid-sixteenth century that glass began to be produced in fixed locations. Brushwood was the main fuel, and fern ash, mixed with potassium, formed a solid that could be shaped with tongs. From the sixteenth to the eighteenth century, this common, light, and brilliant glass, known as *verre de fougère* ("fern glass"), whose hue varied

2.

Preceding page:

Left: Aperitif glasses, early 20th century.
Right: Three examples of cut-crystal water glasses.

1. Delicately colored crystal glasses, circa 1880

2. Three double crystal Bohemian glasses, 19th century.

from region to region, was firmly in fashion. But toward the mid-eighteenth century, the authorities became alarmed by the increasing deforestation of the country, and the use of fern as fuel was prohibited.

In the seventeenth century, in parallel with the French production of *verre de fougère*, Italian glassmakers from the town of Altara, near Genoa, emigrated to France's Nevers region. These skillful artisans began fashioning glasses in the Venetian style, stretching the material into fillets as delicate as lace. Among these extraordinarily innovative craftsmen was Bernardo Perrotto, known in France as Bernard Perrot, who started a factory in Orleans in 1662 and invented, among many things, a translucent red glass that imitated agate and porcelain.

By the beginning of the eighteenth century, Lorraine and Normandy, as well as Nevers, Nantes, Paris, and Orleans, had become famous centers of glassmaking.

Perfecting the French Crystal

Throughout the nineteenth century, French crystal was distinguished for its purity—and for its makers' continual quest for technical advances and new levels of perfection.

Among the foremost producers was the Munzthal glassworks, created in Lorraine in 1586, which became the *Verreries Royales de Saint-Louis* in 1787. In 1781, this factory, which also specialized in windowpanes and goblets, was the first in France to produce genuine crystal and in 1825 it ceased manufacture of any other products. Saint-Louis achieved complete mastery of color, created opalines of wondrous beauty, and, among other things, invented the first *millefiori*—floral pattern meaning "thousand flowers"—ball.

Baccarat had a roughly similar experience. Founded in 1764 by the Bishop of Metz, Baccarat began by producing window glass at a hamlet of the Vosges forest some 31 miles from Nancy, then moved on to Bohemian-style glass before focusing entirely on the manufacture of crystal. With its carefully weighted composition of materials and artisans who were incom-

parably skilled at glass cutting and engraving, Baccarat became synonymous with perfection.

In the Paris region, Madame de Pompadour acquired in 1750 the privilege of the *Verrerie de Chaillot*, which she later transferred to Sèvres, where she installed the glassworks in the precincts of her chateau. Also at Sèvres was the *Manufacture des Cristaux et Èmaux de la Reine*, founded in 1784; this was subsequently moved to Moncenis, near Le Creusot, and finally closed down in 1832. Other high quality glassworks in the Paris region were Choisy-le-Roi (1821–1851), Bercy (1827–1835), and Boulogne, which became Clichy in 1844. Clichy, the third largest French producer of crystal, was absorbed by Sèvres in 1885.

At the close of the nineteenth century, art nouveau, under the influence of Emile Gallé and the Ecole de Nancy, introduced new forms that were more attuned to decorative pieces than glassware. This was the case of Daum, founded in 1870. It was not until the 1920s and René Lalique that glassware regained the same level of importance it had enjoyed in the nineteenth century.

TIPS FOR COLLECTORS

Distinguishing glass from crystal
Crystal should sound "crystalline" like a bell. It is usually more transparent than glass, heavier, and more reflective of light.

Old glasses
To identify an old glass, pass your finger under its foot. If you feel the unevenness caused by the glassmaker's pontil rod, it is old; this unevenness was smoothed off beginning in the nineteenth century.
An old glass is irregular, with imperfections, bubbles, and impurities.
The lighter the glass is, the older it is.
The foot of an old glass is often almost as wide as its lip.
Bohemian glass, cut and colored, is coming back into fashion today. The older it is, the deeper and more iridescent its colors.

1. Series of European crystal glasses, 18th and 19th century.

2. Exquisitely colored Rhine wine glasses, 18th century.

3. Lorraine crystal glasses engraved with Joan of Arc motif.

4. Champagne coupes, carafe, and Portuguese tall glasses made of colored crystal.

ETYMOLOGY

Superior crystal is a grade of glass containing at least 30% lead oxide; **crystal** contains at least 24% lead oxide; **crystalline** or **half-crystal** contains between 10% and 24%; **sonore** ("resonant") glass contains about 10%.

1.

2.

3.

4.

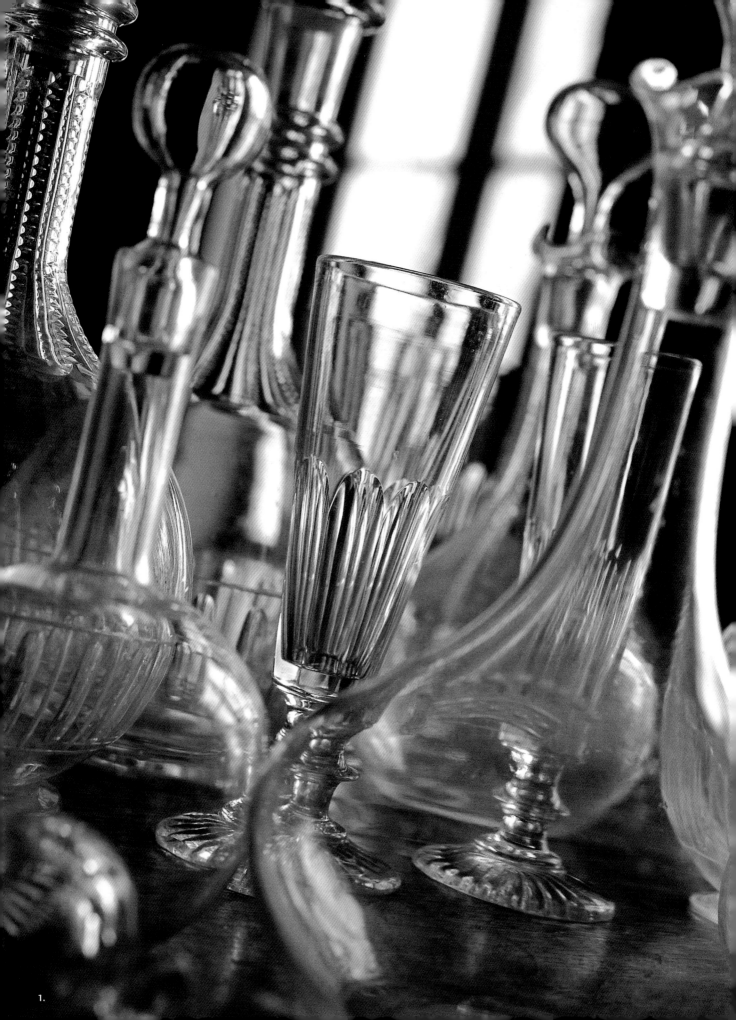

Bottles, Carafes, and Pitchers

Should wine be served in a decanter? In France people tend to pour really good wine from where it lives, in the bottle. But for domestic wines and cool light wines, a carafe with its fine, full shape is ideal (hence the expression *vin de carafe*). The decanter is also useful for water, but an interesting pitcher will do quite as well.

2.

Old Bottles

The French word *carafe* derives from the Arabic *gharaf*, meaning a bottle. Up until the close of the seventeenth century, bottles used for serving wine (the practice of bottling and corking them came later) were made on the spot, in the wine-producing zones. Such bottles were made of metal, faience, or blown glass, which was transparent, light green, dark green, or amber according to the region. They also had differing shapes: cylindrical, spherical with a long, ringed collar or handle, smooth sided or ribbed, with bottoms bulging inward to settle the lees. In the eighteenth century, certain bottles represented the measuring units for particular types of wine, and acquired the names of their regions: thus the *frontignan*, the *bordelaise*, or the flat Armagnac bottle inherited from the Spanish wine flask, which was generally popular until that period. Some bottles were made of black glass, invented a century earlier in England and based on coal.

Chilled wine was served at meals in the seventeenth and eighteenth centuries in preference to water, which was generally of poor quality and only used to dilute the wine. Like glasses in their racks, bottles were kept throughout the meal in coolers placed on a side table or on the floor. For many centuries, bottles were made exclusively of blown glass, which accounts for the diversity of their shapes, irregularities, and defects. In the eighteenth century, they were blown in molds, in two parts decorated with melon sides, ribs, and spirals. The decanter proper was invented in England in 1780.

3.

The Carafe Comes to the Table

In the nineteenth century, the carafe was admitted to the table, along with the sets of individual glasses with which it was invariably matched. As a rule, each service included two models of carafe: the larger of the two was for water, the smaller for wine. In a nod to the past, some were shaped like ewers, amphoras, or helmets; others were bellied out at the bottom, or straight-sided, with or without handles and stoppers. Red wine carafes were cut, engraved, or chased in gold; Rhine wine carafes were made of simple cut crystal. Opaque or transparent, colorless or tinted, carafes were the fruit of glassmakers' boundless imaginations.

For those who insist on serving wine straight from the bottle, metal bottle carriers or panniers in plated silver and wickerwork have existed since the nineteenth century. For the rest, the decanter—with or without a handle—and the funnel are indispensable.

4.

1.

2.

3.

4.

1. Ice bowl.

2. Champagne bucket.

3. Soda-water holder with thumb grip.

4. Rhine wine bucket.

5. 19th-century, twisted glass carafe and a set of glass stoppers.

6. Beautifully wrought, cut-glass vinegar and oil cruets with silver lids, 18th century.

7. Blown glass and cider carafe, 19th century.

8. Carafe and cider or lemonade glasses, 19th century, and ribbed carafe, 18th century.

Pitchers

Pitchers are small, beaked jugs that served, first and foremost, as measures of capacity. Their thick sides helped to keep water cool. They were made of glazed terra-cotta in the countryside and of faience in the towns. Every region in France had its own type of pitcher: azure terra-cotta around Beauvais, blue terra-cotta in Burgundy, glazed terra-cotta for the high-necked, spherical, or oval jugs of Puisaye.

At the end of the nineteenth century, faience manufacturers such as Hamage, Sarreguemines, Clairefontaine, Dèvres, Salins, Saint-Amand, and Saint-Clément, which had enthusiastically embraced the new vogue for barbotine, began producing jugs depicting droll human or animal forms and themes. In northern France, Orchies came up with an original line of unexpected creatures like moray eels, swans, and donkeys. But perhaps the most interesting and the most carefully crafted pitchers of all came from the pottery of Onnaing, near Valenciennes. Onnaing's production was highly varied, with animals treated wittily, along with famous people of the period and professions—sailors, railroad workers, miners, and monks. These pitchers tended to be lined in red.

A distinct curiosity was the *pichet trompeur* or trick jug. This piece had a hollow handle, attached to a hollow rim extending all round the perforated neck of the jug, which made it possible to suck the liquid directly into the mouth—provided that a little hole under the handle was blocked with the thumb. Malicorne produced large numbers of these.

Champagne Buckets

Coolers made of precious metals, faience, and porcelain underwent a transformation in the nineteenth century to emerge as buckets for chilling champagne on ice. Most were made of cut crystal with a rim encircled by metal, which became silver plate after 1850. They were shaped like small conical or cylindrical casks, with or without a low stand; they had lugs, ring-handles, or knobs on the side for carrying. A similar type of bucket, though narrower and taller, was used for chilling Rhine wine. Other table utensils relating to champagne were the cork gripper and the cork with movable or static rings.

TIPS FOR COLLECTORS

Old bottles are all the more valuable because they are handmade. Their irregularities of shape and color make them highly sought after by collectors.

Marks of wear and tear are perfectly acceptable on a very old piece.

Eighteenth-century carafes are lighter than ones from the nineteenth century. Sometimes you can make out the trace of the glassblowers' pontil rod on the bottom of a carafe—a proof that it is genuinely old.

Nineteenth-century carafes are not particularly prized and so are plentiful and affordable. Check that the stopper is the original one made for the piece: there should be no play between the stopper and the neck of the carafe, and the decoration on the body of the carafe should be reproduced on the stopper.

Among the most common themes for pitchers are roosters, dogs, and owls.

Taking care of carafes and pitchers

To clean the inside, mix white vinegar and coarse salt, shake thoroughly, allow to soak for a while, and rinse.

For the exterior, use burning alcohol, window cleaner, or acetone. Never stopper a wet carafe.

If the stopper gets stuck in the neck, apply a few drops of oil.

5.

6.

7.

8.

ETYMOLOGY

In eighteenth-century France, the word **gobelet** could mean a mug as well as a glass, or a goblet. You could drink from a **gobelet** à **lait**, (milk mug), a **gobelet** à café (coffee mug), or a **gobelet** à **chocolat** (chocolate mug).

2.

Cups and Water Goblets

In the old days, the water goblet was soberly married to the wine glass and was slightly bigger. Today it is freed of that bondage. Double-crystal goblets, tinted or delicately enameled glasses, and silver or porcelain mugs are all fine for an original table setting.

3.

The Cup

From the remotest antiquity, the cup has been a cylindrical drinking cup, taller than it is wide, without a handle and often without a foot, with or without a cover, and mainly used for drinking water. It began small, with thick and smooth, or ribbed sides; later, in the Middle Ages, it became a luxury item of gold or silver, sometimes studded with precious stones. As such it featured strongly on the tables of the great, where it would be shared by several guests at a time. During the Renaissance, it lengthened and became a kind of tankard, a valuable, richly worked receptacle made variously of wood, pewter, porcelain, precious metal, rock crystal, or glass and was often personalized with an inscribed date or event. In the seventeenth century it sobered up, but in the eighteenth century, it was a standard feature of every aristocratic table: with or without a foot and stem, in porcelain, faience, or glass—preferably Bohemian cut glass. At the beginning of the nineteenth century, the cup was encrusted with stones and later with medallions, figurines, or cut panels obtained by the pressed glass technique. After 1830, the crystal water goblet, usually with a stem and matching the other components of a set, took the place of the cup.

Timbale or the Metal Cup

The French word *timbale* appeared at the end of the eighteenth century to distinguish a drinking cup made of metal from one made of glass, faience, or porcelain. But the object itself had already been in existence for many centuries. During the Renaissance it took the form of a truncated cone and was rather rustic looking. In the early seventeenth century it acquired a foot and stem, which made it look more elegant, though its body remained dead straight. By the eighteenth century, the sides of the cup were bell- or tulip-shaped, with lambrequin decorations characteristic of the period. Under Louis XV rocaille took over, with *piédouche* (the "foot") ever more finely worked. Under Louis XVI the cup became taller and straighter in outline, with designs drawn from nature. By the end of the eighteenth century and during the Empire period, the *timbale* had once again become cylindrical, with no stem or foot, but with a flat, smooth bottom. When it was small, ultra-simple, and with rounded angles, it was called *cul rond* ("round-bottomed").

In the nineteenth century, three types of *timbale* drinking cups were in use: *à piédouche* ("with a foot and stem"), *goblet droit* ("straight-sided"), and *cul rond*. With the invention of silver plate, they became

4.

1. Water glasses, 20th century.

2. Japanese-style glass, circa 1880.

3. Bohemian cut-glass with flat sides, 1860.

4. Bohemian double crystal cure glass, 1860.

1.

2.

1. *Timbales*, or metal drinking cups: conical, with bee frieze; plain doucine; doucine with twisted grooves and boss beading; conical with straight grooves; conical with ribbon fillets; with bent ribs; telescopic traveling cup; cactus; and flat-sided traveling cup.

2. Assorted water glasses.

3. Short glasses used as candle jars.

4. Late-19th-century, silver-plated cup; two 19th-century, sterling silver cups; and a 20th-century, sterling silver cup.

standard family heirlooms when people started giving them to children as christening gifts, presented in a case and engraved with the name of the recipient. They also came accompanied by a napkin ring, an eggcup with matching spoon, a dish, a teacup, dessert knife, fork, and spoon, and a coffee spoon. Their eclectic designs were inspired by the different styles of the past and could be very elaborate. In the 1920s, the *timbale* bowed to the more sober and elegant criteria of the time and reverted to its former identity as a discreet drinking cup.

TIPS FOR COLLECTORS

The choice of cups and water goblets is quite frankly infinite, as are their materials, shapes, colors, and origins.

Rather than buying a brand new **timbale**, it may be more interesting to seek out an attractive antique one. A dent or two can add a certain charm. The most sought-after **timbales** are old ones, with sophisticated designs, perhaps dating from the Empire and the Restoration. Appliqué decorations are particularly prized, and **timbales** from Strasbourg—which was famous for its silversmiths—are also at a premium today, as are antique pieces by the Parisian silversmiths Berti, Burron, Chéret, Delannoy, Tassin, and Thonelier. Joubert of Angers, Bataille and Béchard of Orleans, and Busnel, Le Mire, and Roussel of Rouen are other well-known names.

3.

Elisa

Juliette

Benoît

4.

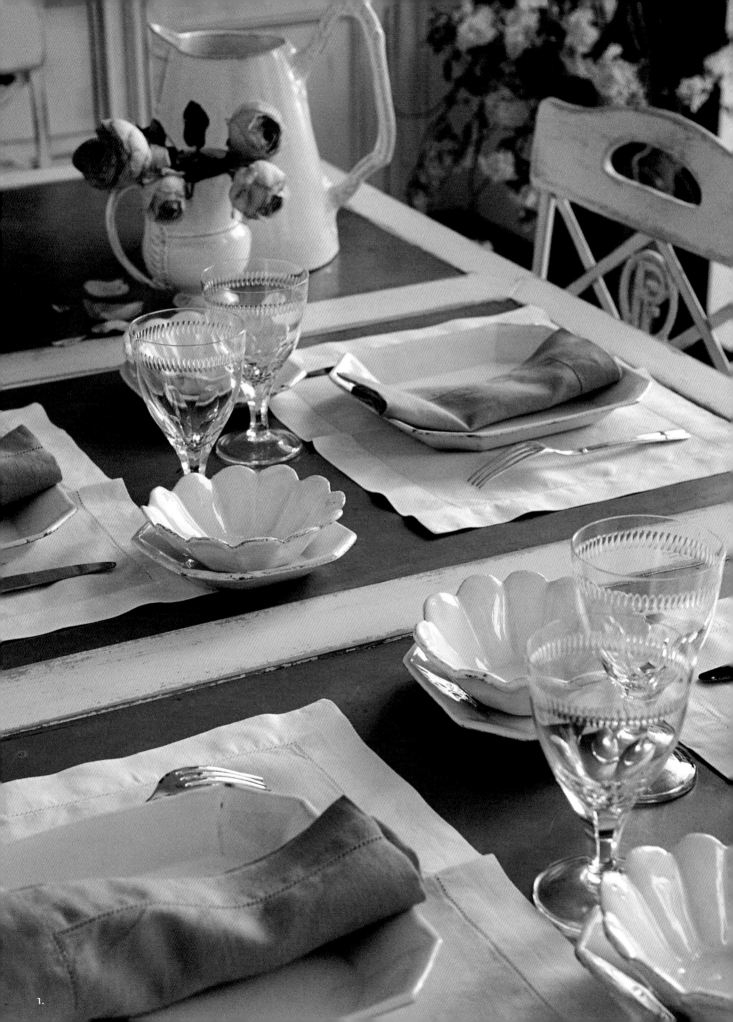

1. Cut-crystal water glasses, 19th century. Contemporary plates.

2. Champagne flute, Napoléon III.

3. Beer glass, late 19th century.

4. Cut-crystal glass, 19th century.

5. Blown glass flute, 18th century.

2.

3.

4.

5.

Nineteenth-Century Crystal Stemware

Crystal stemware from the nineteenth century came in many forms, from cut crystal glasses reflecting the light from a thousand facets, to infinitely delicate engraved crystal, gilded crystal, and lined crystal of unearthly visual depth. We have yet to find a more exquisite means of making our table beautiful than to load it with these small, slender-stemmed masterpieces.

Orgues du Plaisir

Until the eighteenth century, glasses were not set on the dining table but kept in racks on the side. The diners called servants to bring them a glass of wine, immediately handing it back when it was drained. The one drinking cup was used by several different people, and in the more distant past it was no more than a simple cup made of metal or ceramic. In the reign of Louis XIV, glasses appeared whose sizes were specially adapted to the drink they were supposed to contain. They were known as *orgues du plaisir* ("organs of pleasure") and were extravagantly luxurious pieces, taking a proud place on a side table or dining table, but not always assigned to individual guests: they were shared by all. It was only from about 1880 onward that diners were each provided with three to six glasses of the same pattern and decoration, positioned in a diamond, rectangular, or square formation in front of their plate and attended by matching carafes.

The new trend inspired crystal makers to new heights of creativity, which had its effect not only on the shapes but also on the decoration of the glass, not to mention the use of white glass, tinted glass, and lined crystal. Before long you could obtain sets of water tumblers, beer glasses, glasses for different red wines, Madeira glasses, liqueur glasses, champagne glasses (in the shape of a coupe or a flute, these were used as early as the sixteenth century in Lorraine), and even "impossible" glasses (also known as *culs secs* or "dry bottoms"), which had nothing to stand on and so had to be drained in one gulp. All these glassware were blown individually and hand-decorated by glassmakers.

Blown Crystal

Glass and crystal both come from the fusion of a vitrifying element (silica or sand), a melting element (sodium carbonate, potassium, red oxide of lead) and a stabilizing element.

To shape a glass, the glassblower begins with a parison, or small bubble of molten glass. The exact quantity of melting crystal needed to make a particular stage of the glass is scooped on to the end of the slender blowpipe. The air is blown into the blowpipe, and the glass takes its form. Once the parison is created, the master glassblower places the stem on the wine glass, using a small quantity of crystal brought to him by another craftsman; after which he stretches it and gives it its final shape. Next, following the same sequence

of actions, another glassblower brings the molten crystal needed to attach the foot of the glass. Once shaping of the glass is finished, it is detached from the pipe and refired, after which it is carefully examined—and thrown away if it presents the smallest imperfection. After this "hot" stage of manufacture comes the "cold" stage—the decoration stage.

Cut Glass

Cutting is one of the oldest techniques for decorating glass, and it allows the material to absorb the light and better refract it. Because of this process, it gives the impression of sparkling from hundreds of different angles.

The cutter uses a diamond grinder, a pumice, sandstone, or Carborundum stone to score the surface of the glass. Designs are reproduced fixed on a board, tracing all manner of motifs: flat, fluted, or diamond points (the Trianon pattern made by the Saint-Louis glassworks blends flat sides with diamond points), medallions, pearls, olives, fillets, bands, lozenges, festoons, and draperies. Once the cutting is completed, the glass is moved on to the polishing stage, which is carried out mechanically by a cork disk, or by immersion in a batch of acid, whereby its rough edges are removed and its surfaces smoothed.

Engraved Glass

Cold engraving, also known as sand engraving, is done with a thin jet of sand directed against the surface of the glass. With the use of a stencil, only the exposed areas are touched. Chemical engraving, which was perfected in 1860, is done with acid. Wheel engraving is done with a copper wheel cooled with water or with a grinder. Specialists engrave all kinds of motifs on glass, such as flowers, friezes, nature and mythological scenes, geometric designs, checkers, monograms, and coats of arms.

Tinted Glass

Coloration can be obtained in two ways. The first is by tinting in mass, by adding metal oxides at the time of firing. This coloration begins from the presence of metallic ions in the crystal during melting (cobalt oxide gives blue, chrome oxide gives green, tin oxide gives white, nickel oxide and potassium give purple, copper oxide gives turquoise, and copper oxide plus gold chloride gives ruby).

Coloration can also be obtained by adding mineral components that do not dissolve in the mix during the melting process, but which, as the mix cools, form fine particles within it. These minerals cause the light to diffract and produce rich tinting effects: ruby for gold, red for copper, yellow for silver, and pink for selenium. Glasses tinted this way became very fashionable after 1830. Between 1837 and 1845, Saint-Louis revived the filigree technique and produced articles in previously untried materials such as alabaster or aventurine. The Saint-Louis glassworks also perfected opaline crystal, which all the great glassmakers were to reproduce in the later nineteenth century.

Double-Crystal Glass

Double-, triple-, and even multi-layered crystal, which are specialties of the glassmakers of Bohemia, are made by superimposing hot layers of crystal onto others, according to a predetermined design. In double-crystal glass, one layer is colored, the other is not. The technique is the same as the one used to make the Rhine wine glasses, which the Germans call *roemer*. This type of glass, which has existed since the fourteenth century, started out as a bulky goblet decorated with cabochons. In the nineteenth century, it acquired an ample hollow stem, and at the beginning of the twentieth century, it became significantly taller. Blue, red, and pistachio green are the most common colors for double crystal, which is often cut, filigreed, or wheel engraved—though it also exists in rarer tones like amber or copper-gold. The wine glasses of Alsace, which are long-stemmed with small bowls, are nearly always made of double crystal.

Enameled Glass

A strong presence in Islamic art from the twelfth to the fourteenth century, in the Ottoman Empire and Damascus and then

1. 2. 3. 4. 5.

1. Double crystal enameled glass. Bohemia.

2. Bohemian gold and enameled molded glass, 19th century.

3. Gold and enameled glass. Bohemia, 1850.

4. Colored crystal stemware, Louis-Philippe period.

5. Ruby glass. Bohemia, 1860.

6. Assortment of cut-crystal champagne glasses.

7. Cut-crystal, diamond-point liqueur set, engraved and gilded, 19th century.

Following pages :

1. Colored cut-crystal glasses for white wine.

2. Guilloched crystal stemware. Manufacture de Bayel, 19th century.

3. Richly engraved German glass with vegetable motifs and coat of arms, 17th century.

4. Engraved, lightly tinted glass with a chateau design, 19th century.

5. Wine and orange soda glasses, cut crystal, early 20th century.

in Renaissance Venice, painted enamel is applied by hand to the surface of the glass, which is then fired at a temperature of about 850°F. Sometimes the piece is not refired, which renders the enamel much more fragile.

Gilded Glass

Gold decoration applied to crystal glasses first made its appearance around 1880. It tended to be restricted to really fine sets because it involved hand-brushing a precious layer of gold on to the glass, and then refiring it at a temperature of about 900°F. When the glass comes out of the kiln, its gilded areas appear matte textured, and their luster must be revived by rubbing with red iron ore.

TIPS FOR COLLECTORS

The crystal glasses manufactured today cost considerably more than the same patterns bought secondhand.

Red wine and water glasses are more sought after than white wine, port, or liqueur glasses, which are used less often. Very deep cutting indicates that the glass dates from the end of the nineteenth century or the early twentieth century.

The most sought-after crystal glasses are from the period of Louis-Philippe.

If the enamel of a glass is in any way impaired, the glass loses much of its value.

Taking care of glassware

Crystal glasses can be washed in the dishwasher if certain precautions are taken: Do not wash them with silver or crockery.

Use a light cycle for glasses and use a very gentle detergent. .

When ordinary glasses are mixed with other tableware, there is a risk of dulling, due to the combination of certain detergents with water of poor quality.

Repairing broken glassware

Rub the areas to be joined with sandpaper to make the surfaces as smooth as possible. Heat the glass in very hot water for one minute. Wipe quickly, apply a thin layer of Superglue or Krazy Glue on one of the two broken edges to be glued, and apply the other edge.

Repairing a broken stem

It is best to leave this task to a professional. However, if you must do it yourself, first clean and dry the two pieces. Lay the top of the glass upside down on a clean cloth. Adjust the foot on top of it. Hold the two parts together with a thick roll of clay or plasticine to support the foot. Apply a drop of water-resistant synthetic glue to the cup section, taking care not to let the glue run: if it does, remove the excess with a matchstick. Allow to dry for twenty-four hours.

Repairing a small chip

Polish the chipped edge with medium-grain sandpaper rolled around the shaft of a pencil. If the chip is too big, leave the work to a professional.

Separating a glass stuck inside another

Plunge the lower glass into hot water, then immediately fill the upper one with cold; then pull gently to separate the two.

2.

3.

4.

5.

1.

2.

Art Deco Glassware

With their straight lines, simple forms, and discreet ornamentations, art deco glasses are astonishingly modern, a perfect match for contemporary tableware and silverware.

The Taste for Simplicity

During the International Decorative Arts Exhibition in Paris in 1925, a number of artists working with glass demonstrated their collective preference for form over ornament, the innate beauty of materials over their decoration, and transparency over color.

A case in point was Jean Luce, who, after serving his apprenticeship with the firm acquired by his father in 1888, founded a company of his own in 1901. Luce designed sets of china for several different factories, Sèvres among them, and it was he who first had the idea of matching glassware with ceramics, silverware, and even table linen. He created several sets of porcelain and crystal for the liner *Normandie* and collaborated with the Saint-Louis glassworks, for which he invented his *Hossegor* and *Eva* patterns, which are quintessential art deco. Saint-Louis committed itself to this modernist movement by commissioning other artists such as Jean Sala, from a famous dynasty of Italian glassmakers, Maurice Dufrene, Marcel Goupy, and Max Ingrand.

Baccarat responded with the great designer Georges Chevalier, who came up with his very own ultralight muslin glasses. These were conical or slightly flared and tuliplike, with a parison of extraordinary purity. Chevalier also designed sets of stable, stemless glasses with broad, thick bases, especially for wealthy yacht owners. His *Jets d'eau* service was a model of sobriety and harmony, with parisons etched with acid representing stylized streams of water, and stems and feet decorated with frosted and molded flower patterns.

The Reign of Lalique

Without a doubt, the dominant figure of the era was Rene Lalique. Lalique's first research into glass and crystal dated from 1890, when he was still a jeweler by trade. In 1902, he made some molded glass panels for his townhouse at Cours-la-Reine, and in 1906, Francois Coty commissioned him to design perfume bottles, which were made by Legras at Saint-Denis. After this project, Lalique set up his own workshop and in 1911 gave up jewelry altogether to concentrate on glass, reacting against overuse of color and working skillfully around the contrast between transparent and burnished glass. He was the inventor of a particularly strong "half-crystal," which had both the luster and the transparency of traditional crystal. His glasses were simple in construction, with refined outlines; he successfully applied his manufacturing methods to vases, decorative panels, and table services, and his firm supplied all the glass for the *Normandie*'s most luxurious staterooms.

Daum, another famous name, began producing crystal in 1934 with an order for one hundred thousand pieces—again for the *Normandie*. The Daum glassworks was a leading light of art nouveau decoration and eventually specialized more in decorative crystal than in drinking glasses. Choisy-le-Reine and Val Saint-Lambert, whose most gifted designers were Simonet and Marcel Goupy respectively, also produced very beautiful art deco glasses, as did Pantin, Clichy, and Sèvres.

3.

1. Detail of the foot of an orange soda glass. Cristal Lalique, 1920–1930. (Lalique pieces are always signed).

2. Detail of the foot of a glass from Lalique's *Nippon* service. Cristal Lalique, 20th century.

3. Unsigned art deco glasses are often found in secondhand shops, selling at reasonable prices. This model is by Saint-Louis.

TIPS FOR COLLECTORS

Genuine Lalique pieces are all signed. Glass by Jean Luce appears on the market only on very rare occasions. Some of the original art deco designs are still produced today by Saint-Louis and Baccarat.

Bistrot Glasses

Bistrot glasses are modest in aspect, in stark contrast to spectacular table crystal; but this modesty is very much a virtue, given that they are invariably well designed and perfectly adapted to the drinks they are meant to contain. Used as part of a table setting, they have a way of making the occasion informal; you can almost feel the friendly bistro atmosphere surrounding them.

Absinthe Glasses

The "Green Fairy" absinthe, a potent blend of the diluted essences of Artemisia, aniseed, and fennel mixed with alcohol, was originally sold in French pharmacies before it became publicly available in bars, cafés, and wine shops. The first absinthe was created in the Doubs department of France by Pernod Fils—and caused much havoc and misery before it was banned on March 6, 1915, for the very good reason that it drove people mad. The traditional absinthe glass had a stem and a conical shape with thick sides. It came with a small, slotted spoon; this was laid across the rim with a lump of sugar in it, over which water was poured drop by drop until the precise moment when absinthe beneath turned cloudy.

Martini Glasses

The martini glass was also conical, with thick sides.

The Shot Glass

Stemmed shot glasses were intentionally small, only meant to contain a very small quantity of alcohol. You could always order a second.

Tankards and Beer Glasses

The tankard, which was traditionally made in eastern and northern France, had a cover to keep the beer at the right tepid temperature. In the Middle Ages, it was heavily and ornately decorated; later in the sixteenth century, it spread all over Europe, adopting a cylindrical shape with a pewter cover. In more recent times, porcelain tankards were produced by factories, such as Hannong of Strasbourg, in eastern France. From the nineteenth century onward, people began serving beer in tall, thick glasses, and as the years went by, the glasses were adapted to specific types of beer. Thus a frothy brew came in a tulip-shaped glass, Belgian beer arrived in a round goblet on a stem, and ordinary cylindrical glasses were used for ordinary pale lagers. Later, the breweries began distributing glasses advertising their own brands and logos, which were immediately adopted by the bars.

Lemonade Glasses

Originally from southern France, lemonade glasses were thick, shaped like a truncated cone, and etched with broad diamonds.

The Voleur Glass

This curiosity was also known as *verre du patron* ("host's glass"), or *verre faux-cul* ("cheating glass") because it allowed the bar owners to drink with their customers while consuming less alcohol. It had a solid glass bottom and thick sides, which meant that it could contain only the minimum amount of alcohol.

2.

1. Molded cider and lemonade glasses, assorted motifs.

2. Three Bohemian crystal beer mugs with pewter additions, 19th century.

1.

The Mazagran, Coffee Glasses, and Burned-Brandy Glasses

The Mazagran glass was named after a town in Algeria, where a French garrison of 123 chasseurs commanded by the gallant Capitaine Lièvre managed to repel an army of fourteen thosand men under Sheik Abd el-Kader. The French troopers were fortified during their ordeal by scalding hot coffee laced with sugar and eau-de-vie. To commemorate their feat of arms, a factory in Bourges created and marketed a large, thick-sided porcelain cup called a "Mazagran."

Coffee is still occasionally served in French cafés in a glass with thick sides to keep it hot. The shape is the same as that of a Mazagran.

The *brulot* (burned brandy) glass, or *tasse de bistrot* ("bistro cup"), is made of thick porcelain and has the same heat-retaining function, provided it is heated well before the liquid is poured in. Other hot drinks are also consumed from this kind of cup.

Verre de curiste or the "Spa Glass"

In the last quarter of the nineteenth century, it became ultrafashionable to drink the waters annually at French spa towns such as Aix-les-Bains. At the start of a treatment, the patients would be presented with a glass—sometimes calibrated—and usually engraved with the name of the spa. They then kept it for the duration of the entire treatment, carrying it in a sling over their shoulders or at their belts, in a small wickerwork pouch.

TIPS FOR COLLECTORS

Old **bistrot** glasses, so conducive to geniality and friendliness, are becoming hard to find—and their prices are going up as well. Don't hesitate to snap up individual pieces if they appeal to you. They can only increase in value.

2.

3.

4.

5.

1.

2.

3.

4.

Pressed Glass

Their colors are enchanting to many; their heaviness can be inconvenient to some; and their price is reasonable all around the world. Pressed glass, which resembles cut glass, were mechanically produced in large numbers. It's time to rediscover their beauty.

Instead of Cutting

For centuries cutting was the most favored technique for decorating glasses. Cut glass was the height of fashion at the beginning and end of the nineteenth century, when makers like Baccarat were producing richly ornamented pieces of heavy crystal. The invention of a process for pressing glass with a machine supplied a fair imitation of cut glass that was considerably cheaper. It involved pouring molten glass into a mold bearing the ornamental details in relief, and pressing it with a counter-mold harnessed to a piston. The glass that emerged would be smooth on the inside and sculpted on the outside.

This technique was perfected in the United States in 1820 by the New England Glass Company. It was then immediately copied by its bitter rival, the Boston and Sandwich Glass Company in Cape Cod, Massachusetts, which employed a number of artisans from Europe. The latter produced pressed glass in such quantity that before long "sandwich glass" became the common name for American pressed glass in general. An impressive variety of objects emerged from the molds: bowls, dishes, vases, compotes, candlesticks, fruit bowls, and cups and glasses of all sizes. They were engraved, like their hand-cut models, with sides that were flat or patterned with stars, diamonds, bevels, and squares. They also came in splendid colors such as cobalt blue, green, amber, and turquoise.

Around 1830, the pressed glass technique spread to Europe, notably by major glass producers such as Baccarat and Saint-Louis.

5.

6.

TIPS FOR COLLECTORS

Pieces made by glass pressing, such as water tumblers and goblets and colored candlesticks, are very decorative on a table, though their weight and, occasionally, their excessive ornamentations may not suit everyone's taste. In any event, pressed glass can be purchased at reasonable prices today, though its value is steadily on the rise.

The shapes of mechanically pressed glass are more uniform than those of hand-cut glass.

Pressed glass always carries the vertical impression of the joints of its mold.

1. Italian pressed glass.

2. Glass candy dish, early 20th century.

3 and 5. Candlesticks and pressed dishes, 19th century.

4. Different designs for pressed glasses.

6. Night-light, 19th century.

TABLE ACCESSORIES

This is a broad field offering plenty of possibilities for fun, self-expression, and originality. All the more so since nowadays, people no longer have any reservations about mixing styles, materials, and periods to create a desirable table and are ready to find and embrace inspirations wherever they may be.

Basically anything goes, so you can pick and choose from the vast quantities of items available. Certain traditions still remain, and that is not a bad thing—for example, we still like to dine by candlelight. You might opt for a pair of thoroughly eighteenth-century candelabras, or nonmatching sconces, or candle jars set at intervals around the table. And it is equally fashionable to arrange individual bouquets of flowers in metal cups by every place setting or place a big cut-glass bowl on a stem, piled high with fruit as a centerpiece.

Then there is the indispensable trio of salt cellar, pepper mill, and mustard pot—which have inspired so many artisans all through the ages. They come in every shape and size, from staid and conventional to completely outlandish, as do place mats and hot plates, and all their kin. There are also cohorts of smaller accessories—menu holders, place cards, knife rests, and so on; the possibilities are endless.

Candlesticks and Candelabras

Dinner by candlelight is always a delight, with its power to make silver and crystal glitter, faces look glamorous, and eyes shine. Candle jars may be very fashionable today, but there is still a lot to be said for the grand candelabras and candlesticks of the past—made of fine materials and beautifully crafted.

Candlestick or Girandole?

The French word *chandelier* does not necessarily mean a cluster of lights or candles suspended from the ceiling, as it does in English. Instead it describes anything in which a candle can be placed. The small portable candleholder is its simplest form. The French *flambeau* is more precise: it is a candlestick with a single holder. In the seventeenth century, *flambeau* became the customary word for a vertical stem with a circular or polygonal foot, a candle socket on top, and no handle. The candelabra, by contrast, is a candleholder with several branches, while the girandole is a ornamental candelabra whose stem is composed of human figures. It can also describe a candelabra with cut-glass pendants. As for the French *bougeoir* (a flat candlestick), it appeared around 1824 with the invention of the wax candle.

Eighteenth-Century Shapes and Outlines

When the tallow candle was invented in the Middle Ages, it brought with it the *flambeau* candlestick. Prior to that time, a *flambeau* in French meant a blazing oil torch on a stick, used to light the way along dark streets at night. By the seventeenth century, the *flambeau* candlestick had already assumed the form we recognize today: a fluted, square-cut, or balustered stem, set on a broad base, square or with the corners cut off.

At the end of the century, the French introduced a technique for molding candlesticks in sterling silver, with base and stems separately made, then soldered or—more rarely—screwed together. At this time, ornamentation entered the equation. In the eighteenth century, the faience and porcelain makers of Rouen, Moustiers, Saint-Cloud, and Sèvres began making candlesticks whose shapes were based on those of gold and silverware, with decorations of a piece with their styles. As the century wore on, these shapes evolved. Next came two-branched candelabras, then appeared candlesticks with multiple branches with sophisticated designs devised by famous silver and gold workers for the tables of the great. Many of these formed diminutive elements of a gigantic table centerpiece. Imagination and flawless craftsmanship were at a premium during the reign of Louis XV, with the coming of a flamboyant rocaille style based on intertwined candelabra branches and asymmetrical ornamentation

Shapes and decorations only settled down at the end of the century, with the return to neoclassicism under Louis XVI. While the candelabras flooded tables with glittering light, pairs of candlesticks were placed on fireplaces on either side of clocks. They were made of sterling silver, bronze, silver, or gold plate and consisted of three sections—base, stem, and candle socket—screwed together to form a single entity.

2.

1.

2.

3.

4.

1, 3, and 4. Designs for Louis XV-style candelabras

2. Louis XVI-style candelabra.

5. Design for a four-armed candelabra by Cardeilhac for Christofle, 1925–1930.

6. Assorted molded glass and crystal candlesticks, late 19th and early 20th century.

7. Assorted candlesticks, 19th to 20th century.

8. Assortment of French and English sterling silver candlesticks, 18th century.

The Nineteenth Century: the Age of Decorum

During the First Empire, leading craftsmen, such as Odiot, were inspired by antiquity to produce pieces with fluted or balustered stems, and silver gave way to gilded bronze and vermeil. However, with the invention of silver electroplating, the decorum-obsessed Second Empire developed a predilection for large decorative candelabras based on models from the reigns of Louis XIV and Louis XV, such as those made by Christofle and Boin-Taburet. Meanwhile glassmakers such as Saint-Louis and Baccarat were producing immense chandeliers, decked with thousands of glass pendants, for the townhouses of the rich and the palaces of princes.

Curious Oddities

The *amusoir* or "flycatcher" is a glass candelabra incorporating a water-filled container for drowning flies attracted by the light. The candlesnuffer is a metal rod with a small hollow cap at its end for dousing candles. Scissors snuffers were used to snip blackened wicks, which fell neatly into a little metal box attached to one blade.

TIPS FOR COLLECTORS

Candlesticks and candelabras predating the Revolution—meaning they escaped the wholesale melting down of silver to pay for France's wars—are few and far between these days. They are usually sold in pairs today, which adds to their value.

When a silver candelabra is composed of several sections, check that each section bears the same hallmark. Also verify that the sockets are the original ones and that all the branches are intact—these can be very awkward to repair.

Nineteenth-century, silver-plated copies of older candlesticks and candelabras are plentiful on the market, and many go for bargain prices.

Oil lamps made of blown glass, which were produced in Provence during the 1830s, make very attractive candleholders.

5.

8.

Centerpieces

Table centerpieces have never gone out of style. In the eighteenth century, the trend was for the precious *cadenas* (shackled casket); in the nineteenth century, the towering *surtout* predominated. Today the choice of what to place in the middle of a dinner table is a matter of individual taste and imagination.

Nefs and Cadenas

The ancestors of centerpiece were the *nef* and the *cadenas*. From the Middle Ages through to the late sixteenth century, the most spectacular item on the royal table was the *cadenas*, a gold or silver casket with a shackle to discourage assassination by poison. Along with a set of antidotes to various toxins, it contained the king's napkin, his flatware, and assorted small vessels containing spices, salt, and sugar, all of which were rare and precious commodities. These small vessels were couched in a boat-shaped receptacle, the *nef*. The most celebrated of these was the one designed by Le Brun and made by Jean Gravet for Louis XIV.

From Surtout to Présentoir

The French word *surtout* first surfaced in 1692, in a description of the festivities surrounding the wedding of the Duc de Chartres. It designated a single piece of silver or gold work that brought together the salt cellar, spice box, oil pitcher, and vinegar jug with various vases, candleholders, sconces, and candelabras. Throughout the eighteenth century, this spectacular object accompanied the tableware delivered to the courts of Europe and the houses of wealthy aristocrats by the greatest living craftsmen in silver and gold (Louis XIV's *surtout* was made by Delaunay).

In the nineteenth century, the surtout lost its utilitarian function and became purely decorative, while remaining a fixture throughout the meal. Sometimes it covered the whole length of the table and represented a nature scene from mythology or the hunting chase; it might also be a skillfully engineered construction made from a large number of sculpted components, placed on a platter with a mirror bottom representing a lake. It could be made of gold, silver, crystal, biscuit, or porcelain.

The vogue for these elaborate pieces died away at the Restoration of the French monarchy. They were replaced by dessert services, comprised of series of cut-glass fruit stands on stems of different heights made of beautifully worked metal. These stems were sculpted in the forms of children, or animals and were topped by a high crystal cone entirely filled with fruits or cakes. Dessert services were accompanied by stands with several tiers and baskets and candelabras mass-produced by firms such as Christofle. They offered plenty of options for flights of fancy: "white glass bowls filled with water, with goldfish and baby turtles swimming about, are quite the thing these days," noted a late-nineteenth-century lifestyle manual.

The twentieth century sternly jettisoned all such extravagance, preferring the unostentatious display of a vase of flowers and plain but refined candlesticks.

TIPS FOR COLLECTORS

Big, impressive, complete **surtouts** are no longer interesting to anyone but specialist collectors. Even so, it is not unusual to come across odds and ends of old ones, in the form of crystal, biscuitware statuettes, porcelain figurines, woven silver baskets, and the like.

1. Fine porcelain Medici mini-vases, for table decoration.

2. Centerpiece, with cornet and four cut-glass dishes.

3. Tall fruit stand with children and vine decoration.

4. Cut-crystal fruit stand on a silver-plated base.

1.

2.

3.

4.

Individual Accessories

Nothing is ruled out when it comes to an original table setting, especially the objects that have preserved real charm and personality though they may have gone out of fashion long ago.

5.

Menu Holders and Menus

In the nineteenth century, when people gave dinner parties, it was customary to place a card with the evening's menu before each guest. The card was held vertically upright in a little stand with a clip on top, or was fitted into a metal frame. These small accessories were mass-produced in silver, tin, glass, brass, or china, and sometimes came with a matching holder for the card bearing the name of the guest.

The menu itself was created with the utmost care and included line drawings of landscapes, flowers, and figures on Japanese vellum, parchment, or a broad ribbon of colored satin placed in a glass.

The Knife Rest

Knife rests made their appearance in the second half of the nineteenth century. They were a bourgeois invention, enabling diners to keep the same knife for several successive courses and eliminating the need to change the tablecloth for each new meal. They came in many forms, from the diminutive rectangle in earthenware, porcelain, and cut crystal, to the match-stick-sized silver rod with bobbles, rings, or claws at either end. The knife rest also lent itself to fanciful portrayals of fish, dogs, and birds; the animals of La Fontaine's fables were all pressed into dinnerware, as were those of Benjamin Rabier.

The Napkin Ring

The napkin ring made it possible for people to identify their own napkin for the next meal and the next. It tended to be used within families, rather than for dinner or lunch parties when outsiders were invited. Like the knife rest, the napkin ring first appeared in the nineteenth century and was often given to babies at their birth along with a silver drinking cup and an eggcup. Like the latter, it might be in sterling silver, silver plate, nickel-plated copper, aluminum, ivory, horn, ceramic, wood, or even flexible celluloid. Since the napkin ring was a personal object, it was often engraved with a Christian name or initials.

The Finger Bowl

The finger bowls first came into general use around 1760, along with the habit of eating shellfish and crustaceans. In general it was an opaque crystal bowl occupying a small tray of its own. In the nineteenth century, it was frequently accompanied by a three-piece mouth-rinsing set, which included a small crystal bowl, a saucer, and a goblet that could be filled with a mixture of water and mint or lemon-flavored alcohol. Guests would take a mouthful of this brew from the goblet, rinse it round their teeth, and spit it discreetly into the bowl. "In many houses, a sterilized quill toothpick is laid on the cloth to the right of each guest, wrapped in tissue paper. I formally admonish ladies not to make use of these, because personally I find the habit of picking the teeth publicly after a meal most unattractive. For the same reason, the finger bowl no longer appears with the little cup people once used to rinse their mouths," notes an early-twentieth-century-lifestyle manual. But the finger bowls themselves are still essential objects for our tables.

TIPS FOR COLLECTORS

Napkin rings are used less and less nowadays, with paper napkins having largely taken the place of cloth ones. On the other hand, these attractive, inexpensive items seem to be making a comeback for intimate meals among friends.

1. Silver-plated metal knife rests, 1940–1950.

2. Souvenir napkin rings, 1920s.

3. Spade-shaped knife rests, 1950s.

4. Porcelain knife rest, 1930s.

5. Assorted knife rests offered in the 1913 Christofle catalogue. Prices varied between 16.5 and 40 francs per dozen at that time.

2.

Salt Cellars, Mustard Pots, and Cruets

The salt, side by side with the pepper; the mustard in its little pot; the oil and vinegar in their sophisticated cruet—they have all been faithfully present at our meals for generations now. No receptacle is too good for them.

Salt Cellars

In the Middle Ages, salt made it possible to preserve meat and vegetables. It was a rare and expensive commodity in France, subject to a tax of its own. It also had a symbolic religious value, representing a mystical alliance between God and his people. For this reason, it was out of the question for anyone in a position of importance to keep his salt in a commonplace container. Salt cellars were prestige items, made of gold, encrusted with precious stones, and decorated with symbols.

In the sixteenth century, the salt cellars gradually lost its religious mystique and began to be decorated in a style more in keeping with salt's natural origin—sea gods, sea symbols, and fish. This trend reached its crowning moment with the vogue for rocaille, which had salt nestling in containers resembling seashells and decorated with motifs of marine life. The most celebrated example was produced by Thomas Germain, which was covered in sculpted crabs, turtles, and scallops. Marie-Antoinette launched a trend for tiny blue crystal salt bowls set in perforated silver base, with matching mustard pots. The nineteenth century saw the arrival of the *Cérébos* salt cellar or salt shaker, made of ribbed or smooth crystal with a screw-on, perforated metal top.

This, of course, is the basic design that remains in use today.

Pepper Pots and Pepper Mills

In the eighteenth century, salt and pepper began to be presented together in a twin "double cellar" made of silver or glass with a silver base. The table pepper mill, again made of silver or glass, did not emerge until the nineteenth century. Other spices that were so prized in the seventeenth century gradually fell out of favor, and by the end of the eighteenth century, only cloves, nutmeg, and cinnamon remained on the table, in a spice box that had several compartments.

Mustard Pots

Mustard has been used as a condiment in Europe since the thirteenth century. In eighteenth-century France, it was sold on the streets by children who transported it in casks, using wheelbarrows. For this reason, the first table mustard pots, which appeared around 1752, were shaped like tiny barrels. Madame de Pompadour had a pair of silver mustard pots made for her by the silversmith Antoine-Sébastien Durand, in the figure of cupid wheeling a barrel of mustard along in a delicately engraved barrow; beside the cupid is a greyhound standing on its hind legs.

3.

4.

5.

1. Crystal and silver-plate oil cruet.

2. Assorted silver-plated pepper mills.

3. Porcelain salt cellar and pepper pot, 1930s.

4. Sterling silver shakers by Keller, 19th century.

5. Salt and pepper pots shaped like scallops, a seaside souvenir.

1.

2.

In the nineteenth century, the mustard pot, as in the time of Marie-Antoinette, came in the form of a tiny tub of clear or dark blue crystal set in a heavily worked silver structure. It had a hinged lid and a side handle for opening the lid. Some of these lids had notches in them to accommodate a little mustard spoon.

From the late nineteenth century onward, salt cellars, pepper mills, and mustard pots—though they still matched and were brought together—lost their conventional character. Imagination ran wild as potters and porcelain manufacturers produced a large number of cheap, vividly colored, and often humorous variations on the themes of fruit, vegetables, crustaceans, animals, children, and different professions.

Oil and Vinegar Cruets

Gabrielle d'Estrées, the favorite of Henri IV, was unusually fond of vinegar and was the first to bring it to the dinner table. The earliest version of the combination oil and vinegar cruet was called a *guédoufle* and consisted of two transparent glass or crystal bottles, with entwined necks, set in an oval dish or on a broad, stable base. In the seventeenth century, oil and vinegar began to be presented in oval or octagonal boxes,

whose tops contained four holes, two for the bottles and two for their stoppers. During the rocaille period, they gained oval platters with perforated mounts and cork holders and ornamentations of olive trees and vines to show their function. In the reign of Louis XVI, the platter became a tray and the bottles were blue crystal.

In the eighteenth century, cruet stands were of metal with a central stem topped by a handle and four rings—two large ones to hold the bottles, and two smaller ones for the stoppers. The same principle applied to the *ménagère* cruet stands of the early nineteenth century, some of which contained not only oil and vinegar but also salt, pepper, powdered sugar, and even mustard and pickles.

TIPS FOR COLLECTORS

The value of antique salt cellars, mustard pots, and oil cruets has remained more or less stable, though fine oil and vinegar cruets have become expensive.

With patience, it may be possible not only to find a cruet stand on its own, but also the cruets to fit it. Likewise, the stoppers, which is usually missing, can eventually be found one way or another.

3.

4.

5.

6.

2. 3. 4.

Ice Buckets, Glass Holders, and Hot Plates

These table accessories—jewels of the old domestic economy whose original purpose was always to make things easier for the household—have come back with a vengeance in recent years to the delight of anyone interested in the art of the table.

Ice Buckets, Glass Holders, and Coolers

In the eighteenth century, bottles and glasses never appeared on the table at all. Instead they were left on the side table, plunged into glass holders or coolers, ready to be carried to the guests when required. The buckets were made of silver, faience, or porcelain; they were round or oval, with crenellated rims to hold the bottles and glasses securely in place.

By the early nineteenth century, individual glasses and carafes moved to the table and the old coolers ceased to have any real purpose. Still, individual glass holders were used, according to the type of wine being served, either to cool a glass in ice or to warm it in tepid water. Ceramic manufacturers and leading goldsmiths and silversmiths, such as Charles-Nicolas Odiot and Boulenger, continued to make coolers and glass holders. Their elegance is timeless, which is why they are still in use even today as planters or centerpieces filled with fresh fruit or flowers.

Hot Plates

The hot plate was another nineteenth-century invention, which began as a decorative ceramic plaque, square or round in shape, with or without feet, and snugly fitted into a wooden casing. Some faience manufacturers produced fanciful versions of this useful object, with, for example, music boxes capable of playing one or two tunes or sliding casters for feet. Later, table hot plates came in wood, porcelain, pressed glass, or aluminum; certain models, made of nickel-plated copper, could be folded or opened out and had matching chafing dishes.

Coasters and Decanter Stands

These objects naturally came into being as soon as bottles and glasses made the leap from coolers and glass holders on the side table to the table proper. After all, it was important to protect the tablecloth from wine stains. Later, toward the end of the nineteenth century, these objects began to diversify.

1. Faience cistern used as a glass holder. Pont-aux-Choux or Rouen, 18th century.

2. Lacquered tin glass holder with Chinese decorations, circa 1765.

3. Hard-paste porcelain cooler. Manufacture Nast, 1783–1835.

4. Silver glass bucket by Auguste Robert-Joseph, 1778–1779.

1. Designs for silver-plated bells.

2. Silver hot plates and warmers.

3. Silver chafing dish, 19th century.

The simplest ones were aluminum or copper, and the most refined were silver plate or pressed and cut crystal with silver or wood bands. Generally, a small crosspiece of wood was set into the crystal to prevent the bottle from damaging it.

Chafing Dishes

The French were accustomed to laying their various cooked dishes on the table prior to the arrival of the guests. Even though many of them had fitted covers to keep them hot, chafing dishes were still a necessity. The eighteenth-century chafing dish sat on a metal stand over hot coals. In the nineteenth century, the stand was made of silver plate, and the heating was done by a candle or a small tub of burning alcohol with a wick in it. Some of the structures were no more than simple metal frames; others had four feet and were decorated in the same patterns as the hot plates, whose function they sometimes shared. Especially interesting were silver vegetable dishes with built-in metal heating components. In the early twentieth century, goldsmiths and silversmiths began producing simple, candle-warmed metal chafing dishes.

Handbells and Gongs

To summon the servants between courses, the hostess would ring a small handbell made of silver, nickel-plated copper, decorated porcelain, or even cut crystal. The hostess would also slap a little gong with the flat of her hand or twist a button on it to and fro. An interesting variation was the table gong, a metal stand with a round piece of copper hanging on it, which was struck with a stick of boxwood.

1. 2.

2.

For Bread

Bread has been a staple of every European table since the Middle Ages and it occupies a vital if humble role as an accompaniment to many dishes. The bread basket is now a fixture everywhere, but other objects for bread have largely disappeared from the table.

Silent Butler

At the end of the nineteenth century, it was the general practice to clear away the bread crumbs on the table before serving the dessert (the French do not lay individual plates for bread like the English). The crumb clearing was done either with a crumb tray—a kind of straight-edged miniature shovel with a handle—or with a semicircular silent butler with a thumb catch. Both were used together with a long-handled soft brush.

In the reign of Napoleon III, many of these utensils were made of lacquered papier-mâché, but there are plenty of other variations in metal that have the standard range of decorations—seashells, palm leaves, ribbons, and garlands—as well as minor masterpieces of marquetry. The silent butler and brush were often made with matching bread baskets. In the 1920s, they were replaced by a single tool, a circular brush that was built into a silver-plated case.

The Bread Basket

The bread basket first appeared on the tables in France at the end of the eighteenth century. The early ones were oval or rectangular, occasionally square. When made of faience or porcelain, they tended to have an openwork design; when made of sterling silver, they were often decorated with appliqué motifs. Whatever the mate-

rial, the bread baskets were elegant, beautifully crafted objects that could just as easily be used for serving fruits and cakes instead of slices of bread. In the second half of the nineteenth century, the bread basket was frequently accompanied by the silent butler and its brush, all three being made of novel materials, such as silver plate, wood marquetry, or papier-mâché.

When imported Asian rattan and wickerwork were all the rage at the turn of the twentieth century, finely woven bread baskets of different colors began to appear. These were made not only of rattan, but plated silver that imitated the characteristics of woven rattan and wickerwork.

The Butter Board

This was a decorated piece of faience, with a hole at one end from which it could be hung on the wall. It was used for spreading butter or cheese on slices of bread.

3.

TIPS FOR COLLECTORS

Nowadays, silent butlers are rarely used outside restaurants, but they have plenty of appeal for enthusiasts, especially the Napoleon III lacquered variety, which can be collected as ornamental objects. Sold without its brush, or if the brush is in poor condition, the silent butler loses its market value but not its decorative quality.

1. Bread baskets made in older designs, 19th and 20th century.

2. Shell-shaped, spade-shaped, and Louis XV-style silent butlers.

3. Crumb scrapers: shell-shaped, swivel-sided, Louis XV, Empire, and Louis XV.

TEA, COFFEE, AND CHOCOLATE

Toward the end of the seventeenth century, three novelties revolutionized people's dining habits. All of Europe embraced these beverages from distant lands, and they soon became an inspiration to silversmiths, goldsmiths, and ceramists.

Tea from India and China was introduced to Europe by sailors working with the Dutch East India Company. The French discovered it around 1636. Louis XIV quickly became a fervent consumer, after receiving a solid gold teacup as a gift from the king of Siam. The tea drinking spread quickly among Europe's middle class beginning around 1840.

Coffee, originating in Abyssinia, arrived in Europe in the 1630s and began to be imported on a large scale to France via the port of Marseille in 1850. It quickly overtook tea as the preferred drink of the aristocracy, before becoming a staple of the cafés named in its honor.

Hernan Cortes was officially the first European to discover chocolatl in 1589, during his conquest of Mexico. This "food of the gods" arrived in France around 1670, following the marriage of the Infanta Anne of Austria to Louis XIII. Between 1670 and 1680, the introduction of the cacao tree to the West Indies (Martinique) dramatically lowered the price of cocoa and its chocolate products, making them available to all levels of society.

Preceding pages:
Saxe porcelain pot and Limoges coffee
cup, 19th century.

Pots and Jugs

Prior to the late seventeenth century, a single all-purpose pot was used for tea, coffee, and chocolate. The teapot or coffeepot began to be distinguishable only in the later years of Louis XIV. Originally the teapot was quite small, used only for pouring boiling water over the tea leaves in the cup. It was oval or pear shaped, and pot-bellied. Like the coffeepot, it had a long curving spout, a shapely handle, and a bulging lid with a bump on top.

Shapes

From the moment when tea drinkers began brewing their tea leaves in the teapot itself, it began to grow in stature. Before long a small, sievelike barrier was installed between the base of the spout and the main body of the pot, allowing the tea to be separated from the leaves. The spherical teapot made its first appearance in about 1720. Most antique French teapots were made in towns that maintained close ties with England, such as Lille, Douai, Arras, Valenciennes, Bordeaux, and Paris.

The first coffeepots, dating from the end of the seventeenth century, had flat sides and were called *marabouts* after the Asian kettles of that name. They had a beak set high up in the wall of the pot, allowing the liquid to be poured off the coffee grounds as they settled to the bottom. In the late eighteenth century, coffeepot types ranged from the so-called *egoiste*, which yielded a single cup, to the family pot—mainly manufactured in northern France—which made up to a dozen cups. Between the reigns of Louis XIV and Napoleon III, the shape of the coffeepot altered little; it had a curved outline, three feet, a projecting S-shaped handle made of turned ivory or ebony, and a beaked spout that was sometimes shaped like the neck of a swan. The only substantial variations were in the decorative details, such as rounded corners and straight or crooked sides.

The chocolate jug tended to have the same forms and decorations as the coffeepot: tall, pear shaped, and often with three feet. The only difference was its notched lid, through where the handle of the chocolate whisk was placed. The whisk was made of boxwood, with grooves at the top end so it could be twiddled between the fingers to whip the chocolate and milk to a froth, just as the Indians did.

In the late nineteenth century, serving tea was of great importance. It required plates, flatware, glasses, and platters for the cakes, sweets, fruits, and syrups that accompanied the tea. The tea itself was brewed on a side table, where there might be a samovar or an old French kettle.

It was not until 1925, when the influence of Jean Puiforcat began to spread that the shapes of coffeepots and teapots were completely renewed. They became simpler, squatter, plainer, and less adorned, with beautiful handles made of rare wood.

Sets and Services

The breakfast set (*cabaret* in French) consisted of a tray, a teapot, a coffeepot, a creamer, a sugar bowl, and a single cup and saucer. The word *cabaret* derives from the small table formerly used for serving tea and liqueurs; later it came to mean a tea or coffee service proper, with several matching cups and saucers. Such sets occasionally came accompanied by a

2.

1. Tea and coffee set in the style of Louis XV.

2. Chocolate pots: Louis XVI with fillets and ribbons, Louis XIV with ovolos and traceries, Louis XVI straight-sided, Louis XV with claw feet, and Louis XVI boss-beaded.

1.

1. Illustration by Achille Deveria, circa 1830.

2 . Assorted teapots: "falling pearls," pear-shaped with tight ribbing, wooden handled, and gourd-shaped.

3. Tea set with its own porcelain tray, 19th century.

4. Coffee and tea set, bone china and gilded, 1910.

2.

samovar or a heating stand, or even a bowl for used tea leaves or coffee grounds.

Changing Style

The first pouring pots were in the rocaille manner. In the second half of the eighteenth century, they often stood on three feet, and their sides were either ribbed or flat. During the neoclassical period, they took the shapes of urns, drums, or vases. During the Empire and *Directoire* eras, the trend for antiquity made them oval, with spindlier legs and spouts resembling a swan's neck. After 1830, there was a return to the styles of Louis XV and Louis XVI, with ribs and chasing; and later, art nouveau contributed its vegetable motifs, which married very well with the natural curves of the teapot. Art deco revolutionized styles by adopting sober, geometric shapes that were plain and unembellished.

Materials

In the early days, tea, coffee, and chocolate were mainly consumed by the aristocracy, and the first pots were made of silver. Vincennes, Paris, Limoges, and Sèvres porcelain and faience pots quickly followed. In the nineteenth century, sterling silver and silver plate coffeepots were preferred, and they were made by all the

great manufacturers of the time— Grattepin, Tétard, Durand, Veyrat, Odiot, Cardeilha, and Christofle among others. More modest tea and coffee sets were produced in large numbers by all the porcelain and faience makers.

Tisanières or Herbal Tea Sets

The French *tisanière* usually consisted of a pouring pot, a cylinder open at the top and sides, and a cup containing a wick and burning oil for keeping the *tisane*, or herbal tea, warm while creating a faint light.

These utensils were rare in the eighteenth century, largely because herbal teas were regarded as purely medicinal: people only began drinking them for pleasure in the nineteenth century.

During the Empire period, *tisanières* were manufactured in plain white porcelain, occasionally with a decorative border. Later they were decorated with patterns, tableaux, and landscapes.

In the time of Louis XVIII and Charles X, they blossomed into reproductions of famous paintings and military, historical, mythological, and biblical scenes.

The faience *tisanières* of Apt and Lunéville are considered the most beautiful, along with the porcelain models of Paris and Limoges.

3.

4.

1. Full set offered by Christofle in the style of Louis XV. Top to bottom and left to right: creamer, tea bowl, coffeepot, boiler, kettle, tray, sugar bowl, milk jug, and teapot.

2. Fine porcelain coffee pot and coffee cups, Restoration.

3. Sterling silver teapot with wooden handle, circa 1925.

4. English milk jug and teapot for a hotel.

5. Gilded-edged, porcelain sugar bowl, circa 1925.

TIPS FOR COLLECTORS

Coffeepots are much more abundant on the secondhand market than teapots and therefore considerably cheaper. If you are thinking of buying a silver pot, verify that the soldering work around the spout, feet, and handle is in good condition.

Chocolate jugs are rarely used nowadays, but they make attractive decorative items. When purchasing a **tisanière**, make sure that all the components are included in the set.

Antique pieces are twice as valuable if their hallmarks are visible in the correct location. A piece's richness of ornament is an important criterion of value, as are its age, provenance, and the renown of its maker.

Art deco sets are always at a premium, but you can still buy attractive porcelain services for bargain prices.

Pros and cons of resilvering

Resilvering is a costly and time-consuming process that involves numerous manual procedures. It is never wise to think that it will be cheaper to buy and resilver a worn coffeepot than to purchase one in good condition.

Nevertheless resilvering can pay dividends in the case of historically interesting or very precious pieces, or objects with a strong sentimental value.

To keep teapots and coffeepots smelling fresh, drop in a lump of sugar before putting them away.

Don't try to repair leaky spouts or loose handles. Leave these jobs to a specialist.

1.

2.

3.

4.

5.

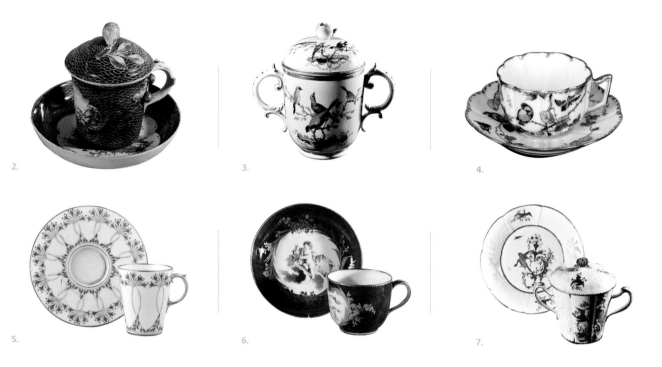

2.

3.

4.

5.

6.

7.

Cups

The new beverages — tea, coffee, and chocolate — required their own specially made cups. In the early days, tea was taken in the Chinese manner from little porcelain bowls imported by the East India Company. The invention of a cup with a handle — the teacup as we know it today — was attributed to the Meissen porcelain works in the first half of the eighteenth century. The delicacy and lightness of soft-paste porcelain made it an ideal material for teacups, which were painted by the period's greatest masters of porcelain decoration.

Early Forms and Shapes

Tea and coffee started out in Europe as rare and precious substances that only the wealthy could afford. Soft-paste porcelain manufacturers such as Saint-Cloud, Vincennes, Sèvres, Chantilly, and Mennec produced wonderfully delicate, hand-painted cups for them. At first, there was only one form: it had a lid and was used for both beverages.

In the mid-eighteenth century, Saint-Cloud, Vincennes, and Sèvres began making cups in different sizes: the smallest was known as a *mignonnette*, and the most commonly used measured about 2½ inches in height. By the end of the century, there was a clear difference between the cups used for the each of the three drinks. Coffee cups had a cylindrical shape with equal diameter and height; the chocolate cup was larger than the coffee cup and had two handles; and the teacup was slightly widemouthed. In 1784, gilded porcelain ceased to be a Sèvres monopoly.

1. Porcelain teacups, gilded-rimmed with serrated pattern. Limoges, 19th century.

2. Porcelain cup and saucer. Manufacture de Sceaux, 18th century.

3. Rocaille two-handled porcelain cup with cover. Custine stamped. Manufacture de Niderviller, 18th century.

4. Hard-paste porcelain teacup and saucer, lobed and boss-beaded. 1880–1890.

5. *Trembleuse* cup and saucer. Sèvres, 1902–1907.

6. Porcelain cup and saucer. Manufacture de Vincennes, 1753.

7. Porcelain "milk cup" with motifs imitated from Asian, Meissen, and Saint-Cloud originals. Manufacture de Vincennes, 18th century.

1.

2.

3.

1. , *À la reine*, hard-paste porcelain cup with cover. Manufacture du Comte d'Artois, Limoges, 1774–1789.

2. Empire porcelain cup.

3. Hard-paste porcelain cup with serrated pattern and gilded edges. Manufacture Pierre Antoine Hannong, Paris, circa 1775.

4. Porcelain cups with flowerets. Limoges, 19th century.

5. White porcelain "moustache" cup. Limoges, late 19th century.

6. *The Waitress*, oil on canvas by John Robert Dicksee, 1872.

7. English porcelain teacup, plate, and cake dish. Royal Doulton, late 19th century.

Then, the discovery of kaolin led to the founding of a number of bone china potteries, notably in Paris and the Limoges region, which were at last freed to meet the contemporary demand for rich decoration. Alongside such simple patterns as scattered flowers against a white background, they produced cups that were entirely covered with multicolored ornamentation outlined in gold.

During the Empire period, many porcelain manufacturers assigned the decoration of their pieces to *chambrelans*, or specialist painters, who worked at home. After that the porcelain manufacturers of Sèvres began making small masterpieces of lightness and elegance in muslin porcelain, whose immaculate white was ideal for tea since it allowed people to appreciate the tea's delicate color.

Trembleuse and à la reine Cups

The *trembleuse* cup contradicted its name, since it was notably stable, standing square in its high saucer. It was mainly used for drinking chocolate. It usually had handles and occasionally came with a lid of its own. The *à la reine* cup, also called a milk goblet, was used during breakfast and had the shape of a plain truncated cone—a Sèvres invention. Some were made without handles or lids, while others had both.

The cup known as *gobelet Calabre* ("Calabrian goblet") was slightly rounded at its base with an wide mouth. The litron (literally meaning "liquid measure") cup, with or without a lid, was perfectly cylindrical and the direct ancestor of our own coffee cup.

With the Empire period came the jasmine cup, which was used for chocolate. This cup was slightly widemouthed with a stem and stand and was commonly decorated with animal claws. It had two coiled handles that projected above its bowl.

The tiny *tasse canard* ("duck" cup) was used for dipping sugar lumps into a tiny pool of coffee. The filter cup, or herbal tea cup, was much larger and had its own built-in filtering component. Finally, the broth bowl came with a broad mouth, a lid, and two side handles.

TIPS FOR COLLECTORS

If you find a set of cups without matching saucers, don't assume the saucers have all been lost or broken. In the old days, many people preferred to buy sterling silver or silver-plated saucers to go with their cups. Porcelain cups from Paris are still available at highly reasonable prices, which is remarkable given their rarity. If the cup's interior decoration matches that of its exterior or if it is signed by the maker, it will have greater value.

Plenty of common but charming porcelain cups and saucers can be found on the market at reasonable prices. By contrast, genuine eighteenth-century pieces are very expensive.

4.

5.

7.

1.

1. Assorted designs and shapes
for porcelain teacups, from an
English catalogue.

2. Top: faience tableware
from various French potteries,
19th and 20th century.

Bottom: English porcelain from
Minton and French porcelain
from Sarreguemines.

3. Coffee set with flower medallion
decoration, Limoges.

2.

1. Design for a pear-shaped tea jar with of floral decorations framed against a guilloched background and matching scoop. Christofle archives.

2. Faience tray with Chinese decoration. Manufacture de Lunéville, 17th century.

3. Silver-plated tray.

4. Porcelain tray. Manufacture de Vincennes, 18th century.

5. Wood marquetry tray, 1900.

6. Porcelain tray, imitation of the Chinese "green family" pattern. Manufacture de Saint-Cloud, 18th century.

2.

3.

4.

5.

6.

Accessories

Trays, sugar shakers, sugar bowls, tea strainers, and jam dishes are the kinds of accessories whose presence alongside breakfast coffee or tea is in itself a charming refinement.

Matching Trays

From the sophisticated silver tray to its wooden version, by way of wickerwork, marquetry, and painted metal, there is a wide choice—and because few collectors are really interested in trays, there are bargains to be had.

In the eighteenth century, the tray was used to display specific dishes or services; it was made of the same material as the service and had the same outlines. Thus the round trays were used for *pots à oille*, and the oval ones for terrines and porringers—all made of ornate silver or delicate hand-painted porcelain. Similarly, breakfast, tea, and coffee were served on round, square, or triangular trays matching the services, whether they were in ceramic or silverware. Many smaller trays were designed to accompany bowls of ice cream, milk jugs, or creamers. Smallest of all were the ones that came with oil cruets, butter dishes, and sugar bowls.

Serving Trays

In the nineteenth century, the serving tray was essential to the household. It was a simple item, usually made of varnished oak or walnut in the *bistrot* style. It existed in many sizes and was most often used for carrying tea, coffee, or liqueurs. In their grander English form, they were the removable tops of small tables. The end of the century saw the appearance of papier-mâché and metal trays with painted designs against a black background. Foreign influences had their effect, notably those of China, Japan, and the Middle East. Wooden, mother-of-pearl encrusted trays from Syria, as well as lacquered trays and trays made of straw marquetry or rattan, competed with the traditional European ones. But the invention of the electroplating technique made possible the manufacture of magnificent formal trays with beautifully engraved handles, whose decoration recalled the great period of rocaille; these were a major feature of wedding sets.

In the early twentieth century and throughout the art nouveau era, wood was the preferred material for trays—generally pale fruitwood, inlaid with vegetable designs. In the art deco years that ensued, silver trays with grips or handles made of exotic wood or stone gained popularity, as did simple burled wood trays lined with silver.

1. Sugar shakers: matching cap and flat glass sides; single hole cap and glass bottom; oval, grooved sides, and all-metal; Louis XVI, all-metal; and boss-beaded cap and glass bottom.

3. Two 18th-century sterling silver sugar shakers, silver sugar bowl and spoon, and vermeil spoon.

1.

2. Two wooden tea tables, with silver-plated tray tops and complete tea and coffee sets.

2.

Sugar Shakers

Cane sugar in the early days was viewed as a rare and expensive condiment, along with salt and spices. It was kept under lock and key when away from the table and stood alone when it was on it. From the seventeenth century onward, it was more and more widely consumed, in drinks and sauces. The sugar shaker was used between the mid-seventeenth century and the mid-eighteenth century. At first, it was cone-shaped and graduated to the form of a baluster around 1700. It was made in two parts that could be screwed or fitted together, and was filled either from the bottom—which was corked—or from the top. Its removable head was full of tiny holes through which the sugar could be shaken out. It was originally made of silver, but the early faience potteries soon began making sugar shakers using the hot firing process: Nevers with its characteristic cobalt blue, Rouen with its wrought iron and lambrequin motifs, and Moustiers with its Bérain designs.

The slow firing technique later became dominant in this area, including the Chinese patterns of Sincény, and the refined decorations of Saint Jean du Désert, Leroy of Marseille, and Hannong of Strasbourg. The stoneware sugar shakers from Lunéville and Niderviller and the soft-paste porcelain ones made at Chantilly, Saint-Cloud, Vincennes, and Sévres were also very popular, as were the simple glass versions made in Normandy and their taller, more elegant cousins of Tours. Very fine shakers made of opaline and cut crystal were produced by the glassworks of Clichy, Saint-Louis, and Baccarat, before the utensil was rendered obsolete around 1750 by the advent of the sugar bowl and sugar pot.

Sugar Pots and Sugar Bowls

The sugar shaker gave way to the sugar bowl, a kind of small oval basin with four or more sides that had its own tray—either separate or attached to its bottom—and its own porcelain or silver spoon with holes in it for scattering the condiment. Sugar bowls were integral features of the centerpiece or *surtout*; some were boat shaped, with slightly raised ends. The round sugar bowl, on the other hand, was a fixture at the breakfast table.

The invention of a process for extracting sugar from sugar beet, during the Empire period, made sugar far cheaper and more readily available, and the sugar bowl became a widespread, standard item. Yet during this time, sugar also lost its permanent place on the table, only appearing when the dessert was served, inside a transparent crystal shaker with a perforated silver top. Sometimes it was entirely made of sterling silver or silver plate, and recaptured the baluster-shape of the original sugar shakers of the early eighteenth century.

The sugar bowl has kept its place as an indispensable companion to hot drinks and beverages, and it is the formal accessory of any tea or coffee tray worthy of the name. Whether made in sterling silver, silver plate, or porcelain, it is invariably matched with the pot, along with the creamer.

1. Assorted tea strainers with handles.

2. Assorted tea strainers that fit into the spouts of teapots.

3. Candy bowl, silver and crystal, 1920s.

4. 19th-century porcelain sugar bowl on a stand with cornflowers decorations.

5. Crystal sugar shaker with silver top; a restaurant model by Christofle.

6. Small, silver ice cream bowls, 19th century.

Following pages:
Still Life with Salad Greens, Édouard Vuillard, circa 1887–1888.

1. 2.

The Preserve Dish

Just before the French Revolution, the Indian habit of eating jams and preserves at the end of a meal became common in Europe, lasting until the mid-nineteenth century. The great silversmiths Froment-Meurice and Veyrat, among others, created spectacular preserve dishes, which took the form of a crystal basin with a lid, held in a carefully decorated metal frame with a stand. The rim was slotted to receive a dozen little spoons. Later the preserve dish disappeared from the dinner table to resurface on a much-reduced scale at breakfast, becoming a discreet, little covered crystal pot with a silver-plated lid. The lid sometimes had a notch in it for a jam spoon.

The Cookie Jar

This was probably an English invention: a beautifully wrought object made of porcelain or cut or pressed crystal, with a silver mounting, handle, and cover. It was shaped like a small barrel, or was plainly cylindrical, square, or rectangular.

TIPS FOR COLLECTORS

Sugar shakers are rare; Rouen porcelain baluster-shaped shakers are particularly sought after.

By contrast, there are plenty of crystal preserve dishes, which make excellent fruit bowls.

3.

4.

5.

6.

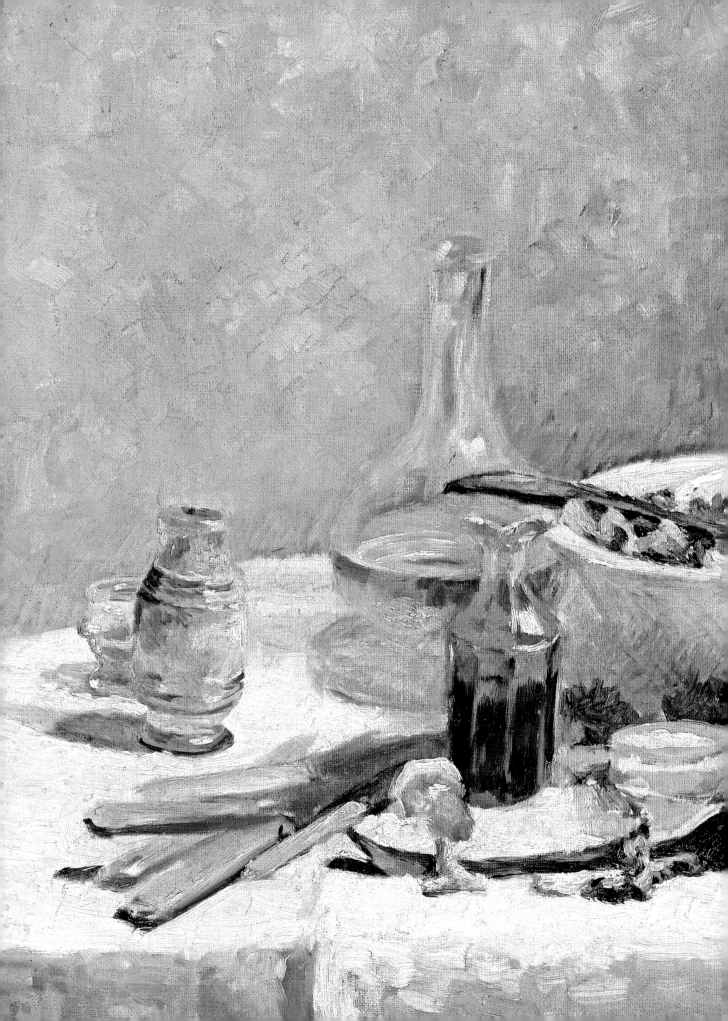

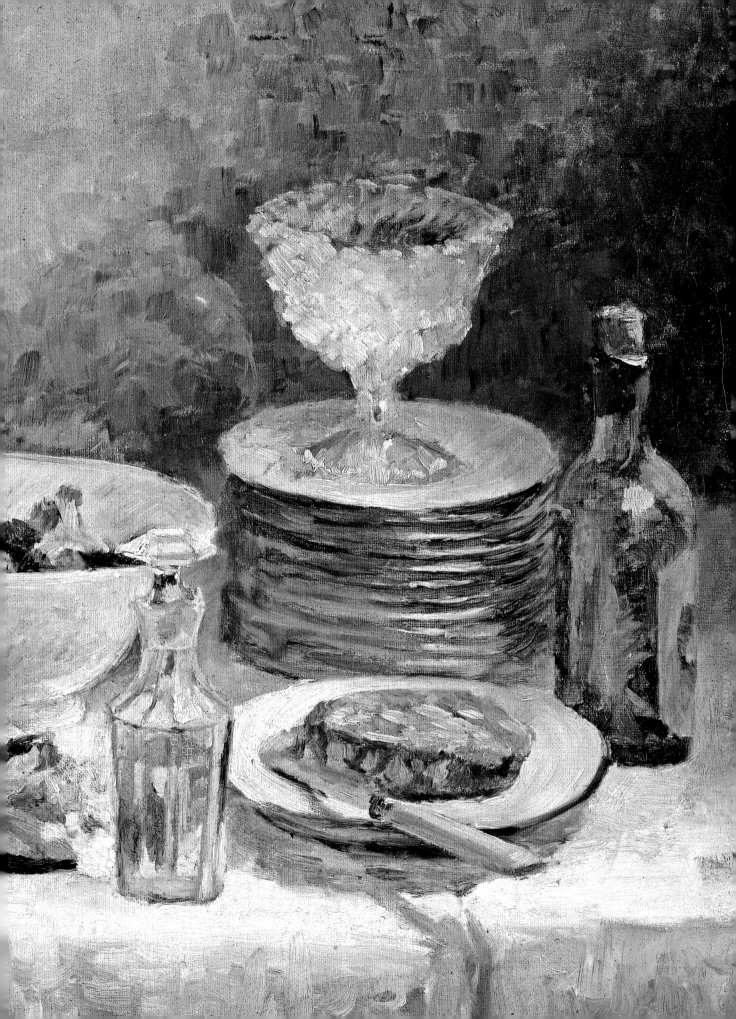

Acknowledgements

Christian Sarramon wishes to express his warm gratitude to the following people, who allowed him access to their collections or otherwise helped with the photographs for this book:

Inès, Béatrice Augié ("Jardin Secrand," Deauville), Ysabel and Pierre Bels, Safia Bendali, Élisabeth Brac de La Perrière, Franck Delmarcelle, Clodine Demoncheaux, Denise and Jean-Marie Derisbourg, Martine de Fontanes ("La Maison d'Uzès," Uzès), Brigitte Forgeur, Christine and Michel Guérard (Eugénie-les-Bains), Dorothée de la Houssaye, Jean-François Le Guillou (Marché Vernaison, Saint-Ouen), Anne-Marie Mesnil ("La Maison de Tara," Boissy-Maugis), Béatrice Pelpel, Chantal and François Perrard, Pascale and Philippe Pierrelée, Nello Renault, Caroline de Roquemaurel, Caroline de Roquette, Jean-Claude Roucheray, and Catherine Synave. Special thanks, also, to L'Argenterie de Turenne (Paris) and la Maison d'Horbé (La Perrière, Orne).

The publishers are particularly grateful to Anne Gros and Magali Lacroix, of the Musée Christofle (Saint-Denis), to the Manufacture de Porcelaine Haviland (Limoges), and to the Musée de Sarreguemines. These institutions placed their archives and photographs at our disposal. Special thanks are also due to Sylvie Gabriel, who kindly gave access to material from the Photothèque Hachette.

Photography Credits

Editorial Director: Odile Perrard
with collaboration of Aurélie Dombes, Florence Renner,
Nathalie Lefebvre, and Clémentine Petit
Art Director: Sabine Houplain
Art Assistant: Laurent Nicole
Design and Layout: Ellen Gögler
Production: Nicole Thiériot-Pichon
English Translation: Anthony Roberts
Color Separation: Reproscan, Italy

First published in the United States of America in 2006 by
Rizzoli International Publications, Inc.
300 Park Avenue South
New York, NY 10010
www.rizzoliusa.com

Originally published in French in 2005 as
La Passion des Arts de la Table by
Èditions du Chêne
A division of Hachette Livres
43 quai de Grenelle
75905 Paris Cedex 15
France

© 2005 Èditions du Chêne

ISBN-10: 0-8478-2844-1
ISBN-13: 978-0-8478-2844-9

Library of Congress Control Number: 2006925128

2006 2007 2008 2009 / 10 9 8 7 6 5 4 3 2 1

Printed in China